i **blu** pagine di scienza

Angelo Adamo

Pianeti tra le note

Appunti di un astronomo divulgatore

 Springer

ANGELO ADAMO
Bologna

Collana *i blu - pagine di scienza* ideata e curata da Marina Forlizzi

ISBN 978-88-470-1184-7 e-ISBN 978-88-470-1185-4

DOI 10.1007/978-88-470-1185-4

Coordinamento editoriale: Barbara Amorese
Curatore scientifico: Massimo Calvani, INAF Osservatorio Astronomico di Padova
In copertina: *Velocità di fuga*, Angelo Adamo
Progetto grafico della copertina: Simona Colombo, Milano
Rielaborazione grafica: Ikona s.r.l., Milano
Impaginazione: Ikona s.r.l., Milano
Stampa: Grafiche Porpora, Segrate, Milano

Stampato in Italia
Springer-Verlag Italia S.r.l., via Decembrio 28, I-20137 Milano
Springer-Verlag fa parte di Springer Science+Business Media (www.springer.com)

Ai pianeti del mio personale universo affettivo-tolemaico:
a quelli prossimi, che vedo spesso;
a quelli poco più in là, che vedo più di rado;
e a quelli che – mi piacerebbe fosse così – mi seguono lentissimi
scrutandomi dal buio nel quale da un po' si celano.

Indice

Astronomia e dialetti 1

 Preludio
 Come leggere una partitura 6

Una cipolla di vetro: l'Universo Swarovski 10

Gravità, mele e cipolle 32

 Intermezzo
 Galileo + Keplero = Newton! 62

La gocciolina di Mercurio 64

Venere: le fregature della bellezza 80

 Interludio
 Giuseppe, un pianeta senza tempo 96

La Luna, lo specchietto retrovisore 98

 Improvviso
 Evasioni planetarie 112

La Terra, il covo dei cafoni 118

Marte, la terra promessa (ma non ancora mantenuta!) 138

I mattoni avanzati: la Fascia degli asteroidi 162

Giove, il gigante o la bambina? 174

Saturno, la lama rotante 194

Urano, il corpo... celeste! 208

Intermezzo
Spazz-Aree: fondamenti di scopone scientifico 222

Nettuno, il pianeta venuto dal freddo... calcolo 226

Plutone, il bocciato 234

La fascia di Kuiper e la nube di Oort: confini? Steccato? 242
Fortificazioni? Gabbia?

Coda o Epilogo 254

Appendice A - Indice delle illustrazioni 262

Appendice B - Un po' di numeri 268

Ringraziamenti 270

Biblio-disco-filmo-web-grafia 272

Astronomia e dialetti

(…) Ma io devo dibattermi attraverso i metri, e nomi di cose
sconosciuti e periodi dell'anno e casi diversi e movimenti
del cosmo e vicende di segni e partizioni che sono
nelle partizioni. Al limite delle forze il saperne: come darne conto?

35 Come farlo in poesia originale? Come connetterlo a schemi di verso?
Qua sopraggiungi, o chiunque sei in grado di porgere orecchi
e occhi al mio tentativo, e cogli la voce del vero.
Dà fondo al tuo intelletto e non t'aspettare dolcezze di canti:
non ammette ornati una materia paga solo d'essere esposta.

40 E se qualche termine verrà riportato in lingua straniera,
l'opera ne sarà responsabile, non il cantore: non ogni cosa è possibile
tradurre e meglio la si definisce con l'espressione originale.

 Manilio, *Il poema degli astri* (Astronomica) Libro III

Spero che questo libro verrà posto in uno scaffale di testi scientifici, in quella sezione strabordante di meravigliosi resoconti astronomici, zeppi di incredibili fotografie regalateci da quasi vent'anni di uso del Telescopio Spaziale Hubble nonché da decenni di attività degli altri potentissimi telescopi di terra posti a La Silla, a Cerro Paranal, a La Palma, in sud Africa…

Una cosa che però, a mio parere, purtroppo manca è qualche pubblicazione che ancora abbia il sapore di quelle su cui ho cominciato a sognare da bambino. Erano libri illustrati con tecniche non sempre iperrealiste – quelle in voga oggi, per intenderci – ma di stampo più fumettistico. Imprecise, se vogliamo, ma magiche. Non intendo ovviamente scagliarmi contro l'uso di fotografie o illustrazioni estremamente aderenti al vero che hanno donato e donano alla ricerca astronomica e alla sua divulgazione un nuovo corso. Anzi. Vedere le cose esattamente come stanno permette di studiare meglio i fenomeni anche se a grande distanza, stimolando in modo adeguato la curiosità dei lettori abitanti un mondo che è comunque sempre più abituato alla precisione e alla spettacolarizzazione di tutto; qualcosa che, in altre sedi, sfrutto anche io. Quello che viene a mancare invece – perché

qualcosa si perde sempre – è la possibilità di avere un forte punto di vista grafico. L'illustrare senza cercare di riprodurre fedelmente l'oggetto – una cosa che moltissimi professionisti oggi sanno fare egregiamente – ma introducendo nelle immagini ciò che la Natura non ha creato se non nella mente di chi disegna, costituisce forse un plusvalore che, andandosi ad aggiungere alla vasta collezione di immagini veritiere, precise, esaustive, non può che dirottarci nella direzione di un arricchimento del quadro generale. Quindi anche l'immagine realistica può stimolare tantissimo la ricerca e la fantasia. Ma quest'ultima mi sembra possa essere messa in moto in misura maggiore se l'immagine cerca di riprodurre una suggestione più che un dato, alimentando un processo creativo simile a quello che differenzia un romanzo da una cronaca asettica. L'eminente psichiatra Eugéne Minkowski, nel suo saggio *Verso una cosmologia*, si chiede: "(…) perché e come l'uomo giunge a cantare la natura?" E continua rispondendosi provocatoriamente che

> Già abbiamo indicato il tipo di risposta offerto dallo scienziato a questa domanda. Il poeta popola la natura di immagini da lui stesso create, così come – e non ci vuole molto a stabilire un paragone simile – il primitivo popola la natura di divinità e di creature che sono il frutto della sua immaginazione. E c'è motivo di credere, in questa prospettiva, che l'uomo, progredendo ancora, riuscirà un giorno a disfarsi completamente di questa fastidiosa inclinazione alla poesia, così come si è disfatto in passato delle superstizioni e credenze primitive, per assumere infine un atteggiamento puramente scientifico ["astronomico" nel testo originale (N.d.A.)].

Ritengo risulti abbastanza chiaro che la prospettiva di perdita di poeticità sarebbe un disastro, anche perché sono portato a credere che in Natura nulla sopravviva alle dure leggi selettive se non si rivela in una qualche misura utile. Sono quindi altresì convinto che, nell'essersi sviluppata ed evoluta spontaneamente nell'uomo e nell'essere sopravvissuta per milioni di anni una così spiccata intelligenza emozionale, risieda, ancora celata ai nostri occhi, una utilità fondamentale la quale, assieme ad altre caratteristiche fisiche e mentali più facilmente oggettivabili, ha decretato il nostro successo in un ambiente tutto sommato molto ostile.

Non mi trovo ancora d'accordo con il Minkowski quando, poco più avanti nel testo, concede: "Siamo chiari ad ogni modo: la scienza non sa che farsene della poesia". È indubbio che sia molto difficile ricreare il percorso delle idee scientifiche moderne per ritrovare il germe primigenio da cui hanno preso le mosse. In molti casi però si ha chiara la percezione che a monte di nostre acquisizioni "certe" vi siano concezioni, immagini, spiegazioni errate, generate proprio da sviste, paure e superstizioni che hanno costituito il corpo della conoscenza prima dell'avvento di quella che oggi chiamiamo, spesso atteggiandoci con un certo tronfio compiacimento, scienza. Senza volere in nessun modo dare l'idea di vagheggiare la necessità di tornare a posizioni oscurantiste che troppo a lungo hanno bloccato il cammino

della comprensione della Natura e che, mai sopite, continuano ad assediare il nostro mondo, allettandolo a ogni suo pericoloso oscillare verso questa o quella facile millanteria, nondimeno mi sento in debito verso tutti coloro i quali in modo sincero, timido e senza pretese politiche, commerciali o didascaliche, hanno dato spiegazioni della Natura con linguaggi tra i più disparati. Pittori, musicisti, registi, narratori, hanno misurato il mondo con le loro pellicole, le loro tinte, le loro note e le loro parole; tutte descrizioni che, se prese insieme al linguaggio scientifico loro complementare, non indeboliscono la nostra comprensione del cosmo, bensì l'arricchiscono di cose che la misurazione – intesa solo come processo fisico – non può darci. Fare scienza può essere sintetizzato in qualche modo con "descrivere spiegando e prevedendo". La scienza ha quindi in comune con le altre attività il descrivere, che spesso ha valore di teorema, di spiegazione. Tanta fantascienza ha addirittura descritto mondi, spiegandoli e prevedendo un corso che solo molto a posteriori si è verificato. Inoltre si pensi a tutte le scienze che ancora si muovono in una melma tassonomica, senza riuscire a distillare una qualche legge universale capace di riassumere in pochi tratti essenziali tutto l'oggetto della loro ricerca, come invece avviene nelle discipline scientifiche cosiddette "dure". In effetti, a ben vedere, sembra che io mi sia dimenticato di un'altra caratteristica fondamentale del processo di indagine scientifica, forse quella più importante e che va sotto il nome di "riproducibilità". Con questo termine si indica in ambito scientifico la normale prassi che prevede di mettere alla prova una nuova teoria scientifica, cercando di riprodurne le conseguenze in più laboratori e da più sperimentatori, così da corroborarne la validità in luoghi e tempi differenti. Bene, moltissime opere d'arte considerate patrimonio dell'umanità hanno superato proprio questo genere di esame, almeno presso la razza umana. Hanno quindi conquistato lo statuto di "universalità" e vengono annoverate tra "i fatti" che caratterizzano il sentire artistico della nostra specie. Questo significa che, nonostante oscillazioni ineludibili del gusto dipendenti dal periodo storico e dai singoli individui, esse fanno registrare da sempre la stessa misura "media" allo strumento uomo, venendo considerate come universali dell'arte. Inoltre vengono da sempre riprodotte permettendo così di riverberare gli effetti di questa misurazione in tutto il globo, come già nel 1955 ci spiegava Benjamin nel suo saggio, oramai un classico, *L'opera d'arte nell'epoca della sua riproducibilità tecnica*, al giorno d'oggi quanto mai attuale.

Questo libro sarà incentrato sul Sistema Solare, ma cercherò di darne una spiegazione che passerà, con una traiettoria che non pretende di certo di essere *geodetica* ma semplicemente vorrebbe essere affascinante (geodetica per lo spirito?), attraverso alcune delle spiegazioni congiunte fornite di volta in volta da diversi scienziati, scrittori, musicisti a cui aggiungerò il mio contributo sotto forma di idee forse (spero) originali e di illustrazioni.

Il procedere della narrazione per immagini scorrerà parallela al testo e alla musica. Sarà la narrazione di quelle visioni regalatemi dal frequentare sovente le tematiche astronomiche e costituirà la "colonna visiva" di accompagnamento al testo, mentre quell'altra, quella sonora, continuerà il suo corso sotto a tutto il resto. A ben vedere, questo libro potrebbe essere riguardato come uno *story-board* di un film sul Sistema Solare o comunque come un

documentario congelato su pagine, in fotogrammi. E, così come accade nei format televisivi, i vari linguaggi – i "dialetti" mentali, ognuno dei quali è più adatto degli altri a raccontare le suggestioni da sempre di sua competenza – si contenderanno il primo piano nella pagina. Quando verrà fuori la musica, il volume delle immagini e del testo verranno abbassati per poi tornare più alti quando saranno testo o immagini a dovere urlare.

Nel testo saranno ovviamente importanti i dati scientifici, non potrebbe essere altrimenti. Ma una cosa che mi premeva fare era proprio non continuare a schiacciare un libro che parla di un argomento classicamente "più" scientifico, perché da sempre è visto così, sull'unica dimensione del discorso fisico-matematico.

Ancora una volta posso permettermi di attuare un'operazione di tipo diverso perché consapevole che vi è una quantità enorme di ottimi libri tecnici, molti dei quali saranno citati nella bibliografia, estremamente precisi nel descrivere tutti gli argomenti che andrò a toccare nella mia trattazione. Quello che invece mi interessa in questa sede è tentare di dare un quadro a più dimensioni di ciò che sappiamo circa il Sistema Solare, mettendo in evidenza come siamo arrivati a saperlo non solo grazie agli scienziati, ma anche agli scrittori, ai registi, agli illustratori e disegnatori di fumetti, agli inventori, ai politici e a tutti i visionari che in ogni periodo storico guidano, ispirano e trainano la società verso le nuove mete. Qualcuno ha affermato che "tutte le scienze sono cosmologia". Amplierei il concetto aggiungendo che, operando in questo cosmo e con gli elementi che esso ci propone (tra questi annovero anche i nostri neuroni e il loro misterioso connettersi in modo creativo), ogni attività di indagine è, in ultima analisi, cosmologica. E infine, *mutatis mutandis*, la scienza è anche arte; la scienza è emozione, un'emozione fortissima che va perfettamente d'accordo con immagini, musiche, parole... esattamente come tutte le altre nostre attività. All'imprecisione della descrizione artistica del resto fa eco l'imprecisione di molte nostre misure condotte sulla grande scala del cosmo in cui viviamo. Misure che, ottenute spingendo il nostro sguardo fino a miliardi di anni luce da noi, necessariamente possiedono barre di errore che raggiungono anche il dieci per cento del valore della nostra stima. L'uomo quindi, a mio modesto parere, è solo un complicato strumento di misura, grossolano e qualitativo, con grande sensibilità e grandi velleità quantitative. Egli misura tutto, di continuo e, al di fuori dei laboratori scientifici, similmente a quanto rappresentato da Leonardo con il suo *Uomo Vitruviano*, continua a riportare la realtà alle proprie categorie e alle proprie dimensioni. Una tendenza comune anche agli scienziati, i quali, in quanto uomini che vivono in società, non ne sono affatto immuni. In definitiva, non vi è scienza senza economia, politica, istruzione, sport. E, parimenti, non vi è avanzamento di tutta la società senza la scienza. Essa scorre sotto la pelle del tessuto sociale e stiamo imparando a valutarla con criteri economici da quando sappiamo che alcuni dei tanti problemi che affliggono la nostra società sono "la fuga dei cervelli" e "i tagli alla ricerca", facili slogan entrati nel patrimonio fraseologico di chiunque con il loro carattere negativo. Tutto ciò ha avuto almeno il pregio di restituire al ricercatore una dimensione umana che da sempre gli è stata negata dall'opinione pubblica. Gli si preferiva quella di studioso in camice bianco che, im-

maginato lontano dalle distrazioni mondane, lavora su una realtà astrusa ma, dicono, comunque utile. Oggi ancora a molti non è chiaro cosa esattamente sia il mondo della ricerca e l'unica cosa veramente chiara è che la scienza è un'attività che non paga, con la quale non ci si arricchisce se non da un punto di vista intellettuale, qualcosa che non prevede ancora una quotazione esplicita in borsa in termini di MIBTEL o di PIL. Questo libro nasce quindi come una collezione delle cose che spesso racconto da astronomo che si occupa di divulgazione e che ha avuto modo di vedere che funzionano, che fanno presa sul pubblico perché donano una dimensione umana al procedere della ricerca scientifica percepita di solito così lontana. Divulgare, a mio parere, non è solo tradurre con parole semplici ciò che di solito viene detto in modo complicato. È anche mostrare di continuo che la scienza ci somiglia; che è storia, ovvero racconti di individui che fanno scienza, di quelli che ne vengono toccati in seconda battuta e anche di quanti a volte la subiscono. Così facendo, si può arrivare anche a scoprire che spesso divulgare non è solo spiegare a chi non sa, ma risulta avere il carattere del *puro spiegare*, cosa che di solito immaginiamo sia appannaggio del solo discorso fisico-matematico usato da chi la ricerca la fa davvero.

Auspicherei a questo punto l'ingresso nel nostro patrimonio linguistico di slogan positivi, che connettano non solo la scienza alla dimensione economica, ma anche a quella storica e culturale in generale, perché un giorno abiteremo su Marte e, per chi si trasferirà sul pianeta rosso, esso non sarà più solo un corpo solido orbitante a duecentoventi milioni di chilometri dal Sole, ma sarà anche paesaggi romantici, malinconie, lotte politiche, economia, cronaca, gossip, amori…

Asiago, settembre 2008 Angelo Adamo

PRELUDIO

Come leggere una partitura

Tutta la nostra esistenza si svolge nel tempo, esso ci domina. Mi sento di dire che viviamo *nel dominio del tempo* e, se ne avrete *il tempo*, soffermatevi *per un po'* a meditare su queste parole. Come tutte quelle udibili in Natura, anche le nostre voci si odono nel tempo e in esso vengono modulate; molti degli strumenti musicali sono stati inventati nel tentativo di riprodurre i timbri naturali, quelli degli uomini e degli animali, e per comprendere meglio quanto dico, vi invito ad ascoltare il brano *Pierino e il lupo* di Serge Prokofiev nel quale a ogni strumento viene associato un personaggio di una semplice fiaba. La musica così diventa, almeno in parte, Natura spiegata e la partitura di un brano è Natura trascritta, una formula fisica particolare che associa a suoni (= frequenze) durate (= tempi) e il cui esperimento è dato dal suonare.

La fisica, quella vera, fa qualcosa di simile e con l'ausilio della matematica pone sul piano cartesiano tutto ciò che in Natura accade. Qui vi invito allora a riguardare la partitura come piano cartesiano della Natura, questa volta spiegata con la musica che tanto ha in comune con la matematica. In quest'ottica, l'ascissa sarà occupata dal tempo: esso scorrerà in modo regolare verso destra. Giunti a questo punto, vi chiedo di immaginarvi un alto condominio con tanti piani quanti sono gli strumenti dell'orchestra. Una riunione condominiale tenutasi tanto tempo fa ha stabilito che le voci più gravi devono abitare i piani bassi mentre le

altre, quelle più acute, devono progressivamente andare a occupare i piani superiori. Il sot-
totetto è quindi abitato dai flauti e, soprattutto, dagli ottavini che sono ancora più acuti. At-
tenzione: quando parlo di voci *gravi o basse* e *acute o alte* non intendo parlare di volumi ma
di frequenze. In parole povere, sto parlando della stessa differenza che vi è in Natura tra voci
maschili e femminili: di solito, le prime hanno un timbro più basso (leggi *profondo*) delle se-
conde. Allora, se l'ascissa è il *dominio* del tempo, sull'ordinata sistemeremo le altezze: tutto
il *co(n)dominio* dei suoni orchestrali. Procedendo dalla parte più alta della partitura (leggi
suoni acuti) verso il basso (leggi *suoni gravi*) incontreremo: ottavini, flauti, oboi, ..., violon-
celli, contrabbassi. In realtà, accade che i vari strumenti, piuttosto che possedere una
estensione che inizia da dove quella del precedente strumento finisce, in parte si sovrap-
pongono. Per esempio, i violini hanno note gravi in comune con le viole, le viole con i vio-
loncelli, i violoncelli con i contrabbassi.

Potremo così guardare alla musica scritta come agli andamenti delle borse o di qualche
fenomeno fisico: considerando le note per quello che sono, ovvero *punti nel piano cartesiano
della partitura*, vedremo come esse andranno a costruire rette e curve e chi si cimenterà nel-
l'ascolto dei brani che citerò nel corso del libro, sarà aiutato nel seguire la partitura dal sa-
lire e scendere dei grafici delle varie voci. Provate in un primo momento a fissarvi sul

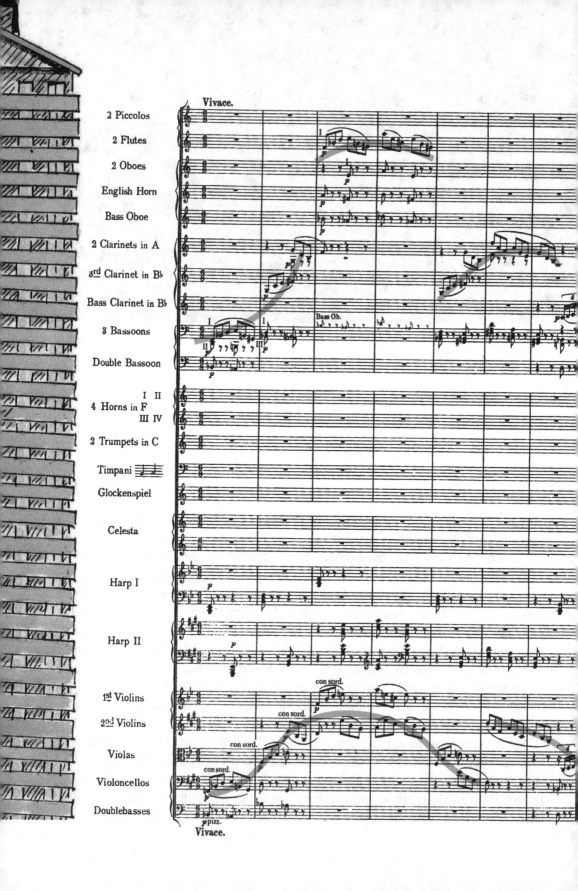

suono di uno strumento di cui conoscete bene il timbro e a seguirne l'andamento grafico: scoprirete che esso si snoderà verso destra *salendo* e *scendendo* in perfetta sintonia con l'andamento dei punti sullo spartito immaginato scritto come di seguito.

Sarebbe bello poter *ascoltare* anche gli andamenti della borsa o di qualsiasi altra cosa ci viene presentata con dei grafici, vero?

Intanto, pur non sapendo suonare uno strumento, potete divertirvi a fare musica con qualcosa di analogo: considerate la vostra auto alla stregua di uno strano strumento musicale[1] che suonerete accelerando e decelerando. Queste semplici azioni vi permetteranno di sentire che il rumore del motore diventerà rispettivamente più acuto e più grave e lo spartito sarà il vostro tachimetro. Attenti ai limiti di velocità: dicono che la vostra macchina non può urlare oltre una certa nota…

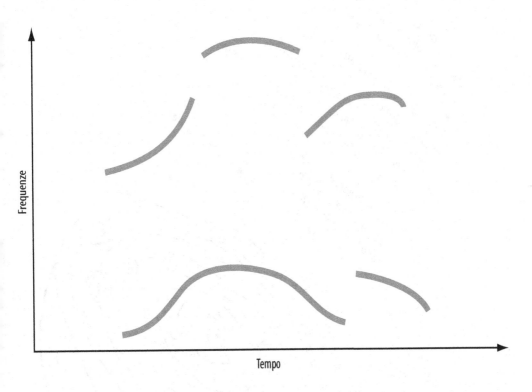

[1] Assomiglierà ai cosiddetti *intonarumori*, strumenti inventati dal musicista e pittore Luigi Russolo afferente a una corrente artistica nata esattamente cento anni fa, denominata Futurismo. Nel *Manifesto della Musica Futurista* a opera di Francesco Balilla Patella si legge:

> Portare nella musica tutti i nuovi atteggiamenti della natura, sempre diversamente domata dall'uomo per virtù delle incessanti scoperte scientifiche. Dare l'anima musicale delle folle, dei grandi cantieri industriali, dei treni, dei transatlantici, delle corazzate, degli automobili e degli aeroplani. Aggiungere ai grandi motivi centrali del poema musicale il dominio della Macchina ed il regno vittorioso della Elettricità.

Che cosa è tanto confuso in apparenza,
così tanto stabile nelle sue vicende?
(Manilio, Il poema degli astri I, 482)

Il silenzio ha in sé qualcosa di vasto,
di ampio, di grande:
riempie l'universo intero della sua gravità,
schiudendolo così dinanzi a noi
(Eugène Minkowski, Verso una cosmologia)

Le costellazioni incipriavano
il cielo nero e Giove era
una biglia luminosa
(Isaac Asimov, Lucky Starr e le lune di Giove)

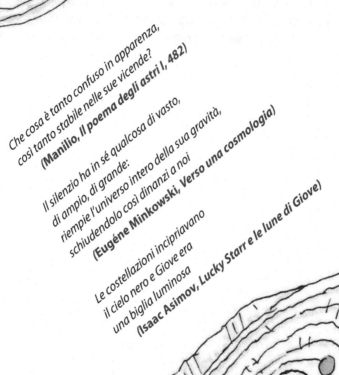

Sole
Terra
Luna
Mercurio
Venere
Marte
Giove
Saturno
Stelle fisse

Schema di universo tolemaico

Una cipolla di vetro: l'Universo Swarovski

Immaginate di essere stati uomini-scimmia vissuti all'incirca un milione di anni fa. Per inciso, in ottemperanza alle leggi sulle pari opportunità, tengo a precisare che il discorso che segue vale anche nel caso vogliate immedesimarvi in donne-scimmia.

Il tempo ve l'ho dato. Ora vi fornisco anche lo spazio di riferimento, così avrete a disposizione tutte le coordinate spazio-temporali: immaginate di essere esattamente dove vi trovate ora, proprio mentre state leggendo, cercando però di riportare mentalmente (ovvio, almeno spero vi sembri ovvio…) e in modo quanto più possibile verosimile lo spazio che vi ospita alle condizioni ambientali di un milione di anni fa. Se sarete bravi a calarvi nel personaggio e a collocarvi idealmente sul giusto palcoscenico, vorrà dire che riuscirete a riprodurre un comunque sbiadito scenario in cui la crudeltà, la violenza e la paura regnano incontrastati. Dico sbiadito perché oggi, 2009 anni dopo Cristo, siamo così tanto lontani dalla vita selvaggia che spettava ai nostri antenati, da dover essere consapevolmente sospettosi circa la nostra reale capacità di immaginarci come poteva essere davvero vivere a quei tempi. In ogni caso, apprezzo molto il vostro tentativo. Ma ora vi chiedo di riprovarci, concentrandovi stavolta su come doveva essere una notte tipica di quei *secoli bui*. L'aggettivo *buio* penso calzi benissimo alla situazione. Il buio della notte va coniugato con quello mentale che doveva regnare incontrastato nei cervelli dei nostri predecessori, qualcosa a cui fa riferimento anche Arthur C. Clarke nel suo romanzo *2001: Odissea nello spazio* nel quale descrive proprio la vita di una via di mezzo tra la scimmia e l'uomo in un'area geografica che molto più tardi diventerà l'Africa. Alto circa un metro e mezzo, peloso e muscoloso con

la testa che si avvicinava molto di più a quella dell'uomo che a quella della scimmia. La fronte era bassa, con sporgenze ossee sopra le orbite, eppure egli possedeva inequivocabilmente nei propri geni la promessa dell'umanità. Mentre contemplava fuori della caverna il mondo ostile del pleistocene, v'era già qualcosa nel suo sguardo che trascendeva le capacità di qualsiasi scimmia. In quegli occhi scuri, profondamente infossati, si celava una nascente consapevolezza. (…) Nelle caverne, tra periodi di sonno intermittente e di timorosa attesa, nascevano gli incubi di generazioni di là da venire.

Questi incubi li ritroviamo tutti nel mito tramandatoci dalla cultura greca. Un mito che il Ver-nant, grande studioso di queste tematiche, così ci racconta:

> Caos ha generato la Notte, e la Notte ha dato vita a tutte le forze del male. Lo schieramento delle forze malvagie comprende innanzitutto la morte, le Parche, le Chere, l'omicidio, la strage, la carneficina, e quindi tutti i mali come l'Afflizione, la Fame, la Fatica, la Lotta, la Vecchiaia.

Un passo che la dice lunga su quelle che sono le origini delle nostre paure ancestrali, nate molto tempo prima del mito e mai sopite. Oggi, come dimostra l'ultima citazione, sappia-mo dare diversi nomi e volti al terrore, e sappiamo farlo perché lo abbiamo visto raffigura-to tante volte in fumetti, spettacoli teatrali, film; lo abbiamo ascoltato sotto forma di colon-ne sonore di questi film; ne abbiamo parlato spesso; lo abbiamo descritto o ne abbiamo let-to la descrizione datane da qualcuno in libri, riviste; infine qualcun altro più sfortunato lo ha vissuto. È cosa di sicuro nota che, nonostante tutto, poter dare una faccia e uno o più nomi alla paura sia un grosso vantaggio, uno fra tutti quelli offerti dall'avere maturato un linguaggio costituito non da grugniti ma da una gran quantità di parole, belle o brutte, ma in ogni caso adatte a tutte le occasioni. A complicare la situazione di quel tempo lontano quindi bisogna registrare anche l'assenza di termini adeguati per esprimere qualsiasi cosa e, in particolare, questo stupore misto a timore e rispetto. Vi sarebbe tornato utile per descrverlo e magari, parlandone, per stigmatizzarlo, per farvelo in qualche modo amico; farlo vostro. In parole po-vere, *in principio era il caos*, e voi vivevate nel caos. Addirittura il caos era in voi. Un Caos che più che essere una divinità come lo diventerà in seguito, ritengo che all'inizio possa essere stato quel particolare disagio generato dall'ingresso di una quantità enorme di dati attirati dal vuoto pneumatico dei vostri cervelli privi di idee e schemi preconcetti sulla realtà.

Non offendetevi: state ancora giocando a immedesimarvi. Tutti gli acutissimi sensi dei no-stri antenati registravano di continuo l'ingresso di una cateratta di informazioni su una realtà glo-balmente ignota e da comprendere in fretta per costruire un catalogo di eventi da elaborare.

Insomma, se vi siete immedesimati al meglio, avrete scoperto che ancora non conoscete nul-la o quasi e, proprio per questo, nulla o quasi nulla possiede un nome. Vivete un mondo in cui tutto può in potenza celare un pericolo; un mondo in cui tutto sembra più forte di voi, in cui tut-to ciò che vi circonda vi incute paura e rispetto con la sua forza, tanto da indurvi *presto* a teo-rizzare che "tutto sia pieno di dei" da ingraziarsi in un modo… che ancora dovete scoprire.

Il mito contempla la Voragine che genera l'Erebo, il nero più assoluto. Ecco il buio del-la notte mentale, quello offerto dalla vera ignoranza di menti che devono al più presto ap-prontare dei modelli per comprendere la realtà esterna così da averne in una prima fase meno paura e, in quella successiva, da elaborare strategie per dominarla.

Ed ecco perché non credo che noi oggi siamo adatti a capire cosa possa essere stata la notte preistorica. Una notte gelida, spietata. Una notte in cui la colonna sonora scritta dal-la Natura stessa è costituita da rumori, versi di animali, fruscii del vento. Tutti elementi po-

tenzialmente pericolosi e quindi importanti, tutti protagonisti degli incubi a occhi ben aperti dei nostri predecessori. Tra l'altro, chiedo scusa a coloro i quali sanno leggere la musica e vogliono seguire lo sviluppo della colonna sonora di questo libro, ma al momento non possiedo lo spartito dei rumori primordiali, anche se so che più di un compositore ha tentato di scriverlo. Prometto che mi farò perdonare nelle prossime pagine.

In *Il poema degli astri* del grande poeta latino Manilio, ritroviamo un tentativo di immedesimazione nei panni di uomo-scimmia o comunque di uomo primitivo di fronte allo spettacolo della notte. Il poeta nel Libro I della sua opera descrive come essa potesse apparire a chi l'ha vissuta senza le protezioni offerte dalla civiltà:

66 Infatti, prima di loro[1] la rozza esistenza, senza distinguere nulla,
 era volta all'apparenza, mancandole il senso di quell'operare,
 e stupefatta restava allo strano illuminarsi del cielo,
 ora dolendosi come d'averli perduti, ora lieta del rinnovarsi
70 degli astri, e che vari fossero i giorni e non fissi i tempi
 della notte e dissimile il buio coll'arretrare ora del sole
 ora col suo accostarsi, neanche potevano discernerlo nelle sue cagioni.
 Né aveva ancora l'applicazione suscitato tecniche e conoscenze
 e la terra si estendeva desolata sotto i coltivatori inesperti; (…)

Secondo quanto egli afferma, quindi, ci si poteva dolere della perdita quotidiana della vista degli astri notturni, un sentimento che mi pare possa essere solo di molto successivo al periodo storico al quale egli stesso si riferisce. Trovo comprensibile che la pensi così, dato che nei primi versi del suo poema dichiara il proprio intento:

 Mi volgo con questo mio canto a trarre dall'universo le arti
 arcane, le stelle consce del destino che variano
 i differenti casi degli uomini, attivo effetto della ragione
 celeste, e a sollecitare per primo con parola inaudita
5 l'Elicona e le sue selve, trepide nelle verdi cime,
 peregrine offerte non evocate innanzi da alcuno.
 (…)
 Pure è poco il sapere da solo. Più assai mi è caro conoscere
 fino nell'intime fibre il segreto della potenza dell'universo
 e discernere a quali figure sideree si debba il governo
 di ciascuno degli esseri, e la genitura, e volgerlo in ritmi ispirati da Febo.

[1] Il poeta si riferisce ai "sacerdoti eletti per pregare a nome del pubblico bene", ovvero i primi osservatori mediorientali del cielo di cui ci è giunta notizia.

In parole povere, vuole proprio cantare stelle e pianeti e la loro presunta influenza sulle umane vicende scoprendosi così costretto a trovare esaltante la notte stellata e dimenticandosi di immedesimarsi davvero con quanti molto prima di lui la notte l'hanno vissuta subendola, senza ancora capirla fino in fondo.

In questo tentativo di mettere ordine – ed è interessante notare che in greco la parola ordine trova traduzione in *cosmo* – tra i dati che arrivavano alle menti ancora ubriache per l'incredibile sbornia di informazioni, penso sia stato facile sentirsi sempre sull'orlo della follia, della voragine mentale che, in men che non si dica, avrebbe ricondotto tutto al Caos primigenio. Il solito Vernant ci ricorda che anche la Terra – nella sua definizione *il pavimento del mondo* – è stata generata da Voragine, dal Caos, divinità mai sopite e del tutto sconfitte, che saranno sempre pronte a prendere il sopravvento. All'epoca c'era di sicuro bisogno di certezze,

un articolo che suppongo a quei tempi scarseggiasse, si era precari (!). Tra le poche cose certe, i nostri antenati avranno di sicuro annoverato il riferimento solido e rassicurante su cui tutto e tutti poggiavano e sul quale anche i sensi concordavano: l'esistenza del duro terreno. *Il pavimento del mondo* di cui sopra era quindi stato scoperto. Una scoperta che sottolineerei con la nota di fondo con la quale si apre il brano *Also sprach Zarathustra* di Richard Strauss, ispirato allo scritto omonimo di Nietzsche e composto nel 1896, un'epoca in cui la grandiosità delle opere umane veniva celebrata con le prime esposizioni universali. Un do bassissimo, cupo e continuo, suonato dai contrabbassi, dall'organo, dal controfagotto e dai timpani, prelude all'ingresso degli altri strumenti più squillanti sul finire della sesta battuta.

Non sono poi così originale in questa scelta, anzi. Purtroppo sono stato preceduto da un regista, un certo Stanley Kubrick, il quale ha usato le prime ventuno battute del brano come ideale commento per le scene del film tratto dal già citato romanzo di Clarke. Sono scene nelle quali, guarda caso, per la prima volta un barlume di idea sintetica si fa strada nella mente di un uomo scimmia.

Finalmente, una volta scoperto il pavimento del mondo, ci si poteva concentrare su altri elementi essenziali, come per esempio ciò che stava in alto, il tetto a volta del mondo: il cielo oggetto di questa trattazione. Un cielo traduzione di *Ouranòs*, uno dei figli di Gaia, generato quindi dalla stessa Terra e che comprendeva sia i fenomeni meteorologici che il cielo stellato. In fondo è comprensibile che il cielo non fosse suddiviso in atmosfera e spazio esterno, dato che ancora non si sapeva di vivere in una bolla d'aria minuscola sperduta in uno spazio immenso. Questa seconda scoperta inerente al punto più alto della realtà la farei corrispondere al punto più alto del brano di Strauss. Tutto sommato, mi sembra una buona idea.

Ebbene, su questo scenario parato dinanzi agli occhi di chi ci ha preceduto, dominavano incontrastate le stelle. Una quantità enorme di astri, un numero oggi assolutamente inimmaginabile non perché ai nostri giorni siano diminuite in numero, ma per-

ché i nostri lontani predecessori ancora non sapevano produrre la quantità esagerata di luce che l'uomo moderno proietta stupidamente in tutte le direzioni, concorrendo con le stelle a illuminare la sua realtà. Questi numerosissimi punti luminosi, apparsi per la prima volta a menti molto semplici, devono avere destato sensazioni che difficilmente possiamo pensare di ricostruire anche solo a grandi linee. Forse un modo c'è, e trovo che possa essere suggerito dall'analisi che compie Wassily Kandinsky nel saggio *Punto, linea, superficie* del 1926. In esso, il grande artista tenta una riduzione della pittura agli elementi fondamentali e alle loro relazioni reciproche, nel tentativo di regalare alle arti grafiche una solida base scientifica che ancora agli inizi del '900 tardava ad arrivare, mentre l'architettura e la musica, forti della loro formalizzazione matematica, già possedevano. Nel perseguire il suo obiettivo di uno studio scientifico dell'arte pittorica a partire dai suoi elementi costitutivi più semplici, Kandinsky prova quindi a riscoprire le ragioni primitive del nostro interpretarli e, senza volerlo, con questo forse ci indica la via giusta per intendere la sensazione non verbalizzata vissuta dalle prime menti che hanno registrato la presenza di stelle. Per esempio, parlando del punto, scrive:

> È sufficiente un punto per creare un'opera? Si danno due possibilità. Il caso più semplice e più essenziale è quello del punto che sta al centro della superficie di fondo (…). L'attenuazione dell'effetto della superficie di fondo raggiunge qui il suo massimo (…). Il doppio suono – punto, superficie – prende il carattere di un *unisono*: si può, in una certa misura, non tener conto del suono della superficie. Questo è il caso estremo di semplificazione attraverso la dissoluzione progressiva dei suoni doppi e multipli, con eliminazione di tutti gli elementi più complicati – riduzione della composizione al solo elemento originario. Così questo caso rappresenta il *prototipo dell'espressione pittorica*. Ecco la mia definizione del concetto di "composizione": La composizione è la *subordinazione interno-funzionale* 1. dei singoli elementi e 2. della struttura (costruzione) al *fine pittorico concreto*. Dunque: se un unisono in-

> carna in modo completo il fine pittorico dato, l'unisono deve, in questo caso, essere equiparato a una composizione. In questo caso l'unisono è una composizione. (…) Il doppio suono diventa percepibile nell'istante dello spostamento del punto dal centro della superficie di fondo come: 1. suono assoluto del punto, 2. suono del luogo dato della superficie di fondo.
>
> Questo secondo suono, che nella struttura centrale è stato soffocato fino al silenzio, diventa di nuovo percepibile chiaramente e trasforma il suono assoluto del punto in suono relativo. (…) Poiché, inoltre, il punto è un'unità complessa (la sua grandezza + la sua forma), ci si può facilmente immaginare quale tempesta di suoni si sviluppi sulla superficie, se si accumulano punti in misura sempre crescente – anche se questi punti sono uguali – e come si allarghi sempre di più questo processo tempestoso, se, nel suo corso ulteriore, sono gettati sulla superficie punti che presentano disparità sempre maggiori, sia di grandezza sia di forma.

Mi sembra che, al di là della necessaria complicazione adottata nel brano precedente, si possano comunque scorgere in esso elementi fondamentali per il fine che mi sono prefisso: cercare di capire la sensazione generata da un'osservazione del cielo stellato che sia ingenua, che non poggi su nulla di preconcetto. In fondo, il cielo altro non mostrava se non una distribuzione di punti giudicabile a prima vista disordinata, qualcosa che oggi potremmo battezzare come "gas" di stelle (tra l'altro pare che la parola *gas* nasca dalla più antica *caos*). Per antichi osservatori, il silenzio del cielo connesso al buio dello sfondo, disturbato da quello che oggi, guarda caso, spesso indichiamo come "rumore stellare", forse ha generato inconsce categorie molto simili a quelle descritte nella citazione.

Trovo divertente che John Cage, caposcuola delle avanguardie musicali e teorico di un certo ritorno della musica alla Natura e alla innocenza di un ascolto puro, non condizionato da secoli e secoli di cultura musicale (personaggio divenuto famoso anche per i suoi sforzi tesi a registrare i suoni dell'ambiente naturale), nel 1960 abbia deciso di dare una traduzione sonora proprio di un catalogo stellare nella sua opera per orchestra *Atlas Eclipticalis*. La durata e l'intensità delle note della composizione vengono stabilite dalla magnitudine delle stelle appartenenti al catalogo, qualcosa che, nonostante Cage non abbia mai parlato del testo *Punto, linea, superficie*, restituisce una certa concretezza al discorso di Kandinsky sul *suono* di punti che si stagliano netti su superfici caratterizzate da un suono diverso, più basso in volume. Volume sonoro e intensità luminosa vengono messi così in stretta relazione, proprio come avviene nella legge psicofisica di Weber-Fechner Kandinsky[2].

[2] La legge psico-fisica ci dice che la variazione di percezione di uno stimolo procede logaritmicamente, ovvero la percezione P è uguale a una costante di proporzionalità k per il logaritmo dello stimolo S:

$$\text{Percezione} = \text{Cost} \cdot \log (\text{Stimolo})$$

che risulta essere alla base della percezione del mondo come ci viene fornita dai nostri sensi. Gli occhi che hanno osservato il cielo, sera dopo sera, per milioni di anni, come spettacolo unico imposto loro dalla Natura, connettendolo forse ai suoni tipici dell'ambiente naturale da loro occupato, hanno imparato a notare differenze notevoli di luminosità fra le stelle a prima vista tutte uguali, ed è molto probabile che, a causa della similitudine tra i nostri meccanismi di elaborazione degli stimoli esterni ben esemplificata nella legge psicofisica, abbiano percepito questa certa analogia tra luce e suono, tra differenze di luminosità e differenze di volumi sonori. In seguito a questa acquisizione inconscia, i nostri antenati scoprirono il vantaggio offerto dal connettere i punti più luminosi con linee immaginarie, che gli permisero di ignorare con più facilità il rumore stellare delle stelle meno luminose, e questo li condusse a scorgere in cielo sagome riproducenti elementi del loro vivere sulla Terra. In pratica, sto parlando di quella tipica tendenza umana che va sotto il nome di *pareidolia* e che ci permette di trastullarci con i passatempi contenuti in varie riviste di giochi che propongono "Congiungete i punti da uno a cento e vedrete cosa apparirà" o simili. Una facoltà che usiamo anche nel riconoscere nella forma di una nuvola la sagoma di una zia lontana o di un tostapane e che deve avere avuto anche essa un certo valore ai fini evolutivi e di selezione naturale[3]. Va da sé che gli elementi della quotidianità di un nostro antenato devono avere presentato qualche differenza con quelli della nostra, ed è così che, per esempio, una delle

[3] Mi preme qui citare il celebre P.J.E. Peebles:

> Nel valutare il significato fisico del pattern, si deve tenere conto della tendenza dell'occhio umano a scorgere forme ordinate anche nelle distribuzioni caotiche. (Deve trattarsi di un vantaggio evolutivo il fatto che l'occhio sia così tanto adatto a distinguere la sagoma di un leopardo tra gli alberi, e che, in caso di errore, accidentalmente tenda a scorgerne di inesistenti piuttosto che mancare di vederne uno reale).
>
> P.J.E. Peebles, *Principles of Physical Cosmology*

prime costellazioni – se non addirittura la prima – *intraviste* in cielo è quella che raffi-
gura il grande cacciatore Orione.

Fino al 10.000 a.C. l'uomo ha tratto sussistenza dalla sola attività vena-
toria e quindi per lui la cosa più facile da scorgere in cielo a quel
tempo doveva essere proprio se stesso che cacciava
animali (vedi la lepre e il toro, costellazioni vi-
cine a quella di Orione) accompa-
gnato dai suoi cani (anco-

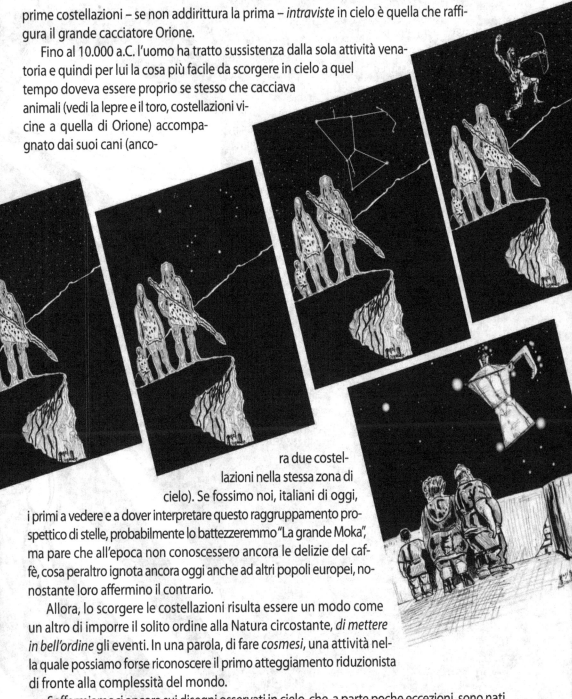

ra due costel-
lazioni nella stessa zona di
cielo). Se fossimo noi, italiani di oggi,
i primi a vedere e a dover interpretare questo raggruppamento pro-
spettico di stelle, probabilmente lo battezzeremmo "La grande Moka",
ma pare che all'epoca non conoscessero ancora le delizie del caf-
fè, cosa peraltro ignota ancora oggi anche ad altri popoli europei, no-
nostante loro affermino il contrario.

Allora, lo scorgere le costellazioni risulta essere un modo come
un altro di imporre il solito ordine alla Natura circostante, *di mettere
in bell'ordine* gli eventi. In una parola, di fare *cosmesi*, una attività nel-
la quale possiamo forse riconoscere il primo atteggiamento riduzionista
di fronte alla complessità del mondo.

Soffermiamoci ancora sui disegni osservati in cielo, che, a parte poche eccezioni, sono nati
dall'osservazione dei sacerdoti assiro-babilonesi, i quali cercavano altre regolarità del cielo ol-
tre quelle evidenti come l'alternarsi del giorno e della notte e l'avvicendarsi delle stagioni. Re-

golarità da sfruttare per intendere meglio i suggeri-
menti dati agli uomini dalla Natura: se per esempio
l'alternarsi delle stagioni spiegava bene quando col-
tivare e quando raccogliere, quando partire per la tran-
sumanza e quando ricoverare le greggi per evitare di
incorrere nei rigori invernali che le avrebbero decimate,
poteva anche darsi che in cielo, nascosti nelle geo-
metrie in movimento disegnate dalle stelle, magari
vi fossero anche altri indizi inerenti aspetti differen-
ti della vita umana, come indicazioni su quando pren-
dere moglie, quando eleggere un capo, quando de-
porlo, quando prepararsi a una battaglia imminen-
te e così via. In parole povere, questa è la nascita del-
la teoria (dalla validità mai dimostrata!) circa il discorso
(*lògos*) degli astri (*àster*), la moderna e – va da sé – al
contempo anacronistica *astrologia*.

Inizialmente, quindi, i raggruppamenti stellari che
per i sacerdoti mesopotamici, occupati a scrutare pa-
zientemente il cielo notte dopo notte dall'alto del-
le *ziqqurat*, avevano valore di *costellazione*, altro non
erano se non insiemi di due, tre o comunque poche
stelle che tramontavano a ovest, mentre altri rag-
gruppamenti dello stesso tipo sorgevano a est,
una "coincidenza" che poteva almeno in potenza ce-
lare qualche oscuro significato.

Le costellazioni che oggi conosciamo sono il frut-
to di un immane sforzo di catalogazione iniziato an-
ticamente (complice il fatto che le popolazioni meso-
potamiche avevano inventato la scrittura e potevano
quindi registrare e tramandare le loro osservazioni) e
ancora in corso, nonché di complicazioni estetiche suc-
cessive applicate a questi inizialmente semplici rag-
gruppamenti, intervenute nel tempo allorché il mon-
do greco, e in seguito quello romano, sono venuti a co-
noscenza di questi disegni celesti e li hanno reinter-
pretati alla luce delle loro diverse esigenze culturali.

In cielo così troviamo stratificazioni storiche di nar-
razioni fondamentali per l'uomo antico. Convivono
nel grande libro della volta celeste tutti quegli elementi
essenziali da sapere per potere affermare di essere sta-

ti uomini di quel tempo. Il cielo stellato quindi, in un primo momento, conteneva anche la legge morale (che impiegherà un bel po' prima di scendere sulla Terra per entrare in alcuni uomini) e incombeva come monito sugli stolti. Era una importantissima *summa* del sapere di quel tempo, qualcosa che doveva essere necessariamente di facile consultazione, da leggere, da tenere d'occhio perché sotto – anzi, sopra – gli occhi di tutti.

Il fatto che la forma delle costellazioni non cambiasse sopra la testa degli astronomi, li indusse a pensare che le stelle che le formavano fossero fisse nel cielo, incastonate nella volta celeste.

E perché meglio tu possa riconoscere i segni illustri,
475 non conoscono essi variati i tramonti e variati i ricorsi,
ma regolarmente si levano le stelle al proprio splendore
e le nascite loro e il calare mantengono nell'ordine debito
(...)

Manilio, *Il poema degli astri* (Astronomica) Libro I

Se non mutavano mai, costituivano il duale, il complementare della nostra Terra creduta ferma nel centro dell'universo e da dove si gode una vista bellissima, ma dove il biglietto per lo spettacolo è estremamente costoso. Qui tutto cambia: un pezzo di carne lasciato fuori dal frigo dopo un po' risulta immangiabile; addirittura, come estremo tributo alla dura seconda legge della termodinamica, qui si muore. Per cui, se qui tutto è *in fieri*, lì il cielo appariva come il regno dell'*essere*. Se qui tutto cambia ed è imperfetta emanazione di un mondo ideale, lì in alto tutto doveva essere perfetto, ideale, sempre uguale a sé stesso, come anche Aristotele ci racconta nel suo trattato *Il cielo*:

> Per tale motivo, le realtà di lassù non sono in un luogo, né il tempo le fa invecchiare, e nemmeno si verifica alcun cambiamento per nessuno degli enti posti sulla traslazione più esterna; invece, inalterabili e impassibili, godendo della vita migliore e della più bastante a sé medesima, essi conducono la loro esistenza per tutta l'estrema durata.

Riassumendo:
1) Terra ferma al centro del cosmo. Sulla sua superficie tutto muta di continuo.
2) La volta celeste si muove trascinando con sé le stelle fisse, ma lì nulla muta nel tempo se non, appunto, la posizione relativa al suo centro, la Terra.
Sembra quasi di trovarsi di fronte a una antenata della legge di conservazione della quantità di moto applicata al cosmo, che dice che vi è un certo quantitativo di movimento, di distanza dall'equilibrio, che in un modo o nell'altro deve sfogare. Oggi comunque, a dispetto di quanto si pensava nell'antichità greca, sappiamo che in cielo tutto cambia e che le velocità delle stelle sono elevatissime e tutte diverse fra loro. Per esempio il Sole si muove attorno al centro galattico alla velocità di circa 200 km al secondo. La ragione per cui non vediamo le costellazioni mutare nella forma è che da qui impiegano centinaia di migliaia di anni a manifestare questi cambiamenti. Ecco perché lo stesso Clarke, nel già citato *2001: Odissea eccetera*, dice a proposito del cielo del Pleistocene:

> La notte continuò a trascorrere, gelida e limpida, senza altri allarmi e la luna salì adagio tra costellazioni equatoriali che nessuno sguardo umano avrebbe mai veduto.

Per capire come mai non possiamo cogliere queste variazioni nella forma delle nostre fantasie proiettate sulla volta celeste che chiamiamo costellazioni, vi invito a valutare due diverse situazioni: pensiamo a come vedremmo la Ferrari passare al gran premio di Imola standocene proprio vicino alla pista. Osservarla ci imporrebbe un velocissimo movimento della testa, da parte a parte. Se invece ci fermiamo a osservare da lontano un aereo che sappiamo volare a velocità ancora superiore a quella della Ferrari, lo possiamo seguire nel suo percorso senza fare movimenti bruschi del capo. Staziona in alto nel nostro campo visivo, molto più a

lungo dell'auto da corsa. L'effetto è dovuto chiaramente alla distanza che ci separa da ciò che osserviamo. Pensiamo ora che la stella a noi più vicina vive la sua esistenza correndo alla velocità di circa qualche centinaio di chilometri al secondo (!), standosene a fluttuare nel vuoto a più di quattro anni luce da noi (all'incirca 40.000.000.000.000 di chilometri)…

Il fatto che gli astri emanassero luce, li fece associare da subito al fuoco, all'epoca unica entità conosciuta capace di generare chiarore, e questo fece sì che tutti i corpi celesti, *in primis* il nostro Sole, fossero ritenuti di natura ignea. A conferma di questa idea vi era il fatto osservabile che le fiamme tendono verso l'alto, una tendenza che in misura minore, solo l'aria manifestava, indicando chiaramente in che direzione si dovesse rivolgere lo sguardo per sapere dove albergasse la perfezione. La terra e l'acqua sono invece costrette a stare in basso, rimanendo indietro agli altri due elementi empedoclei a disegnare il luogo della greve imperfezione. Una visione della realtà che in Aristotele si consoliderà sotto forma di "teoria dei luoghi naturali", di cui avremo modo di parlare meglio nel capitolo successivo e nella quale verrà proposto un punto di vista diverso proprio per ciò

che riguarda la natura delle stelle, a suo parere costituite di un ulteriore elemento, l'*etere* (=altro), che non si mescola con nessuno degli elementi noti. Abbiamo già avuto modo di dire che il cielo stellato non era pensato disgiunto dall'atmosfera per il semplice motivo che non vi erano indizi circa l'esistenza di un suo limite superiore. Ecco che il sommo filosofo, pronunciandosi nel suo già citato *Il cielo* sulla natura degli astri, considera:

> Il calore che promana dagli astri, e parimenti la loro luce, nascono dall'attrito che l'aria subisce per effetto della loro traslazione. Infatti, il movimento è naturalmente atto a infiammare il legno, le pietre e il ferro; a maggior ragione sarà atto a infiammare un corpo che è più prossimo al fuoco, e l'aria è per l'appunto più prossima al fuoco. (…) Ciascuno dei corpi superiori, invece, si muove nella sua sfera. Di conseguenza, essi non si infiammano, mentre l'aria che si trova sotto la sfera del corpo che si muove di moto circolare necessariamente si riscalderà, a causa del moto di tale sfera, e questo soprattutto nel punto in cui si trova infisso il sole. È per tale motivo che il calore si produce quando il sole si avvicina, si leva e si trova sopra di noi. Dunque gli astri non sono di natura ignea, né si muovono nel fuoco: su questi punti basti quel che s'è detto.

Il cielo, unico spettacolo disponibile la sera (lo *zapping* non era contemplato tra le opzioni del programma Terra), deve avere rivelato, da un certo momento storico in poi, alcune caratteristiche fino a quel momento sfuggite agli osservatori. Al *suono* continuo della sfera piena di costellazioni che ruotava coerentemente trascinando con sé tutte le stelle (seguendo il suggerimento di Kandinsky, qui intendo la parola *suono* come *intensità* del carattere visuale), si sovrapponeva sovente il *suono* più intenso di alcuni punti dal chiarore fisso e non vibrante come invece il resto degli astri.

L'osservazione protratta nel tempo di questi oggetti così particolari permise, grazie al loro sorpassarsi per le differenze di velocità di percorrenza del cielo e alle occasionali sovrapposizioni di alcuni di loro col conseguente eclissarsi vicendevole delle loro luci, di stabilire che a loro volta potevano servire per scandire lo spazio in modo più fine, consentendo così agli osservatori di intuire la profondità della sfera celeste e di stabilire all'interno di essa una gerarchia spaziale. Il cosmo veniva così a essere racchiuso tra i due estremi: la Terra, ferma al centro, e la volta, quella che si muoveva trascinando con sé le stelle, le quali, non sovrapponendosi mai tra loro e procedendo tutte attorno alla nostra posizione con uguali velocità a uguali distanze dal polo della rotazione, sembravano dover essere tutte alla stessa distanza da noi su una sfera da esse stesse disegnata. Quelle parti solistiche di voci che allora come oggi emergevano dalla sinfonia dei suoni stellari già permettevano di farsi un'idea della struttura del palcoscenico celeste come organizzato almeno su tre piani: la platea (il nostro, fermo); il palco, occupato da questi oggetti che procedevano a velocità diversa rispetto agli altri punti luminosi sulla scenografia di fondo; la scenografia stessa, costituita dalle stelle incastonate nella

volta che chiaramente si muovevano dietro a tutto il resto, a una distanza maggiore di quella dei corpi a luce costante.

I corpi a luce costante presentavano una ulteriore, preoccupante particolarità: il loro moto non si svolgeva lungo traiettorie regolari come tutti gli altri corpi celesti, ma andava a disegnare percorsi che prevedevano temporanei ritorni indietro lungo la loro traiettoria. Una caratteristica che faceva associare il loro moto a quello di ubriaconi e viandanti che già all'epoca era possibile incontrare nelle cittadine greche e che venivano indicati con la parola *planètai*, vagabondi, appunto.

Oggi sappiamo che questi anelli che i pianeti disegnano nel loro procedere in cielo sono solo apparenti e dovuti al fatto che li osserviamo standocene su un *sasso* che non è al centro del cosmo, ma che a sua volta gira attorno al Sole, cosa che a noi passeggeri dell'astronave Terra ci fa osservare gli altri oggetti da

posizioni sempre diverse lungo l'orbita terrestre. Se fossimo osservatori posti sul Sole, saremmo nel posto giusto per apprezzare la regolarità dei moti planetari. Ma l'uomo di quel tempo non poteva sospettare nulla di tutto ciò e di conseguenza non poteva fare altro che limitarsi a registrare la peculiarità del moto dei pianeti.

Essi quindi si discostavano dal moto circolare puro, ritenuto perfetto perché proprio delle stelle fisse che a intervalli regolari si presentavano nelle stesse identiche posizioni. In ogni caso, standosene distanti da noi, in alto, a delineare diversi livelli intermedi di distanza dalle stelle e dalla loro perfezione, i pianeti dovevano comunque partecipare della perfezione del cielo, ma anche dell'imperfezione di ciò che invece si viveva qui. Per tutti questi motivi, venivano ritenuti corpi celesti di natura perfetta, eterea, quindi diversa da qualsiasi materiale

rinvenibile sulla nostra Terra, ma anche divinità che nei tratti caratteriali assomigliavano in tutto e per tutto agli uomini e, per meglio comprendere questa loro similitudine con noi umani, suggerisco di riandare mentalmente alla descrizione che ne fa Omero e a come, per esempio, per le loro vanità e vendette trasversali, abbiano agito scatenando e gestendo sulla Terra la guerra di Troia.

I racconti per bambini sono sempre favolistici e tutto deve necessariamente passare da una umanizzazione dei caratteri che da adulti appare semplicistica, inadatta. Bene, anche la cosmogonia come spiegazione dell'universo adatta a una "umanità bambina" da un punto di vista culturale, è passata dalla fase di favola, in cui essenzialmente a contendersi la realtà sono principi che, in quanto tali, vengono maneggiati con difficoltà, ed è per questo che diventano divinità con le loro azioni. I pianeti vennero allora riconosciuti come corpi fisici che si muovono attorno alla nostra posizione, ma apparvero anche partecipi di una natura divina, umanizzata. Erano vivi. Ci troviamo così di fronte a qualcosa che mi fa pensare a una dualità simile a quella che si ha in fisica per i fotoni. La dualità *onda-corpuscolo*, nel caso del *dio-pianeta* diventa, per analogia con la radiazione elettromagnetica, dualità *onto-corpuscolo*, forzatura fonetica che mi permette di mantenere una certa assonanza con la definizione quantistica e con la quale affido al prefisso *onto-* il compito di rappresentare la dimensione caratteriale, l'esistenza viva del Dio, che viene osservato con i movimenti del *corpuscolo* planetario.

Una volta stabilita la natura dell'universo da un punto di vista qualitativo, restava da darne una descrizione da un punto di vista quantitativo, problema che assillava il mondo occidentale, tutto preso dal gettare le basi di ciò che diventerà molto tempo dopo la scienza moderna. Sono noti gli ingegnosi tentativi di calcolare le dimensioni del nostro globo terrestre a opera di Eratostene di Cirene o quelli di Aristarco di Samo, che si cimentò con la distanza della Luna, giusto per citare quelli che condussero a misure precisissime per gli stru-

menti e le conoscenze dell'epoca. In generale, però, mancava un metodo che potesse restituire con precisione una misura del raggio della illusoria volta celeste, misura della distanza lungo la quale la realtà si riteneva dovesse subire una degradazione, passando dalla perfezione della sfera delle stelle fisse all'imperfezione del nostro mondo terreno. All'epoca le uniche misure di distanza che era possibile effettuare erano tutte calcolate sulla stessa volta celeste. Erano distanze apparenti, misurate in proiezione usando vari strumenti, tra i quali val la pena di menzionare la nostra mano, capace di offrirci una ampia gamma di spessori, dalla dimensione del polpastrello del dito mignolo (circa mezzo grado), fino alla distanza tra lo stesso mignolo e il pollice quando teniamo la mano bene aperta e con le dita massimamente distese (più o meno venti gradi). Il problema è che il tentativo di misurare la distanza tra due stelle o quella di una stella dall'orizzonte condotta con la mano o con altri rudimentali strumenti poteva condurre solo a una valutazione in termini di ampiezze, quelli che diventeranno in seguito i "gradi" della trigonometria, branca della matematica molto probabilmente nata proprio in *seno* a queste tematiche di tipo astronomico.

Come è noto, per risalire alla misura lineare di un arco di circonferenza che sottende un angolo al centro di ampiezza nota, necessitiamo di sapere qual è la misura lineare del raggio. Ma questo era proprio ciò che mancava alla cosmologia antica, una valutazione numerica della dimensione della cosmo-sfera.

Ancora una volta, l'intuizione di Kandinsky ci torna utile. Grazie a essa possiamo forse comprendere meglio come mai il grande matematico Pitagora teorizzò che i pianeti nel loro moto attorno alla Terra dovessero emettere un suono.

La sua idea nacque all'interno di un sistema del mondo suggerito da un certo Eudosso di Cnido, il quale riteneva che ogni pianeta si trovasse collocato su una sfera la quale, ruotando, gli comunicava il moto per effetto dell'attrito. Tutto il cosmo era collocato dentro l'ultima sfera, quella più grande disegnata dalle stelle fisse, la quale ruotando, sempre per attrito, comunicava la rotazione a tutte le altre al suo interno. Naturalmente le sfere dei vari pianeti, dovendo anche permetterci di scorgere la volta stellata in fondo a tutto, dovevano essere trasparenti o, come venivano definite, *cristalline*, un'idea che mi diverte alquanto facendomi immaginare il cosmo antico come una preziosa, fragile, vitrea e immane cipolla (tra l'altro, chi lavava le sfere per farle apparire così trasparenti? E con cosa?). Allora secondo Pitagora, ogni pianeta, standosene su una sfera di dimensione diversa da quella degli altri, doveva emettere un suono di differente altezza così come un calice... di cristallo ben lavato, se sfiorato adeguatamente, emette un suono... cristallino diverso da quello ottenibile con un calice di diverse dimensioni. Un'idea, questa, che l'extracomunitario nato a Samo e trapiantatosi nella Magna Grecia, aveva mutuato dai suoi studi sulle proprietà di una corda tesa, il cosiddetto *monocordo*, uno strumento che gli consentì di trovare una connessione precisa tra lunghezza della corda e suono da essa emesso se pizzicata e fatta vibrare. Una volta scoperta questa interessantissima proprietà delle corde, Pitagora pensò quindi di avere trovato il modo di *bypassare* il problema dell'impossibilità di misurare con i metodi propri della geometria euclidea la lunghezza del raggio della volta celeste. Infatti, paragonando

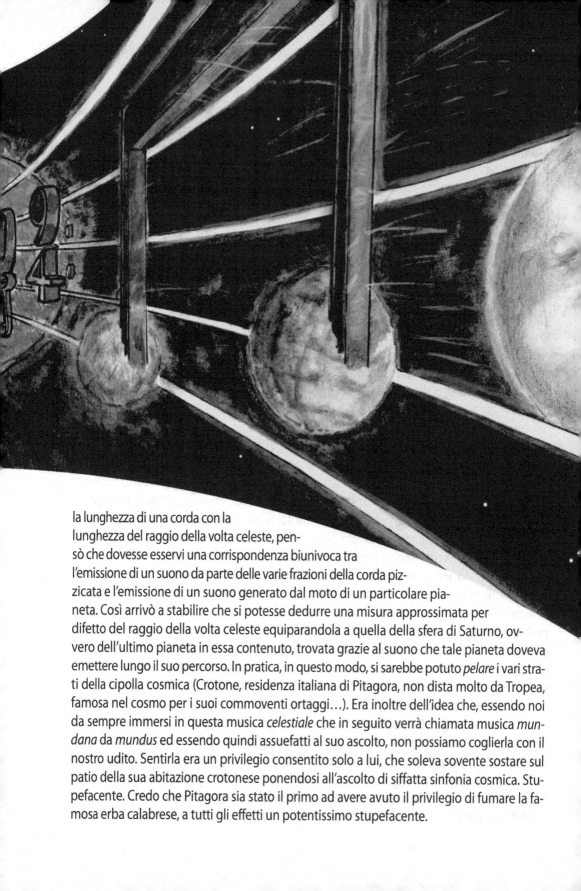

la lunghezza di una corda con la
lunghezza del raggio della volta celeste, pen-
sò che dovesse esservi una corrispondenza biunivoca tra
l'emissione di un suono da parte delle varie frazioni della corda piz-
zicata e l'emissione di un suono generato dal moto di un particolare pia-
neta. Così arrivò a stabilire che si potesse dedurre una misura approssimata per
difetto del raggio della volta celeste equiparandola a quella della sfera di Saturno, ov-
vero dell'ultimo pianeta in essa contenuto, trovata grazie al suono che tale pianeta doveva
emettere lungo il suo percorso. In pratica, in questo modo, si sarebbe potuto *pelare* i vari stra-
ti della cipolla cosmica (Crotone, residenza italiana di Pitagora, non dista molto da Tropea,
famosa nel cosmo per i suoi commoventi ortaggi…). Era inoltre dell'idea che, essendo noi
da sempre immersi in questa musica *celestiale* che in seguito verrà chiamata musica *mun-
dana* da *mundus* ed essendo quindi assuefatti al suo ascolto, non possiamo coglierla con il
nostro udito. Sentirla era un privilegio consentito solo a lui, che soleva sovente sostare sul
patio della sua abitazione crotonese ponendosi all'ascolto di siffatta sinfonia cosmica. Stu-
pefacente. Credo che Pitagora sia stato il primo ad avere avuto il privilegio di fumare la fa-
mosa erba calabrese, a tutti gli effetti un potentissimo stupefacente.

Comunque, che le ferree regole matematiche alla base dell'armonia musicale siano da connettere alle armonie del procedere universale è un'idea che solca tutta la storia del genere umano, spingendo qualcuno anche a chiedersi se per caso l'universo non sia altro che un suono. Senza voler arrivare a parlare di come quest'idea trovi applicazione nella cosmologia dei giorni nostri, cosa che esulerebbe dai compiti di questa trattazione, mi limito soltanto a citare l'uso che ne fa Isaac Asimov nel suo romanzo *Lucky Starr e le lune di Giove*

> E se mai si fosse potuto dire che la favoleggiata "musica delle sfere" era diventata letteralmente una realtà, essa consisteva nel ronzio dei motori iperatomici che rappresentavano l'essenza stessa del volo spaziale.

Mi preme inoltre far notare che l'idea pitagorica riuscì a sopravvivere fino al XVII secolo, nonostante fosse osteggiata dal grande Aristotele, che con le sue obiezioni ebbe la forza di detronizzare per più di mille anni tante posizioni diverse, alcune delle quali forse ci avrebbero accelerato una crescita culturale arrivata comunque molto tempo dopo (si pensi alla teoria eliocentrica di Aristarco di Samo). All'epoca, a causa delle grandi discrepanze tra le previsioni sulle posizioni dei pianeti e le osservazioni, l'idea della posizione centrale della Terra aveva già da un po' cominciato a ricevere diversi scossoni, che avrebbero portato la nostra residenza cosmica a spostarsi, *urto dopo urto*, in una posizione più decentrata. Già

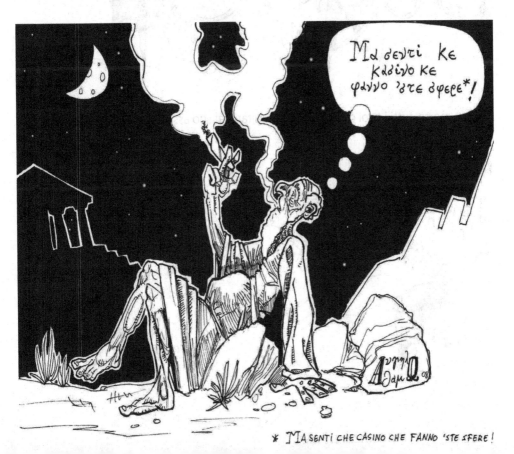

* *MA* SENTI CHE CASINO CHE FANNO 'STE SFERE !

Niccolò Copernico nel suo *De revolutionibus orbium caelestium* fa l'ipotesi matematica della centralità del Sole, mostrando come, assumendo l'astro invece che la Terra al centro del cosmo, si riusciva a guadagnare una maggiore precisione nelle previsioni dei moti planetari. L'astronomo danese Tycho Brahe, convinto della centralità della Terra e ideatore del sistema cosiddetto *ticonico*, strana mescolanza tra quello geocentrico e quello eliocentrico, in cui le orbite rimanevano circolari (sistema che proprio per la sua peculiarità non ebbe molta fortuna), si convinse che una reale svolta nella scienza astronomica sarebbe arrivata solo grazie a osservazioni quanto mai precise e inaugurò una campagna di misurazioni dei movimenti planetari condotte con una precisione fino a quel momento sconosciuta.

Alla sua morte, tutti i suoi dati verranno ereditati dal suo assistente, l'astronomo Keplero.

Questi noterà che l'orbita di Marte non può assolutamente essere assimilata a un cerchio mostrando invece di venire rappresentata degnamente da un'ellisse con il Sole in uno dei fuochi.

Convinto della bontà delle intuizioni pitagoriche, Keplero considererà allora il Sole alla stregua di direttore del coro celeste, un coro di armonie prodotte dai pianeti che nel loro moto mostrano di variare la velocità lungo la traiettoria ellittica variando così anche l'altezza della nota emessa.

Se quindi per Pitagora i pianeti dovevano con il loro moto emettere complessivamente un accordo dato dalla sovrapposizione delle singole note da loro generate e stabilite in eterno dal loro procedere regolare sulle sfere celesti (il cosiddetto "moto armonico"), per Keplero le armonie dovevano essere variabili e molto più complesse perché date dalla sovrapposizione di note di altezza variabile nel tempo.

Riassumendo, in questo capitolo abbiamo visto come la comprensione del cosmo sia necessariamente passata da elaborazione di storie sottoforma di mito, da musiche ispirate dal cielo e al cielo; dalla proiezione di immaginari disegni sulla volta celeste come antichi graffiti sulle volte di caverne o affreschi in quelle delle cattedrali; da valutazioni di distanze tra i punti luminosi come distanze angolari e valutazione di distanze tra pianeti in termini di non sempre esatti computi lineari. In pratica, continuando nell'operazione di riassumere quanto detto, la comprensione del cosmo, almeno in questa fase iniziale, è passata attraverso l'uso di parole, disegni, note, numeri. Esattamente ciò di cui mi avvarrò nel prosieguo di questo libro.

Gravità, mele e cipolle

Giro giro tondo, quanto è tondo il mondo

Perché la Terra è tonda? Perché lo sono anche gli altri pianeti? Non potrebbero essere – che so? – cubici o parallelepipedi irregolari?

Che la Terra fosse tonda era cosa nota sin dall'antichità, almeno fin dall'antichità greca, quando già qualcuno aveva fornito a sufficienza spiegazioni di varie osservazioni alla portata di tutti. La prima è stata probabilmente quella offerta dall'arrivo tanto atteso delle navi mercantili che facevano il loro ingresso nel campo visivo di chi stava sulla spiaggia, mostrando all'orizzonte prima le vele, poi la tolda e infine – raggiunte distanze minori dal porto – anche lo scafo.

Qualcosa del genere si sarebbe potuto osservare anche nel caso di una Terra non proprio cubica ma comunque con spigoli un po' smussati con ampiezze comprese tra i 90° e i

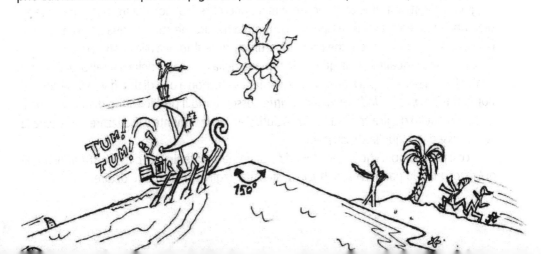

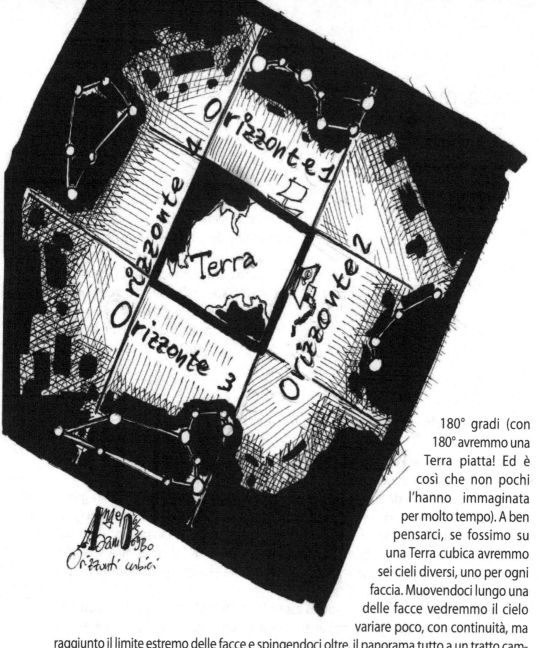

180° gradi (con 180° avremmo una Terra piatta! Ed è così che non pochi l'hanno immaginata per molto tempo). A ben pensarci, se fossimo su una Terra cubica avremmo sei cieli diversi, uno per ogni faccia. Muovendoci lungo una delle facce vedremmo il cielo variare poco, con continuità, ma raggiunto il limite estremo delle facce e spingendoci oltre, il panorama tutto a un tratto cambierebbe mostrandoci la fortissima discontinuità tra ciò che sta al di qua e ciò che si scoprirebbe al di là del limite e che fino a un attimo prima sfuggiva alla nostra vista.

Quindi la gradualità con la quale il fenomeno della comparsa delle navi all'orizzonte avveniva faceva pensare più a una geometria sferica che non a una di tipo diverso. Basandosi poi su un *Principio di Uniformità della Natura*, osservando il profilo tondo di Sole e Luna e intuendo quello degli altri pianeti conosciuti, si arrivò facilmente a ipotizzare che anche la Terra possedesse quella stessa forma.

È così per esempio che il macedone Aristotele, nato a Stagira più o meno 384 anni prima di Cristo, quando parla nel suo *Il Cielo* di sfericità degli astri, ha modo di dire:

> (…) sulla base dei dati di osservazione si dimostra che la luna è sferica; altrimenti, al crescere e al calare essa non assumerebbe nella maggior parte del tempo una forma lunata o arcuata da entrambi i lati, e una sola volta quella di un semicerchio. Lo si dimostra anche con i dati dell'astronomia, perché diversamente le eclissi di sole non avrebbero una forma lunata. Di conseguenza, se è vero che c'è un astro che ha la forma in questione, è chiaro che anche gli astri sono sferici.

Nel seguito del suo trattato, lo stagirita fornirà alcune spiegazioni al perché della sfericità del mondo e della Terra adducendo e inducendo una serie di spiegazioni *de iure* e *de facto*. Ai suoi perché di ordine metafisico, invocati per discettare del mondo e sulle cose lontane dalle umane faccende, parlando di sfericità della Terra, contrappone osservazioni di carattere decisamente più empirico. È così che nel secondo argomento afferma:

> Secondo questa argomentazione, dunque la forma della terra è necessariamente sferica, e lo è anche in quanto tutti i corpi pesanti cadendo formano degli angoli uguali, anziché descrivere traiettorie parallele. Ma questa è la forma naturale della caduta verso ciò che è sferico per natura. La terra è dunque sferica di fatto o, almeno, è nella sua natura l'esserlo (…).

Questa osservazione incontrava facilmente il favore di tutti i suoi discepoli cresciuti in una cultura estremamente estetizzante che associava alle figure di cerchio e sfera un'importanza superiore perché forme geometriche prive di un inizio e di una fine, caratteristica che le rende le migliori rappresentazioni di un essere che si fa divenire e che torna all'essere…

Un fenomeno che destava molta ammirazione per lo spettacolo della Natura era quello delle eclissi, durante le quali poi era possibile osservare la forma circolare del profilo della Terra. Durante un'eclisse di Luna, l'ombra proiettata dalla Terra sul nostro satellite aveva una forma circolare e non spigolosa come ci si sarebbe dovuto attendere nel caso, per esempio, di una Terra cubica. Questo dato osservativo non poteva essere interpretato correttamente se non si aveva una qualche idea di quale fosse la causa di questi fenomeni astronomici e, sempre dal trattato del filosofo macedone, risulta chiaro che tale causa fosse già ampiamente nota:

> Che la terra sia sferica lo si accerta anche mediante i fenomeni che cadono sotto i sensi. Diversamente, le eclissi di luna non presenterebbero le sezioni che vediamo. Ebbene, in occasione delle sue fasi mensili la luna mostra tutti i tipi di divisione (viene infatti tagliata da una linea retta o diviene biconvessa o concava); al momento delle eclissi, invece, ha sempre come linea di delimitazione una linea curva. Di conseguenza, poiché l'eclissi è causata dall'interposizione della terra, è il profilo della terra a determinare tale figura, avendo forma sferica.

Nella stessa sezione del suo trattato si spinge oltre con il dire che:

> D'altra parte, la visione che noi abbiamo degli astri rende evidente non soltanto che la Terra è sferica, ma anche che le sue dimensioni non sono molto grandi. Se ci spostiamo anche di poco verso mezzogiorno o verso l'Orsa, il circolo dell'orizzonte muta visibilmente, per cui gli astri che si trovano sopra la nostra testa cambiano in misura rilevante, e non sono gli stessi ad apparirci quando andiamo verso l'Orsa e quando andiamo verso mezzogiorno. Alcuni astri sono visibili in Egitto o in prossimità di Cipro e invisibili, invece, nelle regioni settentrionali. Peraltro, gli astri che nelle regioni settentrionali appaiono per tutto il tempo, nei luoghi menzionati in precedenza invece tramontano. Da queste osservazioni risulta chiaro non soltanto che la forma della Terra è quella di una sfera, ma anche che si tratta di una sfera di modeste dimensioni; altrimenti, gli effetti di uno spostamento tanto piccolo non si manifesterebbero con tale rapidità (…).

Un altro dato a favore dell'idea di vivere su una Terra sferica proviene dall'osservare che, come appena descritto nell'ultimo passo, mentre procedendo lungo un meridiano, non importa se verso sud o verso nord, si osserva che le costellazioni cambiano con gradualità la loro posizione rispetto alla verticale sulla nostra testa (Zenith), ovunque ci si trovi, gli oggetti lasciati cadere seguono sempre la stessa direzione perpendicolare al suolo: ancora una volta, a ben vedere, l'unica geometria che può rendere possibile una cosa del genere è proprio quella sferica. Detto in altri termini: in due o più posti lontani tra loro sulla superficie terrestre gli oggetti cadono, e possono colpirvi i piedi. Ovunque vi troviate, *ritornerete a veder le stelle*, ma non le stesse stelle!

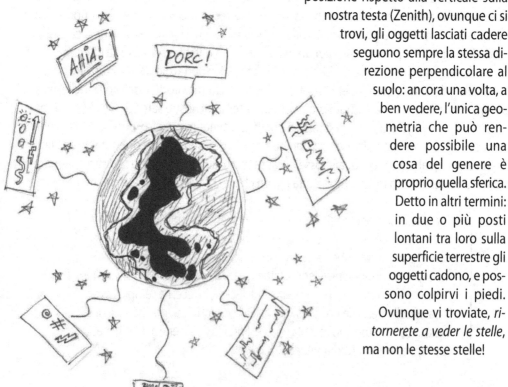

Fratello Sole, Sorella Luna

In cielo si osserva una certa similitudine tra le dimensioni angolari dei dischi solare e lunare, un dato osservativo che indurrà in errore quanti hanno redatto nel tempo la Bibbia, nella quale, nel libro della Genesi, si narra:

> [14]Dio disse: "Ci siano luci nel firmamento del cielo, per distinguere il giorno dalla notte; servano da segni per le stagioni, per i giorni e per gli anni [15]e servano da luci nel firmamento per illuminare la terra". E così avvenne: [16]Dio fece le due luci grandi, la luce maggiore per regolare il giorno e la luce minore per regolare la notte, e le stelle. [17]Dio le pose nel firmamento del cielo per illuminare la terra [18]e per regolare giorno e notte e per separare la luce dalle tenebre. E Dio vide che era cosa buona. [19]E fu sera e fu mattina (…)[1]

Per fortuna, oggi sappiamo come stanno realmente le cose. Ce lo ricorda il celebre scrittore-scienziato Arthur C. Clarke che, nel suo *2010 Odissea due,* valuterà questa similitudine come fatto privo di qualsiasi valore:

> L'Astronomia è ricca di coincidenze affascinanti ma prive di significato. La più nota è il fatto che, dalla Terra, sia il Sole sia la Luna hanno lo stesso diametro apparente.

Come possiamo vedere anche in questo passo, all'origine di qualsiasi manifestazione della Natura, vi è sempre nella cultura cristiano-cattolica una parola, una frase, pronunciata da Dio, il quale, nel passo citato, sceglie di creare due astri per illuminare la Terra, il Sole e la Luna. Se ne evince che essi debbano avere la stessa importanza (da notare che è proprio "dottrina", ovvero non si spiega, anzi, con essa non ci si chiede neanche, perché debbano esservi giorno e notte; volendo dare forza a una spiegazione preconcetta, ci si ferma a una conveniente descrizione della realtà), un'idea corroborata dal fatto che, come abbiamo già avuto modo di dire, per un caso "meccanico" che non si verificherà in eterno (vedi il capitolo dedicato al nostro satellite naturale), la nostra distanza dalla Luna ce la fa vedere di dimensioni angolari molto simili a quelle del disco solare.

Nel 310 a.C. nacque a Samo un personaggio molto particolare che, con le sue idee, avrebbe forse potuto indirizzare meglio di quanto non abbia fatto Aristotele lo sviluppo culturale di tutta l'antichità fino al me-

[1] La Sacra Bibbia (1992) Versione ufficiale, conferenza Episcopale Italiana, Libreria Editrice Vaticana, Città del Vaticano.

dioevo, e anche oltre. Si tratta di Aristarco, ideatore della *concezione eliocentrica* poi ripresa in seguito da Copernico e da Galilei. In *Sulle dimensioni e sulle distanze del Sole e della Luna*, suo unico trattato pervenutoci, egli fornirà una misura di quella che per l'epoca era una buona fetta di Universo e lo farà assumendo da subito che noi si sia molto più vicini alla Luna che al Sole.

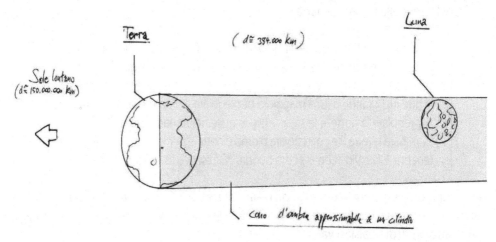

Il suo modello prevedeva che il Sole fosse al centro del mondo e che noi fossimo a grande distanza da esso. Con queste due semplici assunzioni di base fu così in grado di dare una valutazione di quanto distiamo dal nostro satellite naturale mediante una geniale considerazione geometrica: durante una qualsiasi eclisse di Luna, la sezione circolare del cono d'ombra proiettato dalla Terra (sferica) per l'arrivo dei raggi dal lontanissimo Sole, alla modesta distanza del nostro satellite, non deve differire molto dalle dimensioni della sezione circolare della Terra stessa. In pratica, approssimò il tronco di cono d'ombra compreso fra il nostro pianeta e la distanza della Luna con un cilindro retto avente le due basi uguali alla sezione circolare terrestre. Misurando il tempo intercorso tra l'ingresso della Luna nel cono d'ombra e la sua fuoriuscita, calcolò che il rapporto tra i raggi lunare e terrestre doveva essere approssimativamente 1/3. Sapendo inoltre che la Luna può essere "eclissata" con il polpastrello del dito mignolo (più o meno mezzo grado), trovò che un cerchio di dimensione data, per poter apparire delle stesse dimensioni angolari della Luna, andava posto a una distanza dall'osservatore pari a circa 120 volte il suo diametro. Quindi:

$$\text{Distanza}_{\text{Terra-Luna}} = 120 \cdot \text{diametro}_{\text{Luna}} = 120 \cdot (1/3) \cdot (\text{diametro}_{\text{Terra}}) =$$
$$= 40 \cdot \text{diametro}_{\text{Terra}}$$

Con questa e con altre relazioni numeriche dell'epoca, dopo secoli di descrizioni spesso verbose, inizia a fare la sua comparsa nelle dispute filosofiche sulla Natura un *dialetto* diverso, conciso e preciso, già da tempo in uso per attività più pratiche come per esempio quelle commerciali, che si rivelò per certi versi più adatto a colloquiare con gli oggetti che popolano la realtà: la matematica.

A questo punto, alla cosmologia comparativa di Aristarco, costruita sui raffronti fra le dimensioni apparenti degli astri vicini e le dimensioni ignote del nostro pianeta, mancava proprio questo dato: il raggio terrestre, la cui valutazione non dovrà attendere tantissimo. Nel 276 a.C. infatti nasce a Cirene, sulla costa egiziana, un certo Eratostene il quale noterà che, diversamente dagli altri oggetti, i raggi di luce solare "cadendo" al suolo cambiano angolo di incidenza al variare della posizione sulla Terra. Analogamente a quanto già detto prima parlando dell'esperimento del mattone sui piedi (fate pure l'esercizio, è molto istruttivo!), Eratostene notò che ad Alessandria d'Egitto un sasso lasciato cadere a mezzogiorno del solstizio estivo segue, al solito, una traiettoria rettilinea e perpendicolare al suolo. Stessa cosa fa un raggio di luce solare e, arrivando anch'esso perpendicolare al suolo, non fa proiettare ombre laterali agli oggetti che incontra sul suo cammino. Lo stesso esperimento condotto alla stessa ora dello stesso giorno dell'anno, ma stavolta a Syene, l'odierna Assuan, sita a 5.000 stadi di distanza da Alessandria, rivela invece che il sasso segue sempre la solita traiettoria rettilinea e perpendicolare al suolo mentre l'altro "oggetto" – il raggio di luce solare – cade con un'inclinazione diversa, secondo una traiettoria che fa proiettare a un palo conficcato perpendicolare al terreno, il cosiddetto "gnomone", un angolo di 7° misurato rispetto alla verticale.

Oltre a stimolare un mucchio di domande sulla natura del bizzarro oggetto *luce*, domande che dai tempi di Eratostene dovranno attendere ben 2.200 anni – settimana più, settimana meno – per ricevere degna risposta, vien da chiedersi ancora una volta: qual è la geometria del nostro pianeta che permette di veder cadere gli oggetti sempre perpendicolari al terreno mentre i raggi del Sole dimostrano che ci si sta spostando sulla sua superficie? Facendo l'assunzione, utile ma errata (anche se non di molto), che Alessandria e Syene fossero sullo stesso meridiano terrestre e attuando un con-

fronto tra il rapporto *angolo sotteso dall'ombra – angolo giro* e quello tra la *distanza delle due città* e la *circonferenza della Terra*, Eratostene riuscì a farsi un'idea abbastanza precisa della lunghezza della circonferenza del nostro pianeta che risultava essere pari a circa 252.000 stadi. A questo punto il gioco si poteva dire concluso: una volta nota la misura della circonferenza, il raggio terrestre risultava univocamente determinato e ottenibile, sempre in stadi, dividendo la circonferenza per 2π. Da fine telepate quale io sono, so che vi state chiedendo che accidenti sia questa strana cosa chiamata *stadio*, quindi ve lo spiego senza ulteriori indugi: si tratta di un'unità di misura alquanto instabile dacché veniva usata riferendosi alle dimensioni delle piste per le gare atletiche le quali, ben lungi dall'essere come oggi uniformate a uno standard preciso, variavano di città in città, di regione in regione, costringendoci ad accontentarci di darne una valutazione media. Dai ritrovamenti archeologici si è riusciti a calcolare questa media, che risulta essere pari a 157 metri e che ci consente di tradurre in metri i 252.000 stadi di circonferenza terrestre ottenendo 39.564 km. Con un ultimo sforzo – mediante la solita, semplice relazione che lega il raggio alla circonferenza – otteniamo finalmente la tanto agognata lunghezza del raggio terrestre: 39.564 km / $2\pi \approx$ 6.300 km. Ecco quindi prendere forma il cosmo disegnato da Aristarco che, con la semplice lunghezza-cardine del raggio terrestre, conquistò improvvisamente dignità di luogo fisico, di ente reale perché dotato di dimensioni misurabili in cui si poteva addirittura dare una stima numerica della distanza Terra-Luna della quale in un primo momento il greco aveva potuto fornire solo una valutazione comparativa. Se ci sono riusciti loro, *col senno di poi* possiamo provare a calcolarla anche noi riproducendo un ragionamento che per la prima volta venne fatto 2.300 anni fa! Non siete emozionati? Io sì. Procediamo:

$$\text{Distanza}_{\text{Terra-Luna}} = 40 \cdot \text{diametro}_{\text{Terra}} = 40 \cdot 12.000 \text{ km} = 480.000 \text{ km}$$

misura da confrontare con i valori oggi accettati del raggio medio equatoriale terrestre, pari a 6.378 km, e della distanza Terra-Luna, valutata in circa 384.000 km.

Direi due gran bei risultati questi di Aristarco e di Eratostene, se solo pensiamo che sono stati ottenuti da uomini dalla forte fiducia in una logica non supportata dalle foto della Terra riprese da satellite di cui oggi disponiamo! Costoro, più o meno trecento anni prima di Cristo, 2.300 anni fa, hanno fornito per la prima volta misure dello spazio vuoto e buio che giace al di là della nostra percezione quotidiana di esseri schiacciati sulla superficie terrestre. Nonostante tutto questo sforzo quantificatore di immensa immaginazione scientifica, alla fine prevalse comunque il pensiero qualitativo Aristotelico e sarebbe interessante indagare sui perché – immagino ce ne sia più d'uno – della vittoria delle sue teorie su quelle antagoniste. Forse il motivo è da ricercare nel fatto che il macedone fondò una scuola che annoverava molti più allievi di quanti non facessero quelle degli altri, complice la grande pubblicità che si era fatto come insegnante di Alessandro Magno. Di certo le teorie aristoteliche sulla costituzione del cosmo non implicavano un salto mentale così difficile da concepire come quello necessario per apprezzare il pensiero di Aristarco il quale di sicuro non era capace come Aristotele di ab-

bagliare gli astanti con il suo metodo di indagine tanto coerente da poter essere applicato a tutti i campi dello scibile del suo tempo. Fatto sta che, di fronte al bivio tra le due opzioni, eliocentrica e geocentrica, quest'ultima detronizzò la prima, e lo fece per molto, molto tempo. La costituzione del mondo fisico teorizzata da Aristotele era di tal fatta da sembrare conformata apposta per poter ospitare un mondo di idee al tempo ancora al di là da venire e assolutamente non intuibile dallo stagirita: l'edificio culturale della *scolastica*. C'è da chiedersi cosa avrebbe fatto il sommo filosofo se gli avessero spiegato in quale baratro culturale avrebbe fatto cadere con le sue teorie tutto il mondo occidentale per molti secoli a venire... In ogni caso, dicevo, la forma del mondo aristotelico, col suo essere ancora strutturato come una cipolla con la Terra ferma al centro (vedi cap. precedente), ben si prestava a fare da astuccio per accogliere le idee cristiano-cattoliche che disegnavano il progetto cosmico voluto da Dio come costituito essenzialmente da una realtà divina al di là della sfera delle stelle fisse, il piano di esistenza umana posto a un livello inferiore e inferi ancora più in basso. In pratica un sopra, un centro e un sotto. Un ideale viaggio in questo schema è quello compiuto da Dante Alighieri il quale, partendo dalla base – l'Inferno, appunto – e passando attraverso uno stadio intermedio, giungerà a godere della luce divina emanata dal responsabile della creazione del mondo. Queste idee nascevano prima di Aristotele. Dante Alighieri e la società tutta del suo tempo le riteneva vere ancora nel 1300 d.C., ben 1.600 anni dopo la nascita del filosofo macedone, ma la cosa che ha dell'incredibile è che, con alcune piccole – minime direi – modifiche, a dispetto del lungo tempo da allora trascorso, questo schema teorico di spiegazione della realtà continua a essere quello preferito da circa 3 miliardi di persone, molte delle quali credono alla scienza solo fintanto che non entri in collisione con quanto le *Scritture* affermano. Qualcuno sarà portato a pensare che, proprio per i grandi numeri coinvolti, questo schema sia da ritenersi il più valido, almeno da un punto di vista statistico. Purtroppo a tutt'oggi – *ahimè!* – manca ancora il conforto di misure che possano accalorare il furore fideistico dei più. Questa, si badi, non vuole essere una critica mossa contro la struttura della religione cristiano-cattolica, contro il sentimento di fede e quant'altro c'è di fondamentale nel credere e che coinvolge in qualche misura anche chi scrive queste righe. È di sicuro una critica a tutto ciò che è sovrastruttura, ovvero l'apparato di superstizioni che si fanno derivare dai principi della fede e che arrivano a dare finanche spiegazioni "dettagliate" della realtà in contrapposizione evidente con quanto il cammino delle idee *che camminano*, siano esse politiche o scientifiche, suggerisce di pensare sul mondo. Sospenderei quindi il giudizio, anche se il processo viene correntemente assunto come vinto dalla solita maggioranza per decorrenza dei termini.

Un Aristarco nostrano

Igino, mitografo vissuto nel primo secolo dopo Cristo, ci riporta un ragionamento che ci offre la possibilità di capire come potrebbe essere venuta in mente ad Aristarco l'idea della grande distanza del Sole e dei vari pianeti da noi, semplicemente basandosi sui tempi che que-

sti corpi impiegano per compiere un giro delle costellazioni dello zodiaco. Nel passo riportato più sotto forse risulta più chiara pure l'origine dell'idea stessa della musica delle sfere a cui pare si sia ispirato anche Eratostene. In esso si parla infatti di "toni" e di "semitoni", due parole appartenenti soprattutto alla terminologia musicale moderna e che derivano dal verbo *tèino*, in greco "tendere". Questo etimo mi fa pensare, oltre che al monocorde pitagorico, anche all'antica pratica egiziana degli *harpedonaptai*, ovvero "coloro che tendono la fune", esperti misuratori degli appezzamenti di terreno che si servivano proprio di corde tese per ristabilire i confini delle proprietà dopo i periodici straripamenti del Nilo; una pratica da cui si fa derivare la *geometria*, letteralmente *misura della terra*. Chissà, probabilmente da questa teoria derivano anche l'uso del rigo musicale e delle note segnate come circoli su di esso. In ogni caso, più leggo il suo argomento e più lo trovo sensato, evidente, quasi banale, anche se la storia ci mostra come un tempo non lo fosse affatto. Vediamo se vi fa lo stesso effetto:

La Luna infatti è vicina alla Terra: ci mette trenta giorni, si ritiene, ad attraversare la totalità del cielo. Ed ecco la spiegazione di tale fenomeno: supponiamo che uno tracci dei cerchi all'interno del circolo zodiacale ponendoli a intervalli tali che la Terra sia al centro e che dalla Terra alla Luna la misura sia data da quella che i Greci chiamano "tono" (non potendo precisare la distanza, hanno utilizzato il termine "tono"): la Luna dista così dalla Terra un tono. Per il fatto che essa percorre il cerchio più corto, in trenta giorni ritorna al primo segno. Da tale cerchio dista un semi-tono quello percorso dall'astro di Mercurio; così procedendo più piano, esso ci mette trenta giorni per passare al segno successivo. Da tale cerchio dista un semi-tono quello percorso dall'astro di Venere, procedendo più lentamente di quello di Mercurio: passa infatti al segno successivo in trenta giorni. Al di sopra di tale astro gira il Sole, che dista da Espero, l'astro di Venere, un semitono. Accompagnando i pianeti inferiori con il suo volo alato esso percorre in un anno i dodici segni, passando ogni trenta giorni da un segno al successivo. Al di sopra del Sole e della sua orbita si trova l'astro di Marte, che dista dal Sole un semi-tono. Si dice perciò che passi al segno successivo ogni sessanta giorni. Al di sopra di tale cerchio c'è l'astro di Giove, che dista da quello di Marte un semi-tono. Ci mette un anno a passare da un segno al successivo. L'ultimo è l'astro di Saturno, che percorre l'orbita più grande: dista da Giove un tono. Ci mette trent'anni a percorrere i dodici segni. Le figure delle costellazioni, per parte loro, distano da Saturno un tono e mezzo. (…) Questa teoria ti fa capire che né il Sole né la Luna toccano le stelle, nonostante la loro rivoluzione lungo il circolo zodiacale. Da essa possiamo anche dedurre che la Luna è più piccola del Sole. Giacché tutti i corpi più vicini a noi hanno necessariamente una dimensione maggiore rispetto a quelli che vediamo a grande distanza. Dunque noi vediamo che la Luna è

> vicina a noi, ma non appare alla nostra vista più grande del Sole. Siccome il Sole si trova lontano dalla Luna e da noi e appare più grande, ne consegue che se potesse avvicinarsi a noi, apparirebbe molto più grande.

Per inciso, in questo passo si trova anche un'osservazione che, con le dovute modifiche, quindici secoli più tardi diverrà la terza legge di Keplero. Il mitografo di epoca romana, rifacendosi ad Aristarco, supponeva infatti che i pianeti ruotassero attorno al Sole tutti alla stessa velocità costante, ma su orbite diverse per grandezza. Questo significa che le loro diverse distanze dal centro fossero la chiave per capire il perché dei diversi tempi che i vari pianeti impiegavano per compiere un giro completo rispetto alle stelle fisse. Tali tempi risultavano sempre più lunghi man mano che si procedeva dal Sole verso l'esterno…

Il grave gravita e il lieve… *lievita*

Aristotele, nel Libro IV del suo già citato *Il Cielo*, affrontando il tema di cosa sia pesante e cosa sia leggero, afferma:

> Riguardo al pesante e al leggero, si deve esaminare che cosa siano, quale sia la loro natura e anche quale sia la ragione per cui hanno tali potenze. Lo studio di questi temi rientra nelle ricerche sul movimento, in quanto diciamo che una cosa è pesante o leggera in base alla sua attitudine a muoversi naturalmente in un certo modo. Poiché lo studio della natura tratta del movimento, e poiché le cose leggere e quelle pesanti hanno in se stesse, per dir così, le scintille che generano il movimento, tutti gli studiosi della natura ricorrono alle loro potenze; tuttavia, tranne che in pochi casi, non ne danno alcuna definizione. (…) Pesante e leggero si dicono sia in assoluto, sia in relazione ad altro. Di più cose che hanno peso, diciamo che l'una è più leggera e l'altra senza la cupola più pesante: per esempio, diciamo che il bronzo è più pesante del legno. (…) Che esistano un leggero assoluto e un pesante assoluto risulta evidente da quanto segue. Intendo per "leggero assoluto" ciò che è portato per natura a dirigersi sempre verso l'alto, e per "pesante assoluto" ciò che è portato per natura a dirigersi sempre verso il basso, a condizione di non esserne impedito. Esistono realmente dei corpi di tal genere, e le cose non stanno come credono alcuni, secondo cui tutte le cose hanno un peso. Che vi sia il pesante e che esso si diriga sempre verso il centro, lo ammettono anche altri. Allo stesso titolo esiste anche il leggero. Constatiamo infatti, come si è rilevato in precedenza, che i corpi composti di terra si collocano al di sotto di tutti gli altri e si dirigono verso il centro. Ma il centro è determinato. Se dun-

que esiste un corpo che si colloca al di sopra di tutti gli altri – ed è ciò che fa manifestamente il fuoco, il quale, anche nell'aria, si porta verso l'alto, mentre l'aria rimane immobile – è evidente che questo corpo si dirige verso l'estremità. Di conseguenza, esso non può avere nessun peso, perché in tal caso si situerebbe sotto un altro corpo; ma se le cose andassero in questo modo, ci sarebbe un altro corpo che si dirigerebbe verso l'estremità e si disporrebbe al di sopra di tutti i corpi che si muovono. In realtà, nulla di tal genere risulta all'osservazione. Il fuoco dunque non ha peso, e la terra non ha leggerezza, se è vero che si colloca sotto tutti i corpi e che quando si colloca sotto tutti gli altri corpi si dirige verso il centro. (…) Inoltre, si constata che il fuoco quando si dirige verso l'alto, e la terra quando si dirige verso il basso, formano degli angoli uguali. Di conseguenza, è verso il centro che debbono dirigersi i corpi pesanti. (Il problema se sia verso il centro della terra o verso quello dell'universo, dal momento che essi di fatto coincidono, è stato oggetto di un'altra indagine). Poiché il corpo che si colloca sotto tutti gli altri si dirige verso il centro, è necessario che quello che si solleva al di sopra di tutti gli altri si diriga verso l'estremità della regione nella quale i corpi effettuano il loro movimento. Infatti, il centro è il contrario dell'estremità, e il corpo che si colloca sempre sotto gli altri è il contrario di quello che si dispone sempre sopra di essi. Pertanto, la dualità del pesante e del leggero risulta conforme alla ragione, dal momento che anche i luoghi sono due: il centro e l'estremità.

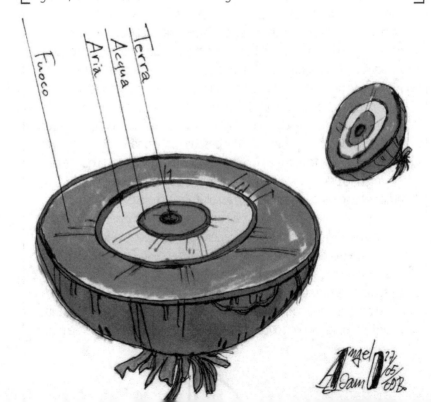

Ecco delineata una seconda cipolla: dopo le sfere omocentriche di Eudosso di Cnido ancora vive nella cosmologia aristotelica, si teorizza un'ulteriore suddivisione del mondo basata sulla stratificazione degli enti che questo mondo riempiono. Nel seguito del suo trattato, Aristotele arriverà infatti a parlare degli altri elementi intermedi, l'acqua e l'aria, che si disporranno la prima direttamente sopra la terra e la seconda direttamente sotto il fuoco. Questa nuova cipolla *chimica* ha quindi quattro strati all'interno dei quali sono possibili trasferimenti destinati a non perdurare perché in ogni caso ogni corpo deve tornare, prima o poi, a quello che è il suo *luogo naturale*, il solo posto del mondo dove può trovare la quiete perché quella è la sua collocazione naturale, che gli spetta di diritto; il suo *autostato*.

Lumi e tenebre

Nonostante i matematici dell'epoca si adoperassero per costruire modelli sempre più aderenti al vero – e quindi sempre più complicati – dei moti celesti, la precisione raggiungibile dallo schema aristotelico-tolemaico nella predizione dei movimenti planetari era molto limitata. Questa imprecisione aveva delle ripercussioni notevoli e sempre meno accettate sulla misura del tempo e sulle tecniche di navigazione le quali erano basate proprio sull'osservazione costante e attenta di quanto in cielo avveniva. In questo contesto si inserì timidamente l'opera del pavido polacco Niccolò Copernico il quale, nel suo *De revolutionibus orbium caelestium* finito di scrivere nel 1530, riprese l'ipotesi della centralità del Sole già immaginata da Aristarco grazie alla quale dimostrò come fosse possibile ottenere una certa semplificazione e una presunta maggior precisione dei calcoli dei moti celesti. Il filosofo, temendo il *calumniatorum morsus*, ovvero quella ritorsione del mondo ecclesiastico che aveva già colpito duramente molti in passato e che continuerà a farlo ancora per diversi decenni dopo la sua morte, non volle pubblicare la sua opera, eccezion fatta per alcuni piccoli estratti. Si deciderà a farlo oramai molto avanti negli anni, acconsentendo alle pressioni del suo aiutante *Retico* e di quanti avevano avuto modo di apprezzare il contenuto della sua teoria. Il 24 maggio 1543 riceverà così, proprio sul letto di morte, la prima copia stampata del libro che, per venire alla luce, aveva dovuto attendere che le tenebre scendessero sull'autore. Per meglio capire quanto fosse asfittica l'atmosfera che si respirava all'epoca, leggiamo la prefazione del teologo Andrea Osiander – incaricato dall'amico Retico di seguire la stampa del *De Revolutionibus* – da lui aggiunta al testo così pericolosamente innovativo per evitare di incorrere in ritorsioni da parte della Chiesa:

> Al lettore, sulle ipotesi di quest'opera
>
> Non dubito che alcuni dotti – poiché già si è divulgata notizia della novità delle ipotesi di quest'opera, che pone la Terra mobile e il Sole invece immobile in mezzo all'universo – ne siano rimasti vivamente offesi e giudichino

> inopportuno turbare le discipline liberali da tempo istituite. Ma se vorranno ponderare esattamente la cosa, troveranno che l'autore di quest'opera nulla ha commesso che meriti di essere biasimato. È proprio dell'astronomo, infatti, mettere insieme con osservazione diligente e conforme alle regole, la storia dei movimenti celesti; poi le loro cause, ossia – non potendo in alcun modo raggiungere quelle vere – escogitare e inventare qualunque ipotesi, con la cui supposizione sia possibile calcolare quei medesimi movimenti secondo i principi della geometria, tanto nel futuro quanto nel passato. Ora, l'autore ha assolto egregiamente questi compiti. Non è infatti necessario che queste ipotesi siano vere, e persino nemmeno verosimili, ma è sufficiente solo questo: che presentino un calcolo conforme alle osservazioni; (…) Lasciamo dunque che anche queste nuove ipotesi si facciano conoscere accanto a quelle antiche, per nulla più verosimili, tanto più che esse sono insieme ammirevoli e facili, e portano seco un ingente tesoro di dottissime osservazioni. E perché non si lasci questo studio più stolti di quando lo si era intrapreso, prendendo per vere cose preparate per altro uso, nessuno si aspetti dall'astronomia, per quello che si attiene alle ipotesi, alcunché di certo, perché niente di simile essa può mostrare. Salute.

Il terrore che trapela da queste righe di sicuro non divertiva nessuno all'epoca in cui venivano scritte ma, col giusto *senno di poi*, potendo sentirsi fuori pericolo, c'è chi ha deciso di farne occasione di risate a denti stretti. La comicità della faccenda non è sfuggita al nostro Giacomo Leopardi il quale dedica una delle sue *Operette Morali* alla vicenda della lenta affermazione della teoria copernicana. In quella intitolata, appunto, *Il Copernico*, il Sole, "stanco di questo continuo andare attorno per far lume a quattro animaluzzi", sciopera e convoca il filosofo per incaricarlo di spiegare alla Terra che da quel momento in poi toccherà a lei di girare attorno a lui. Nel finale, si legge:

> Sole: Bene sta, Copernico mio: prova.
> Copernico: Ci resterebbe una certa difficoltà solamente.
> Sole: Via, qual è?
> Copernico: Che io non vorrei, per questo fatto, essere abbruciato vivo, a uso della fenice: perché accadendo questo, io sono sicuro, di non avere a risuscitare dalle mie ceneri come fa quell'uccello, e di non vedere mai più, da quell'ora innanzi, la faccia della signoria vostra.
> Sole: Senti, Copernico: tu sai che un tempo, quando voi altri filosofi non eravate appena nati, dico al tempo che la poesia teneva il campo, io sono stato profeta. Voglio che adesso tu mi lasci profetare per l'ultima volta, e che per la memoria di quella mia virtù antica, tu mi presti fede. Ti dico io dunque che forse dopo te, ad alcuni i quali approveranno quello che tu

> avrai fatto, potrà essere che tocchi qualche scottatura, o altra cosa simile; ma che tu per conto di questa impresa, a quel ch'io posso conoscere, non patirai nulla. E se tu vuoi essere più sicuro, prendi questo partito: il libro che tu scriverai a questo proposito, dedicalo al papa. In questo modo, ti prometto che né anche hai da perdere il canonicato.

A onor del vero, c'è comunque da notare che, leggendo il seguito del *De Revolutionibus*, si evince quanto Copernico in buona parte della sua visione del mondo è e rimane – e, del resto, non poteva che essere così – un aristotelico convinto. Leggiamo infatti:

> Ora nulla repugna tanto all'ordine del tutto e alla forma del mondo quanto il fatto che qualcosa sia fuori dal suo posto. Dunque il movimento rettilineo non accade se non alle cose che non si trovano a posto, e non sono perfette secondo natura, ma si separano dal loro tutto e abbandonano la loro unità. (…) Quelle che cadono, facendo all'inizio un movimento lento, aumentano di velocità cadendo. Mentre vediamo d'altra parte che il fuoco terrestre (e noi non ne vediamo altro) portato verso l'alto langue immediatamente, come se palesasse la causa della violenza della materia terrestre. Ora il movimento circolare prosegue sempre in modo uniforme, poiché ha una causa costante; quello rettilineo, invece, smette il moto accelerato per il quale le cose che hanno raggiunto il loro luogo cessano di essere gravi o leggere e cessa quel moto. (…) A ciò si aggiunge ancora che la condizione d'immobilità è giudicata più nobile e divina di quella di mutazione e di instabilità, che meglio, perciò, si addice alla Terra che al mondo. Per di più sembra piuttosto assurdo attribuire movimento al contenente e collocante e non invece al contenuto e collocato, che è la Terra. (…) Vediamo, dunque, che per tutte queste cose è più probabile la mobilità della Terra, che non il suo stato di quiete, soprattutto per la rivoluzione quotidiana, in quanto propria soprattutto della Terra.

L'osservatore pisano

In questa staffetta nella comprensione del mondo iniziata molto prima della nascita di Cristo e ancora in corso, a questo punto della storia il testimone passa a un altro nostro illustre connazionale, il pisano Galileo Galilei. Numerose sono le novità apportate dall'operato di questo grande osservatore della Natura; e tutte meriterebbero di comparire in una qualsiasi trattazione sui temi di cui stiamo parlando. Per ovvi motivi di spazio, nel presente capitolo mi limiterò a riportare solo due aspetti del suo lavoro che molto hanno a che vedere con quanto qui stiamo raccontando. È anzitutto importante ricordare che, a fianco degli

esperimenti mentali che si trovò costretto a immaginare, non essendo all'epoca possibile creare le condizioni per metterli in atto in modo corretto, egli si ingegnò per studiare in modo empirico il moto di caduta dei gravi.

È interessante notare come dai suoi studi nascano nuovi significati, più precisi di quelli già esistenti, delle parole già usate da Aristotele, come per esempio accade per la parola "accelerazione". Essa, nel caso di un corpo lasciato scendere lungo un piano inclinato preparato in modo adeguato allo scopo – una situazione fisica il cui caso particolare è quello di un corpo in caduta libera, ovvero di un corpo su di un piano inclinato che formi un angolo di 90° con il suolo – viene misurata da Galilei come variazione delle distanze in proporzione ai quadrati dei tempi impiegati a percorrerle. La pretesa differenziazione dei comportamenti dei gravi al cambiare della natura dei corpi stessi – un'idea di aristotelica memoria – venne confutata in vari modi, non ultimo il famoso esperimento (solo mentale o davvero effettuato da Galilei?) di caduta contemporanea di gravi di dimensione e densità diverse dalla torre di Pisa. Infine, mi preme ricordare che egli fu il primo a scoprire per via sperimentale che la frequenza delle oscillazioni di un pendolo – un sistema che può essere sempre riguardato come un corpo che cade lungo una serie di piani inclinati con inclinazione variabile – non dipende dall'ampiezza delle oscillazioni o dalla massa del pendolo stesso, ma solo dalla lunghezza L del filo, anzi – per essere più precisi – dalla radice quadrata di questa lunghezza. Detto in altro modo:

$$
\begin{aligned}
&\text{Tempo di un'oscillazione completa del pendolo} = \\
&= T = (\text{costante di proporzionalità}_1) \cdot L^{1/2} = A \cdot L^{1/2} \quad \textbf{(2.1)}
\end{aligned}
$$

Bisogna tener presente che il pisano disponeva solo di pochi e rozzi strumenti di misura come per esempio orologi ad acqua sostituiti a volte con il computo dei suoi stessi battiti cardiaci usati come fossero lancette dei secondi. Per capire oggi quale difficoltà e frustrazione introdurrebbe nei nostri esperimenti il non possedere strumenti adeguati, mi piace riportare qui una *misurazione* compiuta da un'immaginaria vittima degli inquisitori che lo vorrebbero far morire proprio mediante una lama oscillante: un terrificante pendolo, un incubo affilato ed esatto da un punto di vista scientifico, partorito dalla fantasia informata di Edgar Allan Poe. Forse con questo racconto voleva solo ricordarci l'orrore che, come è noto, stava per troncare la vita di Galileo allorché a causa dei suoi studi gli venne intentato dall'inquisizione un processo per eresia. Ne *Il pozzo e il pendolo*, Poe fa così compiere al protagonista le sue annotazioni:

> Alzai gli occhi, esaminai il soffitto della prigione. Era alto trenta o quaranta piedi, e non dissimile dai muri laterali. In uno dei riquadri una figura assai singolare attrasse la mia attenzione. Vi era rappresentata, nella guisa più consueta, la figura del Tempo; solo che, al posto della falce, reggeva in mano ciò che, ad uno sguardo frettoloso, mi parve l'immagine dipinta di un enorme pendolo, come se ne vedono negli orologi antichi. V'era, tuttavia,

nella sagoma di quell'oggetto, qualcosa che mi indusse ad un più attento esame. Quando alzai lo sguardo per fissarlo – era direttamente al di sopra di me – mi sembrò di vederlo in movimento. L'impressione fu subito confermata. L'oscillazione era breve e, naturalmente lenta. La osservai per alcuni minuti, tra stupito e spaurito. Stanco alla fine di tener d'occhio quel monotono moto, mi volsi a guardare gli altri oggetti della cella. (…) Dopo forse mezz'ora, forse un'ora, giacché non potevo che misurare il tempo in modo imperfetto, alzai di nuovo lo sguardo. Quel che vidi mi sorprese e confuse. L'oscillazione del pendolo era cresciuta d'ampiezza di circa una yarda. Di conseguenza, la velocità era d'assai maggiore. Ma soprattutto mi turbò l'impressione che fosse disceso, e di molto. Ora notai – con quale orrore non occorre dire – che all'estremità inferiore era una mezzaluna di acciaio splendente, della lunghezza di un piede circa da corno a corno; questi erano volto verso l'alto, e la lama inferiore appariva affilata come quella di un rasoio.

Come si può notare osservando la (2.1), in essa non compare in nessun modo un qualche attributo del corpo appeso al filo che serva a specificarne la natura. Questo significa che, qualsiasi sia il corpo scelto per creare il pendolo, quindi qualsiasi sia la sua massa, l'unico fattore capace di influenzare la durata delle oscillazioni sarà la lunghezza del filo al quale esso verrà appeso. La scoperta suggerì a Galileo come dovesse esservi qualcosa di universale che agiva sui corpi "da fuori" e indipendente dalla loro natura interna, dal loro "dentro". Mi interessa questa legge perché mi sembra contenere *in nuce* ciò che Keplero scoprì per altra via, quando arrivò a enunciare la terza delle sue famose tre leggi.

In essa si afferma che i pianeti percorrono le loro orbite ellittiche mantenendo costante il rapporto tra il quadrato dei tempi impiegati a percorrerle e i cubi dei loro raggi vettori. Questo significa che, indipendentemente dalla massa e dalle dimensioni del pianeta, una volta stabilita la sua distanza dal Sole, il tempo che esso impiega a rivolgere intorno all'astro e, quindi, la sua velocità di rivoluzione risultano univocamente determinati. Volendo semplificare, consideriamo un pianeta su un'orbita circolare – caso particolare di un'orbita ellittica in cui i due fuochi coincidono. A questo punto possiamo semplificarci ulteriormente la vita evitando di parlare di *raggi vettori* per usare il concetto più facile di *raggio* di una circonferenza. Sia che si parli di orbite circolari, sia che si tratti di ellittiche, la terza legge di Keplero potrà essere espressa nella forma:

$$T^2 / L^3 = \text{(costante di proporzionalità}_2) = B \quad (2.2)$$

Esprimiamo la legge del pendolo (2.1) trovata da Galileo in un modo che permetta di vedere l'analogia con quanto trovato da Keplero con la sua terza legge enunciata qui sopra (2.2):

$$T^2 / L^{1/2} = \text{(costante di proporzionalità}_1) = A \quad (2.1 \text{ bis})$$

A parte una certa parentela visiva con la precedente (differiscono solo per l'esponente della L e la costante di proporzionalità), mi preme far notare che in ambedue i casi si mette in relazione stretta il tempo impiegato da un oggetto a percorrere il suo tragitto attorno a un punto dato e la sua la distanza da tale punto. La similitudine tra le due la si ritrova anche sotto un altro punto di vista. Vi invito a farvi coraggio e a immaginare di stare al di sotto del pendolo del racconto di Poe: lo vedrete andare avanti e indietro a disegnare una linea ideale. Ora invece respirate, rilassatevi e immaginate di mettervi a osservare da lontano una giostra con sopra dei bambini. Ne converrete che li vedrete muovere da una parte all'altra del centro della giostra, arrivando a discostarsi da esso al massimo di una lunghezza pari al raggio della giostra stessa. Sapete bene che in realtà essi si stanno muovendo di moto circolare, ma voi da lontano vedrete soltanto il loro movimento periodico, da un lato all'altro su una stessa linea, esattamente come accadeva nel caso del pendolo. Nel primo caso, la circonferenza di raggio pari alla lunghezza del filo del pendolo viene percorsa solo in parte. Nel secondo caso invece i bambini compiono giri completi attorno al centro della giostra. In entrambe le situazioni, il percorso si svolge lungo una circonferenza. A spingermi a credere che Galileo fosse a un passo dal trovare le leggi che ora portano il nome di Keplero e che in pratica già le avesse espresse in una forma implicita, ma pur sempre corretta, vi è un altro passo del solito *Sidereus Nuncius* in cui, a proposito dei movimenti delle quattro lune gioviane da lui osservate, Galileo afferma:

> Si rileva inoltre che sono più veloci i giri dei Pianeti che descrivono circoli più stretti intorno a Giove; poiché le Stelle più vicine a Giove si vedono per lo più ad oriente quando il giorno prima siano apparse a occidente, e viceversa: ma il Pianeta che traccia l'orbita più grande, a chi esanima accuratamente i su notati ritorni, sembra avere periodi semi-mensili

Sempre nello stesso libro, un testo che sappiamo che era noto a Keplero, Galileo arriva a dire qualcosa che può avere stimolato anche l'idea della prima delle tre leggi dell'astronomo svevo, quella nella quale si afferma che i pianeti rivoluzionano attorno al Sole muovendosi su orbite ellittiche. Infatti, commentando la sua scoperta delle lune di Giove, il pisano aveva già osservato:

> E finalmente non si deve tralasciare, per qual ragione accada che gli Astri Medicei, mentre compiono rotazioni assai ristrette intorno a Giove, sembrino a volte più grandi del doppio. Non possiamo minimamente ricercarne la causa nei vapori terrestri, poiché essi appaiono accresciuti o diminuiti, mentre le moli di Giove e delle vicine fisse non si scorgono affatto mutate. Che poi essi s'accostino tanto alla Terra nel perigeo della loro rotazione, e tanto se ne discostino nell'apogeo, da causare con ciò un così grande mutamento, sembra del tutto impensabile; poiché una ro-

> tazione circolare stretta non può produrre questo effetto in alcun modo;
> e un moto ovale (che in questo caso sarebbe quasi retto) sembra non solo
> impensabile, ma neppure in alcun modo consono con le apparenze.

Il nostro scienziato ritiene l'ipotesi di orbite ovali assolutamente da rigettare, "impensabile", ma intanto, anche solo per un attimo, ci pensa...

Un "assolo" di chitarra: il monocorde

Può essere interessante capire come i due sono arrivati a stabilire la particolare forma delle relazioni di cui sopra. Nel caso di Galileo è presto detto: pare che l'idea gli sia venuta osservando un lampadario oscillare nel duomo di Pisa. Sembra anche che, grazie alla sua grande conoscenza della musica, sia riuscito a misurare i tempi delle oscillazioni mettendoli in relazione al tempo tenuto dai musicisti che stavano accompagnando la funzione religiosa. Questa osservazione lo indusse a produrre una serie di esperimenti con pendoli di masse e lunghezze diverse, prendendo molte misure dei tempi delle oscillazioni. Keplero, come già si è detto nel capitolo precedente, era un pitagorico convinto. Come l'antico crotonese, anche lui credeva nella musica prodotta dai pianeti e, nonostante oggi si sappia che nulla di ciò che era alla base delle loro teorie sulla musica delle sfere sia da ritenersi vero, dobbiamo riconoscere che l'erroneo persistere di entrambi in una visione così piena di *appeal* da un punto di vista estetico, li ha condotti a scoprire due leggi fondamentali. La prima, quella scoperta da Pitagora che mise in relazione il suono prodotto dal monocorde con la lunghezza della corda usata, pare essere in assoluto la prima legge fisica mai scoperta.

Vale la pena di darne una spiegazione un po' più dettagliata. Pitagora vide che la corda libera produce un suono che si ottiene all'ottava superiore se la si preme esattamente a metà della sua lunghezza. Traducendo il tutto in espressioni numeriche, indicando con la lettera *i* la lunghezza della corda intera e con *m* un segmento preso su di essa lungo esattamente la *metà* di *i*, si ha:

$$i/m = 2/1$$

Egli vide poi che interrompendo la corda a 2/3 della lunghezza totale, si otteneva la quinta nota della scala. Questa volta chiamiamo *d* il segmento considerato e scriviamo:

$$i/d = 3/2$$

Premendo poi la corda in modo da lasciarne vibrare soltanto un segmento *b* pari a un quarto della sua lunghezza totale *i*, si scopre che si ottiene la quarta nota della scala:

$$i/s = 4/3$$

Se siete chitarristi o se semplicemente avete in casa uno strumento a corde, vi invito a fare l'esperimento. Io l'ho fatto con la mia chitarra classica. Delle sei corde, ne ho presa in considerazione solo una per volta e, scegliendo per esempio il Mi basso – prima corda in alto se avete imbracciato bene lo strumento –, premendola a metà della sua lunghezza, ho ottenuto davvero la stessa nota Mi all'ottava superiore. Se la metà si è rivelata facile da misurare a occhio, per trovare le altre frazioni mi sono dovuto servire di una riga. Ho misurato la lunghezza della corda da un ponticello all'altro (circa 63 cm) e ne ho trovato le frazioni di cui sopra, verificando che premendola ai 3/4 della sua lunghezza (47,25 cm) si ottiene il La, mentre premendola ai 2/3 (42 cm) si ottiene il Si, rispettivamente 4° e 5° grado della scala costruita sul Mi (per inciso, le note della scala maggiore di Mi sono: Mi, Fa diesis, Sol diesis, La, Si, Do diesis, Re diesis). La tonica, in questo caso sempre il Mi, la *sottodominante* o quarta (La) e la *dominante* o quinta (Si) sono anche le note sulle quali si costruiscono gli accordi fondamentali dell'armonia blues e di molta musica pop e rock. Pitagora la sapeva molto, molto lunga. Oltre alla musica delle sfere, aveva già scoperto quella dei dischi…

A parte queste divagazioni, c'è da dire che la sequenza dei numeri interi che entrano nelle frazioni precedenti, ovvero 1, 2, 3 e 4, riveste una certa importanza nella visione pitagorica. La somma di questi numeri è pari a 10, numero considerato magico e indicato come *tetraktys*, sul cui simbolo gli adepti della consorteria (a tutti gli effetti una setta) giuravano fedeltà.

Nello scoprire che le orbite dei pianeti erano ellittiche (prima legge) e intuendo che essi si muovevano mantenendo costante il rapporto tra una qualche potenza del tempo T impiegato a percorrere un'orbita completa e una certa altra potenza della loro distanza L dal centro del moto, pare che Keplero abbia ricercato innanzitutto questi esponenti proprio tra i numeri della *tetraktys* scoprendo, abbastanza fortunosamente, che 2 e 3 andavano benissimo. Ecco che pervenne così alla formulazione della sua terza legge (abbiate pazienza: la seconda ve la racconterò nell'Intermezzo *Spazz-Aree*) e ci riuscì ancora una volta basandosi sull'idea profondamente sbagliata della musica delle sfere.

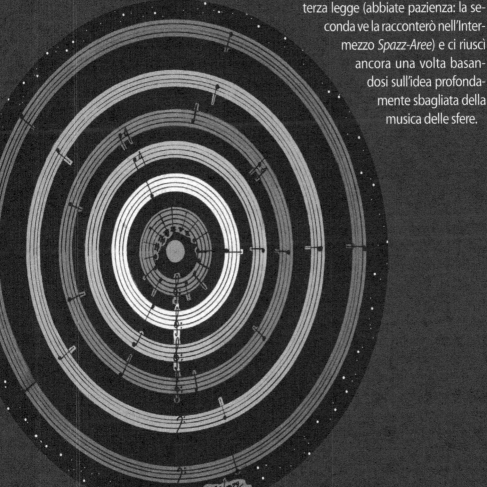

Newton, la vedetta

Tornando alle due relazioni precedenti (2.1 bis) e (2.2), ancora all'epoca non si sapeva molto della forma che dovevano possedere i termini a destra del segno di uguaglianza. In sostanza, non si sapeva affatto quale fosse il valore delle due costanti A e B. Per scoprirlo bisognerà attendere l'arrivo di un altro personaggio molto particolare. Intelligentissimo, schivo, superbo ma non a tal punto da non riconoscere, come ebbe a dire egli stesso, di essere riuscito a scoprire le sue leggi solo grazie al fatto di essere salito "sulle spalle di giganti" che lo hanno preceduto e che così gli hanno permesso di vedere più lontano (il riferimento all'opera di molti, in particolare quella di Copernico, Galileo e Keplero, è evidente), l'inglese Isaac Newton, classe 1642, arriverà a trovare la cosiddetta "Legge di Gravitazione Universale". Un nome meritatamente altisonante che indica una scoperta pubblicata nel 1687 e grazie alla quale ancora oggi mandiamo con successo le nostre sonde a spasso per il Sistema Solare.

Una precisazione: spesso sento dire che "Newton ha inventato la gravità". Mi sento di poter affermare con una certa sicurezza che non è stato lui. Non l'ha nemmeno scoperta: la palma di scopritore della gravità va a quel malcapitato che per primo ha fatto quel famoso esperimento consistente nel far cadere un peso. Il risultato, molto probabilmente disastroso, fu che il peso raggiunse velocemente i suoi piedi, al suolo. Anche prima di Newton le cose andavano così… Il merito di Newton fu *solo* quello di dare una matematizzazione esatta della forza di gravità. Dalla sua formula si può scoprire quanto male sentirete con un'incudine su un alluce; e scusate se è poco…

Nei suoi *Principia*, lo studioso inglese provvederà a fornire una descrizione rigorosa di tutte le questioni fisiche sin qui dibattute servendosi di un poderoso apparato matematico e geometrico che risulterà essere la traduzione esatta del calcolo di infinitesimi già vagheggiata, per esempio, nell'opera di Galileo *Dialogo su due massimi sistemi del mondo*. Nelle sue mani, l'espressione della forza con la quale la Terra ci tiene avvinti a sé diventa quella che oggi siamo soliti indicare col nome di *peso*, qualcosa che Newton mette in relazione alla massa dei corpi e all'accelerazione costante che detti corpi subiscono in virtù del loro essere sempre immersi nel campo gravitazionale prodotto dalla Terra grazie alla sua stessa massa. Sintetizzando con una facile espressione algebrica si ha:

$$\mathbf{P} = -m\mathbf{g} \quad (2.3)$$

nella quale il segno meno sta a indicare che \mathbf{P} è una forza che tende ad attrarre i corpi, a "sottrarre distanza" tra essi, e \mathbf{g}, accelerazione di gravità, essendo generata dalla massa del nostro pianeta, risulta essere uguale per qualsiasi corpo sulla Terra – sia esso solido, liquido o aeriforme: un duro colpo per gli aristotelici! – e pari a 9,8 metri/sec^2. Grazie a Newton, quindi, il pensiero di Galileo trionfa definitivamente su quello di Aristotele che fino all'arrivo delle teorie newtoniane risultava imbattuto.

Dato che, come si è detto, la forza **P** esiste in quanto la Terra con la sua massa si rende responsabile di questa attrazione, possiamo raccontare la relazione precedente nel seguente modo: **P** ci dice come si comportano un corpo di massa m e la Terra quando si incontrano; m rappresenta, appunto il corpo e **g** invece la Terra.

Per meglio comprenderla da un punto di vista matematico, è importante sapere che la (2.3) non è altro che la versione sintetica della seguente espressione di carattere più generale:

$$F = -G\, m\, M_{Terra}/ L^2 \quad (2.4)$$

E questa è proprio l'espressione della Legge di Gravitazione Universale prima citata, partorita dalla mente di Newton e della quale si può apprezzare il carattere di universalità, se si pensa che per trovare quale sarebbe la sorte gravitazionale di una massa m qualsiasi su di un altro pianeta – il suo peso altrove, per intenderci – basterebbe cambiare la M facendole assumere il valore della massa del nuovo responsabile del campo gravitazionale. Potrebbe quindi diventare M_{Luna}, $M_{Shuttle}$, M_{Giove}, $M_{Galassia}$, o anche $M_{zia\,Carmela}$: la legge sarebbe sempre valida. In essa compare la G detta *costante di Gravitazione Universale*, la quale vale soltanto $6,67 \cdot 10^{-8}$ dyne grammi^{-2} cm^2 (1 dyne = 1 g · 1 cm · 1 s^{-1}). Essa non viene creata dal campo gravitazionale terrestre, ma comparirebbe in qualsiasi calcolo condotto su qualsivoglia altro corpo di questo nostro universo, sia esso Plutone, una galassia lontana o la mia auto lanciata nello spazio siderale.

Essa ha quindi davvero un valore universale, risultando essere la prima costante di Natura di portata così ampia scoperta dall'uomo: siamo qui in presenza di quella che, se vi fosse una carta di identità del nostro Universo, comparirebbe alla voce "segni particolari", assieme ad altri pochi, essenziali, tratti distintivi.

Arrivati a questo punto, mi preme far notare come la forza F che si crea tra due corpi dipenda allo stesso modo sia da m che da M, il che vuol dire che non solo le masse grandi attirano le piccole, ma che anche le piccole si danno molto da fare. Sarà per questo che a sera siamo tutti a pezzi: per tutta la giornata non abbiamo fatto altro che tirare la Terra a noi!

Ora è la volta del termine L^2 presente al denominatore. Esaminiamolo bene perché esso è di estrema importanza in quanto ci spiega che la forza gravitazionale, allontanandosi dall'oggetto che con la sua massa crea attrazione, diminuisce molto velocemente, addirittura come il quadrato della distanza! Ecco perché se al suolo qualcuno riesce a saltare facendo in rapida sequenza delle veloci piro-

Maledetti GPS...

ette risulta essere agli occhi di tutti un campione di agilità e invece un qualsiasi astronauta nella stazione spaziale può muoversi in tutti i modi possibili senza che nessuno si meravigli più di tanto. Qui da noi, a soli 6.378 km dal centro della Terra, l'attrazione gravitazionale su un uomo di 80 kg è pari a:

$$F_{al\ suolo} = 6,67 \cdot 10^{-8}\ dyne\ cm^2\ g^{-2} \cdot 8 \cdot 10^4\ g \cdot 5,97 \cdot 10^{27}\ g\ /(6.378 \cdot 10^5\ cm)^2 = \\ = 7,83 \cdot 10^7\ dyne$$

Invece lo stesso uomo che, lo abbiamo scoperto nel frattempo, non era un astronauta e in un primo momento è morto di paura (pare che ora si stia divertendo un mondo), a 200.000 km di altezza dal suolo sente una forza di attrazione pari a:

$$F_{in\ orbita\ a\ 200.000\ km} = 6,67 \cdot 10^{-8}\ dyne\ cm^2\ g^{-2} \cdot 8 \cdot 10^4\ g \cdot 5,97 \cdot 10^{27}\ g\ / \\ / (2 \cdot 10^{10}\ cm + 6.378 \cdot 10^5\ cm)^2 = 74.793\ dyne$$

Facendo un confronto fra le due intensità, otteniamo:

$$F_{al\ suolo}\ /\ F_{in\ orbita\ a\ 200.000\ km} = 7,83 \cdot 10^7\ dyne\ /74.793\ dyne = 1.046$$

Il che significa che tutti noi al suolo sentiamo un'attrazione che è più o meno mille (1.000!!!) volte maggiore di quella che sentiremmo a circa metà della distanza Terra-Luna (≈ 384.000 km).

Proviamo a dire la stessa cosa in un altro modo: per quanto grande possa essere la massa M che si va a sostituire nell'espressione di F, preso un numero piccolo che scegliamo di indicare con f – per esempio $f = 0,1$ oppure $f = 0,000034…$ – ci sarà sempre una distanza a partire dalla quale sarà $F < f$, ovvero a partire dalla quale, man mano che ci si allontanerà, gli effetti dell'attrazione diventeranno minimi se non addirittura nulli. Ecco spiegato come mai chi si occupa di matematizzare il cielo proprio non riesce a credere che pianeti e – peggio! – stelle

abbiano un'influenza sul nostro destino: sono troppo lontani da noi e se fossero vicini, tratterebbero tutti i nati nei vari segni zodiacali allo stesso modo. Questa sì che è democrazia! È più o meno come dire che di sicuro siamo nati tutti nel segno di un astro molto particolare, la nostra Terra. La sua gravità, tramite il valore della **g**, risulta essere uguale per tutti noi suoi figli perché, a parte piccole e trascurabili differenze, siamo nati tutti alla stessa distanza… dal nostro pianeta.

Un'altra considerazione interessante che possiamo fare circa la forma della legge trovata da Newton è che si tratta di una forza *centrale*, ovvero di una forza che si manifesta nella direzione congiungente i centri degli oggetti considerati. Proprio per questo suo carattere, tutti i corpi attraggono verso il proprio centro gli altri *più o meno allo stesso modo*, qualsiasi sia la direzione attorno a esso considerata. Sarebbe esattamente *allo stesso modo* solo nel caso di corpi esattamente sferici. Questo vuol dire che la legge di Newton descrive una nuova cipolla – ancora una! – nella quale i vari strati sferici, a diverse distanze dal centro, sono quelli sui quali si avverte un'uguale gravità. A tal proposito, si pensi che l'accelerazione g sulla superficie terrestre risulta essere ovunque più o meno pari a 9,8 m/s^2. Non essendo una sfera perfetta, ai poli dove la Terra presenta un certo schiacciamento, essa risulta essere più grande di questo valore (perché siamo più vicini al centro) e all'equatore, dove invece la Terra presenta un rigonfiamento, g fa registrare un valore minore (siamo più lontani dal centro). Possiamo finalmente rispondere a una delle domande di inizio capitolo: i pianeti non sono cubici o di altra forma perché, per potere ottenere qualcosa del genere, bisognerebbe che il corpo centrale esercitasse un'attrazione diversa nelle diverse direzioni, cosa che non è contemplata dalla forma stessa che la forza mostra di avere una volta matematizzata.

Nulla a che vedere quindi con quanto si pensava prima della rivoluzione culturale provocata dall'arrivo di queste nuove consapevolezze fisiche. Si pensi, per esempio, che Copernico, uno che di rivoluzioni se ne intendeva, scriveva a tal proposito:

> In principio va rilevato che il mondo è sferico, sia perché questa forma è la più perfetta di tutte, un'integrità totale, non bisognosa di alcuna commensura; sia perché è la forma più capace, che meglio conviene a tutto comprendere e custodire; sia anche perché ogni parte separata del mondo – intendo il Sole, la Luna e le stelle – sono ravvisate in tale forma; sia perché in essa tendono a determinarsi tutte le cose, come appare nelle gocce d'acqua e negli altri corpi liquidi, quando tendono a circoscriversi da soli. Perciò nessuno metterà in dubbio che tale forma sia da attribuirsi ai corpi divini. (…) Anche la Terra è sferica, giacché da ogni parte si appoggia sul suo centro.

Qualcuno sarà portato a chiedere come mai un asteroide non è quasi mai sferico. Il motivo è che la sfericizzazione di un oggetto si ottiene solo superata una certa quantità di massa. A partire da un certo valore della M, l'attrazione della massa su se stessa riesce a diventare

così tanto importante da potere influenzare la sua stessa forma. Come dire, una persona molto magra non sarà mai a simmetria sferica e se un giorno avrà un po' di pancetta, questa non si distribuirà uniformemente su tutto il corpo per renderlo un po' più sferico. Rimarrà una persona magra con la pancetta, e basta. Ma, se gli imponiamo una dieta ingrassante a base di estrogeni, ormoni, pasta e pane, aumentando progressivamente la massa, il malcapitato diventerà sempre più tondo e, nei casi estremi, potrà diventare caricaturabile con una sfera.

Incidentalmente val la pena di riferire che da studi geologici è stato stabilito come, all'eventuale superamento di una quota di circa 10 km, un monte terrestre diventerebbe instabile e franerebbe sotto il suo stesso peso. La Terra così smusserebbe un allontanamento troppo evidente dalla sua forma tendenzialmente sferica.

Grazie alla formulazione matematica della Legge di Gravitazione Universale, con una serie di passaggi algebrici e di considerazioni non banali, si arriva finalmente a trovare per l'espressione galileiana del tempo che impiega un pendolo a compiere un'oscillazione e per quella di Keplero che mette in rapporto il tempo impiegato da un pianeta a compiere un'orbita di lunghezza L, le seguenti espressioni matematiche esatte:

$$T = 2\pi \cdot (L/g)^{1/2} \qquad (2.5)$$

$$T^2 / L^3 = 4\pi^2 / [G (M + m)] \qquad (2.6)$$

La seconda di esse risulterà particolarmente utile nel prosieguo del libro per capire come fare a calcolare la massa dei pianeti del nostro Sistema Solare. In essa di volta in volta potremo considerare M la massa del Sole ed m quella di un qualsiasi pianeta, oppure M la massa di un pianeta e m la massa di un suo satellite. Spesso scopriremo di potere allegramente semplificarci la vita in quanto vedremo che la massa del Sole è estremamente più grande della massa di qualsiasi pianeta e che la massa dei pianeti è, nella maggioranza dei casi, molto più grande della massa dei loro satelliti. Questo ci permetterà di fare la seguente approssimazione:

$$M + m \approx M \qquad (2.7)$$

Di conseguenza, in questi casi fortunati potremo usare la terza legge di Keplero nella sua forma semplificata:

$$T^2 / L^3 \approx 4\pi^2 / GM \qquad (2.8)$$

Ach! Forse dovevo fissarla meglio...
Speriamo che non si sia fatto male nessuno!

Si narra che Newton, standosene sotto un melo a meditare, sia stato colpito in testa proprio da una mela (incredibile, vero? Pensate un po' se, stando sotto un *melo*, fosse stato colpito da una *pera*. Forse, nel caso, avrebbe scoperto qualcos'altro!), che nel frattempo aveva deciso che *i tempi erano maturi* per staccarsi dall'albero che l'aveva generata. All'epoca ancora non c'erano le lampadine a simboleggiare le idee e la mela di biblica memoria poteva servire bene all'uopo. Forse è andata veramente così: Newton colpito vigliaccamente dal frutto si chiede "Come mai la mela cade e la Luna no? E se la Luna cadesse continuamente verso la Terra perché da essa attirata come la mela, ma fosse in ogni istante rilanciata in alto da una forza che si oppone a questa caduta?"

La leggenda vuole che siano stati pensieri simili a condurlo sulla retta via, facendogli capire come fosse il bilanciamento tra la forza centripeta (data dall'attrazione gravitazionale tra la massa della Terra e quella del nostro satellite) e la forza centrifuga creata dalla rotazione della Luna attorno al nostro pianeta a creare questo equilibrio salvando così la Luna da una caduta al suolo come mela matura e noi da un urto così imbarazzante. Di sicuro, se ciò accadesse, non sarebbe un evento foriero di nuove idee ma, bensì, la fine di tutte quelle vecchie.

Dice Ernst Mach che:

> Se ammiriamo questo lavoro compiuto dalla ragione, e perfettamente preparato dalle idee di Keplero, Galileo e Huygens, non stimiamo meno un altro, in cui ebbe parte la fantasia. Anzi non esitiamo a considerare quest'ultimo il più importante. Di quale natura è il moto curvilineo dei pianeti intorno al Sole, dei satelliti intorno ai pianeti?
> Con grande audacia Newton ha affermato, riferendosi in particolare alla Luna,

che l'accelerazione dei pianeti non è essenzialmente diversa da quella di gravità a noi nota. È probabile che lo abbia condotto a questa scoperta il principio di continuità, che già nelle scoperte galileiane aveva avuto una funzione importante. Newton era solito, e questo comportamento sembra comune a tutti i grandi scienziati, mantenere immutata una rappresentazione finché era possibile, anche per i casi che si presentavano con circostanze variate, e così conservate nelle rappresentazioni quell'uniformità che la natura ci fa conoscere nei suoi processi. Ciò che è proprietà della natura in un qualche tempo e luogo, si ritrova sempre e ovunque anche se a prima vista può sembrare diverso. Il fisico abituato alla continuità dei pensieri, poiché constata la presenza dell'attrazione gravitazionale non solo sulla superficie della Terra, ma anche in cima alle montagne e in fondo alle miniere, immagina che quest'attrazione agisca ad altezze e profondità per lui inaccessibili. Egli si chiede: dov'è il limite per l'azione della gravità terrestre? Non si estenderà per caso fino alla Luna? Con queste domande è guadagnato un potente slancio della fantasia, che unito a un forte raziocinio, com'è nel caso di Newton, non può non portare a grandi risultati scientifici.

Gli fa eco Paolo Rossi il quale, ricordando altri pensatori che potrebbero aver condotto lo scienziato inglese alle sue scoperte, afferma:

La storia millenaria di riflessioni sulla gravitazione fu cancellata anch'essa dalla coscienza collettiva, che accettò che si fosse trattato di un parto improvviso del genio di Newton. Il nuovo atteggiamento è bene illustrato dalla storiella della mela di Newton: una leggenda diffusa da Voltaire, che fu tra i più attivi e violenti nell'opera di rimozione del passato.

A mio parere, come già ho avuto di dire qualche pagina fa, senza nulla togliere al genio incredibile di Newton, osservando dalla spalla di Galileo le leggi del pendolo e osservando da quella di Keplero le leggi del moto dei pianeti e notandone le similitudini, si deve essere sentito nella possibilità di applicare ancora una volta il principio di continuità ricordatoci da Mach per estendere ciò che era stato scoperto su di un oggetto terrestre a ciò che si osservava degli oggetti celesti. Il *qui e ora* che influenza ciò che sta lontano in virtù delle interazioni tra masse, grande rivincita dell'astronomia sulla astrologia che da sempre si occupa della situazione opposta.

Ciò che sappiamo per certo qui, lo possiamo applicare anche a ciò che vediamo altrove, da lontano. In questo era stato abbondantemente preparato dal pensiero greco di Aristarco, di Pitagora, di Anassimandro, ma anche e soprattutto del più vicino nel tempo Galileo il quale queste similitudini tra Terra e cielo le aveva rese manifeste con l'invenzione del suo rivoluzionario strumento: il cannocchiale.

INTERMEZZO

Galileo + Keplero = Newton!

In questa sezione vorrei dare una dimostrazione più rigorosa della similitudine tra la legge del pendolo trovata da Galileo nel 1583 e la terza legge di Keplero. Mi preme ricordare che fu proprio Galileo a scoprire che l'accelerazione subita da un corpo ha le dimensioni di una lunghezza fratto un tempo al quadrato (in pratica, per misurarla abbiamo bisogno di un righello e di un cronometro da usare due volte).

 Consideriamo un corpo che ruoti in un tempo T attorno a un pianeta con la stessa massa e dimensioni della Terra, mantenendo da esso una distanza costante L. La sua velocità di rotazione sarà allora pari a $v = 2\pi L/T$ mentre la sua accelerazione centripeta, come è noto, varrà: $a = v^2/L = 4\pi^2 L/T^2$. Avendo considerato il corpo vicino alla superficie del pianeta, potremo approssimare la sua accelerazione centripeta con g, accelerazione di gravità, per cui avremo anche: $g = 4\pi^2 L/T^2$ dalla quale, risolvendo rispetto a T, si ricava:

$$T = 2\pi \cdot (L/g)^{1/2} \quad (*)$$

che è proprio la legge trovata da Galileo per il moto del pendolo, valida per piccole oscillazioni. Giunti a questo punto, ricordiamoci che tra la forza peso e l'espressione trovata da Newton della forza di attrazione gravitazionale che subiscono due corpi di massa m ed M_{Terra} posti a una distanza L l'uno dall'altro, vale la seguente uguaglianza:

$$P = mg = G\, m\, M_{Terra} / L^2$$

Semplifichiamo in ambo i membri il termine esprimente la massa m del corpo che subisce il campo gravitazionale generato da M_{Terra}

$$g = L/T^2 = G\, M_{Terra}/ L^2$$

e, elevando la (∗) al quadrato e sostituendovi l'espressione di g in termini di G, M ed L appena trovata, si ottiene:

$$T^2 = 4\pi^2 L/g = 4\pi^2 L^3 / (G\, M_{Terra})$$

dalla quale si ricava facilmente la

$$T^2 / L^3 = 4\pi^2 / (G\, M_{Terra})$$

che altro non è che l'espressione della terza legge di Keplero.

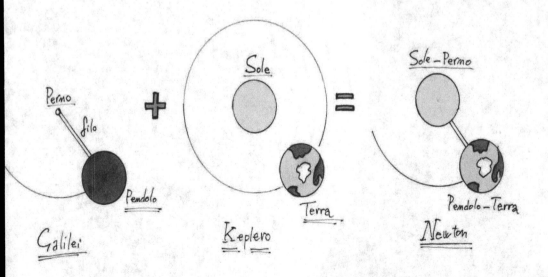

La gocciolina di Mercurio

Ed eccoci finalmente a parlare del primo dei corpi che incontriamo partendo dal Sole, introducendo così il vero argomento di questo libro, ovvero gli otto pianeti, le lune e gli altri oggetti minori che orbitano attorno alla nostra stella. Il protagonista di questo capitolo, prima tappa del nostro viaggio, è Mercurio, uno dei posti più *sfigati* di tutto il Sistema Solare.

Infatti, primo dei pianeti cosiddetti *terrestri* o *tellurici*, la faccia che di volta in volta viene rivolta al Sole durante la lenta rotazione attorno al suo asse (un giorno su Mercurio equivale a 58,65 giorni terrestri!) vivendo così il giorno mercuriano, arriva a registrare temperature dell'ordine dei 400 gradi centigradi, mentre la faccia opposta, che evidentemente si trova a vivere… la notte mercuriana, patisce un freddo da circa duecento gradi sotto lo zero.

Queste enormi differenze di temperatura sono dovute essenzialmente alla mancanza di una reale atmosfera: se ve ne fosse una come quella terrestre, il calore accumulato su un lato si propagherebbe – accettando un passaggio dai venti e dalle correnti atmosferiche, anche sull'altro – ristabilendo così l'equilibrio termico. Anche sulla Terra le differenze tra la notte e il giorno sarebbero enormi e per noi letali se non vi fossero la circolazione delle masse d'aria e quella delle masse d'acqua la cui azione congiunta ripristina un certo equilibrio termico su tutta la superficie del nostro pianeta.

Quindi Mercurio offre l'esotica possibilità di morire o di troppo caldo o di troppo freddo. Anticamente offriva un'ulteriore opzione *eutanasica*: nell'indecisione fra temperature assassine, si poteva scegliere di defungere ricevendo una incredibile sassata sulla testa gentilmente offerta dal traffico di asteroidi che un tempo affollavano le lande – molto più affollate di quanto non lo siano oggi – del nostro sistema planetario. Bisogna tenere conto che *No!*, non è la stessa cosa che ricevere una sassata analoga su un altro pianeta! Il Sole è il punto in cui si concentra ben il 99,9 % della massa dell'intero Sistema Solare e questo fa sì che se qualcosa si muove al di fuori delle buche di potenziale degli altri pianeti, be', vorrà dire che viaggerà inesorabilmente verso la nostra stella, che lo attirerà facendogli assumere un moto uniformemente accelerato, molto accelerato; sempre più accelerato. Acceleratissimo. Se malauguratamente il piccolo Mercurio si trova a passare da quelle parti, proprio mentre qualcosa sta viaggiando diretto verso il Sole con velocità sempre più elevate per effetto dell'intensissima forza di attrazione gravitazionale esercitata dall'astro vicino, allora l'im-

patto è tremendo. Si pensi, per esempio, al bacino Caloris, che sta lì a testimoniare ancora l'incidente occorso al pianeta più di 3 miliardi di anni fa, allorché un oggetto di notevoli dimensioni lo colpì in pieno: le increspature date dall'onda d'urto che seguì all'impatto si propagarono dentro il pianeta e per tutta la sua superficie, come fanno i classici cerchi nell'acqua in seguito alla caduta in essa di un sasso. Nel caso di un grande lago, la superficie è piana e molto ampia, e quindi vi è tutto lo spazio e il tempo perché le increspature generate dalla caduta del sasso nell'acqua si smorzino progressivamente fino a scomparire.

Ma se la superficie sulla quale le increspature si muovono è sferica e non eccessivamente grande, proprio come può essere quella di Mercurio, e se l'impatto è forte e causato non da un ciottolo qualsiasi, bensì da un corpo di notevoli dimensioni (circa 1 km), allora esse potranno incontrarsi dalla parte opposta al punto di caduta dell'asteroide. Questo è proprio ciò che è capitato al povero Mercurio che, in seguito al fortissimo urto, si è ritrovato ad avere agli antipodi del Bacino Caloris una serie di monticcioli e di pinnacoli, creati proprio dall'arrivo concentrico delle onde d'urto che si sono scontrate… con le onde d'urto (uno dei pochi casi in cui ci si può scontrare frontalmente con se stessi…). Un po' come dire: ti do una sberla così forte da farti uscire il naso sulla nuca!

Come già annunciato precedentemente, ci faremo aiutare nel nostro viaggio anche dalle *spiegazioni sonore* fornite da grandi compositori. In questo, come nella maggioranza dei casi, ad accompagnarci sarà il brano dedicato a Mercurio contenuto nella suite *The Planets* di Gustav Holst. Di tutte quelle facenti parte della suite, questa composizione è la più breve, come del resto, nella *suite* delle rotazioni planetarie, quello del vero Mercurio – quello solido che ruota attorno alla nostra stella in soli 87,97 giorni – è il periodo di rivoluzione più breve rinvenibile all'interno del Sistema Solare. Tra le varie cose, questo implica che se fossimo nati su questo pianeta, saremmo matematicamente più vecchi, dato che l'anno verrebbe a essere una unità di tempo circa quattro volte più breve di quella di 365 giorni circa che abbiamo adottato qui sulla Terra, pari al tempo che la Terra impiega per tornare nella stessa posizione dopo aver completato un giro attorno al Sole. Il brano, guarda caso, è veloce: un *vivace* 6/8 introdotto

dal volo degli strumenti che sullo spartito descrivono un'onda rapida propagantesi dalle basse frequenze e dal basso della partitura, e che guadagna subito le altezze dei suoni più acuti e della pagina musicale.

È un brano che nel suo svolgimento viene sovente impreziosito dall'intervento di suoni particolarmente brillanti. Si pensi per esempio all'uso dei violini dalla battuta quarantuno in poi...

... che dopo poche misure passeranno il testimone al Glockenspiel per andare a rinforzare la frase pronunciata dalla Celesta, tutti strumenti usati nel registro acuto e capaci di donare al brano un tocco particolarmente giocoso, magico, favolistico.

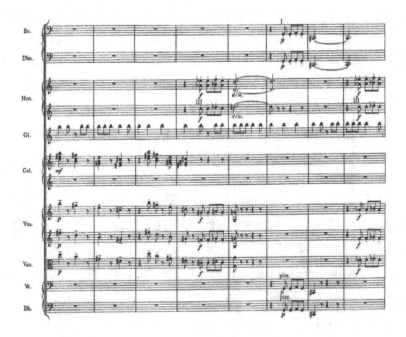

A ogni ascolto, la loro voce mi fa riandare con la mente alla fatina Trilli del controverso romanzo per bambini *Peter Pan* di James Barrie. Pubblicato nel 1906 e tradotto in cartone animato dalla Walt Disney nel 1951, nel *cast* prevede una piccola Trilli le cui apparizioni sono sempre accompagnate da questo scampanellio acuto (il suo nome nel romanzo è proprio Campanellino e Trilli altro non è che il suo nomignolo onomatopeico affibbiatole da Barrie), che ricalca alcune delle caratteristiche di quella che era l'immagine di Mercurio: luminosa, veloce, benevola anche se, comunque, capricciosa e dotata di ali e di una bacchetta magica del tutto simile al caduceo d'ordinanza del dio alato. Fintanto che le sue descrizioni sono state affidate solo alla vista dei vari sacerdoti-astronomi che l'hanno lungamente osservato, questo pianeta è stato sempre associato al *Messaggero Alato* – che è anche la traduzione del titolo della composizione di Holst. Questo perché, essendo il pianeta più interno del Sistema Solare, quindi il più vicino alla nostra stella, lo si può scorgere soltanto quando dalla nostra posizione viene visto al lato del Sole, a soli 28 gradi di massima distanza angolare da esso.

La luce del nostro astro durante il giorno si impadronisce totalmente della scena impedendoci in generale di vedere a occhio nudo cos'altro si muove fuori dall'atmosfera. Ma vi sono due fasi nel corso di una giornata che favoriscono l'osservazione dei due pianeti più interni, Mercurio e Venere, e capitano quando il cielo non è completamente invaso dal fluido luminoso proveniente dal Sole: l'alba e il tramonto. Grazie al contrasto offerto dalle tenebre notturne che contendono la scena alla luminosità solare, è possibile vedere questi due pianeti quando non sono né davanti né dietro al disco del Sole ma – come si diceva – più laterali, una posizione che viene detta *elongazione*. A causa della sua rapida rivoluzione, già nell'antichità era stato notato come Mercurio si spostasse velocemente alla destra e alla sinistra della nostra stella e questo fece pensare che, arguto e veloce come il pensiero, potesse essere il messaggero degli dei, i quali gli affidavano il compito di portare le informazioni in giro nel cosmo. Per esempio, nel libro ventesimo dell'*Iliade*, Omero descrive Mercurio come "Ermete, che brilla per pensieri sottili". Poi, nel libro ventiquattresimo della stessa opera, ne dà un'immagine di divinità caritatevole quando racconta di come Zeus gli abbia affidato il compito di accompagnare il re troiano Priamo alla tenda di Achille. L'intento era di proteggere e consigliare il vecchio re che si stava recando dal nemico, noncurante del pericolo, nella speranza che gli venisse reso il corpo di suo figlio, il valoroso Ettore, morto per mano dello stesso semidio Achille:

> E subito (Zeus) disse a Ermete, il suo caro figlio:
> "Ermete, sempre ti è graditissimo
> accompagnare un mortale, e ascolti chi vuoi:
> 335 muovi ora, e Priamo alle concave navi dei Danai
> accompagna, così che nessuno lo veda e conosca
> degli altri Achei, prima che arrivi al Pelide".
> Disse così, non fu sordo il messaggero Argheifonte;
> 340 subito sotto i piedi legò i sandali belli,
> ambrosi, d'oro, che lo portano e sopra l'acqua

e sulla terra infinita, insieme col soffio del vento;
e prese la verga con cui gli occhi degli uomini affascina,
di quelli che vuole e può svegliare chi dorme.
345 Questa tenendo in mano, volò il potente Argheifonte
e giunse d'un balzo all'Ellesponto e a Troia,
e prese ad andare, sembrando un giovane principe,
cui fiorisce la prima peluria, bella è la sua giovinezza (…)

E più oltre, il dio rivelerà la sua vera identità al re troiano, dicendo:

460 "O vecchio, io, che a te venni, son nume immortale,
Ermete: il padre mi ti diede per guida.
Ma ora bisogna che parta, d'Achille
non voglio apparire allo sguardo: sarebbe degno di biasimo
che un dio immortale amasse così apertamente i mortali"
(…)
468 Detto così, ritornò al vasto Olimpo.

Dai pianeti dell'ottavo secolo a.C., con le loro "immagini immaginate", alle prime fotografie del Sistema Solare riprese dalle sonde della seconda metà del ventesimo secolo, le "immagini fotografate", intercorrono circa ventotto secoli. Ecco una buona scala del nostro lento incedere nella comprensione della Natura. Se non vogliamo farci deprimere, confrontiamo questo lasso di tempo con l'età dell'Universo. Così facendo scopriamo che ci è bastato *solo* un attimo per renderci conto di dove siamo… Dai versi omerici, riscopriamo ciò che si diceva già prima, ovvero che Mercurio risulta essere anche un protettore dotato di bacchetta, il *caduceo*, con la quale *sparaflashiava* come un qualsiasi "Man in Black" gli umani testimoni indesiderati delle sue prodezze divine, per addormentarli e in seguito ridestarli nell'oblio di ciò che avevano visto. Se ne servirà, per esempio, nell'accompagnare Priamo al campo degli assedianti:

E quando al muro e alla fossa delle navi arrivarono,
da poco le guardie s'affaccendavano per la cena:
445 ma sonno versò su di loro il messaggero Argheifonte,
su tutti, e aperse i chiavistelli
e Priamo introdusse e i bei doni sul carro.

Capace di movimenti rapidissimi grazie ai suoi calzari alati, il suo ruolo di messaggero veniva compiuto in pratica alla velocità della luce, un elemento della realtà che veniva connesso ovviamente alla presenza del Sole, dal quale l'immagine ottica di Mercurio, quando visibile, per quanto abbiamo precedentemente detto non si discostava mai molto.

Un'autorevole traduzione, quella di Vittorio Monti, prevede che Mercurio raggiunga Priamo "in un batter di ciglio (...)", un gesto di cui i fisiologi hanno misurato la velocità stabilendo che dura circa cento millisecondi. Essendo Ermete partito dall'Olimpo, residenza degli dei, ed essendo la distanza in linea d'aria tra questo monte e la posizione della città di Troia di circa trecentocinquanta chilometri (il monte Olimpo è alto 2.917 m, quindi il percorso lungo l'ipotenusa del triangolo cima del monte-piede del monte-spiaggia di Troia è praticamente uguale alla distanza piede del monte-spiaggia di Troia), a conti fatti, grazie ai suoi calzari alati il nostro dio procedeva alla incredibile velocità di circa 3.500 km al secondo, quindi circa cento volte più lento della luce. Un dato questo che, per le conoscenze dell'epoca, immagino doveva comunque permettere intuitivamente di connettere la figura di Mercurio a quella di un raggio di luce che favorisce la vita sul nostro pianeta, consentendoci di vedere, quindi di conoscere; tutte caratteristiche che venivano riassunte in passato nella figura di Ermete.

Una descrizione più incentrata sul movimento del nostro eroe la fa nell'*Eneide* il poeta Virgilio il quale narra di come stavolta il compito affidato da Zeus a Mercurio (in questo caso il nome è proprio quello del pianeta, dato che il nome Mercurio è quello dato dalla cultura romana al greco Ermete) sia di andare a distogliere il troiano Enea dalle evoluzioni amorose che lo tengono avvinghiato alla bellissima Didone, regina di Cartagine. Enea aveva un destino ben di-

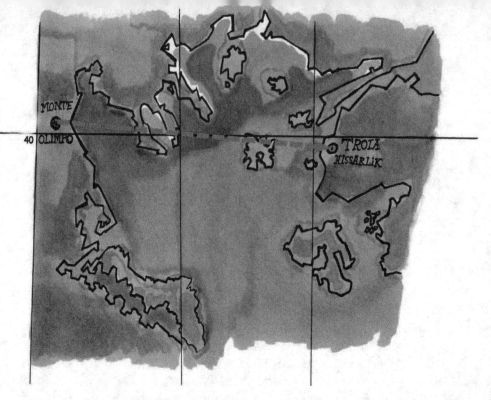

verso al quale obbedire: non quello di *play-boy ante litteram,* ma addirittura quello di progenitore della stirpe romana, e non c'era quindi tempo da perdere!

Ed è così che Mercurio parte alla volta di Cartagine in un volo a rotta di collo, di cui affido la descrizione e il compito di farvi provare la vertigine della caduta a qualcuno ben più titolato di me:

> Aveva detto (Zeus): e quello del gran padre a eseguire
> l'ordine è pronto. Lega ai piedi i calzari
> 240 d'oro, che alto sull'ali lo portano, vuoi sopra le acque
> vuoi sulla terra, pari al rapido soffio del vento.
> Poi prende la verga: con questa dall'Orco egli evoca
> le pallide anime, altre nel Tartaro triste le manda,
> e dà il sonno e lo toglie, apre occhi che morte sigilla;
> 245 con questa guida i venti e trapassa le nuvole
> torbide. E già volando la vetta e i fianchi ardui vedeva
> del duro Atlante, che il cielo col capo sostiene,
> d'Atlante, cui sempre, cinto di nuvole nere,
> il capo ricco di pini battono il vento e la pioggia:
> 250 neve scende a coprirgli le spalle, fiumi dal mento
> del vecchio precipitano, irta di ghiaccio la rigida barba.
> Qui prima, librandosi sull'ali tese, il Cillenio
> si posò, di qui si gettò a corpo morto sull'onde,
> capo in giù, sembrando l'uccello che intorno alle rive,

255 intorno agli scogli pescosi vola basso sul mare.
 Non altrimenti, a mezzo fra terra e cielo volava
 verso le spiagge sabbiose dell'Africa e il vento tagliava
 il dio Cillenio, partito dall'avo materno.

Credo di potere ritrovare traccia di questa immagine antica del dio dai calzari alati nella fa-vola di Pollicino, il quale riesce, durante il sonno dell'Orco, a rubargli gli *stivali delle sette le-ghe* che gli permetteranno di averla vinta sul gigante consentendogli spostamenti di circa trentacinque chilometri (ovvero sette *leghe*) a ogni passo. L'immagine dell'Orco che compare nella favola di Perrault nel 1697 è una traduzione dell'epoca di quella mitologica (verso 242) che compare anche nei versi su citati e che mi fa associare il piccolo Pollicino al pianeta che gira velocemente attorno al grande orco Sole senza che questi riesca a mangiarlo.

La caratteristica di grande mobilità è di sicuro quella che ha indotto ad associare il nome del pianeta all'omonimo elemento chimico le cui caratteristiche tanto interessanti per gli al-chimisti sono state riprese anche da Primo Levi nel suo racconto intitolato proprio "Mercurio":

> È veramente una sostanza bizzarra: è freddo e fuggitivo, sempre inquieto, ma quando è ben fermo ci si specchia meglio che in uno specchio. Se lo si fa girare in una scodella, continua a girare per quasi mezz'ora.

Come novelli Mercurio della letteratura, dopo Omero siamo passati a Levi per tornare di nuovo indietro nel tempo, fino alla descrizione di Mercurio compiuta nel XIV secolo da Dante Alighieri nella sua *Divina Commedia*. Accompagnato da Beatrice nella sua ascesa verso Dio, stavolta quello unico di una tradizione monoteista che nel frattempo in Europa ha avuto la meglio sulla moltitudine di divinità pagane della saga omerica, Mercurio torna a essere un luogo. Un pianeta, sì, ma soprattutto una sfera, un livello morale nella gerarchia del-l'amore divino. E nel canto V del Paradiso, il poeta riferisce che la sua accompagnatrice tutto

a un tratto interrompe il dialogo con lui rivolgendosi, definitivamente catturata dalla bellezza di ciò che scorge, verso i cieli più alti, nella direzione dell'Empireo dove, secondo lo schema del cosmo tolemaico cui si ispira Dante, risiedeva il sommo creatore. E così facendo, avviene il *balzo quantico* dalla sfera della Luna a quella di Mercurio:

> Così Beatrice a me com'ïo scrivo;
> poi si rivolse tutta disïante
87 a quella parte ove 'l mondo è più vivo.
> Lo suo tacere e 'l trasmutar sembiante
> puoser silenzio al mio cupido ingegno,
90 che già nuove questioni avea davante;
> e sì che come saetta che nel segno
> percuote pria che sia la corda queta,
93 così corremmo nel secondo regno.
> Quivi la donna mia vid'io sì lieta,
> come nel lume di quel ciel si mise,
96 che più lucente se ne fè 'l pianeta.

Mi diverte alquanto confrontare le conoscenze che si avevano sui pianeti e sul cielo in generale in epoche storiche molto diverse. Questo ancora una volta ci dà la possibilità di valutare il grande cammino compiuto dall'uomo nel tentativo di capire la realtà e di farsela amica. Potrei condurre quindi questo raffronto prendendo a modello i poemi omerici e un qualsiasi trattato di planetologia moderna ma, quando possibile, trovo molto più divertente, per me e per chi legge, affiancare quanto contenuto nei grandi poemi a ciò che autori dello stampo di Asimov hanno raccontato. Nel fare ciò, implicitamente confido nel fatto che la lettura di brani di fantascienza di scrittori che operano all'interno dei confini stabiliti dalla ricerca scientifica è molto più piacevole della disamina di un articolo scritto da uno specialista per un pubblico di specialisti par suo.

Compiendo di conseguenza un ulteriore balzo temporale che stavolta ci conduca direttamente nel secolo scorso, troviamo tra gli altri anche il racconto asimoviano *Girotondo*. Nella fantasia dello scrittore americano di origine russa, i due protagonisti umani, Gregory Powell e Mike Donovan, in visita alla Stazione Mineraria impiantata anni prima sull'emisfero illuminato del primo pianeta del Sistema Solare, si trovano nel 2015 a dover recuperare sulla sua superficie *Speedy*, un robot di ultima generazione che si era smarrito durante una missione.

All'epoca in cui Asimov immaginava la sua storia, si era già in possesso di un buon numero di nozioni fisiche su questo pianeta, in seguito meglio precisate dalla missione Mariner, che nel 1974 volò fino a incontrare Mercurio e a mapparne con una *survey* fotografica circa il 40% della superficie (panoramica solo di recente completata grazie alla missione Messenger). Asimov, un chimico-scrittore che amava attenersi alla verità scientifica o per lo meno a una certa plausibilità nel descrivere le ambientazioni dei suoi romanzi, ci racconta che l'albedo[1] di

Mercurio è bassa e il suolo è costituito soprattutto da pomice grigia. Qualcosa di simile a quanto accade sulla Luna. Poco più oltre, Powell spiegherà al suo compagno di missione che:

> Mercurio non è completamente privo d'atmosfera. C'è una sottile esalazione che aderisce alla superficie; i vapori degli elementi e dei composti più volatili, che però sono abbastanza pesanti per essere trattenuti dalla gravità di Mercurio. Sai bene: selenio, iodio, mercurio, gallio, potassio, bismuto, ossidi volatili. I vapori si raccolgono nelle zone non illuminate e si condensano, cedendo il loro calore. [Mercurio, N.d.R.] è una specie di gigantesco alambicco. Infatti, se accendi la tua lampada tascabile, vedrai probabilmente che il fianco di questo picco è coperto da una rugiada di solfo o forse di mercurio.

In questo breve passo del racconto di Asimov troviamo la spiegazione corretta del perché su questo pianeta non può esservi un'atmosfera simile a quella che troviamo su Venere o sulla Terra. La risposta la si deve cercare nel fatto che un corpo così piccolo (raggio equatoriale di soli 2.423 km) e con una massa $M_{Mercurio}$ pari a un diciottesimo di quella terrestre (la densità, supposto il pianeta perfettamente sferico e con un raggio pari al suo raggio equatoriale[2], è quindi data da $3M_{Mercurio}/(4\pi R^3_{Mercurio}) = 3 \cdot 0,05 \cdot M_{Terra} / [4\pi(0,38 \cdot 6.378 \text{ km})^3]$ $= 3 \cdot 0,05 \cdot 5,97 \cdot 10^{27}$ g $/ [4\pi(0,38 \cdot 6.378 \cdot 10^5 \text{ cm})^3] = 5,0$ g/cm^3) non riesce a trattenere con la sua gravità le molecole dei vari gas generati dall'interazione del vento solare con la superficie del pianeta. Queste molecole, in prevalenza Ossigeno, Azoto, Idrogeno, Elio e Potassio, a causa della elevata temperatura, dei continui e intensi urti delle particelle che costituiscono il vento solare e dei micrometeoriti che continuano a giungere sulla superficie del pianeta, vengono strappate dal suolo e alcune di loro arrivano a possedere una energia cinetica sufficiente per liberarsi senza eccessivi problemi della timida stretta gravitazionale di Mercurio, che, a conti fatti, impone un limite di soli 4,05 km al secondo di velocità di fuga, un valore facilmente ottenibile dalla relazione:

$$V_{fuga} = (2GM/R)^{1/2} = [2 \cdot 6,67 \cdot 10^{-8} \text{ dyne cm}^2 \text{g}^{-2} \cdot 0,05 \cdot 5,97 \cdot 10^{27} \text{ g}/$$
$$/ (0,38 \cdot 6.378 \cdot 10^5 \text{ cm})]^{1/2} = 405.336 \text{ cm/s} = 4,05 \text{ km/s}$$

Alla fine, vicino alla superficie di Mercurio rimane ben poco a fluttuare intrappolato dal debole campo magnetico e le poche molecole rimastegli fedeli, in parte donategli anche dal

[1] Albedo: percentuale della luce ricevuta da un pianeta e riflessa dalla sua superficie.

[2] Nel prosieguo, riferendo masse e raggi dei vari pianeti a quelli della Terra, eseguiremo i calcoli dei parametri di volta in volta necessari equiparandoli sempre al valore del raggio equatoriale. Di conseguenza, quelli che otterremo, non tenendo conto dello schiacciamento polare dovuto alla rotazione del pianeta, saranno valori necessariamente approssimati.

solito vento che spira dal Sole, esercitano sulla sua superficie una pressione di 10^{-9} mbar, da confrontare con quella terrestre di circa 1 bar. In conseguenza di questa assenza di atmosfera, la superficie di Mercurio non presenta gli effetti di fenomeni di erosione e risulta essere estremamente irregolare e craterizzata, molto simile quindi a quella della nostra Luna. I crateri sono in media più ampi di quelli osservabili sul nostro satellite, un dato da connettere di sicuro con la maggiore intensità del campo gravitazionale mercuriano rispetto a quello lunare e, di conseguenza, capace di accelerare i meteoriti in arrivo molto di più di quanto non faccia la Luna, inducendo così collisioni più intense sulla sua superficie.

Per lo stesso motivo, i crateri cosiddetti secondari, creati dalla ricaduta del materiale espulso durante la creazione dei primari, sono disposti a una distanza minore dal punto di impatto del meteorite rispetto a quanto si riscontra sulla Luna: il pianeta richiama a sé i detriti in volo prima di quanto possa fare la nostra pallida vicina.

Nei racconti che prevedono come scenario Mercurio, accade spesso che esso venga visto come luogo ideale per impiantarvi miniere. Una facile previsione fa in effetti intuire come presto l'umanità si troverà a corto di materie prime ed è nor-

male aspettarsi dalle imprese spaziali del futuro anche questo ulteriore vantaggio: poter avere accesso a quantità enormi, e per il momento intatte, di sostanze chimiche per noi estremamente utili, nascoste nelle viscere degli altri corpi del Sistema Solare. Mercurio deve possedere tutto un repertorio estremamente ricco di elementi, specie i più pesanti, intrappolati nelle vicinanze del Sole durante le prime fasi di formazione del disco protoplanetario.

Dallo studio del debole campo magnetico mercuriano abbiamo tratto il sospetto che possa essere alimentato da grandi quantità di ferro e nichel venutesi a trovare all'interno del pianeta in seguito a una forte collisione con un asteroide, che si è insediato con un vero e proprio atto di forza sotto la sua superficie recando con sé tutto il suo ricco corredo metallico.

Se da un lato i dati scientifici in nostro possesso fanno ipotizzare, sulla scorta di ciò che immaginò lo scrittore russo, che sia estremamente difficile impiantare un insediamento umano su Mercurio, dall'altro è innegabile che questo pianeta sia come un balconcino ideale dal quale affacciarsi per godere di una vista eccezionale della nostra stella. Una vista che la penna felice di Asimov ci descrive, invitandoci a diventare per pochi secondi l'eroe David *Lucky* Starr in missione su Mercurio. Ora che siete diventati lui, imprigionati in una futuristica tuta studiata per resistere alle condizioni estreme presenti sul pianeta, nel raggiungere il terminatore – ovvero la zona dove il buio confina con la luce – così da affacciarvi a guardare il giorno mercuriano lasciandovi la notte alle spalle, vedreste ciò che segue:

> Il terreno era in salita adesso e lui aveva automaticamente adeguato l'andatura, così immerso nei pensieri, che giunto sul crinale, la vista che gli si offrì lo colse impreparato lasciandolo sbalordito.
> Il margine superiore del Sole si profilava al di sopra dell'orizzonte frastagliato, ma non era il Sole vero e proprio: si scorgevano unicamente delle protuberanze che si irradiavano dall'astro, e solo per un piccolo tratto.
> Erano di un rosso vivo e una in particolare

proprio al centro di quelle visibili, era costituita da getti fiammeggianti che si innalzavano e si allargavano con magica lentezza. Vivido e splendente al di sopra delle rocce di Mercurio, non velato dall'atmosfera e dalla polvere, si dispiegava uno spettacolo di bellezza incredibile. La lingua di fiamma pareva scaturire dalla crosta scura di Mercurio come se un incendio divampasse all'orizzonte del pianeta o come se un vulcano di dimensioni titaniche fosse in piena eruzione. Ma quelle protuberanze erano più grandiose di qualsiasi fenomeno su Mercurio. Quella che stava osservando, Lucky lo sapeva, era tale da inghiottire cento pianeti pari alla Terra o cinquemila come Mercurio. E ardeva di fuoco atomico illuminando lui e tutto ciò che lo attorniava.

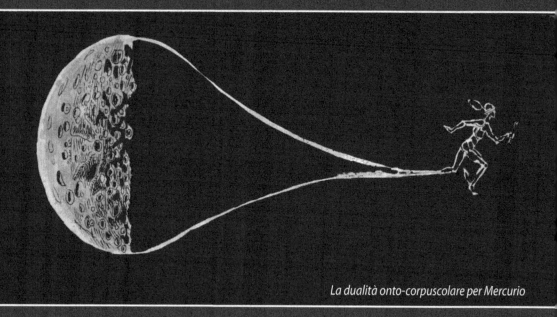

La dualità onto-corpuscolare per Mercurio

Un tempo erano gli dei che venivano a trovarci qui sulla Terra. Man mano che abbiamo incominciato a credere in un solo dio e, in seguito, a capire empiricamente sempre meglio la Natura, le antiche divinità – forse offese o impaurite da curiosità e sfacciataggine umane – si sono ritirate di milioni di chilometri, appiattendo quella famosa dualità onto-corpuscolare di cui ho parlato nel primo capitolo sulla sola dimensione corpuscolare, un *autostato*, e decidendo così di recitare definitivamente la parte di pianeti; e basta. Questa presa di di-

stanza dagli uomini è stata così drastica e di tale entità da costringerci, se proprio vogliamo interagire con essi, ad andare da loro a nostre spese. In circa tremila anni di cultura umana Mercurio è stato quindi divinità tra le divinità, eterea e veloce; livello morale corrispondente a una sfera celeste e, finalmente, pianeta.

E, a conferma di quanto dicevo in apertura di capitolo, in *Girotondo* è sempre Powell a dire del pianeta:

> (…) quel maledetto Mercurio, dotato di una carica di jettatura inversamente proporzionale alle sue dimensioni.

Un concetto che troviamo anche nel suo romanzo di formazione *Lucky Starr e il grande Sole di Mercurio*, quando fa dire a Scott Mindes, ingegnere incaricato del "progetto luce":

> Un pianeta iellato: non ne va mai dritta una qui.

Facendo un breve resoconto delle tappe che ci hanno condotto alla conoscenza di questo bruscolino attorno al Sole, possiamo quindi vedere come la benevolenza e la magia positiva che contraddistingueva il Mercurio dei nostri avi, hanno lasciato il campo a una magia diversa, scientifica e spesso malefica, addolcita solo dalle note della composizione di Holst, che nel finale sembrano descrivere il giocoso tramontare di Mercurio dietro il Sole. Prima di svoltare l'angolo, con un accordo di Mi maggiore suonato da quasi tutta l'orchestra, ci fa un occhiolino malizioso e di colpo sparisce. Su queste note giocose come la filastrocca di Rodari *Comunicato straordinario* nella quale Mercurio cade giù colpito da un missile "q", eclissiamo anche questo capitolo dedicato a… *Merqurio!*

Venere: le fregature della bellezza

Per abbandonare Mercurio e il suo debole campo gravitazionale ci siamo serviti di un oggetto che a prima vista potrebbe sembrare un ombrellone. In realtà si tratta di una vela spaziale, un dispositivo di materiale particolare che permette di muoversi nello spazio sfruttando la pressione di radiazione, quella cioè esercitata dalle particelle di luce che chiamiamo fotoni. Non bisogna meravigliarsi più di tanto, è una cosa da tempo nota agli scienziati: la luce può spingere, e dalle parti del Sole ce n'è tanta, credetemi. Grazie a questa spinta, debole ma gratuita, decidiamo di muoverci verso la parte esterna del Sistema Solare e, procedendo lenti in quella direzione, facciamo un incontro molto piacevole: dopo aver percorso circa 50 milioni di chilometri, incrociamo l'orbita di Venere, la prima signora del nostro sistema planetario. Lasciandoci condurre adagio dalla vela e dall'adagio in Mi bemolle di Holst dedicato a questo pianeta – un brano introdotto dal suono dei corni che dopo poco iniziano a dialogare con i legni dell'orchestra – con garbo veniamo invitati dalla Natura a goderci la bellezza esteriore del manto di nubi, il suo vestito da sera. Gli accordi del brano sono semplici, distensivi e molti dei vezzi armonici novecenteschi presenti negli altri brani della suite *The Planets* in questo non hanno cittadinanza. Il campo sonoro è quindi libero per accordi consonanti di terza e di quinta, che qui governano la scena incastonati su un semplicissimo 4/4. E su di essi l'orecchio riposa. Non a caso, il brano si intitola *Venere, la portatrice di pace*, quella pace interiore che dovrebbe scaturire già dalla semplice contemplazione della bellezza per antonomasia. Una bellezza tutta compresa nel nome e nel mito della dea, nata Afrodite in Grecia e divenuta Venere nel mondo latino.

Consapevoli di muoverci grazie a una brezza luminosa, contemplando l'opera *La nascita di Venere* sembra quasi di sentire soffiare quella che spinge la dea nel dipinto. In esso Zefiro, il vento dell'Ovest, la sospinge per permetterle di giungere sulla terraferma dove l'attende una delle Ore, ninfa della primavera, con un manto porporino. Il Botticelli nel 1485 produsse quest'opera su commissione di un mecenate membro della famiglia dei Medici. In esso, abbracciata a Zefiro, la ninfa Clori sta a rappresentare l'amore fisico, un erotismo che sarà sempre presente nelle storie connesse con l'apparizione di Venere rendendo facilmente intuibile quale possa essere la dualità onto-corpuscolare per questa divinità: pianeta sì, ma anche coinvolgimento erotico e lussuria dovuti alla sua estrema bel-

II. Venus, the Bringer of Peace

lezza, anzi, allo stesso incarnare il concetto di bellezza e il desiderio sessuale che da essa nasce violento.

Non a caso, una tradizione vuole che la nascita di Afrodite (dal greco *afros*: schiuma) sia da far risalire alla castrazione di Urano operata da Crono. Il Vernant ce la racconta così:

A proposito, che cosa accade al membro virile di Urano che Crono ha gettato nel mare, nelle acque di Ponto?

Non sprofonda nei flutti marini, galleggia portato dalle onde, e la schiuma di sperma si mescola a quella del mare. Dalla combinazione spumosa formatasi intorno al sesso di Urano, che si sposta assecondando i flutti, prende forma una straordinaria creatura: Afrodite, la dea nata dal mare e dalla spuma. Afrodite galleggia per un po' sulle onde, quindi approda sulle coste di Cipro, la sua amata isola. A Cipro la dea cammina sulla sabbia, e man mano che avanza, sotto i suoi piedi, spuntano a ogni passo i fiori più belli e i più profumati. Nella scia di Afrodite avanzano Eros e Himeros, Amore e Desiderio. Amore non è però l'eros primordiale, (...) si tratta adesso di un eros che non solo contempla, ma addirittura esige, l'esistenza di un maschile e di un femminile. (...) Mutilando il padre del suo organo genitale, Crono ha creato due potenze che per i Greci sono complementari: l'una si chiama Eris, la Discordia, l'altro Eros, l'Amore.

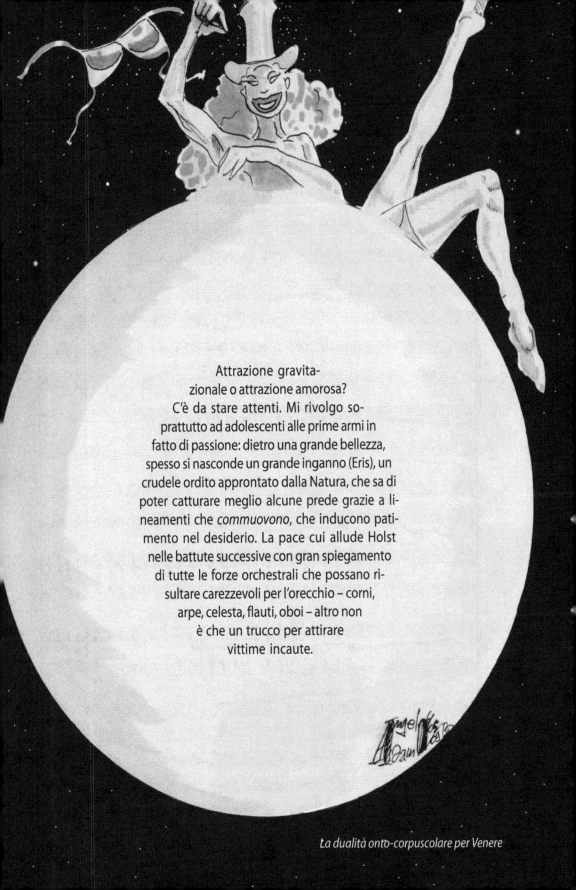

Attrazione gravita-
zionale o attrazione amorosa?
C'è da stare attenti. Mi rivolgo so-
prattutto ad adolescenti alle prime armi in
fatto di passione: dietro una grande bellezza,
spesso si nasconde un grande inganno (Eris), un
crudele ordito approntato dalla Natura, che sa di
poter catturare meglio alcune prede grazie a li-
neamenti che *commuovono*, che inducono pati-
mento nel desiderio. La pace cui allude Holst
nelle battute successive con gran spiegamento
di tutte le forze orchestrali che possano ri-
sultare carezzevoli per l'orecchio – corni,
arpe, celesta, flauti, oboi – altro non
è che un trucco per attirare
vittime incaute.

La dualità onto-corpuscolare per Venere

Cosa nota sin dall'antichità, Omero ci segnala tutte queste insidie e nell'VIII Libro dell'*Odissea* che narra dell'arrivo di Ulisse nella terra dei Feaci, lo ribadisce servendosi dell'araldo Demòdoco, invitato dal suo re Alcìnoo a suonare la cetra per accompagnare le danze in onore dello straniero Ulisse:

<div style="margin-left:2em">

Ed ecco tentando le corde intonò un bel cantare
l'aedo: gli amori d'Ares e d'Afrodite bella corona,
quando la prima volta s'unirono nella casa d'Efesto
furtivi, e molti doni le diede e il letto disonorò
270 del sire Efesto; ma a lui fece la spia
il Sole, perché li vide abbracciati in amore.
E come Efesto udì la parola strazio del cuore,
andò alla fucina, nel cuore profondo meditando vendetta,
e sul sostegno pose la grande incudine e batteva catene
275 da non poter sciogliere o infrangere, perché restassero presi.
Poi com'ebbe finito la trappola, sdegnato contro Ares,
andò nella stanza, dov'era il suo letto,
e ai sostegni del letto attaccò le catene in cerchio, da tutte le parti,
e molte anche dall'alto, dal soffitto pendevano,
280 sottili come fili di ragno, e nessuno avrebbe potuto vederle,
neppure dei numi beati: con grande astuzia eran fatte.
Quando tutta la trappola intorno al letto ebbe stesa,
finse d'andare a Lemno, rocca ben costruita,
che gli è carissima sopra tutte le terre.
285 Non da cieco spiava Ares dalle redini d'oro,
e come vide Efesto, l'inclito artefice, andarsene,
corse alla casa d'Efesto glorioso,
bramando l'amore di Citerea bella corona.
Lei, dalla casa del padre Cronide somma potenza
290 tornata da poco, sedeva; egli entrò nella casa
e le prese la mano e disse parola, diceva:
"Qui cara, andiamo al letto e stendiamoci.
Non è più Efesto fra noi, ma forse a quest'ora
è già a Lemno, fra i Sintii dal rozzo linguaggio".
295 Così disse, e a lei sembrò caro stendersi.
E nella trappola entrati, si stesero; e intorno ricaddero
le ingegnose catene dell'abilissimo Efesto:
non potevan più muovere né alzare le membra,
ma lo capirono solo quando non c'era più scampo.
300 E fu loro addosso lo Zoppo glorioso,

</div>

tornato subito indietro, prima di raggiungere Lemmo,
che il Sole montava la guardia e gli fece la spia:
e lui corse a casa, afflitto nel cuore,
e si fermò sotto il portico: l'ira lo dominava, selvaggia.

305 Paurosamente gridò, e tutti i numi raggiunse:
"Zeus padre, e voi altri, o dèi beati sempre viventi,
qui a veder cose vergognose e ridicole,
come la figlia di Zeus, Afrodite, me che son zoppo,
disprezza sempre, ama Ares crudele,

310 perché è bello e sano di gambe; e io invece
son nato sciancato: e nessun altro ne ha colpa,
tranne i due genitori: oh non m'avessero mai generato!
Ma guardate dove fanno l'amore quei due,
saliti sopra il mio letto… Scoppio di rabbia a vederli (…)"

325 Stavano ritti nel portico i numi datori di beni,
e inestinguibile riso scoppiò fra i numi beati
a vedere la trappola dell'abilissimo Efesto.
Così qualcuno guardando diceva a un altro vicino:
"Non fruttan bene la mali azioni; il lento acchiappa il veloce.

330 Come appunto ora Efesto, che è lento, acchiappò Ares,
il più veloce fra i numi che hanno l'Olimpo,
lui, lo zoppo, con l'arte sua; e pagherà l'adulterio!"
Così dicevano queste cose fra loro.
E il sire Apollo figlio di Zeus diceva a Ermete:

335 "Ermete figlio di Zeus, messaggero, datore di beni,
vorresti, premuto così sotto gagliarde catene,
dormire in letto con l'aurea Afrodite?"
E gli rispose il messaggero Argheifonte:
"Potesse questo avvenire, sovrano lungisaettante Apollo,

340 catene tre volte più grosse, infinite, mi tenessero avvinto,
e tutti veniste a vedermi, voi dèi, e poi anche le dee:
io dormirei volentieri con la dorata Afrodite!"
Così diceva, e una risata scoppiò fra i numi immortali.

La tradizione che vuole la dea Venere connessa all'idea stessa di bellezza ha solcato la storia della letteratura e non poteva mancare un riferimento anche nella *Divina Commedia* dove addirittura il *salto quantico* fra la sfera di Mercurio e la terza – quella, appunto, di Venere – avviene, come del resto tutti gli altri passaggi, per aumento di bellezza di Beatrice, musa ispiratrice e conduttrice di Dante nel suo lungo viaggio nella cosmologia tolemaica:

e da costei ond'io principio piglio
pigliavano il vocabol de la stella
12 che 'l sol vagheggia or da coppa or da ciglio.
Io non m'accorsi del salire in ella;
ma d'esservi entro mi fé assai fede
15 la donna mia ch'i'vidi far più bella

Oggi sappiamo che in effetti è proprio così: Venere risulta davvero sposata con i fenomeni vulcanici! Lo abbiamo scoperto grazie alle sonde che a partire dagli anni '60 abbiamo inviato per approcciarla più da vicino ma soprattutto, più di recente, facendo radiografie alla signora mediante indagini radar capaci di vedere con chiarezza cosa si cela sotto la sua spessa atmosfera. È in effetti risultato che sono proprio le eruzioni vulcaniche che le hanno portato in dote il suo bel vestito, la spessa coltre di nubi che non ci permette di andare con lo sguardo oltre il suo aspetto esteriore, quella veste che Omero ci descrive così:

Disse, e sciolse dal petto la fascia ricamata,
215 a vivi colori, dove stan tutti gli incanti:
lì v'è l'amore e il desiderio e l'incontro,
la seduzione, che ruba il senno anche ai saggi.

Le numerosissime bocche vulcaniche, tra le quali quella del monte Maat spicca con i suoi 8.000 metri di altezza, da sempre immettono nell'atmosfera il contenuto delle viscere del pianeta. Con la complicità del calore emanato dal Sole che ha mutato in vapore quasi tutta l'acqua un tempo presente sulla superficie, costringendo in un secondo momento il leggero idrogeno all'esilio nello spazio, l'atmosfera risulta essere per noi velenosa perché costituita in larga misura da anidride carbonica, un potentissimo gas serra. Il sistema di nubi che avvolge e nasconde il pianeta, a causa della sua composizione chimica, arriva a riflettere ben l'80% circa della luce in arrivo dall'astro vicino donando al pianeta un estremo lucore. Apparendoci tra gli oggetti più brillanti e affascinanti del cielo proprio a causa della sua albedo così alta e della vicinanza alla nostra Terra, diciamocelo pure, Venere non poteva proprio non essere associata alla bellezza! Una dea e non un dio, forse perché il suo splendore rimane visibile nei cieli terrestri per circa nove mesi all'anno, quanto il perdurare dello stato interessante di una gestante. Inoltre, questo gioco femminile che continua ad avere del sensuale, dell'erotico anche ai giorni nostri, questo malizioso vedo-non vedo ha creato un alone di mistero che ha circondato il pianeta fintanto che nuovi metodi di indagine non sono stati approntati. Sarà ancora per la tradizione mitologica che la vuole anche dea dei giardini, sarà per il concetto di umido che viene facilmente connesso a tutta la sfera della nostra esperienza sessuale, in ogni caso, fintanto che non se ne è saputo di più, nell'immaginario collettivo il pianeta Venere doveva custodire sotto le sue nubi un mondo acqueo. In molti romanzi di fantascienza venuti alla luce nel corso dell'ancora giovane vita di questo genere letterario, il pia-

neta Venere è stato dipinto a volte come felice, ricco di vegetazione, di oceani e popolato da una fauna particolarmente interessante. Si pensi per esempio alle rane V o alle immense "toppe" marine di cui parla Asimov nel suo *Lucky Starr e gli oceani di Venere*, terza puntata di una serie di agili storie che abbiamo già avuto modo di citare nel capitolo dedicato a Mercurio e che citeremo ancora nel prosieguo. Nata sulla scorta del successo dello scrittore il quale, per questo, venne stimolato a scrivere qualcosa per il neonato mercato televisivo, si tratta di una saga di romanzi tra il genere cosiddetto "di formazione" e il giallo fantascientifico. Al di là del valore letterario, trovo che siano storie interessanti soprattutto perché ci introducono in modo chiaro a quelle che all'epoca – si trattava degli anni cinquanta – erano le nostre conoscenze sul Sistema Solare, consentendoci di operare un facile raffronto con quello che invece sappiamo oggi sull'argomento grazie all'invio sui vari pianeti di sonde automatiche. Non a caso, le moderne riedizioni di questi romanzi prevedono tutte una breve prefazione dell'autore nella quale egli si giustifica per le inesattezze scientifiche sulle quali addirittura poggiano le impalcature, le stesse trame di questi brevi romanzi. Mi sembra particolarmente interessante osservare l'evolvere del pensiero scientifico attraverso la lente dell'opera d'arte che a esso si ispira. L'arte è spavalda se si sente in una qualche misura autorizzata dalla scienza. E la scienza che fa retromarcia imponendo un'inversione di tendenza al mondo, compreso quello artistico, ha un valore inestimabile da porre immediatamente a raffronto con quanto, per esempio, non è capace di fare la "cultura" di matrice religiosa. Guardando attraverso la lente rappresentata dal romanzo di Asimov dedicato a Venere, leggiamo un brano nel quale si trova il riassunto di ciò che era il secondo pianeta per una persona di sicuro "informata dei fatti" scientifici dell'epoca quale era lo scrittore:

> Riassumendo rapidamente è il secondo pianeta più vicino al Sole dal quale dista circa 67 milioni di miglia. È il pianeta più vicino alla Terra da cui può avere anche una distanza di 26 milioni di miglia. È poco più piccolo della Terra rispetto alla quale ha circa cinque sesti di gravità. Gira attorno al Sole in circa sette mesi e mezzo e il suo giorno dura trentasei ore. La sua temperatura di superficie è un po' più elevata di quella della Terra ma non di molto, a causa delle nubi. E sempre a causa delle nubi non ha vere e proprie stagioni. È coperto dall'oceano che a sua volta è coperto da alghe marine. La sua atmosfera è costituita da anidride carbonica e azoto, e quindi è irrespirabile.

Nonostante fosse cosa nota da studi spettroscopici che l'atmosfera è per noi irrespirabile, lo scrittore immagina ugualmente un certo numero di insediamenti umani sul pianeta.

La storia si svolge proprio in uno di essi, nella grande città di Afrodite, tra tutte la più grande e popolosa, dove, al di sotto di cupole di vetro rinforzato, è stato possibile creare un ambiente adatto alla vita umana. Giuseppe Lippi, in apertura di libro, sente a tal proposito l'esigenza di avvertire subito il lettore:

Questo romanzo (…) è ambientato sul pianeta che più di ogni altro ha cambiato faccia nell'ultimo trentennio. Diremo meglio: il pianeta è sempre quello, ma è radicalmente mutata l'immagine che ce ne eravamo fatta nei decenni precedenti, e che persisteva quando Asimov ha scritto il romanzo. La vecchia, romantica concezione di Venere aveva finito col generare una serie di luoghi comuni fantascientifici, piacevoli e in un certo senso rassicuranti: Venere come un mondo avvolto da spesse nubi, dotato di temperatura tropicale perché più vicino al Sole, coperto di oceani e giungle fumiganti, collocato a uno stadio evolutivo che – in termini geologici – poteva essere paragonato a quello della Terra nell'età dei rettili. Venere, Stella della sera e dunque mondo malinconico del crepuscolo, adatto a ospitare bizzarre avventure e incontri con fantastiche forme di vita.

Ma cosa sappiamo oggi, in definitiva, di questo pianeta? Innanzitutto ci è noto che non possiede satelliti. Sappiamo inoltre che se fossimo sulla sua superficie troveremmo l'atmosfera un po' pesante, ma non per motivi socio-psicologici: è che semplicemente lì l'aria… è davvero pesante! Con un'atmosfera che abbiamo scoperto essere ben novanta volte più densa di quella terrestre, verremmo letteralmente schiacciati dal suo enorme peso come formiche sotto le scarpe. La cosa non dovrebbe stupirci; come abbiamo già detto molte volte, le foto di Venere non ci rivelano nulla di ciò che si cela sotto le sue nubi, mentre tutti abbiamo ben presente come appaia la Terra se osservata da fuori: la nostra atmosfera, poco densa, non nega generose sbirciate ai continenti e agli oceani, rivelando tutte le caratteristiche della

sua morfologia superficiale. Se fossimo imparentati con qualche *highlander*, forse lì potremmo resistere al peso della colonna d'aria sulle nostre spalle che tenderebbe a renderci tutt'uno con il suolo venusiano, ma di sicuro verremmo sciolti dal gran calore che si sperimenta dentro la sua atmosfera. Infatti le nubi di Venere creano un tale effetto serra sulla sua superficie da far sì che il calore in arrivo dal Sole rimanga imprigionato e si vada a sommare col calore che nel frattempo continua a uscire dall'interno del pianeta ancora molto attivo, capace di generare sovente fortissimi *veneremoti*. Tutti questi fattori, opportunamente sommati, restituiscono una temperatura di circa 740° Kelvin (!), più di quanto non si riscontri su Mercurio, rendendo Venere – il secondo pianeta tellurico – il posto più caldo del Sistema Solare... dopo il Sole, ovviamente. Ma supponiamo che siate così forti, mutati, tanto indomabili da resistere anche al gran calore. Be', prima o poi dovrete respirare e in quel momento scoprirete che l'aria che lì si inala è un po' *viziata* in quanto, come si diceva, composta principalmente da anidride carbonica con anche tracce di azoto, diossido di zolfo, acqua (poca) e intere nubi di acido solforico. Insomma, il problema lì è unicamente rappresentato dall'atmosfera: pesante, calda, velenosa, con velocissimi venti bollenti capaci di spezzare le pietre rendendole ciottoli aguzzi; fossi in voi, non la sceglierei come meta di future vacanze, non durereste. È un inferno, anzi, forse è proprio la traduzione moderna dell'inferno dantesco, come faceva notare l'astronomo Paolo Maffei il quale considerava:

> L'inferno dantesco non giungeva a essere così terribile: dopo tutto era concepito a misura d'uomo.

Questo non è un paese per uomini, ma neanche per i manufatti umani: le sonde Venera 9 e 10 che abbiamo fatto scendere sulla superficie del pianeta hanno resistito entrambe meno di un'ora alle condizioni estreme lì presenti e, dopo averci regalato delle splendide fotografie del panorama, sono state stritolate, schiacciate, sciolte... distrutte dal clima locale che non perdona intrusioni da parte di nessuno. Venere sembra volerci dire, stizzita: "Diamine! Come vi permettete di guardare sotto la gonna di una signora?". Le foto che queste sfortunate sonde-paparazzo sono riuscite a inviarci prima di soccombere fanno registrare un altro elemento a favore dell'idea di Venere come dea lussuriosa: sono tutte *a luci rosse*, nel senso che il chiarore diffuso presente all'interno dell'atmosfera possiede questa colorazione uniforme poiché, di tutte le lunghezze d'onda che compongono lo spettro della luce solare proveniente dall'esterno, solo quelle più lunghe (rosse, appunto) risultano capaci di attraversare la coltre così spessa di nubi senza farsi fermare dalla grande densità dei gas atmosferici.

La parte "nuda" di Venere, voglio dire la parte solida sotto il vestito gassoso, ha una massa pari a circa 0,8 volte quella del nostro pianeta. Tutta la sua materia occupa un volume che anche in questo caso abbiamo scoperto essere molto simile a quello terrestre (il raggio di Venere è circa 0,95 volte quello della Terra) e questo implica che anche le densità medie dei due pianeti non differiscono di molto; queste somiglianze convincono molti studiosi della stretta parentela che lega Venere con la Terra. Potrebbe addirittura essere ri-

guardato come pianeta gemello del nostro, da studiare anche per capire come doveva essere la nostra dimora in una fase evolutiva di molto precedente al sorgere del fenomeno vita. Nel secondo capitolo abbiamo visto come, grazie alla terza legge di Keplero, le misurazioni del tempo di rivoluzione e della distanza di una o più lune attorno a un pianeta permettano di calcolare la massa di quest'ultimo. Come facciamo a sapere allora qual è la massa di Venere se non ha neanche una Luna? Semplice, almeno a dirsi: gliene abbiamo fornita una noi, artificiale, solo per un tempo limitato. Per inciso, abbiamo fatto la stessa cosa con Mercurio, privo anche lui di satelliti naturali. Le sonde che abbiamo inviato per studiare le caratteristiche globali di questi corpi, hanno interagito con il campo gravitazionale da essi prodotto. Possiamo dire quindi che le nostre sonde lo hanno "assaggiato"

come fossero semplici particelle di prova dalla massa di sicuro trascurabile rispetto a quella dei pianeti responsabili della presenza di questi campi. Da come si sono mosse, cercando di compensare l'attrazione del pianeta per evitare di assecondarla e di schiantarsi così sulla sua superficie, i computer di bordo hanno capito con quanta forza le sonde venivano attirate e quindi – nota la distanza tra loro e il pianeta, nota la loro massa e il valore della costante universale di gravitazione – si è riuscito a *pesarlo*, a ottenere cioè la massa del pianeta.

Pare che in gioventù, forse per i suoi comportamenti dissoluti, Venere abbia meritato un sonoro scappellotto da qualche asteroide moralizzatore. La punizione deve essere stata così severa da farla cappottare, portandola così a ruo-

tare in senso contrario rispetto a quello della maggior parte degli altri pianeti. Questo in sol-doni significa che se fossimo venusiani, vedremmo il Sole sorgere a Ovest e tramontare a Est! Al momento questa teoria dell'urto violento con un corpo esterno sembra essere quella che meglio spiega la sua rotazione retrograda, ma se davvero questa sua caratteri-stica sia da imputarsi a un urto con uno o più planetesimi non lo sapremo mai: è uno di quei casi in cui il pirata della strada la fa franca in quanto non abbiamo rinvenuto indizi defini-tivi. A parte pochi casi, i crateri da impatto sulla superficie venusiana non hanno lunga vita: il continuo mutare della sua fisionomia sotto il costante influsso delle grandi spinte interne fa sì che la morfologia di Venere sia mutata e muterà ancora molte volte.

Il nostro Ulisse Celeste intanto si è mantenuto prudentemente a una distanza di sicu-rezza intuendo quali pericoli si celino sotto quell'aspetto ammaliante. Preferisce tirare dritto lungo la sua strada ignorando il fascino femmineo del pianeta che lo vorrebbe attrarre a sé accogliendolo sotto la sua gonna per poi farlo sparire quasi fosse una pianta carnivora. Al pari di Odisseo, egli sa che al muto canto di questa sirena è meglio non dare ascolto; me-glio proseguire lungo il percorso che, come gli suggerisce il Botticelli col suo Zefiro, lo con-durrà alla Terra dove l'attende un'atmosfera ben più accogliente, promettente colori e profumi primaverili.

Imparo dal Gombrich che lo stesso mercante Lorenzo di Pierfrancesco de' Medici che aveva commissionato il dipinto al Botticelli, finanziò anche la spedizione di Amerigo Ve-spucci, quella che portò il navigatore a toccare le rive del nuovo continente. Mi faccio "fi-nanziare" nello spirito da tutte queste analogie tra il viaggio del nostro Ulisse Celeste e il quadro botticelliano per infondergli una ulteriore, insperata spinta verso il terzo pianeta.

Se, provenendo dall'orbita di Mercurio, il nostro protagonista poteva ammirare il disco di Venere interamente illuminato dal Sole, ora – lasciandosela alle spalle e voltandosi solo un attimo indulgendo all'appagamento estetico della sua vista – ne vede solo la silhouette in ombra. Questo è esattamente ciò che spinse l'astronomo italiano Galileo Galilei a credere nella teoria copernicana, che voleva il Sole al centro del Sistema Solare con la Terra posta sulla terza orbita dopo Mercurio e Venere. Con il suo telescopio egli poté infatti osservare le fasi di Venere, o come lui ebbe a dire in una lettera a Cosimo de' Medici, suo mecenate, "la madre degli amori (Venere) imita le fasi di Cinthia (la Luna)".

Questo fenomeno poteva essere motivato solo assumendo per vera la nuova configu-razione del Sistema Solare introdotta dalla teoria dell'astronomo polacco, una ulteriore prova della validità delle "sensate esperienze".

E così, dopo aver accompagnato in modo discreto – senza mai aver urlato, accelerato, tuonato – lo spettacolo offerto dalla vista del pianeta, si spegne anche la musica di Holst. Lo fa ricordandoci per poche battute come era iniziata, con quell'adagio suonato dai corni, per poi affievolirsi senza lasciare troppe nostalgie, *morendo al fine* tra pochi amici intimi: i flauti, la celesta, le arpe e gli archi.

Giuseppe,
un pianeta senza tempo

Sulla strada che da Venere conduce al nostro pianeta, facciamo uno strano incontro.

Si tratta dell'abbronzatissimo signor Giuseppe della Seta, quarantatreenne, che, come ci narra Gianni Rodari nel suo meraviglioso *I cinque libri*, già citato in chiusura del capitolo su Mercurio, fa di professione… il pianeta. Un lavoro così stabile, direi a tempo indeterminato, gli è arrivato nel sonno e ora inanella giri intorno al nostro astro in quello che è il suo anno, in trecento giorni,

> sessantacinque meno della Terra,
> con tutto che manca d'allenamento.

Questo unico dato numerico fornito dallo scrittore ci permette di stabilire, grazie alle solite leggi di Keplero, che il signor Giuseppe deve fluttuare a una distanza intermedia tra quella di Venere e quella della Terra. Supponendo infatti che sia di corporatura normale, con la tipica *panzetta* da quarantenne, il nostro avrà una massa di sì e no una novantina di chili, assolutamente trascurabile se la confrontiamo a quella del Sole. Allora nella nostra formula avremo:

$$\left[\quad T^2/R^3 = 4\pi^2/[G(M_{Sole} + m_{Giuseppe})] \approx 4\pi^2/GM_{Sole} \quad \right]$$

dalla quale si può ricavare la distanza dal Sole del signor Giuseppe che sarà pari a:

$$R = (GM_{Sole}T^2/4\pi^2)^{1/3} =$$
$$= [6,67 \cdot 10^{-8} \text{ dyne cm}^2 \text{ g}^{-2} \cdot 1,98 \cdot 10^{33} \text{ g} \cdot (300 \text{ giorni})^2/4\pi^2]^{1/3} =$$
$$= [6,67 \cdot 10^{-8} \text{ dyne cm}^2 \text{ g}^{-2} \cdot 1,98 \cdot 10^{33} \text{ g} \cdot (300 \cdot 24 \cdot 3.600 \text{ s})^2/4\pi^2]^{1/3} =$$
$$= 130,98 \text{ milioni di chilometri}$$

ovvero poco meno di una Unità Astronomica, distanza della Terra dal Sole.

In pratica, il nostro eroe è un bel sonnambulo: dormendo, si è mosso di ben 18 milioni di chilometri! Me lo immagino con il berretto da notte, la mascherina per dormire (sapete, lì fuori il Sole illumina sempre il povero Giuseppe il quale, con la luce forte, non riesce proprio a riposare!) e il suo bel pigiamino rosso. Un look che lo fa assomigliare a un Pulcinella spaziale.

A ricordarci che un tempo era fra noi, rimane giusto la misura del suo tempo personale, proprio quello che scandiva le sue giornate quando era ancora un terrestre e non un pianeta:

Molti sognano di volare
ma non si staccano dal cuscino:
di Giuseppe è rimasto appena
l'orologio sul comodino.

La Luna, lo specchietto retrovisore

E prese lo scudo grande e pesante,
di cui lontano arrivava il chiarore, come di luna.
Omero, *Iliade*, Libro XIX

Passi da gigante sono quelli che hai fatto
Camminando sulla luna
Spero che le mie gambe non si rompano
Camminando sulla luna
Possiamo camminare per sempre
Camminando sulla luna
Possiamo vivere per sempre
Camminando su, camminando sulla luna.
Police, *Walking on the Moon*, Regatta the blanc

E adesso a chi la diamo
questa luna bambina
che vola in un "amen"
dal Polo Nord alla Cina?
…
Se la diamo a un avaro
corre a metterla in banca:
non la vediamo più
né rossa né bianca
Gianni Rodari, *Filastrocche in cielo e in terra*

Diciamo subito che è un corpo solido con un raggio di 1.738 chilometri, una massa di $7,35 \cdot 10^{25}$ grammi e una densità pari a 3,34 grammi per centimetro cubico, attualmente orbitante a circa 384.000 chilometri da noi, poco più di un *secondo-luce* di distanza.

La sua superficie – ricoperta da finissima polvere di *regolite*, ottenuta per frantumazione della crosta a causa dei numerosissimi e violentissimi colpi inferti dall'arrivo dei meteoriti che su di essa cadevano e, oggi in misura minore, continuano a cadere – riflette dal 7 al 12 per cento della luce che le arriva dal Sole, permettendoci così di riceverne di riflesso la luce quando esso

si muove alle nostre spalle. Agisce quindi da specchietto retrovisore per le nostre illuminazioni, ma anche da specchio per le nostre utopie, le nostre tenebrosità e malinconie. Un aspetto molto ben rappresentato in musica dalla sonata per pianoforte in Do diesis minore, Opera 27 meglio nota come *Al chiaro di Luna* di Ludwig van Beethoven, che nell'*Adagio sostenuto* fa galleggiare "l'astro narrante"[1] sul timido moto ondoso di terzine suonate con la mano destra, mentre la sinistra sottolinea con ottave gravi la tragicità della nostra esistenza.

[1] Titolo del libro di Pietro Greco pubblicato a febbraio del 2009 dai tipi di Springer proprio in questa collana.

Ci permette di specchiarci e scoprirci vecchi: dall'analisi dei decadimenti dei materiali ra-dioattivi rinvenuti su di essa e dalla comparazione con un altro metodo di datazione basato sul computo dei crateri, quindi degli impatti subiti dalla sua formazione a oggi, siamo riu-sciti a capire qual è la sua età approssimativa, quindi anche quella del nostro pianeta che, come vedremo, è legato alla Luna non solo da un punto di vista gravitazionale.

Sulla Luna ci siamo stati innumerevoli volte. Abbiamo iniziato a frequentarla con i miti, con la letteratura, con le canzoni, servendoci di qualsiasi mezzo – reale o immaginato – di cui siamo riusciti a dotarci: ippogrifi, scale, proiettili, piante dal fusto lunghissimo, sogni, in-cubi e infine razzi. Il compianto Michael Jackson eseguì per primo una famosa e accattivante camminata lunare, preceduto dai Police che sul nostro satellite hanno fatto passi da gigante rivivendo in parole e musica la magia della spedizione che rese famosi Armstrong, Aldrin e Collins esattamente quarant'anni fa[2]. Il nostro Gianni Rodari, introducendo l'argomento di quanto sto per raccontarvi, nel 1960 verseggiava così:

[2] Scrivo queste righe lunedì 20 luglio 2009!

Vorrei, vorrei…
Volerei sulla Luna
In cerca di fortuna.
E voi ci verreste?
Sarebbe carino,
dondolarsi sulla falce
facendo uno spuntino…

Lei, paziente, è sempre lì a scrutarci con la stessa faccia, a dimostrare una serietà e una onestà sconosciuta a noi che siamo voltafaccia per antonomasia. Poverina, vi è stata costretta dalle forze gravitazionali che la legano al nostro destino da quando si è formata, circa quattro miliardi e mezzo di anni fa. Le due masse, la sua e quella della Terra, hanno stipulato un antico patto che ancora rispettano, anche se viene rinegoziato di continuo in nome di una libertà che da sempre la Luna vorrebbe conquistare e che gli esperti dicono che mai guadagnerà. Il sistema Terra-Luna può essere considerato in qualche modo isolato: su di esso agiscono sì il Sole e, in misura minore, gli altri pianeti, ma l'intensità delle forze reciproche esistenti tra Terra e Luna è tanto più alta delle altre da permetterci di considerarlo isolato. A dimostrazione di ciò, si pensi pure alle maree indotte dalla presenza del nostro satellite naturale sulle acque dei mari, ma non si trascuri di pensare anche – sapendo che la Luna ha una massa che se paragonata a quella terrestre risulta essere pari a solo $7,35 \cdot 10^{25}$ g $/5,97 \cdot 10^{27}$ g = un centesimo della massa terrestre – alle maree che si vivrebbero sulla Luna se su di essa vi fossero distese liquide! Come è noto, sulla Luna non vi sono oceani a permetterci di studiare con facilità l'influenza gravitazionale che essa subisce per la vicinanza del nostro pianeta, ma sappiamo che se la Luna ci guarda sempre con la stessa faccia, è proprio perché le forze mareali della Terra l'hanno costretta a rallentare la sua rotazione (impiega lo stesso tempo a girare attorno alla Terra e attorno al proprio asse) imponendole di non perderci mai di vista. Il rigonfiamento equatoriale della Terra dovuto alla rotazione sul suo asse – rotazione che ne ha modellato la forma in un lontanissimo passato durante il quale essa era ancora un grumo di materiali estremamente caldi e più fluidi, quindi più malleabili – agisce sulla Luna dandole una "spintarella" gravitazionale ogniqualvolta essa si trova a passare da quelle parti. In pratica, la Luna misura di continuo il campo gravitazionale terrestre stabilendo così come si deve comportare. Il rigonfiamento equatoriale le dice di spostarsi più in là ed essa ruba energia dal conto energetico comune che hanno aperto i due corpi allorché hanno deciso di essere soci a vita. Ma, essendo un sistema praticamente isolato, se la Luna fa un prelievo di energia dal conto energetico comune, ciò significa che l'estratto conto generale ne risulta impoverito e che la Terra, facendo un *bancomat energetico*, scopre che può ritirare sempre di meno, una scoperta che la induce a rallentare. Allora si ha che la Luna si sposta verso orbite man mano più ampie prendendo le distanze dal nostro pianeta in ragione di circa sei centimetri all'anno, mentre la Terra rallenta progressivamente la velocità di rotazione attorno al suo asse. La Luna, energeticamente parlando, è un lusso: *ci costa*.

Tra qualche miliardo di anni si avrà che la Luna sarà lontanissima, sempre costretta dalla gravità a guardarci con la stessa faccia, ma la Terra avrà rallentato così tanto che un giorno terrestre sarà pari a cinquanta giorni… dei nostri attuali giorni. Immagino la fatica dei sindacati che dovranno lottare molto per convincere la classe dirigente che non sarà più il caso di farci lavorare dalla mattina alla sera! Poi mi ricordo che, quando le cose saranno cambiate così radicalmente, il nostro Sole sarà prossimo a morire e mi rendo conto che, se esisteranno ancora, i sindacati avranno come tutti ben altro a cui pensare. L'estremo rallentamento della Terra implicherà che anche lei guarderà la Luna sempre con la stessa faccia: pur avendo conquistato una relativa libertà l'una dall'altra, dopo tanto tempo speso insieme, non potranno fare a meno di scoprire che non si possono voltare le spalle al proprio passato. La Luna sarà quindi visibile solo da un continente, ancora non si sa quale, e questo vorrà dire pellegrinaggi di *aficionados* che viaggeranno per rimirarla. Ma se Luna e Terra si stanno allontanando progressivamente, allora tanto tempo fa i due corpi dovevano essere molto più vicini di quanto non lo siano ora. E in effetti è proprio così: supponendo per semplicità che l'allontanamento di sei centimetri all'anno sia stato costante nei quattro miliardi e mezzo di anni di storia planetaria, si ha che

$$\text{distanza iniziale della Luna dalla Terra} =$$
$$= \text{distanza attuale} - (\text{velocità di allontanamento della Luna} \cdot \text{età della Luna}) \approx$$
$$\approx 384.000 \text{ km} - (6 \cdot 10^{-5} \text{ km} \cdot \text{anno}^{-1} \cdot 4,5 \cdot 10^9 \text{ anni}) = 114.000 \text{ km}$$

pari a 114.000 km/ 6.400 km ≈ 18 raggi terrestri.

In realtà sappiamo che la velocità di allontanamento è stata molto più alta nelle prime fasi di vita del sistema Terra-Luna e che all'inizio i due corpi erano molto più vicini tra loro, addirittura circa due-tre raggi terrestri di distanza. Immaginate come doveva apparire il disco lunare visto anche solo da 3 · 6.378 km ≈ 20.000 km! Forse questo fenomeno non è stato visto da niente che assomigliasse a un occhio animale, ma in ogni caso, se solo pensiamo alle maree che una tale vicinanza deve avere indotto sulle masse liquide del nostro pianeta, anche la fantasia può regalarci una vertigine non da poco. Una vertigine che non ha mancato di ispirare lo scrittore Italo Calvino, molto facile a simili fascinazioni, il quale, nel primo racconto delle sue *Cosmicomiche* intitolato proprio *La distanza della Luna*, ci narra di un nostro satellite ancora più vicino, così tanto vicino da permettere a qualcuno di saltargli sopra per andare a raccogliere il "famoso" latte lunare:

Le maree, quando la Luna si faceva più sotto, salivano che non le teneva più nessuno. C'erano delle notti di plenilunio basso basso e d'alta marea alta alta

che se la Luna non si bagnava in mare ci mancava un pelo; diciamo: pochi metri. Se non abbiamo mai provato a salirci? E come no? Bastava andarci proprio sotto con la barca, appoggiarci una scala a pioli e montar su. (…) Il nostro lavoro era così: sulla barca portavamo una scala a pioli: uno la reggeva, uno saliva in cima, e uno ai remi intanto spingeva fin lì sotto la Luna; per questo bisognava che si fosse in tanti. Quello in cima alla scala, come la barca s'avvicinava alla Luna, gridava spaventato: – Alt! Alt! Ci vado a picchiare una testata! – Era l'impressione che dava, a vedersela addosso così immensa, così accidentata di spunzoni taglienti e orli slabbrati e seghettati. (…) In realtà, d'in cima alla scala s'arrivava giusto a toccarla tendendo le braccia, ritti in equilibrio sull'ultimo piolo. Avevamo preso bene le misure (non sospettavamo ancora che si stesse allontanando); l'unica cosa cui bisognava stare molto attenti era come si mettevano le mani. Sceglievo una scaglia che paresse salda (ci toccava salire tutti, a turno, in squadre di cinque o sei), m'aggrappavo con una mano, poi con l'altra e immediatamente sentivo scala e barca scapparmi di sotto, e il moto della Luna svellermi dall'attrazione terrestre. Sì, la Luna aveva una forza che ti strappava, te ne accorgevi in quel momento di passaggio tra l'una e l'altra: bisognava tirarsi su di scatto, con una specie di capriola, afferrarsi alle scaglie, lanciare in su le gambe, per ritrovarsi in piedi sul fondo lunare. Visto dalla Terra apparivi come appeso a testa in giù, ma per te era la solita posizione di sempre, e l'unica cosa strana era, alzando gli occhi, vederti addosso la cappa del mare luccicante con la barca e i compagni capovolti che dondolavano come un grappolo dal tralcio (…). Ora voi mi chiederete cosa diavolo andavamo a fare sulla Luna, e io ve lo spiego. Andavamo a raccogliere il latte, con un grosso cucchiaio e un mastello. Il latte lunare era molto denso, come una specie di ricotta. Si formava negli interstizi tra scaglia e scaglia per la fermentazione di diversi corpi e sostanze di provenienza terrestre, volati su dalle praterie e foreste e lagune che il satellite sorvolava. Era composto essenzialmente di: succhi vegetali, girini di rana, bitume, lenticchie, miele d'api, cristalli d'amido, uova di storione, muffe, pollini, sostanze gelatinose, vermi, resine, pepe, sali minerali, materiale di combustione.

Ora, dopo aver goduto delle incredibili immagini regalateci dalla fantasia debordante dell'autore nostrano, con un piccolo balzo mentale *torniamo con i piedi sulla Terra* per osservare che se la Luna si librasse così vicina alla Terra e così tanto lenta[3], da permettere di tenere ferma una scala tra i due corpi celesti, allora l'attrazione tra i due corpi non verrebbe

[3] In pratica, con una rotazione sincrona che, come si diceva, sappiamo si verificherà solo tra qualche miliardo di anni.

controbilanciata da una adeguata forza centrifuga e la Luna cadrebbe sulla Terra mentre la Terra… cadrebbe sulla Luna, anche se un po' meno. Qualcosa di così catastrofico deve essere successo davvero, molto tempo prima: tra le varie ipotesi sulla formazione della Luna ve ne è una che prevede l'arrivo di un bolide vagante che, colpendo in modo violento una Terra ancora in formazione, ne ha letteralmente strappato un pezzo finito, dopo l'urto, a una certa distanza dalla massa informe terrestre. Lì poi esso avrebbe continuato a evolvere in modo indipendente fino a diventare la Luna che oggi conosciamo. Altre spiegazioni alternative parlano di cattura da parte della Terra di detriti spaziali andati a sistemarsi attorno al pianeta formando un disco che pian piano, sotto la spinta delle forze gravitazionali tra le varie masse, è andato a confluire tutto nella formazione del nostro satellite. Un'altra teoria, l'ultima per il momento, prevede – anzi, post-vede – che la solita Terra in formazione, magmatica e praticamente fluida, a causa dell'elevata forza centrifuga generata dalla grande velocità di rotazione, abbia perso un pezzo che risultava meno legato al resto del materiale. Questa *badilata* di Terra non è riuscita a cadere lontano, trattenuta dal comunque già forte campo gravitazionale terrestre che, come sempre quando si parla di gravità, non dipende dallo stato in cui la materia si presenta, ma solo da quanta materia c'è in un certo posto. Anche qui la fine della storia è sempre la stessa: lì dove è riuscita ad arrivare, 'sta *badilata* di magma con il passare del tempo è diventata la Luna.

Ma torniamo a quanto si diceva nella parte finale della citazione precedente, un brano che mi fornisce l'occasione di parlare di un argomento capace di stuzzicare la mia fantasia in modo particolare. Tutto nasce da una semplice domanda: di chi è la Luna? Può sembrare una domanda stupida, ma a ben vedere non lo è affatto. Cercare il latte lunare, quello che diventerà poi formaggio nel cartone animato di Wallace e Gromit, è un'ottima metafora per esemplificare cosa andremo a fare in futuro su altri pianeti. Lì speriamo di trovare ciò di cui abbiamo bisogno e che qui sulla Terra inizia a scarseggiare: si tratterà di materie prime, combustibili, opportunità ma, soprattutto, spazio. Ce lo spiega Robert A. Heinlein che, nel suo racconto del 1949 *L'uomo che vendette la Luna* contenuto nella raccolta *La storia futura*, fa dire al protagonista, il lungimirante affarista Delos Harriman:

> "Il tempo è ultramaturo per i viaggi spaziali, e questo mondo diventa sempre più affollato. Nonostante i progressi tecnici la razione giornaliera alimentare è più bassa di quanto fosse trent'anni fa e nascono 46 bambini ogni minuto, 65.000 ogni giorno, 25 milioni ogni anno. La nostra razza sta per straripare dal pianeta (…) Questa è la più grossa avventura della Storia. Non domandarmi su cosa guadagneremo: non posso fare un elenco dei vantaggi, ma te li riassumo. I vantaggi sono un pianeta, *un intero pianeta*, Dan, ancora vergine. E molti pianeti al di là di questo! Se non riusciamo a mettere insieme in fretta qualche milione per un'impresa così proficua, allora tu e io faremmo meglio ad andare in pensione. È come se ti offrissero l'isola di Manhattan per 24 dollari e una cassetta di whisky".

Dixon brontolò: "Tu ne parli come dell'occasione di tutta una vita".

"Occasione di tutta una vita! Questa è la più grande invenzione di tutta la storia. È manna: Procuratevi un secchiello".

Vicino a Entenza sedeva Gaston P. Jones, direttore della Trans-America e un'altra mezza dozzina di banche, uno degli uomini più ricchi nella stanza. Scosse lentamente la cenere dal sigaro e disse asciutto: "Signor Harriman, sono disposto a venderle tutti i miei interessi sulla Luna, presenti e futuri, per 50 centesimi!".

Harriman sembrò deliziato: "Venduto".

Entenza ascoltava con espressione meditabonda, mordicchiandosi il labbro inferiore. Infine disse: "Un momento, signor Jones, offro un dollaro".

"Un dollaro e mezzo" rispose Harriman.

"Due dollari" ribatté Entenza.

"Cinque!"

Aumentarono sempre più l'offerta. Arrivati a dieci dollari Entenza cedette ad Harriman e tornò a sedersi con aria pensierosa. Harriman si guardò intorno tutto contento. "Chi tra voi ladri è anche avvocato?" domandò. La richiesta era puramente retorica: su diciassette consiglieri la percentuale normale – undici, per essere esatti – erano avvocati. "Ehi, Tony, preparami subito un atto legale per consacrare questa transazione in modo che non possa essere rotta nemmeno davanti al trono del Signore. Tutti gli interessi, diritti, titoli, interessi naturali, interessi futuri, interessi posseduti direttamente o tramite il possesso di azioni, posseduti attualmente o da acquistarsi e così via. Mettici un bel po' di latino dentro. Il succo è che ogni interesse sulla Luna, che il signor Jones abbia o possa acquistare, è mio per una banconota da dieci dollari, pagamento in contanti". (…) "Bene" disse Harriman. "Signori, Jones ha stabilito il prezzo di mercato per gli interessi di un essere umano sulla Luna. Dato che sulla faccia della Terra siamo circa tre miliardi, se ne ricava che il prezzo della Luna è di trenta miliardi di dollari". Tirò fuori un pacco di banconote. "C'è qualcun altro che voglia approfittarne? Compro ogni parte che mi venga offerta a dieci dollari l'una".

Le cifre riportate dal protagonista si riferiscono a un periodo storico che oramai ci siamo lasciati alle spalle. Normalmente questa frase viene usata per dire che, in un modo o nell'altro, il problema è stato superato, è acqua passata. Invece siamo tutti ben consci del fatto che da allora, in ottemperanza alla legge dell'aumento dell'entropia applicata alle scienze sociali, la situazione è peggiorata drasticamente. L'intera popolazione mondiale ammonta a quasi sette miliardi di persone, più del doppio di quanti ne contasse negli anni in cui Heinlein scriveva le righe su riportate. Il prezzo della Luna oggi sarebbe quindi almeno rad-

doppiato, ma oltre a ciò si ha anche che la quantità di cibo pro capite è di conseguenza diminuita, comportando un impoverimento ancora più drammatico delle fasce di popolazione meno abbienti. Abbiamo quindi urgente bisogno di spazio nel quale cercare nuove opportunità e quale posto migliore dello spazio per cercare… spazio? La Luna non è di sicuro un pianeta così tanto grande da potere costituire una soluzione definitiva, ma è un primo passo che prima o poi qualcuno compirà e forse vi sorprenderà scoprire che c'è già chi si sta mettendo in moto. Si, perché non è la prima volta che la fantascienza propone dei problemi che poi la società si trova a dover affrontare sul serio. La scienza ha da sempre attinto ispirazioni dal mondo fantascientifico (vale anche il viceversa…), ma, in questo caso specifico, scopriamo che vi è stata un'evoluzione silenziosa anche del diritto, ovvero di quella branca del sapere che, con termini altisonanti e a mio parere impropri, qualcuno ama definire "scienze giuridiche". Nel racconto su citato, durante una discussione tra il protagonista Delos Harriman e il socio in affari George Strong, l'autore fa svelare dai suoi personaggi una sua idea sul diritto naturale di alcune nazioni a ritenersi padrone della Luna:

"Ho scoperto qualcosa di molto, molto interessante. Guarda qui… secondo queste tavole la Luna oscilla poco meno di 29° a nord e a sud dell'equatore terrestre." Appoggiò una matita contro il globo e lo fece ruotare. "Non ti suggerisce niente?"

"No, tranne che stai facendo dei segnacci su un mappamondo da sessanta dollari".

"E tu saresti un ex agente immobiliare? Di che cosa è padrone un individuo quando compra un pezzo di terra?"

"Dipende dal contratto di acquisto. Di solito, i diritti sui minerali e altri diritti di sottosuolo sono…".

"Non m'interessa affatto. Supponi che io comperi senza precisare i diritti: fino a quale profondità si spinge la proprietà, e fino a che altezza?"

"Be', si è padroni di un cuneo fino al centro della Terra. Questo fu stabilito nel caso che un terreno venisse affittato per trivellazioni petrolifere. In teoria si è padroni illimitatamente anche dello spazio sopra la Terra, ma questo punto è stato modificato dopo l'avvento dell'aviazione di linea. E buon per noi, altrimenti dovremmo pagare un pedaggio ogni volta che

uno dei nostri razzi va in Australia".

"No, no, George, non hai letto bene la casistica. Fu concesso il diritto di passaggio, ma la proprietà dello spazio sopra la terra è rimasta immutata. E anche il diritto di passaggio non è assoluto: tu puoi costruire una torre di trecento metri sulla tua terra proprio là dove passano aeroplani, razzi o quel che sia, e tutti questi mezzi dovranno passarle al di sopra, senza nessuna possibilità di rivalsa su di te". (…)

Strong sembrò perplesso. "Già, capisco. Il vecchio principio sulla proprietà immobiliare rimane invariato, giù fino al centro della Terra e su fino all'infinito. Ma poi? È una faccenda puramente teorica. Non penserai di pagare un pedaggio ogni volta che vorrai muovere una delle astronavi di cui parli sempre, no?" E Strong sorrise del suo spirito.

"Non è come credi tu. Stavo pensando a tutt'altra cosa. George, *a chi appartiene la Luna?*"

Strong rimase a bocca aperta. "Delos, stai scherzando".

"No, e ti domando ancora: se la legge dice che a un uomo appartiene il cuneo di cielo sopra la sua terra fino all'infinito, *di chi è la Luna?* Da' un'occhiata a questo mappamondo e dimmelo".

Strong guardò. "Ma non significa nulla, Delos. Le leggi della Terra non si applicano alla Luna."

"Ma si applicano qui, ed ecco perché mi preoccupo. La Luna si libra costantemente su una fascia di terra delimitata da una latitudine di circa 29° a nord e lo stesso a sud: se un uomo fosse padrone di tutta questa cintura possiederebbe anche la Luna, in base alle nostre leggi sulla proprietà dei beni immobili applicate dai nostri tribunali. E per derivazione diretta, secondo la logica tanto cara agli avvocati, i vari proprietari di quella fascia di territorio hanno un buon diritto sulla Luna, un diritto, diciamo così, collettivo".

La società dal '49 a oggi è cambiata e sono cambiate anche molte leggi. Ciò che invece non cambierà mai è il desiderio di conquista che caratterizza la nostra razza: se non fosse stato per una notiziola apparsa sui giornali qualche tempo fa e che all'epoca è servita a riempire, assieme ad altre più o meno importanti, le pagine dei quotidiani che devono essere colmate di parole per sostenere gli ampi spazi pubblicitari, nessuno l'avrebbe saputo. In essa – pensate un po'! – si diceva che i cinesi stanno comprando la Luna! C'era da aspettarselo, dal momento che da loro il problema della sovrappopolazione è talmente forte da indurli a colonizzare silenziosamente tutto il globo. Essi si stanno preparando in modo adeguato al grande salto che li porterà presto ad abitare i crateri del nostro satellite: stanno investendo molto in educazione scientifica dei propri figli come in sviluppo tecnologico, e presto i cosiddetti *taikonauti* metteranno piede sul nostro (*nostro?*) satellite naturale con una spedizione scientifica che, immagino, precederà di non molto altre con scopi coloniali.

Non li spaventa il fatto che, a causa della sua bassa gravità, pari a un sesto di quella ter-
restre, la Luna è stata abbandonata dalla sua atmosfera primordiale fuggita nello spazio
quando, ancora caldissimo pianeta in formazione, donò alle particelle gassose che durante
la fase di raffreddamento fuoriuscivano dalla sua superficie, una energia cinetica sufficiente
a vincere la gravità locale[4]. Li spaventa molto di più l'idea di vivere in un mondo povero e so-
vrappopolato. A vendergli ampi appezzamenti pare sia stata una coppia, tali Sue e Francis Wil-
liams, traduzioni in carne e ossa dell'immaginario Delos Harriman partorito dalla penna di
Heinlein. I coniugi hanno messo su un'agenzia, la *Moon Estates*, che mi piace immaginare come
una grande pizzeria – ovviamente si chiamerebbe *Luna Rossa* – capace di vendere la Luna *a
quarti, a spicchi, a tranci, a fasi,* ... La Luna piena costerebbe tantissimo e se si volesse l'aggiunta
di crateri si pagherebbe un supplemento *caduta meteoriti artificiali*. A parte gli scherzi, i due
avranno avviato la loro attività servendosi, in un modo che mi sfugge, di qualche articolo della
nuova legislazione in materia di spazio esterno alla nostra atmosfera, un'appendice del diritto

[4] Da notare che, se fossero state ritenute valide le regole del mercato immobiliare di cui parlava Harriman nel rac-
conto di Heinlein, in prospettiva la Luna sarebbe stata sempre più una nuda proprietà di un solo stato, o di nes-
suno stato se i calcoli un giorno riveleranno come tra qualche miliardo di anni essa si fermerà in corrispondenza
di un oceano.

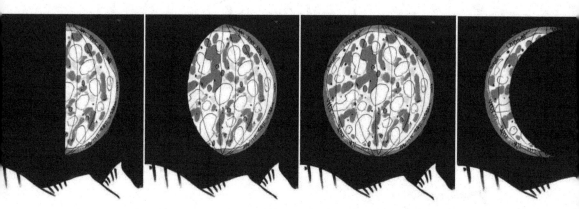

internazionale che va sotto il nome di *Outer Space Treaty*, sottoscritto da Stati Uniti, Gran Bretagna e Russia il 27 gennaio del 1967, diciotto anni dopo la pubblicazione del racconto di Heinlein. La leggerezza con cui simili notizie passano praticamente inosservate è qualcosa che a mio parere non possiamo permetterci. Siamo già nel futuro, ma troviamo così tanto abbacinante il nostro presente da perdere la possibilità di guardare in prospettiva il domani. La levità che dimostriamo nel non occuparci di certe cose trovo sia perfettamente paragonabile alla leggerezza del brevissimo *Allegretto* beethoveniano, un facile tre quarti che solo per poco serve a distogliere l'attenzione dalle pene del brano precedente.

Ahimè! Si rivelerà essere solo un diversivo, un facile preludio alla corsa a perdifiato del *Presto Agitato* che conclude la sonata di Beethoven e che, ancora una volta, rappresenta benissimo lo stato d'animo che assalirà la collettività quando, in un futuro prossimo, ci ritroveremo ad avere a che fare con problemi la cui già grande importanza diverrà finalmente

chiara a tutti. Un giorno, dimostrando scarsa preveggenza, scopriremo che la Luna, lo spazio erano importanti e che, mentre noi li ignoravamo *in altre faccende affaccendati*, qualcuno l'aveva già capito molto prima di noi.

Per fortuna, ancora nessuno mi ha mai chiesto a cosa servano la musica e l'arte in generale (forse non lo chiedono a me perché ritengono sia meglio chiederlo a qualcun altro). Pochi, immagino, si chiedono realmente a cosa serva spendere così tanti soldi per varie attività umane che, anche nei cosiddetti *tempi di crisi*, fanno registrare in modo inspiegabile incassi favolosi. Molti, invece, mi hanno chiesto a che cosa serve spendere per le ricerche astrofisiche. A questo punto, ricordando le parole dei *Police* citate in apertura di capitolo e dimostrando così di *tenere alle nostre gambe*, spero solo che nessuno me lo chieda più…

Evasioni planetarie

Immaginate di essere un atomo di idrogeno e di avere un fratello gemello esattamente uguale a voi. Assieme, voi due costituite qualcosa di molto stabile: una famiglia? No, una molecola di idrogeno. Le vostre masse sono uguali e pari alla somma della piccolissima massa $m_{protone} = 1,67 \cdot 10^{-24}$ g – quella del protone, unico costituente il vostro nucleo – e di quella ancor più piccola del vostro unico elettrone $m_{elettrone} = 0,0009106 \cdot 10^{-24}$ g. Allora la vostra molecola possiederà una massa complessiva data dal semplice raddoppiare il valore di questa somma:

$$
\begin{aligned}
\text{Massa della molecola di idrogeno } H_2 &= \\
= 2 \cdot 1,67 \cdot 10^{-24} \text{ g} + 2 \cdot 0,0009106 \cdot 10^{-24} \text{ g} &= \\
= 2 \cdot 1,6709106 \cdot 10^{-24} \text{ g} = 3,34 \cdot 10^{-24} \text{ g}
\end{aligned}
$$

Dimenticavo: siete ancora sulla Luna. Lo so, pensavate di avere finito il capitolo che ne parla e di essere finalmente riusciti ad andare oltre, ma purtroppo devo trattenervi ancora per un po' da quelle parti. Siete giovani e curiosi e, nonostante stiate vivendo una fase dell'antichissima storia lunare nella

quale siete in compagnia di una quantità enorme di altre molecole di idrogeno – di gran lunga l'elemento più diffuso nel cosmo – e di tante altre di vario tipo, volete ugualmente andare a vedere cosa c'è in giro, lontano da dove vi trovate. La Luna vi attrae con la sua forza gravitazionale e – oramai lo sapete – essa tira il baricentro della vostra molecola verso il suo centro planetario posto 1.738 chilometri sotto la sua crosta, con un'intensità data da:

$$\left[\begin{array}{c} F = -G\, m_{\text{molecola di idrogeno}} \cdot M_{\text{Luna}} / \text{Raggio}^2_{\text{Luna}} = \\ = -6{,}67 \cdot 10^{-8} \text{ dyne cm}^2 \text{ g}^{-2} \cdot 3{,}34 \cdot 10^{-24} \text{g} \cdot 7{,}35 \cdot 10^{25} \text{g} / (1.738 \cdot 10^5 \text{ cm})^2 \end{array} \right]$$

nella quale il segno meno indica che la distanza tra voi e la Luna tende a diminuire perché, come ben sapete, quella che agisce su di voi è una forza attrattiva. Nel tirarvi a sé, essa compie un *lavoro*, una cosa che in fisica consideriamo come equivalente a energia utilizzata per un determinato scopo. È così possibile quantificarlo considerando la forza che viene applicata su un oggetto moltiplicata per la distanza lungo la quale essa agisce. Dato che la Luna tende a trattenervi sulla superficie, a una distanza dal centro pari al suo raggio, il lavoro compiuto dalla massa lunare verrà dato dalla seguente relazione:

$$\left[\begin{array}{c} \text{Lavoro} = F \cdot L = (-G\, m_{\text{molecola di idrogeno}} \cdot M_{\text{Luna}} / \text{Raggio}^2_{\text{Luna}}) \, \text{Raggio}_{\text{Luna}} = \\ = -G\, m_{\text{molecola di idrogeno}} \cdot M_{\text{Luna}} / \text{Raggio}_{\text{Luna}} = \\ = -6{,}67 \cdot 10^{-8} \text{ dyne cm}^2 \text{ g}^{-2} \cdot 3{,}34 \cdot 10^{-24} \text{ g} \cdot 7{,}35 \cdot 10^{25} \text{ g} / 1.738 \cdot 10^5 \text{ cm} \end{array} \right]$$

Siete costretti dalla forza gravitazionale a stare sulla superficie ma questo – badate bene! – non vuol dire che non potete muovervi. Se vi spostate curando di rimanere aderenti al suolo, non sentirete su di voi l'azione della forza gravitazionale in quanto – l'abbiamo già detto nel secondo capitolo – essa è una forza centrale e agisce solo lungo la direzione congiungente i centri delle masse considerate e non perpendicolarmente a essa. Beninteso, potrete anche muovervi verticalmente e, nel caso, avrete un'energia totale data dalla somma della vostra energia potenziale (energia misurata rispetto alla Luna, che potrebbe essere convertita in lavoro) e cinetica (la *vostra* energia già convertita a *vostre* spese nel lavoro dato dal mantenervi in movimento). In formula:

$$
\begin{aligned}
&\text{Energia Totale} = \text{Energia Potenziale} + \text{Energia Cinetica} = \\
&= \text{-G } m_{\text{molecola di idrogeno}} \cdot M_{\text{Luna}} / \text{Raggio}_{\text{Luna}} + \\
&+ (1/2) \cdot m_{\text{molecola di idrogeno}} \cdot v^2_{\text{molecola di idrogeno}} = \\
&= -6{,}67 \cdot 10^{-8} \text{ dyne cm}^2 \text{ g}^{-2} \cdot 3{,}34 \cdot 10^{-24} \cdot 7{,}35 \cdot 10^{25} \text{ g} / 1.738 \cdot 10^5 \text{ cm} + \\
&+ (1/2) \cdot 3{,}34 \cdot 10^{-24} \text{ g } v^2_{\text{molecola di idrogeno}}
\end{aligned}
$$

Se la vostra energia cinetica (considerata positiva) è più piccola di quella potenziale (il termine con il segno meno), allora l'energia totale, somma dei due termini, sarà negativa, il che significa che sarete costretti sulla Luna, sarete prigionieri della sua morsa gravitazionale e potrete fare quello che volete tranne che andare via dalla sua superficie. Se invece le due energie si equivalgono, si ha:

$$
\text{Energia Totale} = \text{Energia Potenziale} + \text{Energia Cinetica} = 0
$$

Questo risultato vuol dire che siete ancora sulla sua superficie, ma basterà un nonnulla perché vinca la vostra voglia di evadere. In pratica, ce l'avete quasi fatta, dovete solo impegnarvi un po' di più nel racimolare energia. Se lavorerete sodo per acquisire una sufficiente quantità di movimento da liberarvi della stretta lunare, allora la vostra energia cinetica diventerà maggiore di quella potenziale e il computo dell'energia totale sarà positivo: potrete scappare via! "Ok", direte voi, "Ma da dove prendiamo questa energia?". E ancora: "A quanto è uguale quella velocità che compare al quadrato nell'espressione precedente?". Le due cose sono intimamente connesse e darò alle due domande un'unica risposta. È stato scoperto che in un gas l'energia cinetica media delle molecole che lo compongono è di circa $1{,}5kT$, nella quale k è la cosiddetta costante di Stefan-Boltzmann pari a $1{,}38 \cdot 10^{-16}$ erg $°K^{-1}$ e T è la temperatura in gradi Kelvin alla quale il gas si trova. Se ne può dedurre che la temperatura di un gas è un indicatore di quanto velocemente corrano le molecole che lo compongono.

Allora si ha che

$$
\frac{3}{2}kT = \frac{1}{2}m\, v^2_{\text{media molecola di idrogeno}}
$$

dalla quale si intuisce facilmente che, misurata la temperatura T, otterremo la velocità media delle molecole gassose facendo semplicemente la seguente operazione:

$$v_{media} = (3kT / m_{molecola\ di\ idrogeno})^{1/2}$$

Allora, se la vostra Energia Cinetica risulterà essere più grande dell'Energia Gravitazionale Potenziale[1], quindi se l'energia totale risulterà essere positiva, potrete andarvene dal suolo lunare verso nuove avventure cosmiche. Il trucco sarà prendere calore da qualcosa che può donarvelo. Sappiamo che nel passato di tutti i corpi del Sistema Solare vi è stata una fase estremamente calda, seguita da un'altra di raffreddamento, che per la Terra fortunatamente è ancora in corso, mentre per la Luna è già giunta a termine molto tempo fa (il nostro satellite naturale non conserva più calore nel suo interno; è un corpo celeste del tutto morto da un punto di vista geologico). L'avere attraversato una fase molto calda, ci autorizza a pensare che una qualsiasi molecola di gas presente sulla superficie abbia in passato beneficiato di un certo apporto di calore che potrebbe aver costituito il lasciapassare per migrare fuori dall'influenza gravitazionale del piccolo pianeta. Possiamo cal-

[1] Diventerà Energia Gravitazionale Effettiva non appena tenterete di allontanarvi dalla Luna e sentirete che essa tenta di tenervi avvinti trasformando l'Energia Potenziale in Lavoro Gravitazionale Attrattivo.

colare qual è la temperatura minima che dovrebbe acquistare una molecola di idrogeno, la vostra molecola di idrogeno, per poter evadere dalla pallida prigione. Per farlo, poniamo che debba essere:

$$\left[\qquad \text{Energia Potenziale} < \text{Energia Cinetica} \qquad \right]$$

Quindi:

$$\left[\begin{array}{c} 6{,}67 \cdot 10^{-8} \text{ dyne cm}^2 \text{ g}^{-2} \cdot 3{,}34 \cdot 10^{-24} \text{ g} \cdot 7{,}35 \cdot 10^{25} \text{g} / (1.738 \cdot 10^5 \text{ cm}) < \\ < 3{,}34 \cdot 10^{-24} \text{ g} \cdot v^2_{\text{media molecola di idrogeno}} \end{array} \right]$$

e sostituendo a v il valore trovato grazie alla relazione che lega velocità a temperatura, otteniamo:

$$\left[\begin{array}{c} 6{,}67 \cdot 10^{-8} \text{ dyne cm}^2 \text{ g}^{-2} \cdot 3{,}34 \cdot 10^{-24} \text{ g} \cdot 7{,}35 \cdot 10^{25} \text{g} / (1.738 \cdot 10^5 \text{ cm}) < \\ < 3{,}34 \cdot 10^{-24} \text{ g} \cdot 3kT / m_{\text{molecola di idrogeno}} \end{array} \right]$$

dalla quale, semplificando il termine $m_{\text{molecola di idrogeno}}$ con il suo valore numerico $3{,}34 \cdot 10^{-24}$ al numeratore si ottiene un valore della temperatura pari a:

$$\left[\begin{array}{c} T > 6{,}67 \cdot 10^{-8} \text{ dyne cm}^2 \text{ g}^{-2} \, 3{,}34 \cdot 10^{-24} \text{ g} \cdot 7{,}35 \cdot 10^{25} \text{ g} / \\ / (3 \cdot 1.738 \cdot 10^5 \text{ cm} \cdot 1{,}38 \cdot 10^{-16} \text{ erg } °K^{-1}) = 227{,}56 \,°K = -45{,}59 \,°C \end{array} \quad (*) \right]$$

Grazie a questo dato, si ricava che la velocità di fuga imposta dal valore della massa lunare[2] è:

$$\left[\begin{array}{c} v_{\text{fuga}} = (3kT / m_{\text{molecola di idrogeno}})^{1/2} = \\ = [3 \cdot 1{,}38 \cdot 10^{-16} \text{ erg } °K^{-1} \cdot 227{,}56 \,°K / (3{,}34 \cdot 10^{-24} \text{ g})]^{1/2} = \\ = 167.948 \text{ cm/s} = 1{,}67 \text{ km/s} \end{array} \right]$$

Ecco perché sia voi due che tutti gli altri composti gassosi evaporati tanto tempo fa da una superficie lunare in raffreddamento, siete scappati via lasciando il nostro satellite solo al suo destino di pianeta senza né mari né atmosfera. Vi è bastato sentire un calore di poco superiore ai meno quarantacinque gradi centigradi per prendere velocità – a ben vedere, una velocità davvero bassa per un gas! – e andarvene via. A questo punto possiamo affermare che sulla Luna non vi è idrogeno gassoso, quindi non vi può essere nemmeno vapore acqueo. Nel suo già citato *Sidereus Nuncius* Galileo Galilei riferiva:

[2] Se volete divertirvi ancora un po' con i calcoli, potete provare a vedere cosa succede quando al posto della massa della Luna si va a sostituire nella (*) il valore della massa degli altri pianeti.

> (…) cosicché, se qualcuno volesse risuscitare l'antica opinione dei Pita-
> gorici, esser cioè la Luna quasi un'altra Terra, la parte di essa più luminosa
> rappresenterebbe più propriamente la superficie solida, la più oscura in-
> vece l'acquea: laddove io ho sempre ritenuto per certo che del globo
> terrestre, veduto da lontano quando sia illuminato dai raggi solari, le terre
> emerse si mostrerebbero più luminose, le acquee invece più oscure

compiendo così un errore di sicuro perdonabile: abbiamo la certezza che su di essa non vi può essere né idrogeno gassoso, né alcun liquido che sia costituito anche da idrogeno e da tutti quegli elementi già sfuggiti in precedenza nello spazio. Le zone scure osservate da Galileo e visibili anche a occhio nudo, quelle che nel secondo canto del Paradiso stimolano la curiosità di Dante quando chiede a Beatrice:

> Ma ditemi: che son li segni bui
> di questo corpo, che là giuso in terra
> 51 fan di Cain favoleggiar altrui?

ricordandoci così che la tradizione le spiegava come ombre proiettate dal fascio di rovi imposto sulle spalle di Caino nel suo esilio lunare, furono scambiate dal grande scienziato italiano per immense distese del prezioso liquido[3], ma oggi sappiamo che altro non sono se non altipiani formatisi in seguito alla fuoriuscita di sotterranei mari, sì, ma di materiale lavico, in seguito a tremendi impatti meteoritici che li hanno liberati perforando la crosta lunare. Questi altipiani, proprio per la loro differente altezza rispetto alle zone circostanti, riflettono la luce solare in modo diverso, creando quell'effetto ottico che, per la solita *pareidolia* già citata nel primo capitolo, induce alcune popolazioni orientali a vedere sulla faccia della Luna rivolta verso di noi l'immagine di un "coniglio lunare" mentre in Occidente si crede di osservare il famoso "man in the Moon". Scagionato Caino, se di traditori si deve parlare, gli unici siete proprio voi, oh miei atomi di idrogeno, che alla prima occasione siete fuggiti via. Vergognatevi!

[3] Alcune sonde in orbita attorno alla Luna hanno captato la presenza di ghiaccio d'acqua all'interno di alcuni crateri posti vicino alle zone polari. Si pensa che possa trattarsi di depositi dovuti alla caduta di comete sulla superficie del nostro satellite in punti dove la luce solare fa fatica ad arrivare a causa della posizione e dell'altezza dei bordi degli stessi crateri.

La Terra, il covo dei cafoni

Secondo me, quello che di eccezionale
la ricerca spaziale ha provocato non è
nuova tecnologia, ma la possibilità per la
prima volta nella storia dell'uomo di
vedere la Terra dallo spazio, e le informazioni
acquisite dalla visione dall'esterno del nostro
pianeta verde-azzurro nella sua bellezza totale,
le quali hanno fatto sorgere un insieme di nuove
domande e risposte.
James Lovelock, *Gaia – Nuove idee sull'ecologia*

Come disse Garrett Hardin, il numero ottimale
della popolazione non è pari al numero massimo che la Terra
può nutrire; oppure, come è stato detto più grossolanamente,
"Vi è un solo inquinare… la gente".
James Lovelock, *Gaia – Nuove idee sull'ecologia*

Ci sono infiniti modi di parlare di qualsiasi cosa; diversi approcci più o meno validi, e ce ne sono infiniti al quadrato, al cubo forse, se si prende in considerazione un oggetto molto particolare: la nostra Terra. Conscio di non potere nemmeno lontanamente riuscire a passare in rassegna anche solo quelli che da sempre siamo portati a immaginare siano i più importanti, mi limiterò a sceglierne uno, pur sapendo che anche in questo caso peccherò di incompletezza. In fondo, è il pianeta dove abitiamo, *casa nostra* e, in quanto tale, lo conosciamo così tanto bene da poter dedicare a questo soggetto miriadi di narrazioni, tutte diverse, almeno una per ogni essere che lo abita e che lo ha abitato. La cosa incredibile è che lo conosciamo anche così poco in tanti suoi aspetti e quello di cui mi interesserò è proprio uno di questi, anzi, un sottoinsieme di un aspetto particolare: l'inquinamento di origine antropica che colpisce lo spazio esterno al nostro pianeta.

Da un po' di tempo se ne parla. Ogni tanto spunta fuori qualche notizia circa il gran traffico di oggetti che congestiona lo spazio immediatamente adiacente ai confini della nostra atmosfera. E ogni volta che se ne sente parlare, risuona come una trovata, una delle tante,

per trattenere il pubblico qualche secondo ancora davanti alla televisione o al giornale, prima dell'arrivo dell'ulteriore notizia che ci sfiora ma, apparentemente, non ci tange affatto. Ebbene, è cosa vera. Da quando abbiamo imparato a liberarci del giogo della gravità, esagerando quella disciplina atletica che chiamiamo "salto in alto", abbiamo iniziato a frequentare lo spazio esterno senza arrischiarci troppo in là, proprio come bambini che imparano a nuotare standosene vicino alla riva, sotto l'occhio vigile dei genitori. La nostra genitrice, la nostra Mamma Terra – diciamolo pure, una signora un po' sovrappeso – anche se ci trovassimo nello spazio esterno alla nostra atmosfera, sarebbe pronta a richiamarci a sé con la forza di gravità generata dai suoi $5,97 \cdot 10^{27}$ g di massa. Una massa con la quale la

matrona riesce a esercitare una notevole forza la cui influenza si estende finanche al di là della Luna. Ed è così che, nel nostro prudente non allontanarci troppo dalla *battigia* atmosferica, da circa sessant'anni lasciamo volontariamente in orbita satelliti in disuso, serbatoi vuoti, stadi di missili ridotti a carcasse destinate alla decomposizione per attrito generato nell'incontrare l'atmosfera, ma anche molti piccoli pezzi di metallo o di plastica come viti, bulloni, guarnizioni. Un recente censimento parla di novemila rottami spaziali di dimensioni maggiori di un decimetro e di almeno centomila oggetti di poco più piccoli. Per non parlare poi di quelli di dimensioni ancora minori e, per questo, più difficili da rilevare da terra. Per essi, pensate un po', il computo approssimativo arriva addirittura a milioni di frammenti.

Tutti rottami che costerebbe troppo recuperare e che si trovano parcheggiati, dimenticati… in zona *rimozione* e che si è pensato addirittura di ammassare in opportune orbite cimitero. In poco più di cinquant'anni di attività a partire dalla messa in orbita del primo satellite artificiale – lo Sputnik, costruito quasi *a immagine e somiglianza* della Luna, nostro unico satellite naturale – al di là dei suoi chilometri di atmosfera, la Terra ha visto crescere velocemente un guscio esterno di detriti alcuni dei quali, spiraleggiando, prima o poi ritorneranno a casa.

Per quanto detto in precedenza, possiamo riguardare alla nostra atmosfera come un'altra *cipolla* costituita da strati di diversa densità d'aria.

Fuori da essa abbiamo provveduto ad accumulare immondizie spaziali che sono andate a formare quella che chiamerei la "tecnosfera", costituita da tutti gli epigoni dello Sputnik ora defunti che si vanno a sommare ai moltissimi satelliti ancora in funzione. Nel nostro continuo e spesso inconscio emulare goffamente la Natura, la tecnosfera risulta essere un nuovo strato della cipolla stavolta *a immagine e somiglianza* di quelli dell'atmosfera sottostante e il rischio per gli astronauti che si avventurano da quelle parti è grande: consideriamo infatti un corpo nello spazio esterno adiacente al nostro pianeta e, per semplicità, prendiamone uno che risulti *fermo* se osservato da un punto particolare scelto sulla superficie della Terra.

Il concetto di *fermo* è relativo e sappiamo che un qualsiasi oggetto considerato immobile al suolo possiede comunque una velocità di rotazione impressagli dalla stessa rotazione terrestre. In orbita risulta più facile pensare a un oggetto *fermo* non tanto in un posto, quanto piuttosto *su* un posto o meglio, *fermo* in una… velocità.

Mi spiego. Consideriamo, per esempio, cosa bisogna fare a un oggetto qualsiasi per renderlo un satellite *geostazionario,* ovvero un satellite che staziona sempre sulla verticale di un luogo particolare della Terra e quindi *fermo* relativamente alle coordinate di questo luogo calcolate su di essa. Bisognerà imporgli un moto sincrono con la rotazione terrestre che lo porti a ruotare attorno alla Terra in 24 ore proprio come se, invece che in orbita, fosse poggiato al suolo, solidale con il pianeta. Una ulteriore condizione da imporre è che la forza di attrazione gravitazionale, che lo porterebbe a cadere al suolo, e la forza centrifuga generata dal suo moto che lo "salva" dalla caduta facendolo galleggiare a debita distanza, si devono equivalere consentendogli di rimanere in alto, bloccato nella posizione voluta. In formule:

$$\left[\quad G\, m_{satellite}\, M_{terra}/L^2 = m\omega^2_{satellite}\, L \quad \right]$$

nella quale $\omega_{satellite} = 2\pi/T$, con T pari al tempo durante il quale il satellite arriva a completare un'orbita, uguale a

$$\left[\quad 24 \text{ ore} = 24 \cdot 3.600 \text{ s} = 86.400 \text{ s} = 8{,}64 \cdot 10^4 \text{ s} \quad \right]$$

Dalla quale si ricava:

$$\left[\begin{array}{l} R = (G\, M_{Terra}/\omega^2_{satellite})^{1/3} = (G\, M_{Terra}\, T^2/4\pi^2)^{1/3} \\[2mm] T^2 = (8{,}64 \cdot 10^4 \text{ s})^2 = 74{,}6 \cdot 10^8 \text{ s}^2 \\[2mm] R = (6{,}67 \cdot 10^{-8} \text{ dyne cm}^2 \text{ g}^{-2} \cdot 5{,}97 \cdot 10^{27} \text{ g} \cdot 74{,}6 \cdot 10^8 \text{ s}^2/39{,}47)^{1/3} = \\[2mm] = (75{,}4 \cdot 10^{27})^{1/3} = 4{,}22 \cdot 10^9 \text{ cm} = 4{,}22 \cdot 10^4 \text{ km, circa 42.000 chilometri} \end{array} \right]$$

più o meno un decimo della distanza Terra-Luna.

Come si può vedere, dato il tempo di percorrenza dell'orbita e la condizione di equilibrio, risulta una e una sola quota alla quale porre il nostro oggetto. Tale quota, indipendente dalla massa del satellite che non compare nei nostri calcoli, ci viene imposta dal solo campo gravitazionale terrestre, rappresentato dal termine M_{Terra}.

Essendo il percorso lungo il quale si svolge il suo movimento un'orbita ellittica che, per semplicità, assumeremo assimilabile a una circolare, il tratto lungo il quale si muoverà in un giorno sarà pari a $2\pi r = 6,28$ ($x + $ Raggio$_{Terra}$) km. Per ottenere la velocità di rotazione lungo la sua orbita basterà quindi sostituire il valore di 6.378 km a Raggio$_{Terra}$, sostituire a x l'altezza trovata con il calcolo precedente e dividere per il tempo, le 24 ore. Così facendo, si ottiene una velocità di più di 12.000 km/h!

Da questo semplice calcolo possiamo facilmente immaginare che, anche se di piccole dimensioni, un qualsiasi oggetto può diventare, a tutti gli effetti, un potentissimo proiettile capace di perforare finanche le costosissime tute spaziali multistrato più resistenti e le carni dei malcapitati astronauti che le indossano.

Lo Shuttle – la navetta che dagli anni '80 usiamo per mettere in orbita i satelliti, per effettuare su di essi tutte quelle necessarie operazioni di manutenzione, nonché per portare uomini, materiali e strumenti alla Stazione Spaziale Internazionale (ISS) che da anni ormai orbita sulle nostre teste – salendo perpendicolarmente ai vari strati di detriti, ne attraversa le orbite, tutte caratterizzate da altezze e velocità diverse.

È facile allora immaginare come, dopo ogni missione, siano molte le parti della sua su-

perficie esterna che necessitano di essere
sostituite perché danneggiate dai numerosi
impatti cui lo Shuttle va soggetto nel suo viaggio.

La cosa in qualche misura paradossale è che sono
proprio gli Shuttle e coloro che li pilotano gli
artefici di questo problema. Proprio
come avviene a terra... sulla Terra,
laddove l'inquinamento da noi
prodotto ci si ritorce contro.
In fondo è un'impronta, un marchio
vitale, una bandiera, l'inquinamento. È un
po' come dire "Siamo arrivati qui!" e così facendo,
pian piano stiamo spostando i limiti fisici della nostra
dimora, limiti inizialmente imposti dalla Natura, por-
tando il nostro simulacro entropico sempre più verso
l'esterno.

Si parla ormai da anni della nuova frontiera spaziale da conqui-
stare, non solo con missioni scientifiche, ma anche con l'arrivo di turi-
sti-coloni che andranno ad affollare alberghi in orbita. Il miliardario Dennis
Tito è stato il primo a fare nel 2002 una costosissima gita di piacere fuori dal-
l'atmosfera e ancora passerà del tempo prima che gli scenari colorati di Gianni Ro-
dari descritti nel suo *La stazione spaziale* potranno realizzarsi:

Nella stazione spaziale
c'è un traffico infernale.
Astronavi che vengono,
astronavi che vanno,
astronavi di prima classe
per quelli che non pagano le tasse. (...)

Nelle future, degradate, periferie spaziali della Terra solcate dai nuovi treni – Shuttle e razzi –
piene di immondizie e cimiteri tecnologici, presto avremo anche fette di popolazione che de-
cideranno di stabilirvi la propria dimora e sono sicuro che si parlerà di esse come di futuristi-
che *banlieue* in rivolta, o di *favelas* malfamate, afflitte da povertà, emarginazione e delinquenza,
ma anche sedi di nuove e interessantissime culture emergenti.

C'è da aspettarsi una cosa del genere anche pensando che, se l'ambiente è piccolo e
chiuso, prima o poi l'aria diventa viziata: l'impressionante crescita demografica fa sì che sulla
Terra siamo sempre in più persone a respirare la miscela che chiamiamo aria come se
fosse immutabile nel tempo, pur sapendo che la stiamo mutando di continuo immet-
tendo in essa composti che la Natura da sola non avrebbe mai saputo sintetizzare. Qualcosa

che spinge Asimov a dire, nel suo *Lucky Starr e gli oceani di Venere*, per il tramite del marziano Bigman:

> Dà una sensazione strana pensare che una volta, molto tempo fa, la gente, era tutta ammassata sulla Terra. Non potevano venirne via, qualunque cosa facessero. Non sapevano nulla di Marte o della Luna, o di qualsiasi altro posto. Mi fa venire i brividi.

Alla luce di quanto detto, forse l'inquinamento presenta una connotazione positiva: è il frutto di uno sforzo continuo per andare al di là dei limiti palesi della Natura che non può fare altro che sintetizzare alcuni elementi chimici nelle varie generazioni stellari e distribuirne un certo quantitativo nei vari pianeti. Leggendo *Gaia – Nuove idee sull'ecologia*, ce-

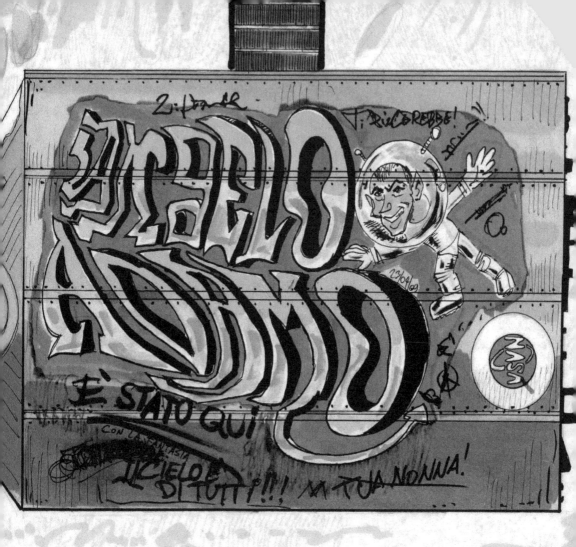

lebre testo scritto da James Lovelock nel 1979, si impara a identificare il nostro pianeta con un essere vivente, il più grande essere vivente che sia possibile incontrare da queste parti, capace di mutare in modo drammatico la concentrazione di alcuni elementi chimici, con lo sviluppare un'attività biologica sulla sua superficie. L'autore infatti osservava come le abbondanze di alcuni di essi non potrebbero trovare una convincente spiegazione se non teorizzando che, da un certo momento in poi, sia stato proprio l'insorgere del fenomeno vita sulla superficie terrestre ad avere indotto un cambiamento radicale nelle loro percentuali relative. Uno di questi elementi è l'azoto, e chi volesse fare un giro in orbita analizzando da fuori, con uno spettrografo, la nostra atmosfera potrebbe identificare la sua abbondanza come traccia inequivocabile del fatto che sulla Terra, ebbene sì, c'è vita! Il titolo del libro di Lovelock non lascia dubbi sul suo riferirsi all'antica cultura greca: già allora Gaia, la madre Terra, veniva personificata e preferisco far raccontare la storia di questa divinità al già citato Vernant:

> La Terra partorisce dapprima un personaggio molto importante, Ouranos, il Cielo, e anche il Cielo Stellato. (…) La Terra li concepisce senza unirsi a nessuno. Attraverso la forza interiore che porta in sé, Terra sviluppa quello che già era in lei e che, dal momento in cui lo libera, diventa il suo doppio e il suo contrario. Perché crea il Cielo stellato uguale a sé, come una replica altrettanto solida, altrettanto stabile e simmetrica. Allora Urano si stende su di lei. Terra e Cielo costituiscono così due piani sovrapposti dell'universo, un pavimento e una volta, un sotto e un sopra che si coprono a vicenda, completamente. (…) L'Urano primordiale non conosce altra attività se non quella sessuale. Coprire Gaia senza sosta, per quanto è nella sua potenza: non pensa che a quello, e non fa che quello. La povera Terra si trova allora in cinta di una prole numerosa che non può neppure uscire dal suo grembo, che deve restare là dove Urano l'ha concepita. Visto che il Cielo non si alza mai da Terra, non si crea mai fra loro uno spazio che permetta ai figli, i Titani, di uscire alla luce e di condurre un'esistenza autonoma. I Titani non possono assumere forma propria, né diventare esseri individuali poiché vengono di continuo ricacciati nel grembo di Gaia.(…) Non esiste ancora la luce, in realtà, poiché Urano, stendendosi su Gaia, mantiene una notte continua. La Terra dà libero sfogo alla sua collera. Non vuole più tenere in grembo i propri figli che, non potendo uscire, la gonfiano, la comprimono, la soffocano. Allora Gaia si rivolge a loro, in particolare ai Titani, dicendo:
>
> Ascoltatemi, vostro padre ci oltraggia, ci sottopone a violenze inaudite, bisogna che tutto questo abbia fine. Dovete ribellarvi al Cielo, vostro padre.
>
> (…) Solo Crono, l'ultimogenito, accetta di aiutare Gaia e di misurarsi così con il proprio padre. (…) Non appena Urano si sfoga in Gaia, Crono gli afferra con la sinistra i genitali, li tiene ben stretti e con il falcetto impugnato nella destra, li taglia in un sol colpo. (…) Alcune gocce di sangue cadono sulla Terra zampillando. (…) Urano lancia con forza un grido di dolore e, allontanandosi da Gaia, si ferma per non muoversi più, in alto, lassù sopra il mondo.

Mi piace vedere in questo passo quasi una profezia la cui spiegazione non risiede in qualcosa di mistico, ma piuttosto nel fatto che l'obiettivo e il destino dell'uomo sono da sempre la conquista del cielo, anche quando non se ne rende conto, preso com'è da problemi più terreni. I figli della Terra, gli uomini, generati da una chimica stellare e dall'incontro tra la Terra e il cielo che la copre (Alan Sorrenti *docet)*, rimangono a lungo schiacciati tra i due amanti, soggiogati dalla incredibile forza di gravità vissuta come peso psicologico degli spazi immensi da sempre posti sulle loro teste. Quando questo peso diventerà insostenibile, quando saremo troppi e soffocati dall'inquinamento da noi stessi prodotto, spezzeremo questa catena che

ci tiene ancorati alla Terra per andare a creare un cielo a somiglianza della Terra, primo passo di una lenta diffusione dell'uomo nello spazio. Nel brano precedente risulta che la Terra genera Urano senza unirsi a nessuno, una specie di mitosi biologica che porterà la Terra a generare un giorno anche un nuovo Urano, suo doppio tecnologico più in alto, sempre più lontano da lei e dal suo giogo gravitazionale. In quest'ottica, il nostro porre satelliti, stazioni spaziali e immondizie varie nello spazio esterno assume una valenza positiva; potrebbe essere un passaggio obbligato per coronare un sogno che da sempre alberga nell'inconscio collettivo, quello di impadronirsi del cosmo, sebbene a piccoli passi.

Da quanto riportato, appare chiaro che anche per la nostra Terra vale la dualità onto-corpuscolare, anzi: forse questa dualità è ancora più valida per essa di quanto non lo sia per gli altri pianeti, dato che trova una ulteriore, possibile interpretazione moderna nella teoria resa nota da Lovelock, il quale così ci racconta della sua nascita:

> A quel momento un'entità a dimensione di pianeta, benché ipotetica, era nata. Le sue proprietà non potevano essere previste dalla pura somma delle sue parti. Bisognava darle un nome. Fortunatamente William Golding faceva parte del gruppo di studio. Senza esitazione egli suggerì che questa creatura fosse chiamata Gaia, dal nome della dea greca della Terra conosciuta anche come Gea, da cui traggono il loro nome scienze come la geografia e la geologia. (…) Da allora abbiamo definito Gaia come un'entità complessa comprendente la biosfera della Terra, l'atmosfera, gli oceani, e il suolo, l'insieme costituendo una retroazione (feedback) o un sistema cibernetico che cerca un ambiente fisico o chimico ottimale per la vita su questo pianeta. Il mantenimento di condizioni relativamente costanti mediante una regolazione attiva può essere adeguatamente descritto con il termine di "omeostasi".

Il film *Contact* del regista Robert Zemeckis, nato come romanzo dalla penna del grande astrofisico Carl Sagan, inizia con una suggestiva corsa nello spazio di qualcosa di invisibile che reca con sé i suoni, le voci, i rumori delle nostre emissioni radio, dalle prime, timide note inviate nell'etere, dai discorsi di Hitler ascoltati da un mondo terrorizzato e incredulo, alle ultime potenti emissioni delle nostre antenne radiotelevisive. Questa emissione, per i nostri occhi invisibile, è radiazione nella banda radio, che – viaggiando anch'essa alla velocità della luce – dopo circa 50 anni di trasmissioni radiofoniche e televisive ha già raggiunto, espandendosi come una sfera in tutte le direzioni, una distanza pari a:

$$d = 3 \cdot 10^5 \text{ km s}^{-1} \cdot 50 \text{ anni} = 3 \cdot 10^5 \text{ km s}^{-1} \cdot 50 \cdot 365 \cdot 24 \cdot 60 \cdot 60 \text{ s} \approx$$
$$\approx 3 \cdot 10^5 \text{ km s}^{-1} \cdot 50 \cdot 3 \cdot 10^7 \text{ s} = 45 \cdot 10^{13} \text{ km} \approx 50 \text{ anni luce}$$

Quella che ho trovato indicata dall'astrofisico Giovanni Bignami con il nome di "Bolla Marconi", poi da lui stesso corretta in "Bolla Marconi-Berlusconi" (personalmente, aggiungerei

anche il nome Murdoch) durante una recente conferenza pubblica. Il numero di cui sopra allora rappresenta il nostro attuale limite di inquinamento o, se preferite, il nostro attuale livello di incidenza sulla Natura. C'è una continua *fuga di notizie* dal nostro pianeta e le nostre informazioni ci precedono di molto, mentre noi che le abbiamo emesse arranchiamo indietro, tentando ancora di battere l'ultimo record stabilito da pochi manipoli di uomini giunti in diverse occasioni *nientepopodimenoche...* sulla Luna.

Se l'azoto può essere usato come indizio che sul nostro pianeta c'è vita, qualcosa di analogo potrebbe essere di certo compiuto analizzando le forme stranamente regolari dei detriti in orbita e la loro chimica costituita da leghe metalliche e plastiche che ne fanno oggetti classificabili come artificiali, non recanti la firma della Natura. Tutto ciò che sulla superficie terrestre è prodotto dal metabolismo di animali e piante può e deve essere reintegrato nel grande meccanismo di riciclo omeostatico operato da sempre dal pianeta stesso. Questi nuovi oggetti artificiali invece, che si tratti di cimiteri delle macchine cittadini, di discariche di periferia o di rottami in orbita, ancora niente e nessuno riesce a inserirli in un valido ciclo di rinnovamento che possa anche solo lontanamente assomigliare a quanto da sempre fa la Natura. Questo vuol dire che i nostri artefatti sono e generano entropia di tipo diverso: fintanto che funzionano sono oggetti utili, ma sono sempre pronti a diventare d'un tratto generatori di un disordine massimo, nuovo e veloce. Può darsi che ci

La dualità onto-corpuscolare per la Terra

stiamo avvicinando al momento in cui riusciremo a trovare un nuovo modo di metaboliz-
zare questi prodotti secondari. Scopriremo un nuovo *processo digestivo* che probabilmente
non avverrà più in intestini ma in volute cerebrali. Ecco, questa nuova *cacca* per il momento
è solo un modo di dire: se c'è, c'è l'uomo e sembra proprio che non si possa fare altrimenti.
Per fortuna il cosmo è grande e non corre ancora il rischio che noi si vada a lordare troppo
in là. Per il momento i panni sporchi rimangono a casa, in attesa che qualcuno inizi a lavarli.

Intanto mi viene da chiedermi: *nomìa o logìa*? Ovvero, alla luce di quanto sto narrando,
che fine fanno le teorie astrologiche che da sempre contendono nell'opinione pubblica lo
spazio all'astronomia e che prevedono una ineludibile influenza degli astri sui nostri caratteri
e sul futuro? Con esse, si pretende che stelle lontanissime da noi abbiano la prerogativa di
operare sui nostri destini tramite sottilissimi e lunghissimi fili. Moderne Parche, lontanissime
parsec[1], kiloparsec addirittura, non avrebbero niente di meglio da fare che tessere le ma-

[1] Un *parsec* è uguale a 3,26 anni luce, ovvero a 3,26 volte la distanza percorsa da un raggio di luce in un anno. Svi-
luppando il conto, risulta $1 \text{ pc} \approx 3{,}26 \cdot 3 \cdot 10^5 \text{ km s}^{-1} \cdot 3 \cdot 10^7 \text{ s} = 2{,}93 \cdot 10^{13}$ km. Un *kiloparsec* indica una distanza
mille volte maggiore.

glie intricate delle nostre vite, complicandocele o rendendocele più piacevoli. Eppure, studiandole come si deve, risultano essere solo stelle di dimensioni immani, tutte occupate a non morire sotto il peso del proprio gas. Secondo gli astrologi, stelle estremamente lontane dovrebbero riuscire a discernere me da te e te da lei in modo da operare cambiamenti diversi nelle nostre vite rispettive e cercando di evitare quelle sovrapposizioni che, quando ci sono – e guarda caso ci sono sempre! – consentono a due persone che non si conoscono affatto di dialogare del più e del meno scoprendo affinità tra i loro caratteri: il cielo li ha fatti incontrare! Bene, se proprio vogliamo teorizzare l'influenza operata da questi oggetti così lontani per i quali, vi garantisco, non siamo neanche discernibili come puntini vicini tra loro, perché non pensare anche alla *profonda* influenza che potrebbero esercitare, da un punto di vista squisitamente astrologico, le innumerevoli costellazioni di detriti che abbiamo provveduto a porre sulla nostra atmosfera? Senza arrivare a pensare a quella tragica eventualità che, per la caduta di uno di essi, potrebbe troncare la vita di qualcuno nato nel mese del serbatoio dello Shuttle o del bullone della ISS, non avrebbero finalmente qualcosa di nuovo su cui lavorare i vari maghi e fattucchiere, astrologi e venditori di fumo che consultiamo allo scadere dell'anno vecchio per previsioni che nell'anno nuovo non si avverano mai? Si è evoluto l'inquinamento materiale, facciamo evolvere anche l'inquinamento culturale, diamine!

E, parlando di queste tematiche, mi preme ricordare che l'opera di Holst *The Planets* prendeva le mosse proprio dalla passione dell'autore per i temi dell'astrologia. Essa, come si diceva, tratta dell'influenza degli astri – e quindi anche dei pianeti – sulle sorti terrene e per questo non annovera un brano dedicato al nostro pianeta. Cercando fra le "descrizioni musicali" dedicate alla Terra per potere dotare anche questo capitolo di una sua degna colonna sonora, sono rimasto alquanto deluso dal non aver trovato nulla che mi potesse soddisfare. Vi sono delle meravigliose cantate profane di Bach dedicate a vari aspetti della Natura; vi è inoltre un bellissimo brano di Mahler, *Il canto della Terra*, che purtroppo risulta essere stato ispirato da temi poco naturalistici e che quindi non è pertinente per questa trattazione. Ma dato che mi sono soffermato sul particolare aspetto dell'inquinamento esterno del nostro pianeta, ho l'occasione di citare un brano fondamentale, che permette di legare assieme molti degli argomenti toccati fino a ora. Si tratta della *Serenata per un satellite* del nostro Bruno Maderna, il quale nel 1969 lo dedicò proprio a un astronomo torinese suo amico, tale Umberto Montalenti, all'epoca direttore del Centro Europeo di Ricerca Spaziale a Darmstadt. La tecnica compositiva usata è quella aleatoria, come aleatoria è anche la scelta della modalità esecutiva. L'autore, infatti, ci tiene a precisare che:

> Possono suonarla violino, flauto (anche ottavino), oboe, (anche oboe d'amore – anche *musette*), clarinetto (trasportando naturalmente la parte), marimba, arpa, chitarra e mandolino (suonando quello che possono, tutti insieme o separati o a gruppi, improvvisando insomma, ma! con le note scritte).

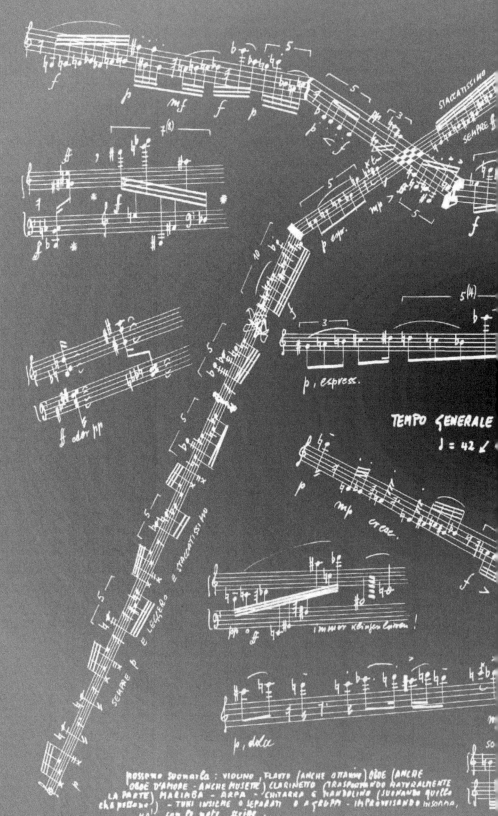

Cito anche la descrizione dell'opera data da Massimo Mila il quale commenta:

> Nella sua vivacissima curiosità intellettuale, Maderna era sempre più intrigato da quelle operazioni stregonesche, finché ne nacque questo progetto di composizione: un reticolato di moduli musicali, notati sulla pagina per dritto e per traverso, incrociati, storti, ma con indicazioni esecutive di assoluta precisione, e affidati alle combinazioni estemporanee, o pre-elaborate, degli interpreti. Un lavoro di questo genere dipende quindi interamente dall'estro d'una serata di vena, e quando l'esecuzione raduna i virtuosi che a Bruno furono artisticamente vicini come Gazzelloni e Faber, ne esce un piccolo capolavoro di umorismo, una specie di *Siegfried-Idyll* spaziale per salutare la nascita del satellite, visto, o piuttosto sentito dall'incoercibile ottimismo del compositore come un piccolo coso buffo, una specie di gnomo bizzarro e benefico.

Un reticolato di satelliti che, già quando Maderna componeva la sua serenata, dopo soli dodici anni dal lancio dello Sputnik, doveva essere disegnato in cielo dalle traiettorie di molti oggetti. I loro muti suoni (fuori dall'atmosfera non si sente rumore alcuno per l'assenza di

stelle
evaporate
Angelo
23/2/

aria, responsabile della trasmissione delle onde acustiche), sibili, rombi immaginati dal compositore erano appena l'inizio di quello stato caotico che stiamo denunciando o esaltando (confesso che ancora non ho deciso se mi piace o meno. A volte lo trovo incredibilmente affascinante; a volte no) e che era destinato a lievitare negli anni fino a raggiungere, al giorno d'oggi, uno spessore di migliaia di chilometri.

Inoltre, l'aleatorietà prevista per la loro esecuzione così come il loro grafico intersecarsi sulla pagina e gli scontri stridenti tra toni vicini inevitabilmente risultanti da un'esecuzione del brano da parte di un organico qualsiasi, riflettono molto bene la confusione che regna nella distribuzione dei detriti in orbita i quali, proprio per questo motivo, sovente impattano gli uni negli altri.

Trovo che l'atmosfera allegra, ottimistica, umoristica addirittura, con la quale Maderna salutava un'era inaugurata più di un decennio prima, sia perfettamente in sintonia con le filastrocche del già citato Rodari, forse a delineare un cerchio massimo ottenibile unendo i punti Maderna-Montalenti-Rodari e a disegnare un'orbita di pensieri geniali che da sempre contraddistinguono la cultura italiana. Un aspetto del nostro paese di cui noi italiani ci dimentichiamo troppo spesso per ricordare cose più facili, spesso più inutili.

Abbiamo parlato del nostro pianeta in espansione, l'unico che sta cambiando il proprio raggio sotto la spinta delle creazioni umane. Forse perché, come si diceva, unico dei pianeti a essere definibile *vivo* nell'accezione suggerita da Lovelock. In ogni caso rimane un pianeta di tutto rispetto, addirittura il più grande tra tutti quelli tellurici.

Di sicuro tra i più vivi da un punto di vista geologico, al centro deve possedere un nucleo di Ferro e Nichel in rapida rotazione tale da generare il campo magnetico necessario per proteggere la sua superficie dalle insidie di quella parte della radiazione solare di intensità tale da risultare estremamente nociva per le specie che vivono su di essa. Questa protezione si estende nello spazio ben al di là dell'atmosfera e prende il nome di *magnetosfera*, una sorta di ombrello magnetico che accompagna all'uscita in modo gentile, ma anche deciso, le particelle veloci del vento, invitandole così ad andare a rompere altrove (cosa che, per esempio, fanno su Marte).

Prima che anche il nostro titanico Ulisse Celeste prenda lo slancio per saltare oltre, verso l'esterno del Sistema Solare, vorrei farvi dare un'occhiata a uno strano satellite. Artificiale? Naturale? Non saprei, giudicate voi. Si tratta della signorina Filomena che

> (…) è diventata
> un satellite artificiale.
> Se ne stava sul terrazzo
> a leggere il giornale,
> e senza alcun sospetto
> né preavviso –
> si è trovata d'improvviso
> in orbita,

né più né meno di un razzo
a seimila chilometri di quota.
Per fortuna aveva gli occhiali,
la vecchia signorina:
così può guardare
il Labrador, la Cina,
le rovine di Palmira,
tutta la Terra che gira
disegnata come un atlante,
coi mari e i continenti al posto giusto. (…)

Un satellite avvistato per la prima volta dal nostro amico Gianni Rodari il quale ci racconta che da lassù la signorina, in paziente attesa che si vada tutti a colonizzare la squallida periferia spaziale, se la spassa un mondo a osservare lo spettacolo del nostro globo che le gira sotto i piedi. Pare che agli astronomi piaccia un sacco. Chissà, magari piace anche a voi.

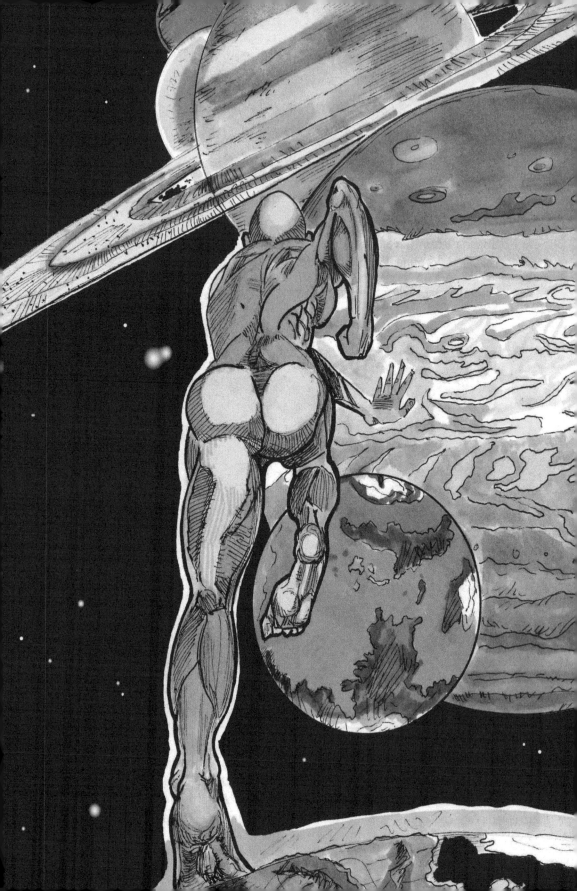

E allora riprendiamo senza ulteriori indugi questo nostro viaggio che ci porterà fino ai confini ultimi del Sistema Solare! Ma non preoccupatevi: non faremo certo la fine delle sonde Pioneer e Voyager dalle quali ci siamo fatti precedere qualche decennio fa! Esse sono ancora in viaggio e non potranno tornare mai più sulla Terra. La luce impiega circa sei ore a raggiungere la quarantina di Unità Astronomiche che ci separa dalla fine del nostro sistema planetario; una distanza che le nostre sonde tentano di coprire da più di trent'anni. A noi invece questo viaggio prenderà solo il tempo di leggere un libro, questo libro. Inoltre, per tornare indietro, ci basterà sfogliare le sue pagine alla rovescia... Nei libri, l'esistenza della freccia del tempo si traduce nella perdita di significato delle parole quando vengono lette al contrario, uno dei prezzi da pagare all'entropia. C'è una soluzione anche a questo: leggete il libro e poi, una volta chiuso, rileggetelo dopo averlo ruotato attorno al suo asse – la costa del volume – portando la quarta di copertina verso il basso a sinistra e facendo emergere la prima di copertina da destra. Il libro può essere un universo ciclico, che si ripete identico a sé stesso. Ma non fatevi illusioni: lui forse non cambia, ma nel frattempo sarete comunque cambiati voi. Dopo avervi rassicurato sulla natura del viaggio che ci accingiamo a continuare, decidiamo di ripartire e – con una rincorsa e uno slancio titanici tali da vincere la forza di attrazione gravitazionale del nostro pianeta che ci impone una velocità maggiore di 11 chilometri al secondo (!) – balziamo al solito in direzione opposta al Sole atterrando dopo poco, a circa settanta milioni di chilometri dalla nostra posizione. Dal momento che stiamo approfittando di un ideale allineamento di tutti i pianeti[1], il nostro balzo ci condurrà dritti dritti su Marte, successiva tappa del nostro viaggio.

Marte, la terra promessa (ma non ancora mantenuta!)

	Quindi ripreser gli occhi miei virtute
	a rilevarsi; e vidimi translato
84	sol con mia donna in più alta salute.
	Ben m'accors'io ch'io era più levato,
	per l'affocato riso de la stella,
87	che mi parea più roggio che l'usato
	Dante, *Paradiso*, Canto XIV

[1] Un allineamento che a volte capita e dal quale ci aspettiamo – al solito – eventi catastrofici che puntualmente... non arrivano!

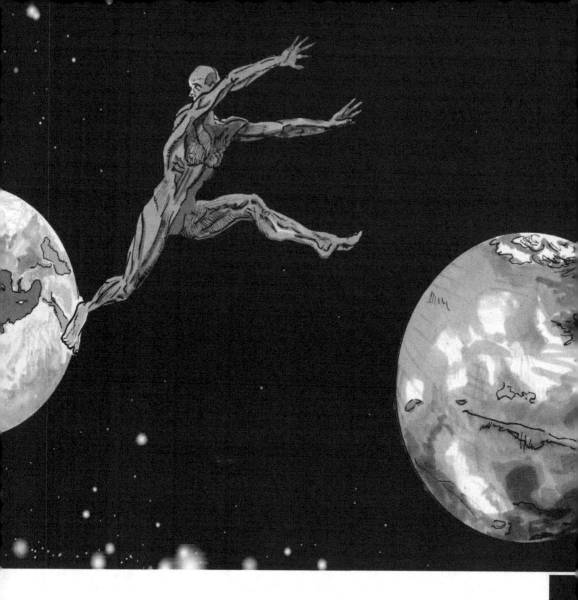

Ora, usciti fuori dalla nostra atmosfera, vediamo molto meglio questo pianeta e, man mano che ci avviciniamo a esso, possiamo distinguere le incredibili tinte che caratterizzano la sua superficie.

Possediamo una cronaca immaginata ma assolutamente affascinante di questo avvicinamento e trovo che riportarla qui sia un ottimo modo di presentarvi questo nostro vicino cosmico. Si tratta della descrizione data da Arthur C. Clarke che nel suo romanzo *Le sabbie di Marte* fa fare al protagonista Gibson quello che nel 2009 ancora attendiamo impazienti di riuscire a realizzare: una spedizione umana sul pianeta rosso:

Gibson non si era mai reso pienamente conto sino a che punto fossero rossi i grandi deserti. Ma il semplice aggettivo rosso non dava un'idea esatta della multiforme gamma di sfumature che distinguevano il disco che ingrandiva lentamente. Alcune regioni apparivano quasi scarlatte, altre erano d'un giallo rossiccio, mentre la tinta forse più diffusa era quella che solitamente va sotto il nome di rosso mattone.

Nell'emisfero meridionale era primavera inoltrata e la calotta polare era ridotta a pochi luccicanti puntini candidi là dove la neve indugiava ancora, cioè sulle alture più elevate.

(…) Su quel disco variegato era possibile trovare le più impensabili sfumature di colore.

A causa di questa sua colorazione rossastra che lo fa sembrare una goccia di sangue posta come monito sulle nostre teste, sin dall'antichità si è guadagnato la fama di portatore di sventure e immediata è da sempre stata l'associazione di Marte con il dio della guerra.

Questa sua caratteristica ne ha fatto un tipo astrologico molto particolare, cosa che ha ispirato pittori, scrittori, musicisti, senza mancare di colpire in qualche modo anche la fantasia di alcuni eminenti scienziati. Quindi continuiamo a usare come colonna sonora della nostra impresa le sette composizioni del grande Gustav Holst, che nella sua suite *The Planets* (ne abbiamo già parlato in occasione di Mercurio e Venere), ha posto il brano dedicato a Marte come primo in ordine di esecuzione. La composizione intitolata *Mars, the bringer of war* ricorda in molti punti le suggestioni tipiche dell'opera *The rite of Spring* composta da Igor Stravinsky nel 1913 e, per quanto concerne invece la struttura ritmica, il ben più famoso *Bolero*, una composizione del celebre Maurice Ravel che la scrisse nel 1928, circa 14 anni dopo la nascita del brano di Holst. Il tempo è un 5/4, un tempo irregolare, dispari, composto dalla somma di un tre quarti e di un due quarti.

*La dualità
onto-corpuscolare
per Marte*

Insomma, qualcosa che, se non supportato da linee e accordi molto melodici, può creare una grande tensione in chi l'ascolta. E questo era proprio l'effetto che il grande compositore voleva ottenere. L'inizio del brano è affidato ai timpani, percussioni dal suono molto profondo, rinforzati da un gong, dalle arpe e dalla sezione d'archi che sosterrà questo ritmo per tutta la durata del brano a sottolineare forse che non è il caso di rilassarsi se, come vicino, si ha *nientepopodimenoche* il Dio della Guerra!

È un inizio cupo, quasi silente che descrive l'arrivo di Marte in sordina, una minaccia che avanza inesorabile, come lento e inesorabile è il sorgere del pianeta. Nelle primissime battute vengono coinvolti quasi esclusivamente gli strumenti che emettono i suoni più gravi, ma da lì a poco verranno chiamati in causa altri strumenti a chiarire con una veloce gradualità che purtroppo la guerra è stata dichiarata. Ed è così che già alla terza battuta entra un accordo di corni (strumenti che rievocano la caccia!), fagotti e controfagotti e il bicordo fuori dalla tonalità della quinta battuta, anche se suonato mezzopiano, leva ogni speranza di pace. Holst nacque nel 1874 e crebbe quindi in un'atmosfera che, tra le cose che lo hanno consapevolmente colpito in gioventù, immagino comprendesse anche ciò che si narrava in campo scientifico e quindi astronomico. Tra le notizie giunte alle orecchie di chiunque come – continuo a supporre - anche a quelle del compositore ancora bambino, immagino vi sia stata la scoperta compiuta nel 1877 dall'astronomo Asaph Hall il quale per primo vide i due satelliti naturali del pianeta rosso. In realtà, non sitrattava di due lune come la nostra, bensì due asteroidi che molto probabilmente non hanno accompagnato Marte sin dai tempi della sua formazione, ma che invece sono stati catturati dalla fitta rete del suo campo gravitazionale solo in tempi più recenti, mentre nel loro viaggio verso il Sole passavano ignari negli spazi di giurisdizione marziana.

A dimostrazione della brutta fama che seguiva da vicino Marte ancora sul finire dell'Ottocento, i nomi che vennero affibbiati ai due satelliti furono *Phobos* e *Deimos*, in greco "Paura" e "Terrore", nomi dei figli del Dio della guerra che, secondo Omero, lo accompagnavano nelle battaglie e che mi ricordano il celebre fumetto *Cattivik* di Silver che apre le sue storie con lo slogan – più che altro una promessa – "Brivido, Terrore, Raccapriccio!".

Immagino quindi che Holst nella sua gioventù possa essere stato raggiunto dalle noti-

zie circa la possibilità che il pianeta rosso fosse abitato, un'idea che iniziava a trovare sostegno anche e soprattutto in ambito scientifico. Infatti, sempre nel 1877, l'astronomo italiano Giovanni Schiaparelli cominciò una serie di osservazioni di Marte per testare le qualità del nuovo telescopio rifrattore dell'Osservatorio di Brera. Ciò che vide, o meglio, ciò che credette persistentemente di vedere fino al 1910, fu una serie di canali che solcavano il suolo marziano in lungo e in largo. Come è noto, la versione in inglese dei suoi lavori conteneva la traduzione errata della parola "canale". Una volta resa con "canal" (letteralmente: canale artificiale) e non con "channel" (canale naturale), quest'articolo indusse molti a credere che finalmente vi fossero le prove scientifiche dell'esistenza della vita sul pianeta a noi più vicino. Ciò indusse l'astronomo Percival Lowell a costruire a Flagstaff, in Arizona, in vista della "grande opposizione" di Marte attesa per il 1894[2], il grande telescopio che porta il suo nome, per potere dare continuità e supporto alla tesi della vita marziana. E fu così che, nel credo popolare supportato dalle considerazioni degli stessi scienziati, Marte risultò essere ogni giorno di più covo di una grande civiltà organizzatasi per sfruttare – mediante canali di irrigazione abbastanza ampi da favorire pure la navigazione – il periodico sciogliersi delle calotte polari ghiacciate, specie quella boreale, portando così l'acqua ovunque sul pianeta. A tal proposito, basti leggere quanto riferiva Schiaparelli nel suo libro *La vita sul pianeta Marte*:

[2] Un fenomeno periodico che vede il pianeta rosso su una linea che lo congiunge alla Terra e al Sole quando la sua distanza dal Sole – e quindi dalla Terra! – è minima, cosa che ne favorisce l'osservazione in quanto Marte appare più grande. Questo fenomeno viene indicato anche come "opposizione perielica".

> Ammesse le linee principali del nostro quadro, non sarà difficile il compierlo nei particolari, e disegnare con l'immaginazione i grandiosi argini necessari per contenere nei giusti limiti l'inondazione boreale, i laghi o serbatoi secondari di distribuzione, necessari per dare le acque a quelle valli, che non fanno capo direttamente a quella inondazione; le opere occorrenti per regolare la distribuzione secondo il tempo e secondo il luogo; i canali di primo, secondo, terzo (…) ordine destinati a condurre le acque su tutto il territorio irrigabile; i numerosi opifici, a cui le acque potranno dar moto nel loro scendere dai ciglioni laterali della valle al fondo della medesima. Marte dev'esser certamente il paradiso degli idraulici!

L'acqua – che vi fosse acqua su Marte lo si sapeva già basandosi sull'analisi spettroscopica proprio delle calotte polari marziane – risultava quindi essere nell'opinione pubblica un bene prezioso anche e soprattutto per la civiltà marziana che dimostrava con i canali osservati di servirsene in modo più capillare di quanto noi stessi non facessimo all'epoca sulla superficie della Terra. Ricordiamo a tal proposito che il dominio e lo sfruttamento delle acque me-

diante grandi opere in quegli anni stimolava l'immaginazione collettiva. Al periodo storico del quale stiamo parlando risalgono infatti l'inaugurazione del canale di Suez che data 1869 e il progetto della costruzione di quello di Panama che invece fu concepito solo dieci anni dopo. Tutto ciò stimolò la convinzione che la civiltà sviluppatasi su un pianeta più piccolo del nostro, e quindi incapace di trattenere con la sua gravità tutta l'atmosfera e l'acqua necessaria per la sopravvivenza delle sue forme di vita, dovesse essere di conseguenza morente (lo diceva il colore di Marte) perché assetata d'acqua e di potere. E l'avere un pianeta azzurro vicino non poteva non avere attirato l'attenzione dei marziani i quali, abitando la dimora del dio della guerra, nella fantasia popolare non avevano altra possibilità che essere estremamente feroci. Se fino a quel momento non vi era stato contatto fra la nostra e la loro civiltà, il motivo poteva risiedere nella possibilità che entrambe si fossero evolute quasi parallelamente e proprio nel momento in cui la Terra iniziava a celebrare il progresso e la tecnologia con esposizioni universali come quella famosissima del 1889 e la fisica terrestre dimostrava di avere profonde connessioni con la fisica altrove – scoperta alla base della nuova disciplina dell'astrofisica – la coscienza collettiva, da sempre antropocentrica, si ritrovava a valutare la possibilità che anche in altri posti dell'universo, almeno in quello vicino, una civiltà aliena si potesse trovare in una fase storica analoga se non più avanzata.

In altri termini, ci si sentì tutto a un tratto esposti all'universo.

Le parole con le loro sfumature sicuramente agiscono nel nostro inconscio molto più di quanto non possiamo renderci conto e forse fu anche la locuzione "grande opposizione di Marte" a favorirne la lettura come di "grande conflitto con Marte". Fatto sta che nel 1897 l'inglese Herbert George Wells immaginò un vero conflitto con la civiltà marziana descrivendolo nel suo *La guerra dei mondi*. Questo scrittore proveniva da studi di biologia compiuti sotto la guida di Thomas Henry Huxley, il famoso "mastino di Darwin" come lui stesso amava definirsi, un fedele sostenitore delle tesi evoluzioniste che tanto erano state ispirate anche dal pensiero economico di Malthus. Nelle pagine iniziali del suo romanzo scrive:

> Il pianeta Marte gira intorno al Sole a una distanza media di duecentoventicinque milioni di chilometri, e riceve dal Sole esattamente la metà della luce e del calore che riceve il nostro mondo. Quel pianeta deve essere, se l'ipotesi delle nebulose è esatta, più vecchio del nostro, e il corso della vita deve essere cominciato sulla sua superficie molto prima che la Terra avesse finito di solidificarsi. Il fatto che il suo volume sia appena un settimo di quello della Terra deve avere accelerato il suo raffreddamento fino alla temperatura in cui la vita può avere inizio. Esso è provvisto di aria e di acqua, e di tutto ciò che è necessario al mantenimento della sua esistenza animale. (…) poiché Marte è più vecchio della Terra, misura appena un quarto della sua superficie, ed è più lontano dal Sole, ne segue che non soltanto è più lontano dall'origine della vita, ma è anche più vicino al suo termine. (…) Sappiamo che anche nella sua regione equatoriale la tem-

> peratura meridiana raggiunge appena quella dei nostri inverni più freddi.
> La sua atmosfera è più rarefatta della nostra (…). L'urgenza della necessità
> ha stimolato i loro [dei marziani, N.d.R.] intelletti, aguzzato le loro facoltà
> e indurito i loro cuori. Guardando attraverso lo spazio, con strumenti e in-
> telligenze che noi non immaginiamo neppure, essi vedono, più vicino di
> tutti gli altri, a cinquantacinque milioni di chilometri, simile a una stella mat-
> tutina della speranza, il nostro pianeta più caldo, con la vegetazione verde
> e le acque grigie, con un'atmosfera nuvolosa – chiaro indice di fertilità –
> con larghe estensioni di popolosi paesi e mari stretti solcati da bastimenti
> che di tanto in tanto s'intravedono tra le ondulanti masse di vapori.

Wells ipotizzò allora che, per un problema squisitamente evoluzionistico e che aveva a che
fare con la lotta per la sopravvivenza (quindi anche economico…), i marziani necessitassero
di impadronirsi del nostro pianeta. Tra l'altro, poco oltre giustifica proprio le pulsioni mar-
ziane constatando, da perfetto evoluzionista, che

> Prima di giudicarli troppo severamente, dobbiamo ricordare quale spie-
> tata e completa distruzione la nostra specie ha compiuto, non solamente
> di animali, come lo scomparso bisonte e il dodo, ma delle stesse razze
> umane inferiori.

Sangue contro acqua

Che la formazione di Wells fosse da biologo mi sembra che venga rivelato sin dalla prima
pagina del suo romanzo quando ipotizza che il popolo marziano, per i motivi su citati, te-
nesse sotto controllo l'umanità ignara

> con la stessa minuzia con cui un uomo potrebbe scrutare al microscopio
> le creature effimere che brulicano e si moltiplicano in una goccia d'acqua.

La Terra, se osservata da lontano poteva certamente sembrare una goccia del prezioso li-
quido – come già abbiamo notato, la presenza dell'acqua è senza dubbio la caratteristica
più evidente del nostro pianeta se osservato dall'esterno – e se gli strumenti di Schiaparelli
avevano rivelato le tracce evidenti di una civiltà marziana molto più evoluta della nostra,
le osservazioni condotte da Marte avrebbero sicuramente rivelato molto di più: i potenti te-
lescopi-microscopi marziani avrebbero visto, in sospensione nel nostro mondo d'acqua e
vapori, il brulicare delle creature effimere che noi chiamiamo uomini.
 Erano gli anni in cui i grandi successi della microbiologia che portavano la firma di Louis
Pasteur avevano finalmente rivelato l'origine organica di molti dei flagelli che periodicamente

si abbattevano sull'umanità decimando la popolazione e quindi – non a caso, credo – l'epilogo del libro è segnato proprio da un problema di ordine medico-biologico: gli invasori – arrivati su proiettili sparati da cannoni marziani proprio come Verne aveva immaginato nel 1865 di mandare l'uomo sul nostro satellite nel romanzo *Dalla Terra alla Luna* – alla fine del libro muoiono sconfitti

> dai bacilli della putrefazione e dal contagio contro i quali i loro organismi non erano preparati; (…) uccisi dalle più umili creature che Dio ha messo sulla Terra (…)

più che dalle ridicole rappresaglie umane. E continua dicendo:

> Questi germi di malattia avevano preteso un tributo dall'umanità sin dall'inizio, dai nostri antenati preistorici sin da quando la vita era cominciata sul nostro pianeta. Ma per merito della selezione naturale del genere umano, la nostra specie ha sviluppato una forza di resistenza; non soccombiamo a nessun germe senza una lotta e da molti – quelli della putrefazione di tutto ciò che è morto, per esempio – il nostro organismo è immune. Su Marte non ci sono batteri, e quando questi invasori arrivarono e incominciarono a nutrirsi, i nostri microscopici alleati cominciarono a lavorare alla loro distruzione. Già quando io li osservavo, essi erano irrevocabilmente condannati, morenti e corrotti anche mentre si affaccendavano. Era inevitabile. Mediante il tributo di milioni di morti, l'uomo ha acquistato il suo diritto di vita sulla Terra, ed essa è sua contro chiunque venga per conquistarla.

Un passo che mi ricorda quanto scriveva nel 1923 Italo Svevo nel suo *La coscienza di Zeno*:

> Naturalmente io non sono un ingenuo e scuso il dottore di vedere nella vita stessa una manifestazione di malattia. La vita somiglia un poco alla malattia come procede per crisi e lisi ed ha i giornalieri miglioramenti e peggioramenti. A differenza delle altre malattie la vita è sempre mortale.

In seguito anche il famoso Camille Flammarion si unirà al coro di voci che descrivevano Marte come mondo abitato e fece molto scalpore il suo *Il pianeta Marte e le sue condizioni di abitabilità*.

Il terreno culturale dell'epoca era comunque fertile per fare attecchire teorie circa la possibilità di vita altrove nel cosmo e, in particolare, nel nostro Sistema Solare. Quindi, a parte le precedenti intuizioni del povero Giordano Bruno e di Bernard Bovier de Fontenelle, entrambi interessati alla "pluralità dei mondi" e alla possibilità di vita altrove che questa pluralità implica, anche William Herschel sul finire del Settecento aveva dedotto l'esistenza di

vita marziana dopo avere osservato sul pianeta rosso col suo rifrattore caratteristiche fisiche simili a quelle terrestri.

Agli inizi del Novecento, grazie soprattutto al colonialismo dei secoli precedenti e alle innumerevoli battaglie che erano state già combattute per mare e per terra, il nostro pianeta era un luogo da ritenere pressoché interamente esplorato. Sul finire dell'Ottocento e agli inizi del Novecento, chiunque poteva ragionevolmente supporre di conoscere molto bene quale crudeltà doveva attendersi dai suoi simili. In questo periodo quindi a incutere il terrore che normalmente viene associato al concetto di ignoto, non vi erano più lande lontane e desolate o colonne d'Ercole da solcare con improbabili imbarcazioni, ma soltanto il buio della notte cosmica. L'uomo, che da sempre ha bisogno di dare un volto e un nome alle sue paure, prima cominciò ad avere la fobia dei marziani, ma presto imparò a temere tutto ciò che in generale poteva giungere dall'alto. I fratelli Wright, figli di un prete anglicano noto secondo alcuni per avere difeso l'idea che il volo fosse di esclusivo appannaggio degli angeli, nel 1903 smentirono clamorosamente il padre volando per una manciata di secondi a bordo del loro primo aeroplano, un trabiccolo infernale che nel 1915 era già diventato una micidiale arma da guerra. Quindi, a confermare che ora la paura non arrivava più dal mare o dalla terraferma bensì dal cielo, non furono i marziani, ma ancora una volta gli uomini e il rosso sanguigno di Marte passò il testimone al rosso delle fiamme delle mitragliatrici montate sugli aeroplani e a quello del biplano del leggendario aviatore tedesco soprannominato, guarda caso, Barone Rosso.

Gustav Holst compose la sua suite tra il 1914 e il 1916 e il suo *Mars, the bringer of war*, uscì dalla sua penna un anno prima che il grande conflitto mondiale iniziasse. Se, come si diceva, nelle prime battute sono solo gli strumenti dal suono più grave a partecipare all'azione sonora, man mano che il pezzo avanza, vengono coinvolti anche gli altri strumenti più alti, più liberi di volare fino agli acuti. È così che il conflitto di note annunciato al "suolo" della partitura si impadronisce del "cielo", delle zone riservate prima ai clarinetti, poi agli oboi, a partire dalla battuta undici, ai flauti nella ventottesima battuta e poi via via più su fino a interessare finanche gli altissimi ottavini dalla battuta trentasette in poi, allorché tutto il mondo udibile viene scosso, tutta l'atmosfera e il suolo vibrano sotto il ruggito della minaccia marziana che alla battuta quaranta emette un terrificante accordo di Re bemolle nona con il basso che suona la nota Do. È il conflitto totale.

Finito il primo conflitto, non sparirono certo i timori che avevano spaventato il mondo fino a pochi anni prima, anzi. Per certi versi, l'aria che si respirava era ancora più elettrica, tesa, piena della consapevolezza che ancora qualcosa poteva succedere, un'atmosfera resa egregiamente da quell'intermezzo tra la battuta 65 e la 105 del brano di Holst, che intanto continua ad accompagnare come colonna sonora questa nostra avventura marziana.

Nel 1927 lo *Spirit of St. Louis* pilotato da Charles Lindbergh compie la prima trasvolata oceanica andando da New York a Parigi e connettendo così in poco tempo due mondi all'epoca ancora molto distanti tra loro. La crisi dei mercati mondiali del '29 e il clima dei primi anni Trenta prepareranno in America il terreno per far attecchire l'intolleranza verso un al-

tro rosso, quello dell'ideologia comunista e quindi verso una possibile ascesa del mondo orientale così diverso e alieno da quello occidentale in cui l'America conquistava sempre più un ruolo preminente. È interessante a tal punto notare come nel suo già citato *La vita sul pianeta Marte*, Schiaparelli si sia fatto promotore di una connessione tra politica e astronomia, annotando:

> E passando ad un ordine più elevato d'idee, interessante sarà ricercare qual forma d'ordinamento sociale sia più conveniente ad un tale stato di cose, quale abbiamo descritto; se l'intreccio, anzi la comunità d'interessi, onde son fra loro inevitabilmente legati gli abitanti d'ogni valle, non rendano qui assai più pratica e più opportuna, che sulla Terra non sia, l'istituzione del socialismo collettivo, formando di ciascuna valle e dei suoi abitanti qualche cosa di simile ad un colossale falanstero, per cui Marte potrebbe diventare anche il paradiso dei socialisti.

Nel giro di un decennio arriverà il maccartismo e, dopo un'altra manciata d'anni, la guerra fredda inasprirà i toni contribuendo con ciò a dare nuovo impulso alla ricerca spaziale, stimolata dalla necessità di dover mostrare i muscoli al di là e al di qua del muro di Berlino. A cavalcare la fase iniziale di questo periodo di grande tensione ci pensò un giovane rampante che avrebbe fatto molto parlare di sé. Si chiamava Orson Welles e dagli studi radiofonici della CBS, la sera del 30 ottobre del 1938, un anno prima quindi che la Germania invadesse la Polonia dando così inizio al secondo conflitto mondiale, manda in onda proprio *La guerra dei mondi* di Wells con una sceneggiatura che prevedeva la continua interruzione dei soliti programmi radiofonici di intrattenimento con dei bollettini allarmistici identici per stile e toni al giornale radio. In queste interruzioni si comunicava l'*escalation* di incidenti con morti e distruzioni dovuti all'arrivo dei marziani nel New Jersey. L'effetto sul pubblico fu incredibile. Ne conseguirono panico, fughe, suicidi e disordini tra la popolazione sintonizzatasi a seguire le fasi concitate dello sbarco alieno e il giorno dopo, quando la calma tornò grazie ai giornali che ebbero modo di spiegare a un popolo americano attonito, completamente in balia della folle paura degli alieni, che si era trattato solo… di uno scherzo, il bilancio fu di diverse perdite e danni per milioni di dollari. Negli anni successivi, la conferma che il pericolo maggiore continuava a venire dal cielo arrivò con una forza mai vista prima: con l'arrivo del secondo conflitto mondiale, le V2 tedesche iniziarono a seminare il terrore in tutta Europa, mentre gli "alieni" orientali, figli di una cultura ancora splendidamente lontana dalla nostra, con la bandiera bianca a circondare un sole rosso nel centro, erano capaci di abbattersi come meteore con i loro caccia sugli obiettivi nemici, sprezzanti della morte per suicidio. Come è noto, la fine della guerra venne decretata dalla comparsa sulla scena delle prime due bombe atomiche sganciate proprio sul Giappone da bombardieri americani. Ancora una volta l'uomo quindi dimostrò che a dover essere temuti non erano certo i marziani, ma i suoi stessi simili. Alla fine del conflitto, l'ottimismo necessario per ricostruire un mondo dilaniato da una guerra rivelatasi di dimensioni planetarie e la consapevolezza (o la speranza?) che la prospettiva di un terzo conflitto mondiale condotto con armi atomiche avrebbe paradossalmente suggerito all'umanità la ricerca di strade da percorrere per arrivare a una pace duratura, permisero di meditare con obiettività e tenerezza sulla nostra vulnerabilità. L'uomo aveva scoperto di essere debole, fragile e di non potersi fare troppe illusioni sul futuro, che si presentava incerto e difficile. È in questa atmosfera di cauto ottimismo che nel '46 nasce il romanzo di Ray Bradbury *Cronache Marziane*, un'opera diversa da quel filone della fantascienza che ostentava rigore scientifico, un'opera più vicina alla letteratura di stampo romantico, attenta alla poesia delle descrizioni umane e paesaggistiche e ai risvolti psicologici e sociologici generati dall'invasione marziana, un'invasione stavolta compiuta dall'uomo.

Marte nelle cronache di Bradbury appare come la sagoma di una belva da sempre temuta. Di fronte al suo corpo disteso, inerme, che non lascia ancora intendere se è morta o solo addormentata, noi curiosi ci avviciniamo cautamente e – alle mancate reazioni ai nostri tocchi inizialmente timidi – facciamo seguire incursioni e violenze sempre più efferate,

esasperate da un odio e un timore subito e soffocato per troppo tempo. Nella narrazione di Bradbury stavolta è l'uomo a scendere sul pianeta rosso a più ondate. Le prime con sparuti equipaggi che verranno uccisi da una violenza dei marziani diversa dalla nostra, dovuta all'impossibilità di capire il dirimpettaio così diverso, all'incapacità di comprendere come andiamo trattati, maneggiati, gestiti. L'autore quasi giustifica il popolo marziano, lo monda da ogni responsabilità, anche se non lo salverà e, altrettanto inconsapevolmente il popolo marziano avrà comunque la peggio: la presenza umana è perniciosa, anche quando sconfitta con la forza e ancora una volta, come nel romanzo di Wells, sarà "ciò che ci portiamo dentro" a fare strage della civiltà marziana che non potrà difendersi dal… morbillo: più che altro un simbolo di ciò che verrà nelle pagine successive. Oltre alla chimica dei nostri virus vi è infatti anche quella delle nostre pulsioni che stavolta Bradbury condanna: su Marte inquineremo, ruberemo, uccideremo, eserciteremo egoismo e sopraffazione del debole come abbiamo sempre fatto, assistendo infine attoniti, da lontano, al disfarsi del nostro pianeta preda della terza, definitiva guerra mondiale. Almeno fintanto che la nostra passionalità e il nostro "attaccamento alla Terra" non riporteranno i pionieri[3] sul pianeta d'origine dove la maggior parte di loro troverà la morte durante il conflitto nucleare. La Terra sofferente ci richiamerà e il male risucchierà il male, liberando finalmente Marte.

Bradbury, nella sua poeticità, sembra quasi tardo-aristotelico. L'uomo non può che tornare nel suo luogo naturale, portato dalle sue bassezze verso il ricettacolo migliore per esse, verso l'inferno terrestre.

Dal '66 in poi anche il cinema si approprierà di un certo modo di fare fantascienza, un modo più sociale che tecnico, in cui lo spazio cosmico diventa necessario ampliamento dello scenario terrestre per le vicende umane.

Con Bradbury Marte diventa luogo di redenzione per il popolo nero e prospettiva eccitante per i più anziani destinati sulla Terra a un'attesa indegna e noiosa della morte. Assurge a prospettiva concreta per tutti coloro i quali hanno bisogno di una reale *chance* di cambiamento. Da notare che nella famosissima saga televisiva *Star Trek* questa prospettiva diventerà il tema portante e anche i palati scientifici più raffinati si appassioneranno ai mondi possibili – anche se spesso scientificamente improbabili – proposti nelle varie serie, tutti variazioni sul tema del nostro mondo e della nostra società.

Negli anni '70 l'uomo prende coraggio: dopo essere stato sulla Luna senza avere in-

[3] Lo scrittore-scienziato Arthur Clarke si chiederà in seguito: "Non vi sembra che ci sia qualche analogia tra Marte e le prime colonie americane?", un'analogia studiata alla perfezione da Bradbury, un autore più attento agli aspetti sociologici generati da una possibile epopea marziana, e notata anche da Giuseppe Lippi, il quale, nell'introduzione al romanzo di Asimov *Lucky Starr, il vagabondo dello spazio*, afferma:

> E lo scenario western di cui approfitta non è una novità introdotta da lui, ma fa parte di una tra le convenzioni più accettate della fantascienza, quella per cui il pianeta rosso sia una specie di deserto dell'Arizona trapiantato lassù, dove i baldi pionieri del futuro si comporteranno come gli eroi della vecchia America.

contrato i *lunatici* (scopre infatti che oramai sono tutti qui, sulla Terra...), si propone di andare a dare una serie di occhiate indiscrete su Marte come anche sugli altri pianeti. I successi si succedono agli insuccessi da una parte all'altra del muro. Ed è così che l'americana Mariner 8 manca l'obiettivo mentre la Mariner 9 si inserisce in un'orbita attorno al pianeta rosso da dove scatta una serie incredibile di foto. Negli stessi anni anche i russi partecipano alla corsa verso il quarto pianeta ma, pur essendo i primi a riuscire a scendere sulla sua superficie, da allora perderanno puntualmente tutte le sonde che invieranno fino al 1996, anno in cui decideranno di desistere. È a tutti gli effetti iniziata l'invasione – *quella vera!* – del pianeta rosso da parte del pianeta azzurro, anche se per il momento è ancora soltanto un'invasione di nostri *avatar* meccanici ed elettronici. I primi reali successi arrivarono nel '76 allorché furono inviate le due sonde Viking che raccolsero un bel po' di dati circa la composizione del suolo e della tenue atmosfera. Da quel momento in poi l'accanimento tecnologico per portare delle sonde su Marte in preparazione di una discesa umana sul pianeta, si è fatto sempre più intenso. Al crescere del numero di missioni, è cresciuto anche il numero degli insuccessi e questo ha comportato ancora una volta il riacuirsi dei sospetti circa l'esistenza di vita marziana stavolta ritenuta da qualcuno dotata di una più che valida contraerea, capace di distruggere in volo la maggior parte delle sonde che abbiamo inviato. In mezzo a tutti questi disastri spaziali che qui e là hanno disseminato il suolo marziano di carcasse distrutte, un tempo promettenti sonde, qualche missione è riuscita a ottenere i risultati sperati ed è così che un paio di piccoli robottini stanno al momento girovagando sulla superficie marziana interrogando a modo loro i massi, per il momento unici abitanti del luogo rinvenuti.

Una delle sonde che ha compiuto diverse orbite, fotografando e analizzando il pianeta, ha inviato sulla Terra l'immagine di quella che verrà battezzata la sfinge marziana: una faccia che sembra proprio guardarci da lontano e che ha alimentato le mai sopite polemiche su presunti complotti tesi a nascondere ai più cosa si è scoperto realmente della civiltà locale che si nasconde chissà dove nelle numerose pieghe di quelle lontane plaghe. La faccia in questione, come del resto anche le piramidi intraviste in un'altra foto, ha mostrato di essere semplicemente l'illusione offerta dalla luce solare che in alcuni periodi incide su un rilievo con una particolare inclinazione dandogli transitoriamente un aspetto di volto umano. Cambiata l'inclinazione, sparita la faccia.

Citare questo strano rinvenimento da parte della sonda in questa sede ha valore solo in relazione a quanto dicevo prima: l'idea che Marte possa essere abitato, anzi, che *debba* essere abitato è qualcosa che preoccupa e insieme intriga a tal punto da risultare ancora oggi irrinunciabile per molta, moltissima gente. Basti pensare alle recentissime polemiche nate intorno alla pubblicazione di una foto che ritrae una roccia levigata dai fortissimi venti e dalle tempeste di polvere marziane fino a farla assomigliare a una donna seduta, sorpresa mentre sta meditando. Forse è così. Medita sulla solitudine infinita di quel pianeta e sulla sua condizione di donna... oggetto.

Ho appena parlato di tempeste di sabbia e di venti marziani che, come fa notare il Lippi,

celebre commentatore di molte delle edizioni italiane dei libri di Asimov, sono al momento gli unici responsabili dell'erosione e quindi dei cambiamenti nell'aspetto del pianeta. Allora forse è arrivato il momento di raccontare cosa sappiamo della fisica, della geologia e della meteorologia di questo pianeta. Sì perché, alieni a parte, l'avere tenuto sotto controllo Marte per così tanto tempo ci ha permesso di scoprire una gran quantità di cose estremamente interessanti da un punto di vista squisitamente scientifico, anche se da quanto raccontato fino a ora potrebbe sembrare che lo studio empirico di Marte sia qualcosa che arrivi a interessare l'uomo solo in seconda o in terza battuta. Ebbene, dallo studio del suo moto, dalla misura della sua distanza da noi e dal Sole, dalla misura dell'inclinazione media del suo asse di rotazione e dall'analisi delle sue rocce abbiamo compreso che Marte assomiglia moltissimo alla Terra se considerata in una fase evolutiva precedente a quella attuale. Servendoci della formula di Keplero spiegata nel secondo capitolo, della misurazione del periodo di rivoluzione attorno a Marte delle sue due piccole lune e assumendo ragionevolmente che le loro masse siano del tutto trascurabili rispetto a quella del pianeta, siamo riusciti a calcolare con una certa facilità la sua massa che è risultata essere circa un decimo di quella del nostro pianeta. Il raggio equatoriale di Marte è poco più della metà di quello terrestre, e la sua densità di conseguenza è di 4,39 g/cm^3, da confrontare al solito con quella della Terra, pari a 5,49 g/cm^3. Con una gravità marziana che fa registrare un'accelerazione al suolo pari a poco meno di un quarto di quella riscontrabile sul suolo terrestre, se ci fossimo evoluti sul pianeta rosso invece che su quello azzurro molto probabilmente avremmo raggiunto un'altezza poco meno che tripla di quella media che spetta al genere umano. Infatti, la nostra crescita verso l'alto come anche quella dei rilievi geologici e delle piante deve essere attuata sempre andando contro la gravità che tira verso il centro del pianeta e già nel 1951 il compianto Arthur Clarke, descrivendo un nostro avamposto marziano, scriveva nel suo già citato *Le sabbie di Marte*:

> A proposito dei fiori, a causa della scarsa gravità essi avevano raggiunto proporzioni smisurate, tanto che Oxford Circus era adesso tutto un'esplosione di girasoli alti tre volte un uomo.

Sulla superficie marziana abbiamo trovato quello che si è rivelato il più alto monte di tutto il Sistema Solare, il monte Olimpo, un ex vulcano che con i suoi circa 25 chilometri di altezza ci suggerisce che saremmo stati mediamente più alti di quanto siamo in modo simile a quanto il colosso marziano risulta essere più alto del monte Everest (8.848 m). La geologia marziana vanta quindi una maggiore libertà creativa dal giogo gravitazionale e ha saputo sfruttarla costruendo rilievi e canyon di dimensioni ciclopiche. Per esempio si pensi, oltre che al già citato monte Olimpo, alla valle Marineris: una lacerazione del suolo profonda ben 6 chilometri e lunga 4.000 che prende il nome dalla sonda che l'ha scoperta il 2 gennaio del 1972. Una ferita geologica profonda che, correndo parallelamente all'equatore del pianeta, mi ricorda le sfere del famoso scultore Arnaldo Pomodoro. L'asse di rotazione di Marte è inclinato rispetto al piano dell'eclittica di un angolo medio pari a 25°, quindi molto simile a quello terrestre. In realtà, come ho appena detto, si tratta di una media condotta fra i due valori estremi 11° e 49° tra i quali l'inclinazione di Marte varia in modo caotico, subendo le perturbazioni gravitazionali dovute alla presenza degli altri pianeti e del Sole che lo tirano da tutte le parti. Probabilmente questa variazione dell'inclinazione dell'asse marziano è dovuta all'assenza di almeno un satellite grande come la nostra Luna che, con la sua notevole massa, dona al nostro pianeta una certa stabilità rendendosi corresponsabile del processo di generazione e mantenimento della vita. L'inclinazione dell'asse di rotazione marziano crea anche qui il fenomeno delle stagioni al trascorrere delle quali si osserva il diminuire del raggio delle calotte polari (estate) o il suo aumentare (inverno). Il giorno marziano è straordinariamente simile a quello terrestre, durando poco più di 24 ore mentre l'anno marziano dura qualcosa come 23 mesi terrestri. La colorazione rossastra del suolo è dovuta alla massiccia presenza di ossido di ferro dovuta alle reazioni che avvengono per l'irraggiamento solare che bombarda la superficie del pianeta ricevendo una mite opposizione da parte di una atmosfera molto più tenue di quella terrestre, come ci spiega il solito Clarke, uno dei massimi esponenti della fantascienza, stavolta quella scientificamente esatta:

> L'esposizione improvvisa della pelle all'aria diede a Gibson un senso sgradevole di prurito; infatti l'atmosfera che lo circondava era più rarefatta di quanto lo sia l'aria terrestre sulla cima dell'Everest.

In parole povere, Marte è arrugginito. Anche Asimov come Clarke si è trovato a fare un giro su Marte reincarnandosi nel suo David "Lucky" Starr. Tra le varie cose stupefacenti che lì ha veduto, mi piace riportare la seguente:

Era la prima volta che vedeva il cielo marziano dopo il tramonto. Le stelle erano le stesse della vecchia Terra, disposte nelle costellazioni familiari: la distanza fra i due pianeti, per grande che fosse, non era sufficiente ad alterare percettibilmente le posizioni relative di stelle lontanissime. Ma sebbene la posizione fosse immutata, la luminosità era molto diversa. L'atmosfera marziana, più sottile, non addolciva la luce delle stelle e le restituiva nella loro durezza di splendidi gioielli; inoltre non c'era la Luna, almeno non nel senso terrestre, e i due satelliti di Marte erano minuscoli pezzi di roccia con un diametro di dieci, venti chilometri al massimo. Nient'altro che ciottoli lanciati nello spazio. La loro vicinanza a Marte era molto superiore a quella della Luna alla Terra, ma nonostante questo non avevano l'aspetto di un disco e sembravano due stelle fra le tante. David le cercò, anche se si rendeva conto che potevano trovarsi sull'altro emisfero. Basso sull'orizzonte occidentale vide qualcos'altro e si voltò lentamente a guardarlo. Era di gran lunga l'oggetto più brillante nel cielo, con una sfumatura verde-azzurra che nessun'altra stella del firmamento eguagliava in bellezza. Separato da esso da una distanza che era pressappoco uguale al diametro del sole visto da Marte, un oggetto giallo splendeva a sua volta con fulgore, ma era offuscato dalla luminosità del vicino. Non c'era bisogno di carte astronomiche per identificare la coppia Terra-Luna, la doppia "stella della sera" di Marte.

È proprio di pochi mesi fa la notizia che alle prove di presenza di acqua nel sottosuolo ottenute con osservazioni radar e spettroscopiche, si è finalmente aggiunta quella data dall'averla finalmente "bevuta" e "assaggiata": la sonda ha trovato un pezzo di roccia che, una volta inghiottito lungo un tubo metallico e fatto evaporare riscaldando questo esofago artificiale, ha rivelato la presenza nel gas emesso di particelle del prezioso solvente. Quindi, nonostante Marte abbia perso molta della sua acqua sotto forma di vapore allorché – quando ancora era un pianeta molto caldo e in via di raffreddamento – il calore donava ai vari vapori in uscita dalla sua superficie una notevole energia cinetica, capace di vincere il debole campo gravitazionale marziano facendoli disperdere nello

spazio, sappiamo che l'acqua filtrata nel sottosuolo attraverso le porosità del terreno è comunque presente in notevoli quantità e ciò che resta da fare è capire come poterla estrarre dal permafrost. Marte assume così l'aspetto di una gigantesca lattina dalla quale dovremmo suggere il liquido che così tanto ci interessa. Questo ci permetterebbe di usare in prima battuta il pianeta come "autogrill" per missioni con equipaggio umano, verso destinazioni più ambiziose come per esempio le lune di Giove o di Saturno.

Terraforming

> – Credete davvero che gli uomini riusciranno ad adattarsi all'atmosfera esterna? – disse Gibson. – Ma se vi riuscissero non resterebbero più tali per molto tempo: si trasformerebbero radicalmente!
> Per un attimo il Presidente non rispose. Quindi disse con voce calma: – Io non ho parlato della possibilità per gli uomini di condizionarsi a Marte. Non avete mai riflettuto invece alla eventualità che possa essere Marte a condizionarsi a noi?

Se Marte descritto da Bradbury è un mondo già pronto ad accoglierci, con acqua e un'atmosfera respirabile anche se rarefatta, come abbiamo letto, con Clarke torna a essere più realisticamente un posto che richiede modifiche sostanziali per preparare l'arrivo in massa di coloni umani. Ed è così che, per bocca di Warren Hadfield, capo supremo della colonia marziana, lo scrittore-scienziato fa intuire al lettore la prospettiva offerta dal *Terraforming*, un processo di *Make-up* planetario[4] che dovrebbe permetterci di rendere abitabile un pianeta come Marte in un lasso di tempo di soli... centomila anni, secolo più, secolo meno. L'idea fu poi sviluppata da un punto di vista scientifico circa un decennio dopo dal grande astrofisico Carl Sagan il quale voleva applicarla al pianeta Venere e dai cui studi è emerso che siamo sicuramente la razza adatta per operare un'operazione del genere. Infatti, dovendo tali operazioni condurre alla creazione su Marte di un'atmosfera respirabile, sufficientemente spessa da trattenere il calore solare per generare un conveniente effetto serra e per schermarci dalle componenti nocive della radiazione proveniente dal Sole, esse richiederanno una attività inquinante di dimensioni planetarie ottenibile andando a costruire fabbriche che producano esclusivamente... inquinamento. Tanto "saggio" inquinamento[5] così da immettere nella tenue atmosfera planetaria elementi chimici schermanti.

Poi, mediante l'uso di specchi ustori di archimedea memoria posti in orbita attorno al

[4] Ne esiste almeno una traduzione cinematografica nel film *Total Recall* diretto da Paul Verhoeven; protagonista: l'attore Arnold Schwarzenegger.

[5] Già immagino l'imbarazzo di associazioni ambientaliste che, avendo adottato come slogan la frase "For a living planet" si troveranno a dover sostenere le attività di inquinamento marziano.

pianeta o grazie a una sapiente spalmata di polveri nere assorbenti la radiazione solare, si potrebbe ottenere lo scioglimento delle calotte polari ghiacciate con conseguente immissione nell'atmosfera di vapore acqueo e anidride carbonica. Infine il tocco da maestro: una spolverata di batteri ci regalerebbe, attendendo il tempo sufficiente per la cottura-incubazione, il risultato desiderato. E così, *voilà!* il piatto è servito e prontamente offerto ai futuri coloni spaziali ai quali verrà data in pasto una seconda Terra con acqua, flora e una micro-fauna. Lì potranno replicarsi e replicare antichi riti ed errori, come Bradbury insegna.

E affidiamo proprio alle ultime battute del suo capolavoro, la fine di questa tappa del nostro viaggio:

> Erano giunti al canale. Un canale lungo, dritto, sottile, un canale ricco di frescura e di umidità e di riflessi, nella notte.
> – Ho sempre voluto tanto vedere un marziano – disse Michael, – ma non lo vedo mai. Eppure me lo avevi promesso, papà!
> – Guardali, dove sono, i marziani – disse il babbo, che si tirò Michael in braccio indicandogli l'acqua.
> Laggiù, i marziani? Michael cominciò a tremare.
> Erano là, i marziani, nell'acqua del canale, che ne rimandava l'immagine. Erano Tim, Mike, Robert, la mamma, il babbo.
> E i marziani rimasero là, a guardarli dal basso, per molto, molto tempo, in silenzio, a guardarli dall'acqua che s'increspava lieve…

Nonostante "l'oro azzurro" marziano sia tutto nel sottosuolo e non scorra più copioso in superficie formando qui e là specchi d'acqua come accadeva un tempo, Bradbury in qualche modo ha visto giusto: da tempo sogniamo di potere andare ovunque nel cosmo e abbiamo idealmente proiettato la nostra società sulla superficie di Marte tante volte, ormai. Marte verrà un giorno popolato di riflesso e i marziani saranno *a nostra immagine e somiglianza*…

E allora, dopo essere diventati anche marziani, ripartiamo alla volta delle pendici ultime del nostro Sistema Solare. Prendiamo una notevole rincorsa che ci porterà ben più lontano di dove ci ha condotto la prima. Infatti, come si diceva, la gravità marziana è minore di quella terrestre e questo comporta che, a parità di slancio, ci si possa liberare prima della morsa gravitazionale a tutto vantaggio di un balzo più lungo. Un balzo che stavolta ci dovrà condurre a circa 500 milioni di chilometri da dove ci troviamo. Ovvero dritti dritti in braccio al re degli dei. In braccio a Giove.

I mattoni avanzati: la Fascia degli asteroidi

Devi saper riconoscere un fatto
quando te lo ritrovi davanti.
Robert A. Heinlein, *Elsewhen*

In realtà, prima ancora di raggiungere Giove, durante il nostro volo scorgiamo ciò che a occhio nudo da Marte non potevamo assolutamente vedere: si tratta della cosiddetta *Fascia degli asteroidi*. Cos'è? È presto detto. Vi è mai capitato di visitare un cantiere poco dopo la fine della costruzione di un edificio? Se la vostra risposta è positiva, allora molto probabilmente vi sarà capitato anche di vedere qua e là diverse cataste di materiali edili di vario tipo: alcune di ferri, altre di pezzi di legno, ma soprattutto mattoni. Tanti cumuli di mattoni, rotti o interi, avanzati; ammassati lì perché, per vari motivi, rimasti inutilizzati.

Ecco, nel percorso che ci sta conducendo da Marte verso Giove, in quella zona intermedia che prima ci sembrava vuota, non possiamo fare a meno di scorgere tanti "mattoni" rimasti dalla costruzione dell'edificio Sistema Solare. L'analogia forse mi è stata suggerita dal rosso mattone del pianeta che abbiamo lasciato da poco alle nostre spalle, non molto distante da dove ci troviamo ora ma, analogie a parte, si tratta appunto di una intera fascia molto ampia di asteroidi, ovvero di pezzi di materiale cosmico primordiale di varia dimensione, dal granello di pochi centimetri fino ai massi di centinaia di chilometri. Disposti lungo orbite giacenti fra l'ultimo dei pianeti tellurici e il primo dei pianeti gassosi giganti, stanno lì quasi a volerci spiegare con la loro muta presenza che lo stato intermedio tra il solido e il gassoso non è il liquido, bensì il

"frammentato". Sappiamo della loro esistenza dal 1° gennaio 1801. Quel giorno, anzi, quella notte, l'astronomo Giuseppe Piazzi stava osservando il cielo dall'osservatorio di Palermo intento nella ricerca della stella *87.a* del Catalogo delle stelle zodiacali dell'Abate La Caille. Cercare una stella di un catalogo zodiacale vuol dire provare a stanarla fra quelle che compongono le costellazioni dello Zodiaco – quelle degli oroscopi, per intenderci – che, per questo, risultano essere disposte tutte a cavallo di una linea immaginaria, un ideale filo al quale sono appese: il percorso chiamato *eclittica* che il Sole sembra seguire durante l'anno. Il motivo per la scelta di questo nome è facile da comprendere: l'eclittica altro non è che il profilo del piano più o meno circolare sul quale i pianeti si muovono attorno al Sole. Se due o più pianeti vengono a essere allineati, tutti *infilzati* da un *raggio-spiedo* di questo grande cerchio con la nostra stella al centro, colpendo il primo, la luce fa proiettare ombra su quelli dietro creando il fenomeno noto con il nome di *eclisse*… Oggi sappiamo che siamo noi a muoverci attorno al Sole e non viceversa, quindi sappiamo anche che, se vediamo il Sole muoversi fra le stelle, vuol dire che stiamo girando attorno alla nostra stella restando su quel piano. Girandole attorno, la vediamo prospetticamente proiettata sullo sfondo delle stelle lontane: mutata la nostra posizione rispetto a essa, mutato lo sfondo che ritroveremo esattamente uguale solo dopo un anno, ovvero solo dopo un giro completo lungo la nostra orbita attorno al Sole. Spiegarlo mi serve per mettere in evidenza che se osserviamo le stelle zodiacali, automaticamente guardiamo quelle che giacciono vicino all'eclittica la quale, come abbiamo visto, piuttosto che essere solo una linea, risulta essere il profilo di una immensa superficie ideale su cui noi, gli altri pianeti e tutti gli innumerevoli piccoli oggetti che compongono il Sistema Solare, trascorriamo la nostra esistenza. Bene, il Piazzi, osservando quell'area di cielo, non stava facendo altro che guardare molto vicino a questo piano e ciò gli ha permesso di imbattersi in uno strano oggetto che sembrava una stella o, come si diceva anticamente, un *astro* e per questo appartenente a quella classe di oggetti che vennero battezzati col nome di *asteroidi*[1].

Le stelle lontane ci appaiono puntiformi a causa dell'enorme distanza che ci separa da loro, ma quell'oggetto si muoveva in un modo da non lasciare dubbi: anche se piccolo, non era affatto una stella. Apparteneva piuttosto al Sistema Solare e spendeva la sua esistenza in prossimità del luogo dove ci si aspettava da tempo di trovare qualcosa. Era infatti dalla prima metà del XVIII secolo che si cercava un corpo celeste capace di riempire, con la sua presenza, quello strano vuoto che le osservazioni, condotte con gli strumenti ancora poco potenti dell'epoca, dicevano esservi tra Marte e Giove. Un vuoto che, secondo la relazione scoperta indipendentemente dai due astronomi Titius e Bode[2], vuoto non doveva essere.

[1] Dal greco *astèr* e *eidòs*, somiglianza (derivato dal greco *orào*, vedo).

[2] Si tratta di una strana corrispondenza che fornisce, in Unità Astronomiche, le distanze dei vari pianeti dal Sole col semplice sostituire alla k che compare nell'espressione $d = (4+3k)/10$ le potenze di 2: $k=2^0=1$, $k=2^1=2$, $k=2^2=4$… Il termine "legge" non è appropriato per questa che è solo una curiosità matematica dato che una vera legge scientifica, non appena trova sulla sua strada un'eccezione, viene rigettata. La legge di Titius e Bode di eccezioni ne presenta molte costituite da alcuni pianeti e altri corpi che proprio non ne vogliono sapere di uniformarsi a essa.

Nel 1781, grazie quindi alla cosiddetta "legge" di Titius e Bode (vedi tabella a p. 172) che suggeriva cosa cercare e dove cercarlo, era stato trovato un oggetto astronomico di cui parleremo più avanti nel libro, un pianeta che, mai visto prima a occhio nudo, aveva fatto intuire come sotto questa relazione potesse celarsi qualche strana proprietà del nostro universo al giorno d'oggi non ancora disvelata. Piazzi, trovando proprio da quelle parti, in modo assolutamente involontario, questo ulteriore oggetto poco luminoso, aveva quindi fornito la seconda conferma della validità di questa cosiddetta legge. È forse appena il caso di notare che situazioni del genere si sono spesso verificate nel corso della storia della scienza, tanto da meritare una denominazione *ad hoc*: vengono indicati come casi di *serendipity*, ovvero momenti in cui, cercando qualcosa, si "incespica" su qualcos'altro compiendo così una scoperta ancora più interessante. Al di là dell'indubbio colpo di fortuna, la bravura di chi si trova in situazioni di questo tipo sta tutta nel capire all'istante in cosa ci si è imbattuti e nel riuscire presto a darne una spiegazione, una necessità ben riassunta dalla citazione di Heinlein all'inizio di questo capitolo. Qualcuno si è cimentato anche con la descrizione musicale di questi oggetti, colmando così un altro vuoto, quello lasciato da Holst tra le sue composizioni dedicate a Marte e a Giove. La spiegazione immagino sia da ricercare nell'ispirazione astrologica dell'intera suite. E l'astrologia – chissà perché – non mi risulta che prenda in considerazione gli oggetti della fascia degli asteroidi. La compositrice Kai Jai Saariaho, non nuova al lasciarsi ispirare dal cielo per le sue opere, ha scritto *Asteroid 4179: Toutatis* cercando di figurarsi come apparirebbe la volta stellata osservandola dall'asteroide citato nel titolo che, a causa della sua forma irregolare, manifesta una complessa dinamica rotazionale. Mark-Anthony Turnage invece confessa che l'ispirazione per il suo *Ceres* (Cerere) gli è venuta associando il Giudizio Universale a un eventuale impatto tra un asteroide e la Terra, una ipotesi che nel brano simula facendo collidere blocchi sonori per poi farli procedere, dopo l'urto, in direzioni differenti. Trovo molto interessanti i lavori di questi due compositori e – rammaricandomi per non essere riuscito a reperirne le partiture con lo scopo di citarle all'interno di questo libro – ve ne consiglio comunque l'ascolto. Ma abbandoniamo le descrizioni musicali per tornare agli asteroidi veri, quelli di roccia dura. Negli anni successivi, ulteriori osservazioni portarono alla scoperta che la zona battuta da Cerere è estremamente popolata da altri corpi del tutto simili, anche se di dimensioni minori: nel 1802 Olbers scoprì Pallade, poi nel 1804 fu la volta di Giunone. Vesta fu *vista* nel 1807 e così via fino all'epoca odierna in cui sappiamo che questa fascia annovera più di 100.000 oggetti. La loro importanza è per noi grande: non essendo finiti dentro al Sole e non essendo andati a formare un pianeta evolvendo poi all'interno di esso sotto intensissime spinte geologiche, questi sassi cosmici sono a tutti gli effetti gli unici spettatori e testimoni – rimasti intatti all'interno, direi *puri dentro* – di quelle che furono le primissime vicende del nostro Sistema Solare. Essi così recano la traccia chimica di quello che il proto-sistema planetario era ben cinque miliardi di anni fa e il loro studio è, forse più di altri, assimilabile a una archeologia cosmica che ci permette di risalire alle condizioni primordiali caratteristiche dello spazio ora occupato dai pianeti e dalla nostra stella.

La domanda nasce spontanea: che ci fanno lì? Che senso ha la loro presenza? Alcuni, i più catastrofisti e hollywoodiani tra voi che leggete (magari siete parenti di Turnage…), hanno di sicuro pensato all'esplosione di un pianeta. Spiacente: i pianeti non scoppiano. Non riescono a produrre nel loro interno energie tanto elevate da poter condurre a un'esplosione così rovinosa, una prerogativa soltanto di alcuni tipi di stelle in fasi particolari della loro esistenza. Qualcun altro, non da meno dei primi in quanto a fantasie di mirabolanti effetti speciali, ha pensato all'incidente occorso a un pianeta che girava beato da quelle parti allorché è entrato in collisione con un proiettile naturale di grandi dimensioni giuntogli addosso a folle velocità da chissà dove. Forse è veramente andata così, ma gli astronomi sono più propensi a pensare che, senza scomodare scenari da *Armageddon*, la fascia degli asteroidi sia semplicemente l'orbita nella quale si sono adagiati i mattoni inutilizzati e, in seguito, mi-

grati lentamente fino a cadere nella sacca, nella piega gravitazionale lì generata dalla cucitura fra i due campi gravitazionali, quello del Sole e quello del gigante Giove.

Tutti gli asteroidi presentano sulla loro superficie le cicatrici lasciate dai loro frequenti scontri reciproci. Si tratta di crateri del tutto simili a quelli che troviamo sulla Luna, sulla Terra o su qualsiasi altro pianeta solido. Unica differenza: le dimensioni dei crateri planetari sono nettamente maggiori di quelle rinvenibili sulla superficie degli asteroidi. Questo perché, in aggiunta all'energia cinetica dei meteoriti, si deve tener conto anche dell'attrazione gravitazionale del corpo che sta per subire l'urto e che, con un certo sadomasochismo, aiuta quello in arrivo a ferirlo meglio. Nel caso in cui un asteroide vada a colpire un pianeta, la grande massa di quest'ultimo fa sì che il cratere da impatto sia considerevolmente grande, circa venti volte le dimensioni del proiettile. Nel caso di un asteroide che ne colpisce un altro, le dimensioni del cratere saranno proporzionalmente minori. Grazie al gran numero di cicatrici che esibiscono, sappiamo che, se lasciati al loro destino di oggetti liberi di circolare all'interno di una fascia circoscritta, sotto la spinta della solita forza di gravità che si palesa ogniqualvolta c'è una massa, essi si unirebbero per formare qualcosa di simile a un pianeta.

Si calcola anche che se la massa totale variamente suddivisa fra tutti questi frammenti di roccia potesse confluire in un punto, riuscirebbe a formare un corpo di massa pari all'incirca a 10^{21} grammi, ovvero più piccolo di Plutone il quale – come vedremo – non si distingue esattamente per essere un pianeta di notevoli dimensioni; tutt'altro. Il nostro Ulisse Celeste, grazie al quale noi stiamo viaggiando da un pianeta all'altro, mi suggerisce proprio una immagine classica da associare alla particolare situazione gravitazionale che regna in questa parte del Sistema Solare. Nell'Odissea, la povera Penelope, moglie del protagonista della saga omerica, cerca di non finire sposa di qualcuno dei pretendenti Proci che oramai da anni occupano il palazzo reale dell'assente Odisseo. Tutti loro fanno pressione sulla regina per averla in sposa e diventare così di diritto regnanti su Itaca e, nel frattempo, saccheggiano senza ritegno le ricchezze della famiglia reale. Ignara di avere davanti a sé proprio il con-

sorte assente da anni che, presentatosi al palazzo come comune mendicante, lercio e malvestito, le cela la propria identità, Penelope nel canto diciannovesimo gli racconta:

> Per questo io non mi curo di stranieri o di supplici,
> 135 non d'araldi che sono a servizio del popolo;
> ma rimpiangendo Odisseo mi struggo nel cuore.
> Costoro affrettan le nozze: e io filo inganni.
> E prima un manto m'ispirò in cuore un dio,
> ordita nelle mie stanze una gran tela, di tessere:
> 140 una tela sottile, smisurata: e dicevo:
> "Giovani miei pretendenti, se morto è Odisseo glorioso,
> aspettate, quantunque impazienti delle mie nozze, che termini
> questo lenzuolo, e non mi si perdano al vento le fila,
> sudario di morte per Laerte divino, il giorno che Moira
> 145 crudele di morte lungo strazio lo colga:
> che nessuna tra il popolo delle Achee mi rimproveri,
> quando senza sudario giacesse chi molto acquistò".
> Così dicevo, a loro fu persuaso il cuore superbo.
> Allora di giorno la gran tela tessevo,
> 150 e la sfacevo di notte, con le fiaccole accanto.

Allora, mentre la gravità-Penelope ordisce la tela di connessioni tra gli asteroidi per costruire qualcosa di simile a un pianetino, sempre la stessa gravità-Penelope, complice forse il buio della notte cosmica, per evitare le *nozze* dei frammenti di roccia, provvede a sfilacciare il suo stesso ordito mediante le forze mareali indotte dalla presenza del vicino e scomodo Giove, che, con la sua enorme massa, riesce a gettare la sua *longa manus* finanche a questa distanza.

Una situazione fisica che, dato il suo grande fascino, ha meritato anche la spiegazione dell'immancabile Isaac Asimov, il quale ha ambientato fra questi massicci spaziali un intero romanzo, *Lucky Starr e i pirati degli asteroidi*:

La "ghiaia cosmica" che si trovava in quella regione – che copriva estensioni di centinaia di milioni di chilometri – non aveva potuto organizzarsi in un singolo pianeta perché Giove l'attraeva in direzione opposta; questo aveva dato origine agli asteroidi. I quattro maggiori superavano i centocinquanta chilometri di diametro; i successivi millecinquecento avevano un diametro oscillante fra quindici e centocinquanta chilometri e infine ce n'era una quantità (nessuno conosceva il numero esatto) il cui diametro non superava il chilometro ma che erano pur sempre grandi quanto la Grande Piramide, o ancora di più. Erano così tanti che gli astronomi li chiamavano "i granelli dello spazio". Gli asteroidi erano sparpagliati nell'intera regione tra Marte e Giove e ognuno girava secondo la propria orbita. Nessun altro sistema conosciuto nella galassia ne era provvisto, ma nel nostro era un bene che ci fossero: gli asteroidi avevano formato una sorta di trampolino di lancio verso

i pianeti maggiori. Per altri versi, tuttavia, avevano costituito una difficoltà. Ogni criminale, fuggendo laggiù, diventava praticamente imprendibile. Nessuna forza di polizia era in grado di scandagliare una a una quelle montagne volanti. Gli asteroidi più piccoli erano terra di nessuno: sui maggiori c'erano attrezzati osservatori astronomici, come ad esempio quello su Cerere. Su Pallade esistevano miniere di Berillio, mentre Vesta e Giunone costituivano importanti stazioni di rifornimento.

Tra proci, pirati di terra e pirati dello spazio, che mi ricordano la saga di *anime* giapponesi *Capitan Harlock*, prepariamoci a ripartire seguendo quanto implicitamente ci suggerisce di fare Asimov, ovvero, non di diventare pirati nascosti fra le insenature di questi scogli spaziali, ma di abbandonare questa zona sfruttando gli asteroidi – ci conviene! – per darci un'ulteriore spinta in avanti. Invece di utilizzare la sola energia accumulata nella rincorsa presa su Marte, compiamo allora una sorta di salto triplo scendendo verso Cerere, poggiando su di esso un piede, sicuri di centrarlo grazie al fatto che questo asteroide – misurando all'incirca un migliaio di chilometri, una dimensione che diventa modellabile dalla gravità tanto

da fargli assumere una forma pressoché sferica[3] – è il più grande di tutti. Poggiando poi l'altro su un secondo asteroide presente lì vicino – essendo più piccolo, sarà di forma irregolare, assimilabile a una *patata spaziale* – ci regaliamo un nuovo impulso.

E allora *oplà!* Ripartiamo con spinta rinnovata per arrivare comodamente al cospetto del re degli dei.

Orbita	Distanza dal sole in unità astronomiche secondo la *legge* di Titius e Bode	Distanza reale media dal sole in unità astronomiche (1 U.A. = 149 · 10^6 km)
Mercurio	$(4 + 3 \cdot 0) / 10 = 0{,}4$	0,39
Venere	$(4 + 3 \cdot 2^0) / 10 = 0{,}7$	0,72
Terra	$(4 + 3 \cdot 2^1) / 10 = 1{,}0$	1,00
Marte	$(4 + 3 \cdot 2^2) / 10 = 1{,}6$	1,52
Fascia degli asteroidi	$(4 + 3 \cdot 2^3) / 10 = 2{,}8$	2,77
Giove	$(4 + 3 \cdot 2^4) / 10 = 5{,}2$	5,20
Saturno	$(4 + 3 \cdot 2^5) / 10 = 10{,}0$	9,54
Urano	$(4 + 3 \cdot 2^6) / 10 = 19{,}6$	19,19
Nettuno	$(4 + 3 \cdot 2^7) / 10 = 38{,}8$	30,06
Plutone	$(4 + 3 \cdot 2^8) / 10 = 77{,}2$	39,53

[3] Tra l'altro, in queste sue caratteristiche risiede il motivo per cui Cerere è stato da poco promosso al rango di pianeta nano o pianetino, al pari di Plutone e di quelli che fino a pochi anni fa venivano indicati con il nome di *Plutini*.

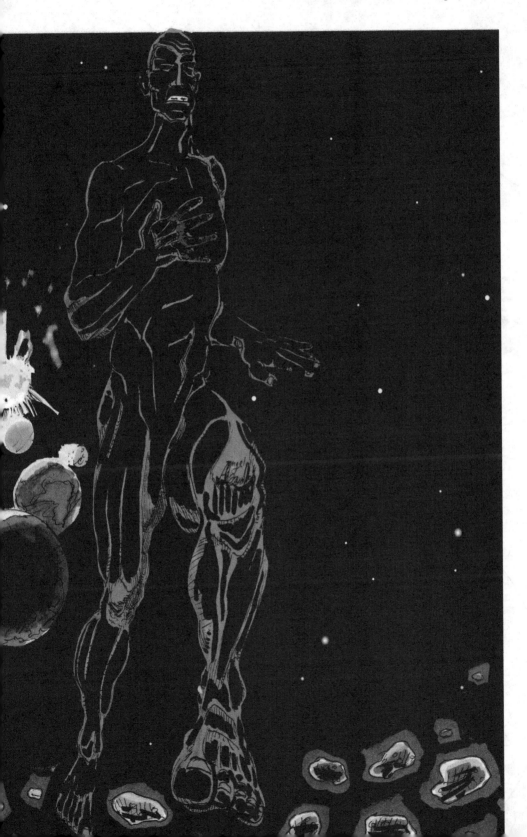

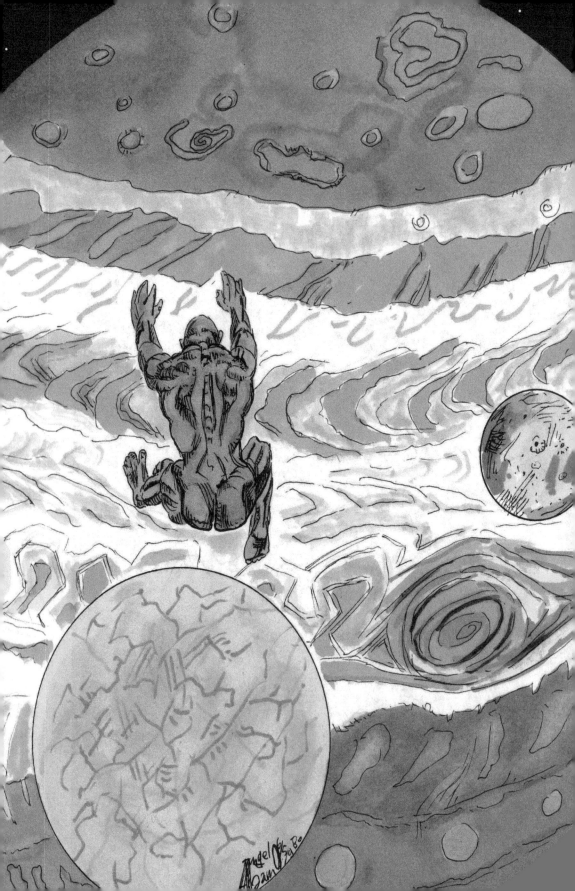

Giove, il gigante o la bambina?

Il gigante e la bambina
sotto il sole contro il vento
in un giorno senza tempo
camminavano tra i sassi
Lucio Dalla, Paola Pallottino, *Il gigante e la bambina*

Io mi rivolsi dal mio destro lato
per vedere in Beatrice il mio dovere,
54 o per parlare o per atto, segnato;
e vidi le sue luci tanto mere,
tanto gioconde, che la sua sembianza
57 vinceva li altri e l'ultimo solere.
E come, per sentir più dilettanza
bene operando, l'uom di giorno in giorno
60 s'accorge che la sua virtute avanza,
sì m'accors'io che 'l mio girare intorno
col cielo insieme avea cresciuto l'arco,
63 veggendo quel miracol più addorno.
E qual è 'l trasmutare in picciol varco
di tempo in bianca donna, quando 'l volto
66 suo si discarchi di vergogna il carco,
tal fu ne li occhi miei, quando fui vòlto,
per lo candor de la temprata stella
69 sesta, che dentro a sé m'avea ricolto.
Dante Alighieri, *Commedia, Paradiso*, Canto XVIII

Cosa è grande? Cosa è piccolo? Queste categorie, anche quando si valuta qualcosa solo da un punto di vista qualitativo, prendono valore sempre in riferimento a qualcos'altro a sua volta ritenuto grande, piccolo, medio o comunque utile per attuare il confronto. È così che, parlando di pianeti, non possiamo fare a meno di notare come Giove sia il più grande, il più variamente colorato, quindi il più maestoso dei corpi orbitanti attorno alla nostra stella.

Abbandonata l'orbita di Marte, ci siamo lasciati dietro anche la zona del Sistema Solare occupata dai pianeti solidi e, dopo essere passati dalla fascia "sbriciolata" degli asteroidi, entriamo finalmente in quella dei pianeti giganti che non saranno più solidi, ma gassosi. Si ha motivo di pensare che al centro delle immense quasi-sfere di Giove, Saturno, Urano e Nettuno, si celino, in fondo ai loro scrigni di gas, delle grandi pietre, "pietre preziose" per ciò che avrebbero da raccontarci su quelle che sono le origini di questi colossi. L'ipotesi più plausibile è che si tratti di grandi asteroidi i quali hanno assolto la funzione di punti di aggregazione gravitazionale dei gas presenti a una certa distanza dalla protostella Sole durante le concitate fasi di costruzione del Sistema Solare. In ogni caso, se anche la precedente ipotesi fosse giusta, questi nuclei rocciosi non basterebbero affatto a far rientrare anche i pianeti giganti nella categoria di quelli tellurici con una estesissima atmosfera attorno, perché non abbiamo nessuna evidenza dell'effettiva esistenza di nuclei solidi, e soprattutto perché, anche se vi fossero, costituirebbero una percentuale troppo piccola delle intere strutture.

Insomma, l'atmosfera di questi pianeti sarebbe in ogni caso molto, molto più importante della parte solida. Così tanto più importante da non lasciare alternative: meglio semplificarci la vita considerandoli gassosi. É curioso scoprire però che, come spesso accade, si può attuare un'altra valutazione capace di ribaltare del tutto il giudizio su almeno uno di essi: Giove. Infatti, date le sue dimensioni, questo pianeta può essere riguardato come immensa *nube di gas auto-gravitante in equilibrio idrostatico*, ovvero qualcosa che lo fa assomigliare molto alla nostra stella Sole. Per spiegarmi meglio, proverò a dire cosa è il Sole e quindi cosa è una stella in generale, dato che le osservazioni ci dicono che il nostro astro appartiene a una categoria molto diffusa di stelle da fargli meritare il ruolo di rappresentante *medio* della categoria. Spero di non far ridere nessuno dicendo che il nostro Sole è una specie di… mongolfiera.

Di sicuro tutti abbiamo almeno una vaga idea di come sia fatto uno di questi strani aeromobili: un telo di forma semisferica o, più spesso, a pera, al quale viene appesa con delle corde una cesta, o *gondola*, dove trovano posto i membri dell'equipaggio. Al centro della cesta, proprio sotto il telo, vi è un bruciatore che, grazie ai gas ottenuti dalla combustione a qualche centinaio di gradi centigradi di un idrocarburo (di solito propano), fa gonfiare il telo di aria calda e, per questo, più leggera dell'aria circostante. A causa della spinta di Archimede che si viene a creare, questa massa d'aria calda di circa 3.000 chilogrammi spingerà il telo fino addirittura a fare innalzare l'intera mongolfiera – telo, cesta, bruciatore ed equipaggio – dal suolo. Se la spinta convettiva impressa all'aria al di sotto del telo non è sufficiente o, peggio, se il combustibile finisce, non solo la mongolfiera non si innalza, ma si rischia anche che il telo cada sulla cesta, nascondendo alla vista tutto ciò che vi è sotto. Questo avviene a causa – non dovrebbe neanche esserci bisogno di dirlo – della presenza della solita gravità che tira sempre e comunque tutto, telo compreso, verso il centro della Terra. Insomma, qualora la spinta dell'aria non dovesse riuscire a controbilanciare il peso del telo, questo avrà la meglio facendolo cadere al suolo. Se siete parte dell'equipaggio, verrete co-

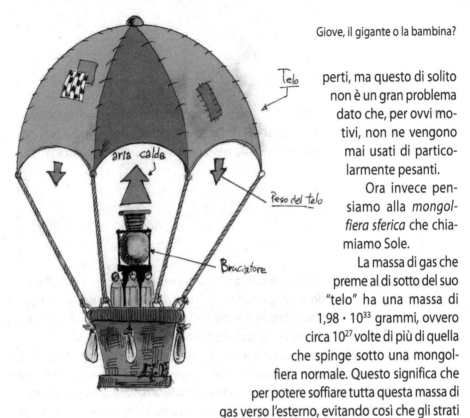

perti, ma questo di solito non è un gran problema dato che, per ovvi motivi, non ne vengono mai usati di particolarmente pesanti.

Ora invece pensiamo alla *mongolfiera sferica* che chiamiamo Sole.

La massa di gas che preme al di sotto del suo "telo" ha una massa di $1{,}98 \cdot 10^{33}$ grammi, ovvero circa 10^{27} volte di più di quella che spinge sotto una mongolfiera normale. Questo significa che per potere soffiare tutta questa massa di gas verso l'esterno, evitando così che gli strati di gas cadano sul centro della mongolfiera-Sole, bisogna che al centro stesso vi sia un bruciatore, in grado di dargli una spinta titanica, capace non di far volare il Sole – non avrebbe senso! Volare rispetto a quale suolo? – ma (questo sì!) di non farlo cadere su sé stesso, accartocciandolo sotto il suo stesso peso. Consideriamo un po' del gas stellare posto sulla sua circonferenza esterna, quella che chiamiamo *fotosfera*, ovvero la sfera da cui ci arriva la luce solare. Una quantità m molto piccola di questo gas si sentirà attratta verso il centro del Sole con una forza data dal prodotto della stessa m per l'accelerazione g_{Sole} con la quale la nostra stella attrae il gas verso il suo centro:

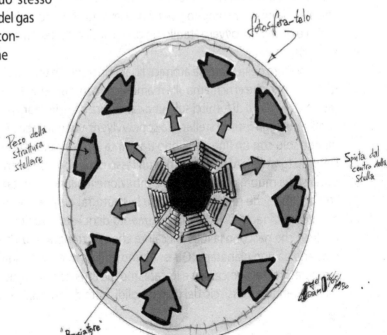

$$\left[\quad F_{\text{peso del gas}} = m_{\text{volumetto di gas}} \cdot g_{\text{Sole}} = - \, G \, m_{\text{volumetto di gas}} \cdot M_{\text{Sole}} / R^2_{\text{Sole}} \quad \right]$$

Semplificando in entrambi i membri la massa del volumetto di gas che risulta del tutto trascurabile rispetto alla massa solare, si ha che l'accelerazione da imprimere al telo della mongolfiera solare in direzione opposta al suo peso per tenerlo su ben gonfio è pari a

$$\left[\begin{array}{c} a_{\text{mongolfiera solare}} = - \, g_{\text{Sole}} = G \, M_{\text{Sole}} / R^2_{\text{Sole}} = \\ = 6{,}67 \cdot 10^{-8} \text{ dyne cm}^2 \, g^{-2} \cdot 1{,}98 \cdot 10^{33} \, g / \, (6{,}9 \cdot 10^{10} \text{ cm})^2 = \\ = 6{,}67 \cdot 10^{-8} \text{ dyne cm}^2 \, g^{-2} \cdot 1{,}98 \cdot 10^{33} \, g \, / \, (47{,}61 \cdot 10^{20} \text{ cm}^2) = \\ = 27.739 \text{ cm/s}^2 = 277 \text{ m/s}^2 \end{array} \right]$$

Una accelerazione spaventosa, se si pensa che all'equatore terrestre è di soli 9,8 m/s^2!

Riassumendo, possiamo allora dire che una stella altro non è se non una massa tanto grande di gas che, per tenere su la propria struttura senza rovinare sotto il suo stesso peso, deve trovare il modo di sprigionare una immensa energia dal suo centro.

Immagino risulti chiaro a tutti che l'enorme massa di gas del Sole c'è riuscita alla grande: ha premuto talmente tanto sulla parte centrale, spingendo allo stesso modo da ogni direzione, da stritolarlo nella morsa gravitazionale generata dalla sua stessa massa. Questa morsa ha prodotto un riscaldamento centrale di circa quindici milioni di gradi, una temperatura alla quale gli atomi solari, intrappolati all'interno di questa specie di camera di combustione dal peso degli strati più esterni di gas, vengono letteralmente aperti, distrutti, scomposti nei loro componenti fondamentali.

Alla faccia di quanto pensava Democrito di Abdera, il greco nato più o meno nel 460 a.C. e ideatore della teoria incentrata appunto sull'idea dell'esistenza di questi minuscoli oggetti chiamati da lui *atomi* proprio perché pensava non fossero divisibili (*atomo* deriva da alfa privativa e da *tèmno*, ovvero "taglio" in greco antico. Letteralmente "che non possono essere suddivisi")!

L'apertura della matassa atomica libera l'incredibile energia in essa contenuta, qualcosa di devastante che ci richiama alla memoria tragedie umane del secolo appena trascorso, comunque in grado di fornirci solo una caricatura delle immani reazioni termonucleari che si verificano negli interni stellari. La sopravvivenza di una stella è un obiettivo che essa raggiunge solo con un fine equilibrio tra spinta interna verso l'esterno e spinta esterna verso l'interno (gravità). Al prevalere per un lasso di tempo abbastanza lungo dell'una o dell'altra, la stella muore o per estrema contrazione (collasso gravitazionale dovuto alla fine del combustibile che serviva a tenere su la struttura) o per estrema espansione (supernovae, nebulose planetarie). È dal mantenimento di questo equilibrio tramite le reazioni termonucleari che nascono la luce e il calore che caratterizzano un corpo stellare e che lo differenziano da uno planetario. Quest'ultimo non ha mai massa sufficiente per generare simili temperature nel suo centro e lo capiamo facilmente pensando, per esempio, che la Terra – il più grande e massiccio dei pianeti solidi, forte dei suoi 5,97 · 10^{27} grammi di massa – non

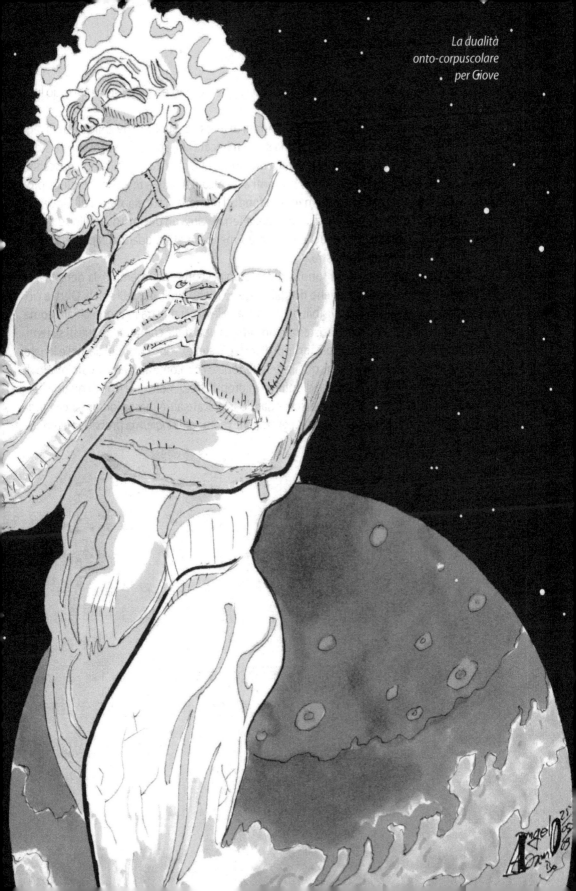

La dualità
onto-corpuscolare
per Giove

ha facoltà di creare nulla di tutto ciò che una stella, invece, riesce a generare irradiando luce e calore tutto intorno.

Ma... e se Giove con i suoi $1,89 \cdot 10^{30}$ grammi di massa e i suoi 71.369 chilometri di raggio equatoriale fosse una quasi-stella, una stella mancata? Mi spiego: e se fosse una stella che, per mancanza di un quantitativo sufficiente di massa, è rimasta bambina non riuscendo a innescare le reazioni termonucleari presenti al centro del Sole e responsabili della produzione di calore e luce che esso emana? In fondo, l'immensa miscela sferica di Giove, col suo raggio dieci volte più grande di quello della Terra e circa un decimo di quello solare, in un diagramma logaritmico si collocherebbe più o meno a metà strada tra un pianeta come il nostro e una stella come la nostra.

Ad avvalorare questa idea vi sono vari dati empirici come, per esempio, la densità e la composizione chimica gioviane che risultano essere molto simili a quelli solari. Oltre a ciò, l'osservazione delle altre stelle visibili della nostra galassia ci mostra in modo chiaro come circa la metà di esse condivida l'esistenza con almeno una stella compagna. Questi sistemi, detti "binari" quando non "multipli" (gruppi di tre o più stelle), sono costituiti da stelle legate dalla più profonda delle attrazioni, quella gravitazionale che, come abbiamo avuto modo di dire nel secondo capitolo, è capace di spingere i propri effetti molto più in là di qualsiasi altra forza conosciuta in questo universo, andando a pescare altre masse lontane nelle profondità dell'abisso cosmico. Sì, vi sono in giro anche molti astri *single*, ma probabilmente an-

che loro, abbagliando tutto intorno, nascondono una compagna di dimensioni più piccole, una cosiddetta *nana bruna*: una "stella bambina" che non crescerà mai e che da tempo, per analogia con quanto avviene qui da noi, usiamo indicare con tono affettuoso "Giovi".

Insomma, se scegliamo come termine di paragone il più grande dei pianeti solidi, la nostra Terra, Giove risulta essere un pianeta gigante. Se invece guardiamo al Sole come termine di paragone, ebbene, Giove risulterà essere solo una stella mancata, una stella bambina dalla crescita inibita. In entrambi i casi, l'osservazione di questo corpo celeste ha da sempre fatto sentire la necessità di connetterlo con idee di grandezza, di ponderatezza e di potere, tanto da fargli assumere nell'immaginario greco al quale fa riferimento tutta la nostra cultura occidentale, il ruolo di re degli dei. Un ruolo che nei canti omerici gli fa meritare vari appellativi come "il cronide", "l'Olimpico", "Zeus vasta voce", "egioco" facendo diventare tutti i regnanti terrestri suoi "allievi".

"Zeus è la causa", si legge nel libro primo dell'Odissea, a significare la grande potenza che rivestiva la sua figura in quella cultura e che ritroviamo ben rappresentato in musica nell'incedere sicuro dell'andante maestoso del brano di Holst dedicato proprio a Giove. In sole quaranta battute di questo 3/4 nella tonalità di Mi bemolle in perfetto stile inno nazionale, con il tema affidato all'unisono dei violini e delle viole, sapientemente sostenuto dagli interventi degli ottoni e dei legni, mi sembra venir fuori con chiarezza un ritratto assolutamente degno del regnante fra gli dei.

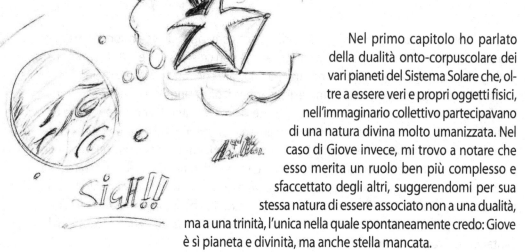

Nel primo capitolo ho parlato della dualità onto-corpuscolare dei vari pianeti del Sistema Solare che, oltre a essere veri e propri oggetti fisici, nell'immaginario collettivo partecipavano di una natura divina molto umanizzata. Nel caso di Giove invece, mi trovo a notare che esso merita un ruolo ben più complesso e sfaccettato degli altri, suggerendomi per sua stessa natura di essere associato non a una dualità, ma a una trinità, l'unica nella quale spontaneamente credo: Giove è sì pianeta e divinità, ma anche stella mancata.

Arrivando al cospetto di cotanta tripla personalità, non possiamo non rimanere affascinati dallo spettacolo offerto dalla sua superficie esterna. Prendo in prestito dal romanzo *Lucky Starr e le lune di Giove* del solito Asimov la seguente descrizione della superficie del gigante gassoso:

> Giove costituiva un disco sufficientemente grande da consentire di vedere a occhio nudo le sue zone colorate. Erano di un tenue rosa e verde azzurro, come se un bambino avesse intinto le dita in una vernice colorata e ce le avesse passate sopra.

I gas che lo compongono si muovono incessantemente a causa della complicata meteorologia gioviana dipendente in larga misura dalle correnti convettive provenienti dall'interno del pianeta e dalla rotazione differenziale delle sue parti. Infatti, a differenza di quanto avviene per una sfera solida, il fatto che Giove sia gassoso fa sì che, al variare della latitudine misurata sulla superficie del pianeta, la velocità di rotazione cresca dall'equatore ai poli. Tra l'altro, la sua rotazione equatoriale avviene già a grande velocità facendo registrare, nonostante la grande mole del pianeta, il record del giorno più breve di tutto il Sistema Solare: solo dieci ore terrestri per completare un intero giro! Tutte queste caratteristiche non fanno altro che creare un'interazione molto caotica al confine tra zone di velocità di rotazione diverse, interazione resa ancor più complicata dal fatto che – in obbedienza a quanto impongono al gas le spinte convettive – alcune parti di esso cadono verso il centro andando a disegnare le cosiddette "zone", ovvero le strisce chiare che si vedono sulla superficie. Al contempo, altre invece salgono dal centro verso l'esterno e le si riconosce come strisce scure di gas indicate con il nome di "fasce". Nella sua essenziale caoticità, questa turbolenta dinamica è capace anche di creare situazioni di grande stabilità come quella che tiene in vita – forse da sempre, ma di sicuro da almeno 400 anni, ovvero da quando nel 1664 è stata osservata la prima volta da Robert Hooke – la caratteristica più famosa del pianeta Giove: la sua immensa macchia ovale rossa, la cui apparizione viene così descritta nel romanzo di Asimov prima citato:

Le sue fasce erano diventate nettissime, striature brunastre dai bordi morbidamente sfocati, su uno sfondo di un bianco cremoso. Fu addirittura facile individuare l'ovale piatto color paglia che era la Grande Macchia Rossa quando comparve da un lato, attraversò la faccia del pianeta e poi scomparve dall'altro.

La grande macchia rossa altro non è che un immenso ciclone il quale, facendo registrare nel tempo solo qualche piccola variazione cromatica sul tema del rosso vermiglio e piccole oscillazioni delle sue dimensioni medie, col suo asse maggiore di circa 39.000 chilometri e con quello minore di circa 14.000, potrebbe ospitare con comodo tre pianeti grandi quanto la nostra Terra. Qualcosa che, oltre al dio greco, mi fa venire in mente l'occhio del semidio Polifemo, il ciclope con un solo occhio di omerica memoria, accecato da Ulisse e dai suoi compagni di viaggio per vendicare la morte di alcuni di loro per mano del gigante:

Così dicevo; e subito mi rispondeva con cuore spietato:
"Nessuno io mangerò per ultimo, dopo i compagni;
370 gli altri prima; questo sarà il dono ospitale".
Disse, e s'arrovesciò cadendo supino, e di colpo
giacque, piegando il grosso collo di lato: lo vinse
il sonno che tutto doma: e dalla gola vino gli usciva,
e pezzi di carne umana; vomitava ubriaco.
375 Allora il palo cacciai sotto la molta brace,
finché fu rovente; e con parole a tutti i compagni
facevo coraggio, perché nessuno, atterrito si ritirasse.
Quando il palo d'ulivo nel fuoco già stava
per infiammarsi, benché fosse verde, splendeva terribilmente,
380 allora in fretta io lo toglievo dal fuoco, e intorno i compagni
mi stavano; certo un dio ci ispirò gran coraggio.
Essi, alzando il palo puntuto d'olivo,
nell'occhio lo spinsero: e io premendo da sopra
giravo, come un uomo col trapano un asse navale
385 trapana; altri sotto con la cinghia lo girano,
tenendola di qua e di là: il trapano corre costante;
così ficcato nell'occhio del mostro il tizzone infuocato,
lo giravamo; il sangue scorreva intorno all'ardente tizzone;
arse tutta la palpebra in giro e le ciglia, la vampa
390 della pupilla infuocata; nel fuoco le radici friggevano.

L'idea che Giove possa essere una stella bambina non è così recente come potrebbe credersi. O, per meglio dire, ritengo che l'idea moderna poggi saldamente su un paragone che per la prima volta fu attuato dal nostro Galileo Galilei il quale 400 anni fa, osservando per la prima volta nella storia umana il cielo non a occhio nudo, ma con il suo cannocchiale, notò che attorno a questo pianeta si scorgevano quattro stelle non segnalate in alcun catalogo di quelli da lui ereditati da una tradizione astronomica che, sin dai tempi degli assiro-babilonesi, aveva imparato a dare nome e posizione a tutte le stelle visibili a occhio nudo. Per circa due mesi, notte dopo notte, tenne d'occhio queste quattro nuove stelle convincendosi alla fine che, a causa dei loro moti rispetto al pianeta, in realtà erano corpi solidi costretti a ruotare attorno al grande corpo gioviano centrale esattamente come fa la nostra Luna attorno alla Terra. Nel suo *Sidereus Nuncius* introdurrà nelle prime pagine quanto da lui osservato, suggerendo così di usare il sistema di Giove e delle sue Lune come modello di riferimento per capire la struttura del sistema eliocentrico copernicano:

Ma quello che supera di gran lunga ogni immaginazione, e che principalmente ci ha spinto a farne avvertiti tutti gli Astronomi e Filosofi, è l'aver

> noi appunto scoperto quattro Stelle erranti, da nessun altro prima di noi
> conosciute né osservate, le quali, a somiglianza di Venere e di Mercurio
> intorno al Sole, hanno lor propri periodi intorno a una certa stella princi-
> pale del numero di quelle conosciute, e ora la precedono, or la seguono,
> senza mai allontanarsi da essa fuor dei loro limiti determinati.

In seguito, con strumenti di osservazione che altro non sono se non l'evoluzione moderna del cannocchiale di Galileo, nonché con sonde inviate da quelle parti a dare un'occhiata ravvicinata a quanto lì accadeva, abbiamo scoperto che il sistema gioviano è ben più complesso, arrivando ad annoverare non quattro, ma addirittura una sessantina di lune. Un dato già parzialmente noto ai tempi in cui Asimov scriveva *Lucky Starr e le lune di Giove*:

> Di fatto Giove aveva catturato tanti di quegli asteroidi che lì, a quindici mi-
> lioni di miglia dal gigantesco pianeta, c'era una sorta di cintura di asteroidi
> in miniatura che apparteneva solo ad esso.

Nel suo libro *2010 Odissea due*, continuazione del più famoso *2001 Odissea nello spazio*, il grande scrittore scienziato Arthur C. Clarke riprende l'idea di Giove-stella bambina e, letteralmente, l'espande, facendo a fine libro espandere... anche il pianeta. È cosa nota che nei due romanzi assumono un ruolo di grande importanza i monoliti neri di natura extraterrestre, che nella geniale vicenda inventata dallo scrittore inglese segnano passaggi fondamentali della storia umana. Questi strani manufatti (manufatti?) verranno chiamati in vari modi: quando TMA, acronimo per *Tycho Magnetic Anomaly*, in riferimento al primo monolite, quello di *2001 Odissea nello spazio*, ritrovato nel cratere lunare intitolato al grande astronomo; quando *Il grande fratello* facendo stavolta riferimento a TMA-2, il monolite di *2010 Odissea due*, più grande del primo e incontrato in orbita attorno a Giove. Nel corso della storia, questo secondo, perfetto parallelepipedo nero viene ribattezzato *Zagadka* (tradotto: enigma) dai russi dell'equipaggio della nave terrestre recatasi da quelle parti per tentare di recuperare l'abbandonata *Discovery*, teatro della tragedia consumatasi nella prima delle due Odissee. Nel romanzo, il tentativo di capire qualcosa di più dell'intima natura del monolite TMA-2 viene attuato inviando sulla sua superficie un astronauta a bordo di *Nina*, un piccolo modulo per ricognizioni esterne alla nave. La discesa di *Nina* sul monolite viene affidata alla sola attrazione gravitazionale che esso esercita sul modulo così da valutarne la massa da misurazioni dell'accelerazione gravitazionale[1], come ci spiega lo stesso Clarke:

> Era vero che Nina aveva finito in ultimo per posarsi sul Grande Fratello,
> dopo una placida caduta protrattasi per cinquanta minuti. Vasili era stato

[1] Qualcosa del genere l'abbiamo già visto nel capitolo su Venere.

> così in grado di calcolare la massa dell'oggetto: risultava sorprendente-
> mente minima, pari cioè a 950.000 tonnellate, la qual cosa faceva sì che
> esso avesse all'incirca la stessa densità dell'aria.

In un altro punto del libro si dice che il monolite misurava più di due chilometri in lunghezza e che i rapporti tra le sue dimensioni erano 1:4:9.

Possiamo allora divertirci a verificare quanto dice lo scrittore calcolando la densità di TMA-2 nel seguente modo. Prima stabiliamo quanto misurano i vari lati. Si ha:

$$\text{lunghezza unitaria} = 2.000 \text{ m} / 9 \approx 222 \text{ m} = 2{,}22 \cdot 10^4 \text{ cm}$$

Allora avremo per la sua altezza:

$$\text{lunghezza unitaria} \cdot 4 = 2{,}22 \cdot 10^4 \text{ cm} \cdot 4 = 8{,}88 \cdot 10^4 \text{ cm}$$

Il volume di TMA-2 risulterà così essere pari a:

$$V_{TMA-2} = \text{lunghezza} \cdot \text{altezza} \cdot \text{profondità} \approx$$
$$\approx 2 \cdot 10^5 \text{ cm} \cdot 8{,}88 \cdot 10^4 \text{ cm} \cdot 2{,}22 \cdot 10^4 \text{ cm} = 3{,}9 \cdot 10^{14} \text{ cm}^3$$

La sua densità diventa a questo punto facilmente determinabile dividendo il peso di TMA-2 per il suo volume:

$$\rho_{TMA-2} = \text{Massa}_{TMA-2} / V_{TMA-2} = 9{,}5 \cdot 10^{11} \text{ g} / 3{,}9 \cdot 10^{14} \text{ cm}^3 = 2{,}43 \cdot 10^{-3} \text{ g/cm}^3$$

In ultimo, per verificare quanto affermato nel romanzo, questo valore è da confrontare con la densità dell'acqua che è pari a 1, ovvero a un grammo su centimetro cubico.

Studi teorici hanno stabilito che a Giove è mancato relativamente poco per poter innescare al suo interno le reazioni termonucleari che differenziano una stella da un grande pianeta gassoso. Infatti dai calcoli si evince che, se solo avesse avuto una massa di circa 80 volte maggiore di quella attuale[2], noi ora forse ci troveremmo a vivere in un sistema binario con Sole e Giove a illuminare e scaldare questa zona di universo. La continua caduta dei gas di Giove verso il cen-

[2] È stato calcolato che si può accedere a far parte del circolo esclusivo delle stelle propriamente dette solo possedendo una massa di almeno 0,08 M_{Sole} = 1,58 · 10^{32} g. Da ciò risulta che Giove è 1,58 · 10^{32} g /(5,97 · 10^{27} g · 317,89) = 83,2 volte più piccolo della massa limite.

tro, ovvero la sua contrazione gravitazionale, è comunque responsabile della produzione di un certo quantitativo di energia capace di opporsi alla contrazione e si scopre che – nonostante quanto si dice di solito circa la differenza tra stelle e pianeti – il pianeta emette più energia di quanta non ne riceva dal lontano Sole dal quale dista circa settecento milioni di chilometri, una distanza alla quale la nostra stella non arriva a scaldare più di tanto. Quindi Giove "brilla di luce propria", ma non abbastanza. Al mutare del punto di vista su questo pianeta, mi sembra necessario cambiarne coerentemente anche il profilo musicale. Nello svolgimento del brano di Holst c'è proprio un motivetto, prima suonato dai violini e poi ripreso da flauti e ottavini, che mi sembra si presti benissimo a disegnare la stella bambina Giove che gioca nel giardino del Sistema Solare canticchiando il motivetto con voce acuta.

Propongo di provare a divertirci cercando una stima della quantità di materia che sarebbe servita al colosso gioviano per essere promosso al rango di stella, per subire cioè qualcosa di analogo alla metamorfosi che anticamente andava sotto il nome di "catasterismo" e che Zeus attuava di continuo mutando in stella qualche mortale, il quale, per un motivo o per l'altro, meritava di essere eternato sulla volta celeste. Come già detto, sappiamo che la massa di Giove è ben 317,89 volte più grande di quella terrestre. In grammi, essa sarà pari a:

$$\left[\quad M_{\text{Pianeta Giove}} \approx M_{\text{Terra}} \cdot 317,89 = 5,97 \cdot 10^{27}\,\text{g} \cdot 317,89 = 1.897 \cdot 10^{27}\,\text{g} \quad \right]$$

La massa della *stella* Giove sarebbe stata quindi maggiore di quella dell'attuale pianeta Giove di una quantità pari *almeno* a:

$$\left[\quad M_{\text{Stella Giove}} \approx 80 \cdot M_{\text{Pianeta Giove}} = 80 \cdot 1.897 \cdot 10^{27}\,\text{g} = 1,51 \cdot 10^{32}\,\text{g} \quad \right]$$

Da confrontare, al solito, con quella del nostro Sole che ammonta a circa $1,98 \cdot 10^{33}$ grammi.

Ora vorrei collegarmi nuovamente alla narrazione di *2010 Odissea due* che, come già preannunciato, presenta nelle pagine finali una evoluzione dai risvolti particolarmente interessanti oltreché eccitanti per avidi lettori di ottima fantascienza come il sottoscritto. Infatti, a un certo punto del romanzo, arriva per l'equipaggio della nave in orbita attorno a Giove la sorpresa: il computer di bordo Hal segnala una strana attività sulla superficie gioviana.

> "Vedo il lato notturno di Giove. V'è un settore circolare, del diametro di 3.250 chilometri, che è quasi completamente coperto da oggetti rettangolari."
> "Quanti?"
> Seguì la più breve delle pause prima che Hal facesse lampeggiare il numero sul display video: 1.355.000 ± 1.000
> "E li riconosci?"
> "Sì. Sono identici, per le dimensioni e la forma, all'oggetto da voi denominato Grande Fratello." (…)
> Nell'euforia del momento, aveva dimenticato completamente la misteriosa macchia nera che andava espandendosi nel cielo di Giove. La rividero al mattino, ora dell'astronave, mentre veniva avanti sul lato di Giove illuminato dalla luce del giorno. Il nero disco si era ormai ampliato fino a ricoprire una frazione apprezzabile del pianeta.

Inizia qui a prendere forma in modo netto il ruolo di questi monoliti, che addensandosi in un particolare punto della superficie gioviana, cominciano a cambiarne l'aspetto, e non solo. Qui la narrazione continua diventando quasi un trattato di astrofisica:

Non è vero che gli eventi astronomici richiedano sempre astronomici periodi di tempo. Il collasso finale di una stella, prima che i frammenti sprizzino via nell'esplosione di una supernova, può aver luogo appena in un secondo; in confronto, la metamorfosi di Giove fu un qualcosa di quasi placido. Ciò nonostante occorsero parecchi minuti prima che Sascia riuscisse a credere ai propri occhi. Stava procedendo a un normale esame telescopico del pianeta – come se *qualsiasi* osservazione potesse essere definita normale! – quando esso cominciò a uscire dal campo visivo. Per un attimo egli pensò che la stabilizzazione dello strumento fosse difettosa; poi si rese conto, con uno choc tale da scuotere la sua intera concezione dell'universo, che era lo stesso Giove a muoversi, e non il telescopio. La dimostrazione di ciò lo guardava in faccia; poteva vedere anche due delle lune più piccole – ed *esse* rimanevano del tutto immobili. Passò a un ingrandimento minore, per poter vedere l'intero disco del pianeta e non soltanto un maculato grigio da lebbrosi. Dopo alcuni altri minuti di incredulità, si rese conto di quello che stava accadendo in effetti; ma ancora stentava a crederlo. Giove non si spostava dalla sua immemorabile orbita, ma faceva qualcosa di altrettanto impossibile. Si stava *restringendo* – con una rapidità tale che l'orlo del pianeta si spostò entro il campo visivo nel momento stesso in cui egli stava mettendo a fuoco lo strumento. Al contempo il pianeta diventava più luminoso e da un grigio opaco passava a un bianco perlaceo. Senza dubbio era più luminoso di quanto lo fosse mai stato nel lungo periodo di tempo trascorso da quando gli uomini avevano cominciato a osservarlo; la luce riflessa del Sole non avrebbe mai potuto… In quel momento, Sascia si rese conto a un tratto di quel che stava accadendo, anche se non del perché, e diede l'allarme. Quando Floyd giunse nel locale delle osservazioni, meno di trenta secondi dopo, la sua prima impressione fu quella di un bagliore abbacinante che si riversava attraverso le finestre, proiettando ovali di luce sulle pareti. Erano così abbaglianti che dovette distogliere lo sguardo; nemmeno il Sole avrebbe potuto causare una simile luminosità. (…)
Floyd era talmente stupefatto che per un momento non associò quella luminosità a Giove. (…) La luminosità si attenuò all'improvviso. (…) Quel puntino non poteva avere nulla a che fare con Giove: quando Floyd aveva osservato il pianeta, appena pochi minuti prima, esso era stato quattro volte più grande del lontano e rimpicciolito Sole. (…) Un momento dopo, la minuscola stella esplose… e, anche attraverso i filtri scuri, divenne impossibile osservarla a occhio nudo.
Ma l'orgasmo finale di luce durò appena per una breve frazione di secondo; poi Giove – o quello che era stato Giove – andò espandendosi una

volta di più. Continuò a espandersi finché divenne di gran lunga più grande di quanto fosse stato prima della trasformazione. Ben presto l'intensità luminosa della sfera prese a diminuire rapidamente, fino a ridursi al mero splendore solare; (…) qualcosa di immenso e di meraviglioso era stato distrutto. Giove, con tutta la sua bellezza e grandiosità, e con tutti i suoi misteri ormai non più risolvibili, aveva cessato di esistere. Il padre di tutti gli dei era stato stroncato nel fiore dell'età. (…) "Si è fatto un'idea di quello che è accaduto?"

"Soltanto che Giove si è trasformato in un sole."

"Ho sempre pensato che fosse troppo piccolo perché questo potesse accadere. Qualcuno non definì una volta Giove 'il sole fallito'?"

"È vero" disse Vasili "Giove è troppo piccolo perché possa innescarsi la fusione… senza un intervento esterno."

"Vuoi dire che abbiamo appena assistito a un esempio di ingegneria astronomica?"

"Senza alcun dubbio. Ora sappiamo qual era lo scopo di *Zagadka*."

"Come ci è riuscito? Se tu ottenessi l'appalto, Vasili, in qual modo trasformeresti Giove in un sole?"

Vasili rifletté a lungo, poi alzò le spalle.

"Sono soltanto un astronomo teorico… non ho una grande esperienza in questo campo. Ma vediamo… be', non essendomi consentito di incrementare di dieci volte la massa di Giove, o di modificare la costante gravitazionale, presumo che dovrei rendere più denso il pianeta… hmmm, questa è un'idea…". (…) La stella che era stata Giove sembrava essersi assestata dopo la nascita esplosiva; era adesso un abbacinante punto luminoso, quasi pari al vero Sole in quanto a luminosità apparente. "Mi sto limitando a pensare a voce alta… ma si potrebbe procedere in questo modo. Giove è – era – composto per la massima parte di idrogeno. Se una notevole percentuale dell'idrogeno potesse essere trasformata in un materiale molto più denso – chissà forse anche in materia di neutroni – questo materiale precipiterebbe nel nucleo. Forse è quello che i miliardi di *Zagadka* stavano facendo con tutto il gas che risucchiavano. Una nucleosintesi, creando elementi pesanti con l'idrogeno puro. *Questo* sì è un segreto che varrebbe la pena di conoscere! Non più carenze di metallo… l'oro abbondante ed economico quanto l'alluminio!"

"Ma tutto questo come spiega quello che è accaduto?" domandò Tanya.

"Una volta che il nucleo avesse raggiunto una densità sufficiente, Giove collasserebbe… probabilmente in pochi secondi. La temperatura aumenterebbe quanto basta per innescare la fusione. Oh, mi rendo conto che esiste una dozzina di obiezioni… come superare il minimo del ferro,

il trasferimento radiattivo, il limite di Chandrasekhar. Ma non importa. Questa teoria può bastare come punto di partenza; elaborerò in seguito tutti i particolari. Oppure ne escogiterò una migliore."

Pensate un po': grazie alla fantasia di Clarke, abbiamo avuto modo di seguire in diretta la nascita di una stella, un evento mai veduto da occhio umano e che molto probabilmente mai nessun occhio umano vedrà: il cosmo con noi terrestri si è dimostrato sempre molto pudico. Da quanto detto si evince che un misterioso popolo extraterrestre, così evoluto da essere capace di agire ingegneristicamente su un pianeta grande come Giove, per qualche oscuro motivo ha deciso di renderlo stella a partire dalle sue caratteristiche che già ne facevano un buon candidato all'avanzamento di livello. Come è avvenuto il tutto? Semplice: come lo stesso Vasili ha modo di supporre, un certo numero di monoliti è andato a coprire la differenza di massa che serviva per aumentare la densità gioviana occupando il volume del pianeta così da indurne il collasso gravitazionale, il conseguente aumento di temperatura al centro e l'accensione delle reazioni termonucleari che lo hanno reso, in via definitiva, una stella.

Quanti monoliti sono stati necessari? Proviamo a fare il conto.

Dai calcoli prima eseguiti risulta:

$$M_{Pianeta\ Giove} \approx 1.897 \cdot 10^{27}\ g$$

$$M_{Stella\ Giove} \approx 1,51 \cdot 10^{32}\ g$$

$$Differenza\ di\ Massa = \Delta M = M_{Stella\ Giove} - M_{Pianeta\ Giove} =$$
$$= (151 - 1,897) \cdot 10^{30}\ g \approx 149,1 \cdot 10^{30}\ g$$

$$Numero\ monoliti = \Delta M\ /\ Massa_{TMA-2} =$$
$$= 149,1 \cdot 10^{30}\ g\ /\ 9,5 \cdot 10^{11}\ g =$$
$$= 1,56 \cdot 10^{20}\ monoliti$$

In parole: circa venti miliardi di miliardi di monoliti. Insomma, un bel po' di 'sti cosi che a qualcuno potrebbe fare sorgere la domanda: ma da dove vengono? E io vi rispondo con un'altra domanda: lo capite o no che sto invitandovi in tutti i modi a leggere i libri che cito? Andate un po' a vedere da voi cosa ha escogitato quel gran mattacchione di Arthur C. Clarke…

Come si diceva, Galileo ha attuato per primo il confronto tra il Sole e i suoi pianeti interni da una parte, e Giove e le sue lune dall'altra. Trovo divertente il fatto che, invertendo la similitudine, possiamo riguardare i pianeti stessi, tutti i pianeti, come lune del Sole, come suoi satelliti. Considerando i pianeti terrestri come sassi, i sessanta sassi veri che sembrano quasi assediare Giove, pensando poi al vento solare, ai venti che muovono inces-

santemente le grandi masse di gas sulla sua superficie e infine al cammino costante di tutti questi corpi iniziato ben cinque miliardi di anni fa – un lungo giorno senza tempo – i primi versi della canzone di Lucio Dalla e di Ron riportati in apertura di capitolo calzano alla perfezione alla situazione che stiamo descrivendo.

Di questa situazione si servirà un altro gigante, se paragonato stavolta alla scala umana: il nostro Ulisse Celeste userà infatti le lune gioviane per muoversi attorno al pianeta così da raggiungere una buona posizione per compiere un ulteriore balzo, quello che lo porterà verso il gigante Saturno.

Saturno, la lama rotante

> Per primo venne Saturno dall'Olimpo celeste,
> 320 l'armi di Giove fuggendo, dal tolto regno scacciato.
> Egli quel popolo barbaro, per gli alti monti disperso,
> riunì, diede leggi e chiamar volle Lazio
> la terra ove latebre aveva trovato, sicure.
> Virgilio, *Eneide,* Libro Ottavo

> Noi sem levati al settimo splendore,
> che sotto 'l petto del Leone ardente
> 15 raggia mo misto giù del suo valore.
> Ficca di retro a li occhi tuoi la mente,
> e fa di quelli specchi a la figura
> 18 Che 'n questo specchio ti sarà parvente.
> Dante Alighieri, *Divina Commedia*, Paradiso, Canto XXI

L'intera storia di Saturno mi sembra possa essere fatta ruotare attorno a una immagine fortemente riassuntiva: quella di una lama.

Figlio, nel mito, delle divinità Urano e Gaia, Crono – che diverrà il Saturno dei romani – viene dotato dalla madre di un affilatissimo falcetto con l'intento di liberare sé stessa e i numerosi figli dall'oppressione del *partner* che la ricopre incessantemente. Unico dei fratelli ad avere il coraggio di scagliarsi contro il padre-padrone, il protagonista di questo capitolo evirerà Urano staccandogli di netto il membro e riscattando così, oltre che la madre Gaia, anche i suoi numerosi fratelli, fino a quel momento costretti come lui nelle viscere materne dalla opprimente violenza sessuale uranica.

Ma leggiamo direttamente dalla penna di Esiodo questa storia tratta proprio dalla sua *Teogonia*:

> Ma quanti da Gaia e da Urano nacquero
> 155 ed erano i più tremendi dei figli, furono presi in odio dal padre
> fin dall'inizio, e appena uno di loro nasceva
> tutti li nascondeva, e non li lasciava venire alla luce,

nel seno di Gaia; e si compiaceva della malvagia sua opera,
Urano, ma dentro si doleva Gaia prodigiosa,
160 stipata; allora escogitò un artificio ingannevole e malvagio.
Presto, creata la specie del livido adamante,
fabbricò una gran falce e si rivolse ai suoi figli
e disse, a loro aggiungendo coraggio, afflitta nel cuore:
"Figli miei e d'un padre scellerato, se voi volete
165 obbedirmi potremo vendicare il malvagio oltraggio del padre
vostro, ché per primo concepì opere infami".
Così disse e tutti allora prese il timore, né alcuno di loro
parlò; ma, preso coraggio, il grande Crono dai torti pensieri
rispose con queste parole alla madre sua illustre:
170 "Madre, sarò io, lo prometto, che compirò questa
opera, ché d'un padre esecrabile cura non ho,
sia pur mio, che per primo compì opere infami".
Così disse, e gioì grandemente nel cuore Gaia prodigiosa,
e lo pose nascosto in agguato; e gli diede in mano
175 la falce dai denti aguzzi e ordì tutto l'inganno.
Venne, portando la notte, il grande Urano, e attorno a Gaia
desideroso d'amore incombette e si stese
dovunque; ma dall'agguato il figlio si sporse con la mano
sinistra e con la destra prese la falce terribile,
180 grande, dai denti aguzzi, e i genitali del padre
con forza tagliò, e poi via li gettò,
dietro; ma non fuggirono invano dalla sua mano:
infatti, quante gocce sprizzarono cruente,
tutte le accolse Gaia e nel volger degli anni
185 generò le Erinni potenti e i grandi Giganti
di armi splendenti, che lunghi dardi tengono in mano,
e le ninfe che chiamano Melie sulla terra infinita.

Urano, offeso nel fisico e nell'animo, fuggirà rancoroso in alto e osserverà da lontano Gaia ricoprendo tutto lo spazio sferico attorno a essa. Di quest'altra divinità-pianeta avremo modo di parlare molto presto, nel prossimo capitolo. Intanto torniamo a Crono, sul quale, leggendo Esiodo e Virgilio, si possono maturare pareri discordanti. Dalla *Teogonia* veniamo a sapere che, non avendo riservato alla sua prole un trattamento di molto diverso da quello da lui stesso e dai suoi fratelli sperimentato in gioventù, doveva essere proprio degno figlio di Urano:

Rea poi, unitasi a Crono, partorì illustri figli:
Istie, Demetra e Era dagli aurei calzari,

455 e il forte Ade, che sotto la terra ha la sua dimora,
 spietato nel cuore, e il forte tonante Ennosigeo,
 e Zeus prudente, degli dèi padre e degli uomini;
 sotto il suo tuono trema l'ampia terra.
 Ma questi li divorava il grande Kronos, non appena ciascuno
460 dal ventre della sacra madre ai ginocchi arrivava,
 e ciò escogitava perché nessun altro degli illustri figli di Urano
 fra gli immortali avesse il potere regale.
 Infatti aveva saputo da Gaia e da Urano stellato
 che per lui era destino essere vinto da un figlio,
465 per forte che fosse, per volere di Zeus grande;
 perciò non inutile guardia faceva, ma sempre in sospetto
 i figli suoi divorava, e un dolore incessante teneva Rea.

Si scopre così che Zeus è figlio di Crono, rimasto in vita con l'inganno perché la madre Rea, volendo salvarlo dall'orrendo destino che lo attendeva, diede al marito una pietra infagottata facendogli credere che fosse il nuovo nato. Crono inghiottì questa pillola *ante litteram* che l'avrebbe dovuto *curare* dalla predetta ritorsione di uno dei suoi figli che l'avrebbe spodestato, e così Zeus – per questo indicato spesso come il Cronide, ovvero figlio di Crono – ebbe modo di crescere indisturbato lontano dalle grinfie del padre, preparandosi ai futuri impegni di re degli dèi.

Nell'*Eneide* di Virgilio troviamo la continuazione della storia. In essa, in ottemperanza a quanto era stato profetizzato, il poeta ritrae il dio nel frattempo divenuto Saturno e privato del trono da suo figlio Giove. Nel poema latino, Saturno sarà una divinità benevola, artefice addirittura della civilizzazione del popolo laziale, che sotto il suo regno conoscerà la famosa età dell'oro:

 Questi boschi, narrava, Fauni indigeni e Ninfe abitavano,
325 popolo forte, nato dai tronchi di rovere duro,
 che civiltà non avevano, né tori aggiogare
 o raccoglier provviste sapevano, o serbare il raccolto;
 ma i boschi e rozza caccia fornivano il cibo.
 Per primo venne Saturno dall'Olimpo celeste,
320 l'armi di Giove fuggendo, dal tolto regno scacciato.
 Egli quel popolo barbaro, per gli alti monti disperso,
 riunì, diede leggi e chiamar volle Lazio
 la terra ove latebre aveva trovato, sicure. L'età d'oro che dicono, fu sotto quel re:
325 così in placida pace egli reggeva il suo popolo,
 finché via via peggiore e più pallido scorse
 il tempo, e nacque rabbia di guerra e brama d'avere.

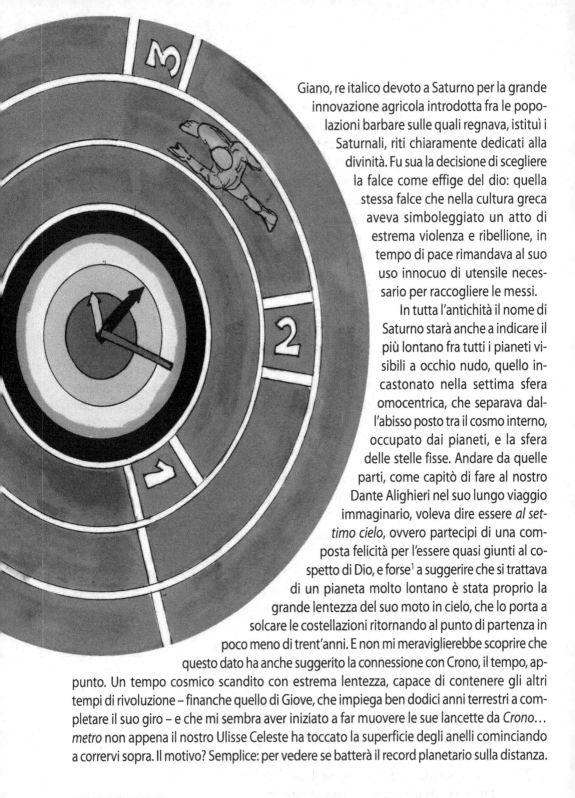

Giano, re italico devoto a Saturno per la grande innovazione agricola introdotta fra le popolazioni barbare sulle quali regnava, istituì i Saturnali, riti chiaramente dedicati alla divinità. Fu sua la decisione di scegliere la falce come effige del dio: quella stessa falce che nella cultura greca aveva simboleggiato un atto di estrema violenza e ribellione, in tempo di pace rimandava al suo uso innocuo di utensile necessario per raccogliere le messi.

In tutta l'antichità il nome di Saturno starà anche a indicare il più lontano fra tutti i pianeti visibili a occhio nudo, quello incastonato nella settima sfera omocentrica, che separava dall'abisso posto tra il cosmo interno, occupato dai pianeti, e la sfera delle stelle fisse. Andare da quelle parti, come capitò di fare al nostro Dante Alighieri nel suo lungo viaggio immaginario, voleva dire essere *al settimo cielo*, ovvero partecipi di una composta felicità per l'essere quasi giunti al cospetto di Dio, e forse[1] a suggerire che si trattava di un pianeta molto lontano è stata proprio la grande lentezza del suo moto in cielo, che lo porta a solcare le costellazioni ritornando al punto di partenza in poco meno di trent'anni. E non mi meraviglierebbe scoprire che questo dato ha anche suggerito la connessione con Crono, il tempo, appunto. Un tempo cosmico scandito con estrema lentezza, capace di contenere gli altri tempi di rivoluzione – finanche quello di Giove, che impiega ben dodici anni terrestri a completare il suo giro – e che mi sembra aver iniziato a far muovere le sue lancette da *Crono… metro* non appena il nostro Ulisse Celeste ha toccato la superficie degli anelli cominciando a corrervi sopra. Il motivo? Semplice: per vedere se batterà il record planetario sulla distanza.

[1] Ricordiamo qui ciò che riferiva Igino, già citato nel secondo capitolo di questa trattazione.

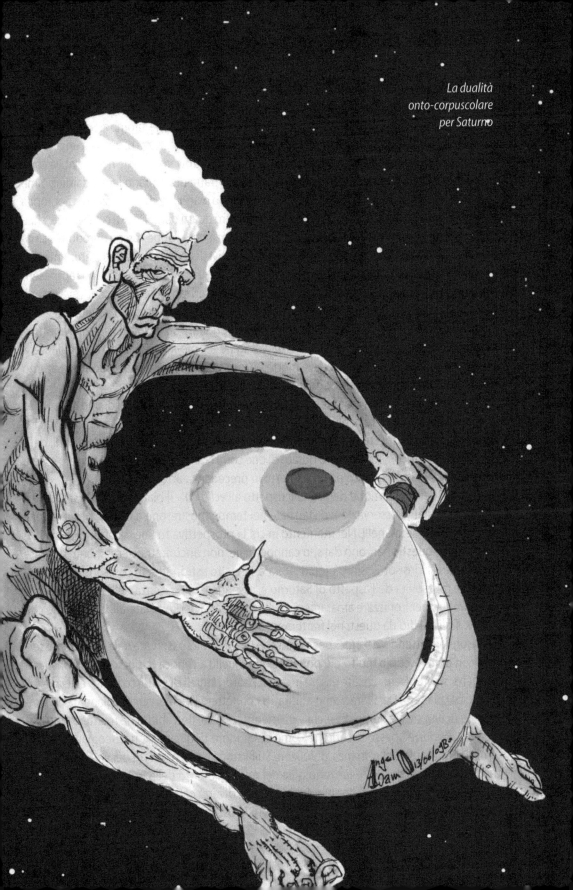

*La dualità
onto-corpuscolare
per Saturno*

In fondo il fenomeno vita sulla Terra ha sempre dato luogo a considerazioni sulla caducità di tutta la nostra esistenza. Il lentissimo incedere di Saturno apriva la prospettiva su di un piano di esistenza in cui i tempi si dilatavano fino a coprire a ogni rivoluzione intorno al Sole – dal quale dista circa 9 Unità Astronomiche e mezzo – quella che era la lunghezza di una vita umana media: trent'anni. Il tema dell'approdo alla fine della vita lo ritroviamo anche nella relativa composizione di Holst *Saturno, il portatore di vecchiaia*. Si tratta di un brano lento, dall'inizio misterioso e oscillante tra una tonalità di La minore e un Do maggiore che pian piano si appropria dello svolgimento. Introdotto con un *Adagio* di quattro quarti dai soli flauti e dalle arpe, chiamerà progressivamente in causa i contrabbassi, gli altri archi e l'oboe, forse a riprodurre la malinconia che era considerata uno dei tanti tratti distintivi di un temperamento saturnino.

Come si diceva, questo pianeta per tutta l'antichità e fino al XVIII secolo ha rappresentato l'ultimo avamposto prima della sfera delle stelle fisse: dopo di esso, non doveva esservi null'altro se non appunto quel lontanissimo mondo di perfezione assoluta raggiungibile solcando un vuoto abisso cosmico di incalcolabile profondità, il *buio oltre la siepe* di pianeti osservabili a occhio nudo. Un abisso che dà vertigine al solo immaginarlo e assimilabile a quello che separa la vita dal buio della morte, altro aspetto dell'esistenza associato a Saturno in quanto padre anche di Ade, regnante sul mondo dell'aldilà.

Galileo lo osservò con il suo cannocchiale ma, non potendo avvalersi di uno strumento con un sufficiente potere risolutivo, invece degli anelli notò solo delle strane appendici ai lati del pianeta. Di questa sua osservazione parlò in una lettera a monsignor Belzoni, definendo Saturno *tricorporeo*, ovvero dotato di due corpi laterali, che ritenne potessero essere lune, in analogia con quanto da lui scoperto in precedenza attorno a Giove.

A causa dell'inclinazione degli anelli rispetto all'*eclittica* – il piano nel quale si svolge il moto dei pianeti – osservazioni distanziate nel tempo mostrarono a Galileo profili diversi del sistema pianeta-anelli. Nel momento in cui la prospettiva fu tale da offrirgli la loro vista di taglio, questi sparirono dal suo cannocchiale, non ancora sufficientemente potente da mostrare il loro sottilissimo profilo laterale. Il nostro astronomo fu così sorpreso dall'incredibile mutabilità dell'aspetto di Saturno e, essendo a conoscenza della dieta di Crono, ne approfittò per ironizzare amaramente sulla scomparsa dei corpi laterali, ipotizzando che fossero figli del dio da questi nel frattempo inghiottiti.

Bisognerà attendere il 1655 per capire che le appendici osservate dal pisano, se osservate con un telescopio molto più potente come quello all'epoca in possesso di Christiaan Huygens, si sarebbero rivelate essere in realtà i bordi laterali di un disco molto esteso e separato dal pianeta. Da allora siamo abituati a connettere l'idea di questo pianeta con l'immagine di una sfera adorna di cerchi variamente colorati, una abitudine mentale tanto radicata da indurre spesso a parlarne come di "Signore degli anelli", riecheggiando così il famosissimo titolo del romanzo di Tolkien. Sulla storia delle scoperte dei vari anelli di Saturno si potrebbe costruire la cronologia del miglioramento della precisione nelle osservazioni astronomiche. L'anello singolo di Huygens diverrà così un sistema di due anelli con Giandomenico Cassini, il quale per primo nel 1675 osserverà il solco buio che divide in due

parti – A quella più esterna e B quella vicino al pianeta – il piano anulare e che da allora porta appunto il nome di "separazione di Cassini". In seguito, nel 1850, ne verrà scoperta una terza denominata C e nella seconda metà del '900 ne verranno avvistate altre quattro indicate con le lettere D, E, F, G, un modo di classificare questi cerchi anulari di diversa luminosità che mi ricorda le sigle con le quali vengono comunemente indicate le sette tonalità musicali, contate a partire dalla A, che sta a indicare il La maggiore. Oggi, grazie alle sonde automatiche che abbiamo inviato a dare sbirciate all'*habitat* naturale in cui vive, sappiamo che le migliaia (!) di anelli diversi[2] di questo gigante gassoso, con i suoi circa 60.000 chilometri di raggio e quindi secondo per dimensioni solo a Giove, costituiscono una struttura estremamente estesa. A conti fatti, essa raggiunge un diametro di circa 300.000 chilometri, a fronte di uno spessore di poche decine di metri che solo in alcuni punti di accumulazione del materiale anulare fa registrare temporaneamente dimensioni di circa un chilometro: di sicuro quindi la cosa più sottile e affilata che conosciamo, se intendiamo con sottigliezza il rapporto tra lo spessore e le altre due dimensioni di un oggetto. Torna ancora una volta l'immagine della lama, una immensa lama rotante, capace di farmi correre con la mente alla saga di Goldrake della mia infanzia. La stessa sottigliezza la si ritrova anche in senso traslato, facendo sovente associare l'idea di Saturno a quella di acume mentale, come si evince dall'*Odissea* nella quale si ritrova spesso l'espressione "Crono, pensiero complesso". Insomma, sembra quasi che, colmo di un certo pensiero idealista, la Natura abbia scelto di assecondare materialmente una idea umana la quale, se così fosse, deve esserle parsa particolarmente affascinante.

Ma di cosa è fatta questa lama? Osservazioni accurate condotte con le solite sonde automatiche hanno rivelato che gli anelli sono composti di polveri e sassi ghiacciati in superficie, con dimensioni comprese tra il centimetro e le decine di metri. È proprio la presenza di questi ghiacci, sostanze caratterizzate da una elevata *albedo* o riflettività della luce su di essi incidente, a rendere gli anelli di Saturno facilmente osservabili. Oggi sappiamo che pure gli altri pianeti giganti e gassosi possiedono anelli del tutto simili a quelli di Saturno anche se meno estesi, a volte incompleti e di conseguenza più difficili da osservare; in pratica, lamette sdentate. Si pensa che all'origine di queste strutture vi possano essere stati uno o più satelliti, che furono sgretolati dalle tremende forze mareali generate dalla presenza delle ingenti masse gassose planetarie attorno ai quali ruotavano a piccola distanza. La massa di Saturno, stimata grazie all'osservazione dei moti delle sue numerosissime lune – ne ha, come Giove, una sessantina – e delle sonde Voyager che lo hanno avvicinato, risulta pari a più o meno 95 volte quella della Terra:

$$\left[\qquad M_{Saturno} = 95 \cdot 5{,}97 \cdot 10^{27}\,g \approx 5{,}6 \cdot 10^{29}\,g \qquad \right]$$

[2] Ve ne sono di molto tenui anche nella divisione di Cassini, nella quale vi è semplicemente una densità più bassa che altrove.

Dalle sue dimensioni, possiamo valutarne facilmente la densità:

$$\rho_{Saturno} = M_{Saturno} / V_{Saturno} = 3 \cdot 5{,}6 \cdot 10^{29} \, g /[4\pi \cdot (9{,}46 \cdot R_{Terra})^3] =$$
$$= 3 \cdot 5{,}6 \cdot 10^{29} \, g /[4\pi \cdot (9{,}46 \cdot 6.378 \cdot 10^5 \, cm)^3] = 0{,}6 \, g/cm^3$$

Al solito, ho trascurato di considerare che il pianeta non è una sfera perfetta. Un calcolo che tenesse conto dello schiacciamento polare condurrebbe al valore esatto di 0,71.

Nell'effettuare questo calcolo ho trascurato un po' di costanti che, se usate, avrebbero condotto al valore esatto di 0,71, da confrontare con il valore della densità di Giove pari a 1,3, a quella media dei pianeti tellurici pari a 5 e a quella della solita acqua che, come già si è detto, è pari all'unità. Da questo ultimo confronto deduciamo che se il *Saturno vegliardo*, come lo definisce Virgilio nel settimo canto dell'Eneide, mettesse in un bicchiere d'acqua la sua dentiera, essa andrebbe a fondo mentre il vegliardo galleggerebbe a pelo d'acqua, incapace di raggiungerla.

Questo significa anche che, pur essendo una enorme sfera auto-gravitante di gas, molto simile per composizione chimica e dimensioni a quella della stella mancata Giove, per il poco denso Saturno e per gli altri pianeti gassosi proprio non può essere usata l'analogia con una stella. Nonostante ciò, anche Saturno risulta emettere più energia di quanta ne riceva dal Sole, a causa della caduta dei suoi strati esterni di gas sul suo centro, una caduta che, similmente a quanto accade all'interno di Giove, sviluppa l'energia di una enorme cascata sull'immenso mare di idrogeno metallico presente nel centro e responsabile dell'inteso campo magnetico registrato attorno a questo pianeta.

Le lune di Saturno sono quasi tutte *a distanza di sicurezza*, cioè situate perlopiù all'esterno di quella zona idealmente contenuta nel cosiddetto *limite di Roche,* entro la quale le forze mareali potrebbero distruggerle, come deve essere capitato a quella (o quelle) ghiacciata all'origine degli anelli. Le due tipologie di strutture riscontrabili attorno al gigante, lune e anelli, sono così intimamente accoppiate da fare diventare le prime dei veri e propri controllori dei moti delle singole particelle rocciose costituenti i secondi. Non appena, infatti, a causa di urti reciproci o altri tipi di spinte gravitazionali che si sviluppano nella struttura planare attorno a Saturno, alcune di esse tentano di sfuggire nello spazio, le lune saturniane le riportano indietro con la persuasione dei loro campi gra-

vitazionali ed è proprio tale funzione normatrice che le vede impegnate a tenere unito il gregge di frammenti anulari il motivo che spinge a indicarle spesso come *lune pastore*. Intanto che leggete queste righe, il nostro Ulisse Celeste sta percorrendo a grande velocità la pista degli anelli, agendo come fosse una puntina sui solchi di un immane vinile dal quale, con il suo veloce passaggio, estrae le note del brano di Holst. Giunto alla quarantesima battuta, i contrabbassi prima e tutta la sezione archi poi, coadiuvata da arpe, basso tuba e timpani, sembrano imprimere agli stessi anelli l'impulso che li porterà a girare attorno al pianeta, suonando solo sui tempi in levare della battuta.

Se ci fosse dato di osservare il sistema di Saturno standocene comodamente seduti su uno dei suoi satelliti naturali, che panorama potremmo osservare? Che tinte creerebbero per i nostri occhi i velocissimi venti, capaci di soffiare fino a un migliaio di chilometri all'ora i gas sulla superficie di Saturno? Da una qualsiasi delle sue lune, nel giro di una decina di ore riusciremmo a vedere scorrere sopra di noi tutta la superficie planetaria, dato che, assieme a Giove, Saturno fa registrare la più alta velocità di rotazione diurna di tutto il Sistema Solare. Ma facciamoci raccontare queste suggestioni da qualcuno che con la fantasia è stato molto prima di me proprio su una luna saturniana. Leggiamo come è apparso Saturno agli occhi della mente di Arthur C. Clarke, che si è goduto lo spettacolo dal palchetto d'onore di Mimas:

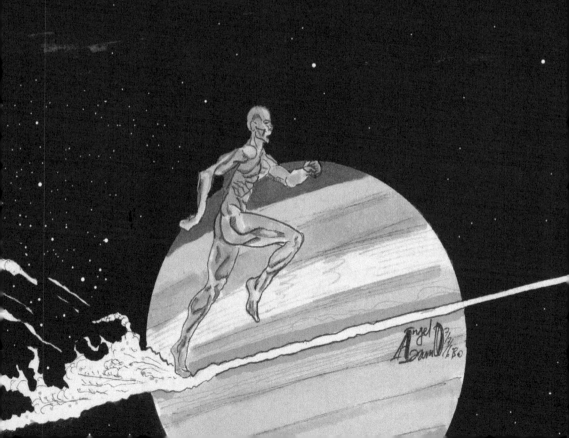

Mimas ha una bassa gravità, solo un centesimo di quella terrestre, ma sufficiente per evitarci di finire nello spazio. (…) Per quanto lungo e alto che fosse il balzo, si poteva stare sicuri che presto o tardi si finiva col ridiscendere, purché si avesse la pazienza di aspettare.

"Quando sbarcammo era mattino presto. Mimas ha le giornate un poco più brevi di quelle terrestri: compie il giro di Saturno in ventidue ore e mezzo. Come la Luna, Mimas ha il periodo di rivoluzione lungo quanto quello di rotazione, quindi offre al suo pianeta sempre la stessa faccia, o meglio, dal pianeta è possibile vederne sempre soltanto una faccia. Eravamo discesi nell'emisfero settentrionale, non lontano dall'equatore e Saturno si trovava già molto sopra l'orizzonte. Aveva un aspetto veramente bizzarro, inquietante, una specie di montagna dalla curvatura assurda e alta migliaia di chilometri.

"Avrete certo visto i film che abbiamo girato, specialmente quello a colori che mostra, accelerato, un ciclo completo delle fasi di Saturno. Ma non credo che i film possano rendere perfettamente quello che significa vivere con quella sfera enorme sempre sospesa lassù nel cielo. È talmente grande che non si riesce a vederla tutta in una volta. Se ci si metteva di fronte e si allargavano le braccia si aveva l'impressione di poter toccare con la punta delle dita le estremità opposte degli anelli. Gli anelli veri e propri non si possono distinguere molto bene perché sono sottilissimi, data la loro posizione quasi verticale, ma è possibile individuarne la posizione dalla grande fascia d'ombra che gettano costantemente sul pianeta.

"Noi non ci stancavamo mai di guardare. Saturno ruota con tanta velocità, che il panorama muta continuamente. Le formazioni di nubi, ammesso che si trattasse effettivamente di nubi, sfrecciavano da un lato all'altro del disco in poche ore, trasformandosi di continuo nel loro fuggire. Ed avevano i colori più meravigliosi ed incredibili. Ce n'erano di verdi, di viola, di gialle soprattutto. Di tanto in tanto si verificavano lente, enormi eruzioni, e dalle profondità si levava un fungo grande quanto la Terra che andava pigramente allargandosi in una macchia immensa che ricopriva metà pianeta.

"Era impossibile non guardare. Persino di notte, quando era completamente invisibile, se ne indovinava la presenza dalla grande porzione di cielo vuoto di stelle.

Trovatosi ora dalla parte opposta a quella d'arrivo, l'Ulisse Celeste decide di varcare le colonne d'Ercole: sa benissimo che lì, *al settimo cielo* del cosmo degli antichi, il Sistema Solare dovrebbe finire, preludendo così alla sfera delle stelle fisse. Ma egli sceglie ugualmente di esplorare l'ignoto, spiccando un balzo poderoso in direzione di una cometa, dalla quale si farà dare un passaggio verso il nulla più in là.

Urano, il corpo... celeste!

Vi sono più cose in cielo e in terra,
Orazio, di quante non ne sogni la tua filosofia.
Shakespeare, *Amleto*, Atto I, scena 5

Corriamo il cielo, dunque, per sette giorni e sette notti;
all'ottavo vediamo sospesa in aria una grande terra, simile a un'isola,
luminosa, a forma di palla e illuminata da una grande luce.
Luciano, *Storia vera*

Quale mezzo migliore di una cometa – strana abitante del cielo che arriva inaspettatamente dal buio profondo per poi ritornarvi dopo un lungo giro attorno al Sole – per andare a esplorare il nulla? In fondo, se dal nulla viene e al nulla torna, quel nulla oscuro poi tanto "nulla" non deve essere.

Qualcosa si dovrà pur celare in quello spazio che precede le stelle fisse e la regolarità dei ritorni di alcune comete fa intuire che quel qualcosa deve essere ordinato, di un'immensa, avvolgente, *iperuranica* bellezza matematica vivente al di sopra del cielo di Saturno. Il nostro Ulisse Celeste, futuristico barone di Münchhausen, si ritrova così a cavalcioni della cometa elevata a strumento di conoscenza, lanciato a squarciare il nero manto stellato. E dopo un percorso lunghissimo, il buio pesto finalmente partorisce un fantasma: il pianeta Urano.

A sottolineare in modo degno l'apparizione, le note iniziali dell'*Allegro* di Holst intitolato *Urano, il Mago* tanto allegre non sono: le trombe e i tromboni annunciano gravi il suo ingresso nel campo visivo, lasciando che i fagotti completino un quadro di mistero capace di ricordarmi le note dello *Scherzo* di Paul Dukas, scritte nel 1897 e sulle quali *l'Apprendista Stregone* Topolino si allenava, nel cartone animato *Fantasia* della Disney, a far muovere catini e scope.

Come ci ha narrato Esiodo, Urano – nome derivato dal termine greco che sta per *cielo* – è fuggito nell'oscurità perché scacciato, allontanato dal figlio Saturno istigato da Gaia. Lì, l'*Urano ampio* della teogonia esiodea si nasconde chiudendosi nel suo manto notturno screziato di stelle e sembra quasi tramare il ritorno, una sua vendetta contro la Terra e i loro figli, dissuaso dal farlo dalla vista della lama scintillante di Saturno di cui, secondo il mito, avrebbe già fatto la poco gradita conoscenza. Quello che ci troviamo di fronte è quindi proprio lui, il personaggio del mito greco il quale, con la sua muta presenza, ci dice che sì, il Sistema Solare arriva fino a qui con il suo corpo di sfere. La nostra sorpresa è grande: in effetti qualcuno l'aveva già osservato sia a occhio nudo che col telescopio, scambiando però quel debole puntino per una stella come tante altre. Addirittura il precisissimo astronomo reale inglese John Flamsteed lo incluse nel suo catalogo redatto nel 1690 con il nome di *34 Tauri*, ovvero trentaquattresima stella della costellazione del Toro, ma da allora l'astro, a parte una decina di sporadici avvistamenti da parte di altrettanti astronomi, fece perdere le sue tracce fintanto che, il 13 marzo del 1781, ricomparve nella costellazione dei Gemelli, vicino alla stella *H Geminorum*. A vederlo fu l'organista William Herschel il quale, appassionato di astronomia e costruttore di ottimi telescopi, lo scorse con uno dei suoi strumenti durante una campagna di osservazione sistematica del cielo alla quale si era dedicato con l'intento di scoprire stelle doppie. Se il cielo è particolarmente pulito, se si sa dove osservare e se il contrasto con il buio cosmico è tale da metterlo bene in evidenza, Urano può essere osservato a occhio nudo. Insomma, non deve esserci inquinamento luminoso, inquinamento atmosferico generico e bisogna essere esperti osservatori: con tutte queste condizioni, credere che quel puntino sia un pianeta è comunque difficile in quanto, per l'occhio umano, risulta indistinguibile da una stella qualunque.

Ma se si prova a osservarlo con un telescopio sufficientemente potente, la differenza con le altre stelle cosiddette *di campo* che entrano nell'oculare appare evidente e la cosa non deve essere sfuggita all'attento Herschel il quale, insospettito, per la prima volta lo studiò usando oculari diversi capaci di creare ingrandimenti differenti. È cosa nota a chi osserva al telescopio che le stelle, anche se osservate con strumenti più grandi, data la loro immensa distanza da noi, appaiono essere nulla di più che puntini luminosi. La nuova stella osservata da Herschel invece esibiva una superficie luminosa che aumentava di dimensioni all'aumentare degli ingrandimenti e ciò lo indusse a pensare di essersi imbattuto in una nuova e strana cometa senza coda. Quando, dopo mesi di osservazioni, ci si rese conto che il suo moto non era affatto quello tipico degli oggetti cometari che, nel migliore dei casi, solcano il Sistema Solare disegnando una ellisse con l'asse maggiore estremamente allungato, allora si capì che era stato scoperto un nuovo pianeta oltre l'orbita di Saturno. L'evento penso possa essere fatto rientrare nella categoria delle rivoluzioni culturali e varrebbe la pena indagare sulla risonanza che fu data alla notizia, magari tramite un attento studio dei giornali dell'epoca. In ogni caso, per capire come questo pianeta si muoveva attorno al Sole, e quindi come fosse fatta la sua orbita, c'era bisogno di consultare il suo *curriculum*: bisognava sapere di più circa le sue precedenti posizioni. E fu così che, dopo attenta e difficile ricerca nei vecchi cataloghi, venne ri-

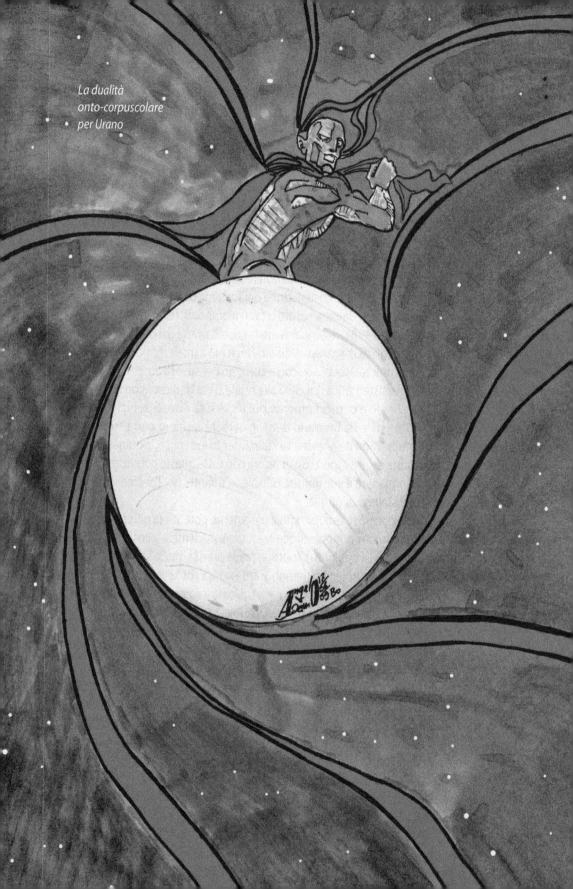

La dualità
onto-corpuscolare
per Urano

trovato in quello di Flamsteed risalente a ben 91 anni prima. Pian piano i vari pezzi del puzzle trovavano la loro giusta collocazione: prima era nella costellazione del Toro, ora lo si ritrovava in quella dei Gemelli... Quella che per Flamsteed era una stella, si muoveva esattamente nella zona in cui si osservano gli altri pianeti conosciuti che intersecano le dodici costellazioni zodiacali poste attorno al piano dell'eclittica. Rimaneva ancora molto da capire e innanzi tutto era importante stabilire a quale distanza dal Sole svolgesse la propria mansione di nuovo limite esterno del nostro sistema planetario. Farò ora qualcosa che potrebbe costituire un'eresia da un punto di vista storico: non avendolo trovato in nessuno dei libri da me consultati sull'argomento, cercherò a modo mio di ricostruire il processo mentale che ha condotto a scoprire questo dato mancante. Gli indizi a disposizione erano due: la posizione nel 1690 e quella nel 1781. Il pianeta quindi poteva aver compiuto attorno al Sole: a) molte orbite (da due orbite in su), b) più o meno un'orbita completa, c) una piccola frazione di orbita. Nel caso a) doveva trattarsi di un pianeta molto veloce e, supponendo che nei 91 anni intercorsi tra le due osservazioni avesse inanellato anche solo due orbite, il suo moto proiettato in cielo avrebbe coperto il percorso angolare di $2 \cdot 360° = 720°$.

Questo implicherebbe un moto annuo pari a 720°/ 91 anni = 7,91° all'anno, una velocità angolare che, se paragonata con i 12° di velocità annua fatti registrare da Saturno, risulta compatibile con il fatto che man mano che ci si sposta verso l'esterno del Sistema Solare i pianeti, obbedendo alla terza legge di Keplero (2.8), rallentano il loro moto. L'ipotesi che avesse compiuto tre rivoluzioni complete avrebbe comportato invece una velocità angolare di (3 · 360°)/ 91 anni = 11,86° all'anno, così simile a quella di Saturno da implicare una loro inconcepibile vicinanza. Con questo stesso ragionamento possiamo tranquillamente rigettare la possibilità che il nuovo pianeta, nel lasso di tempo considerato, possa aver compiuto più di due orbite in quanto, già col solo teorizzarne quattro, si troverebbe a essere in un'orbita interna a quella di Saturno. L'esperienza di millenni di osservazione umana del cielo aveva già mostrato da tempo come al di fuori dei pianeti conosciuti, non vi fosse null'altro di macroscopico a muoversi da quelle parti.

Se i disegni delle dodici costellazioni zodiacali fossero precisamente intervallati, a ognuna di loro spetterebbero in media 360°/ 12 costellazioni = 30° per costellazione.

L'ipotesi b) implica che il nuovo pianeta abbia percorso 360° + 30° = 390° in 91 anni, ovvero una velocità angolare v_{ang} = 4,28° all'anno. Una rivoluzione completa la si avrebbe quindi in 360°/ v_{ang} ≈ 84 anni.

Se consideriamo infine il caso c), dobbiamo supporre che nei novantuno anni trascorsi tra le due osservazioni, il pianeta si sia mosso soltanto della distanza tra le due costellazioni adiacenti del Toro e dei Gemelli. Se nei novantuno anni intercorsi, il nuovo pianeta si fosse così mosso di soli 30°, avrebbe un lentissimo moto annuo di circa 0,3° che lo porrebbe automaticamente a una distanza enorme dal Sole.

A questo punto, propongo di divertirci a calcolare le distanze dal Sole nei vari casi a), b) e c) per cercare di capire dove accidenti dobbiamo immaginare che viva il nuovo arrivato. Armiamoci di pazienza, calcolatrice e procediamo:

Caso a)

Due orbite in novantuno anni implicano, come abbiamo calcolato prima, 7,91° all'anno. Una rivoluzione completa la si avrebbe quindi in 360°/ 7,9° ≈ 45,5 anni.

Inserendo questa durata nella terza legge di Keplero e ricordando che in un anno ci sono più o meno trenta milioni di secondi ($30 \cdot 10^6$ s $= 3 \cdot 10^7$ s) si ottiene una distanza pari a:

$$
\begin{aligned}
L &= (GM_{Sole} \cdot T^2/4\pi^2)^{1/3} = \\
&= [6,67 \cdot 10^{-8} \text{ dyne cm}^2 \text{ g}^{-2} \cdot 1,98 \cdot 10^{33} \text{g} \cdot (45,5 \cdot 10^7 \text{ s})^2/4\pi^2]^{1/3} = \quad (11.1) \\
&= 1.840 \cdot 10^6 \text{ km} \approx 12 \text{ U.A.}
\end{aligned}
$$

Notiamo che Saturno, fino alla sera del 13 marzo 1781 ancora confine ultimo del Sistema Solare, orbita attorno al Sole tenendosi a una distanza di circa 9,5 Unità Astronomiche.

Caso b)

Abbiamo già calcolato che, nel caso in cui il nuovo pianeta abbia percorso 390°, ovvero poco più di un'orbita, risulterà avere un periodo di 84,1 anni. Inserendo stavolta questo nuovo dato nella (12.1) otteniamo:

$$
\begin{aligned}
L &= [6,67 \cdot 10^{-8} \text{ dyne cm}^2 \text{ g}^{-2} \cdot 1,98 \cdot 10^{33} \text{g} \cdot (84,1 \cdot 3 \cdot 10^7 \text{ s})^2 / 4\pi^2]^{1/3} = \\
&= 2.771 \cdot 10^6 \text{ km} \approx 18 \text{ U.A.}
\end{aligned}
$$

che, attuando un confronto con quella del solito Saturno, viene a essere una distanza dal Sole più o meno doppia.

Caso c)

Nel caso in cui il nuovo pianeta abbia percorso solo una trentina di gradi nei novantuno anni considerati per il calcolo dell'orbita, si avrebbe una velocità angolare di 0,3 gradi all'anno che – ricordando come il grado possa essere ulteriormente diviso in sessanta parti – corrispondono a 18 primi. Di conseguenza, se questa fosse l'ipotesi giusta, si avrebbe che il pianeta compirebbe una rotazione completa in (360° · 60') / 18' all'anno = 1.200 anni! Inserendo questo ultimo dato nella (11.1) si otterrà per la sua distanza:

$$
\begin{aligned}
L &= [6,67 \cdot 10^{-8} \text{ dyne cm}^2 \text{ g}^{-2} \cdot 1,98 \cdot 10^{33} \text{g} \cdot (1.200 \cdot 3 \cdot 10^7 \text{ s})^2 / 4\pi^2]^{1/3} = \\
&= 1,6 \cdot 10^{10} \text{ km} \approx 109 \cdot 10^2 \text{ U.A.}
\end{aligned}
$$

verrebbe quindi a essere un oggetto estremamente lontano, posto a un centinaio di volte la distanza che c'è tra il Sole e la Terra.

A decidere tra queste tre possibilità, almeno in linea di principio egualmente valide, fu negli anni successivi la misurazione dei piccoli spostamenti del nuovo pianeta. Le sue variazioni di posizione permisero di ricostruire l'orbita pezzo dopo pezzo mostrando che essa

veniva percorsa in un tempo confrontabile con quello previsto nel caso b) e questo dato pose in modo definitivo il pianeta a una distanza dal Sole di 19 Unità Astronomiche, in strano accordo con quanto diceva la cosiddetta "legge empirica" di Titius e Bode. Di essa abbiamo già avuto modo di parlare nel capitolo dedicato alla fascia degli asteroidi, dicendo che prediceva proprio l'esistenza di un eventuale sesto pianeta orbitante attorno al Sole alla buia distanza di:

$$\left[\qquad d_6 = 0{,}4 + 0{,}3 \cdot 2^6 = 19{,}6 \text{ U.A.} \qquad \right]$$

In un primo momento, Herschel chiamò il nuovo pianeta *Georgium Sidus*. Forse lo fece per autentica riconoscenza o più semplicemente per piaggeria nei confronti del suo re il quale premiò la scoperta riconoscendo al suo autore un notevole vitalizio col quale affrancarsi dal lavoro di musicista per dedicarsi a tempo pieno all'amata astronomia. Il pianeta venne in seguito ribattezzato "Urano" da quello stesso Bode della legge empirica, una scelta che risultò vincente, in quanto si collocava nella scia della millenaria tradizione che affibbiava ai pianeti nomi derivanti dalla mitologia greca, e anche perché risultò più gradita di *Georgium Sidus* a tutti gli abitanti della Terra che non erano sudditi del grazioso re d'Inghilterra. Lo studio successivo del nuovo, ultimo pianeta del Sistema Solare ha permesso di stabilire che in effetti, similmente a quanto narra il mito, qualcosa di violento gli sia capitato davvero in gioventù: i segni lasciati da un vecchio incidente occorsogli sembrano scagionare Saturno e dare la colpa a un corpo comunque massiccio che deve averlo urtato così tanto forte da mandare a tappeto il giovane Urano il quale non è stato più capace di rialzarsi e da allora letteralmente "rotola" sul piano dell'eclittica mantenendo il suo asse di rotazione quasi parallelo a tale piano.

Le osservazioni successive, condotte con un telescopio ancora più potente del precedente, valsero allo stesso Herschel la scoperta delle prime due lune di Urano – oggi se ne conoscono ben ventisette – che vennero battezzate da suo figlio John, futuro grande astronomo, *Oberon* e *Titania*, rispettivamente nomi del re degli Elfi e di sua moglie nella shakespeariana *Sogno di una notte di mezza estate*. Nell'ultimo quarto della trentanovesima battuta del brano di Holst, mi sembra di sentire la voce da oboe di Titania che provoca il marito il quale le risponde due battute più avanti borbottando indispettito con voce da fagotto. Continueranno ancora per un po' inscenando uno dei loro tipici litigi coniugali riportati nella commedia del drammaturgo inglese, fintanto che l'acciglato Urano, irritatosi per il battibeccare dei due, li rimprovererà dalla battuta sessantadue in poi fino a esplodere di rabbia nel tema finale.

A ben vedere, a parte il colore e le minori dimensioni, il gigante celeste Urano è un pianeta molto simile a Giove e Saturno, con i quali condividerebbe molte caratteristiche fisiche come per esempio il fatto di essere un pianeta gassoso. A differenziarlo dai due pianeti posti su orbite più interne, ci pensa la sua composizione chimica che rivela indizi della presenza di composti ghiacciati. In qualche modo, c'era da aspettarselo: orbitando a grande distanza dalla stufa solare, il protagonista di questo capitolo sperimenta condizioni ambientali che favoriscono la formazione di ghiacci. Se la sua fisicità è simile a quella degli altri pianeti, le sue aspirazioni non lo sono affatto. Infatti, per ironia della sorte, mentre Giove *desiderava* diventare una stella, Urano ha da sempre cercato di essere solo quello che di fatto è: un pianeta. E invece, senza mai averlo richiesto, si è visto assegnare un ruolo di stella lontana che gli ha impedito di assurgere al rango di divinità e di essere venerato dagli uomini nel lungo periodo storico in cui andava di moda adorare i pianeti. È stato di sicuro sfortunato e il minimo che possiamo fare per lui è cercare di capire come diavolo sia potuto succedere che nessuno si sia accorto della sua natura planetaria prima delle osservazioni di Herschel. Il problema è squisitamente strumentale e ha a che fare con la sensibilità del nostro dispositivo di osservazione *d'ordinanza*: l'occhio. Da recenti studi, pare che esso riesca a percepire nell'oscurità notturna la fiamma di una candela fino a trenta chilometri di distanza (!). Un dato che ha dell'incredibile e che mi fa domandare come mai le cose siano andate così per Urano che, a conti fatti, doveva essere abbastanza visibile. Non mi credete? Allora, lettori di poca fede, facciamoli 'sti conti! Intanto riconsideriamo la fiamma di una candela: essa avrà una dimensione di più o meno un paio di centimetri che, similmente a quanto avverrà per l'angolo da essa sotteso, appariranno diminuire se sposterò la candela portandola lontano da me.

Immaginiamo ora di porci al centro di un'ideale circonferenza di raggio pari alla distanza della candela da noi e, grazie alla nota relazione trigonometrica $L = R\sin\theta$ che lega la lunghezza L della corda AB alla lunghezza R del raggio tramite l'angolo al centro da essa sotteso, e che per angoli molto piccoli può essere approssimata con la $L \approx R\theta$, possiamo trovare le dimensioni angolari della fiammella posta alla distanza R = 30 km da noi:

$$\theta_{\text{Fiamma candela}} = L/R \approx 0{,}00002 \text{ km} / 30 \text{ km} = 0{,}6 \cdot 10^{-6} \text{ radianti}$$

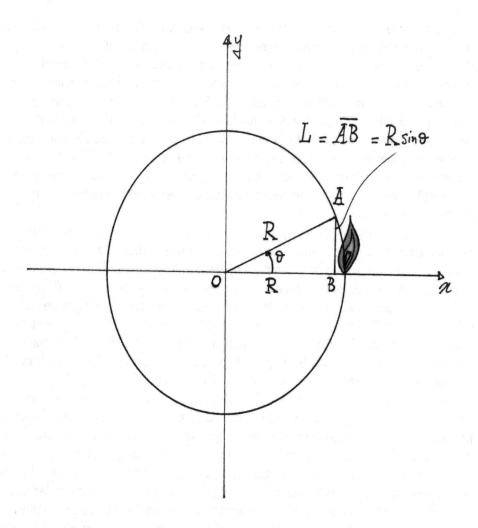

Un angolo minuscolo del quale, se ne vogliamo avere una percezione più familiare, possiamo darne una traduzione in gradi, minuti e secondi trasformandolo con la seguente procedura: dato che 2π radianti = 360°, allora un radiante – ovvero un arco di circonferenza lungo quanto il suo raggio – sarà pari, in gradi, a:

$$1 \text{ radiante} = 360°/2\pi = 57{,}29°$$

Dal momento che i gradi li consideriamo divisibili in 60 primi e i primi li dividiamo in 60 secondi, se vogliamo sapere a quanti secondi d'arco corrisponda un radiante, dobbiamo moltiplicarne la misura in gradi per 3.600 (60 minuti per 60 secondi) ottenendo così:

$$1 \text{ radiante} = 57{,}29° \cdot 3.600'' = 206.264''$$

Vi presento il numero 206.264: è il nostro traduttore dalla lingua dei radianti a quella dei secondi, ovvero il fattore per cui moltiplicare la misura di un arco di circonferenza in *unità di raggi*, per così dire, così da ottenerne una in secondi d'arco. Allora diamo subito qualcosa da fare al nostro interprete chiedendo di tradurci in secondi d'arco la sensibilità di un occhio umano quando riesce a scorgere la fiammella di una candela a trenta chilometri di distanza. Ormai lo abbiamo capito, basta fare semplicemente:

$$\theta \text{ (in secondi d'arco)} = \theta \text{ (in radianti)} \cdot 206.264'' =$$
$$= 0,6 \cdot 10^{-6} \text{ radianti} \cdot 206.264'' = 0,12 \text{ secondi d'arco}$$

Oggi sappiamo che il diametro del gigante gassoso Urano, massiccio quanto quattordici pianeti come la nostra Terra, è di circa 51.000 km. La sua distanza da noi, essendo quella dal Sole di 19 Unità Astronomiche, sarà di 18 U.A., ovvero 18 volte centoquarantanove milioni di chilometri. Allora l'angolo sotto il quale si presenta questo pianeta se osservato a occhio nudo dalla Terra sarà, in radianti:

$$\theta_{Urano} \text{(in radianti)} = 51 \cdot 10^3 \text{ km} / (18 \cdot 149 \cdot 10^6 \text{ km}) = 0,019 \cdot 10^{-3} \text{ radianti}$$

Moltiplichiamo questo numero per il solito fattore di conversione tra radianti e secondi d'arco e otteniamo:

$$\theta_{Urano} \text{ (in secondi d'arco)} = \theta_{Urano} \text{ (in radianti)} \cdot 206.264'' =$$
$$= 0,019 \cdot 10^{-3} \text{ radianti} \cdot 206.264'' = 3,89''$$

Un numero abbastanza al di sopra del limite di visibilità di una persona dalla vista acutissima che fa di Urano un pianeta visibile.

Il problema è che, parlando di acuità visiva umana, molto più di frequente si assume come suo valore medio il primo d'arco, ovvero i sessanta secondi. Appare quindi chiaro come lo scorgere un oggetto di nemmeno quattro secondi d'arco, sperduto in mezzo a una miriade di punti simili, costituisca per un occhio normale un notevole problema. In pratica, per i più, esso non esiste…

Per Saturno, limite visibile a occhio nudo dell'antico Sistema Solare, invece si ha:

$$\theta_{Saturno} \text{(in radianti)} \approx 120.000 \text{ km} / 8,5 \text{ U.A.} =$$
$$= 12 \cdot 10^4 \text{ km} / (8,5 \cdot 150 \cdot 10^6 \text{ km}) = 9 \cdot 10^{-5} \text{ radianti}$$

Esprimendo questo risultato in secondi d'arco, si ottiene:

$$\theta_{Saturno} \text{ (in secondi d'arco)} = \theta_{Saturno} \text{ (in radianti)} \cdot 206.264'' =$$
$$= 9 \cdot 10^{-5} \text{ radianti} \cdot 206.264'' = 18,56''$$

ovvero quasi un terzo di primo: decisamente un angolo più grande di quello sotto il quale vediamo Urano ed ecco spiegato perché Saturno era conosciuto come pianeta e Urano no! Ben due primi al di sopra dell'acutezza di un occhio medio: ecco perché Saturno era conosciuto come pianeta e Urano no!

Il nostro Ulisse Celeste fa tesoro di questa constatazione e, messo sul chi vive dall'amletico aforisma riportato in apertura di capitolo, si lascia condurre dalla cometa con il cuore finalmente colmo di speranza e con mente ancora più curiosa. Scivola silenzioso verso il buio cosmico non più associato al niente, ma piuttosto a una pienezza ancora immanente e di sicuro sorprendente: l'ignoto. Ha il tempo di pensare e si chiede: se davvero – come qualcuno persistentemente sostiene – tutto ciò è stato fatto in nome di un ruolo centrale da assegnare all'umanità all'interno del progetto cosmico, che senso ha non aver dotato l'uomo di sensi abbastanza acuti da cogliere l'Universo nella sua interezza? Un dubbio forte si impadronisce del nostro esploratore il quale si ricorda quanto letto circa un velo di Maya che viene sollevato a svelare la realtà delle cose:

> Nessuna verità è adunque più certa, più indipendente da ogni altra, nessuna ha minor bisogno d'esser provata, di questa: che tutto ciò che esiste per la conoscenza – adunque questo mondo intero – è solamente oggetto in rapporto al soggetto, intuizione di chi intuisce; in una parola, rappresentazione. (...) L'intero mondo degli oggetti è e rimane rappresentazione, e appunto perciò in tutto ed eternamente relativo al soggetto: ossia ha una idealità trascendentale. Tuttavia il mondo non è per questo né menzogna né illusione: si dà per quello che è, come rappresentazione, e precisamente come una serie di rappresentazioni, il cui vincolo comune è il principio di ragione.
>
> Arthur Schopenhauer, *Il mondo come volontà e rappresentazione*

INTERMEZZO

Spazz-Aree: fondamenti di scopone scientifico

Abbiamo parlato dell'apprendista stregone impersonato da Topolino che tenta di comandare a scope e mastelli di pulire il castello in vece sua. Intanto volevo farvi notare che il titolo francese è *L'apprentì sorcier* e quello inglese è *The Sorcerer's Apprentice*. In italiano noi diciamo *stregone* e non qualcosa di simile a *sorcer*, ma guarda caso, in francese le parole per *topo* e *stregone* si assomigliano e così ecco che nel cortometraggio della Disney a commento del brano di Dukas, il protagonista è proprio Topolino, un *sorcio*.

Torniamo ora all'astronomia e approfitto dell'atmosfera del brano citato, di cui ho riportato lo spartito del primo tema suonato dal fagotto, per raccontarvi la seconda cosa migliore che ha detto Keplero nella sua vita. Supponete di essere l'*Apprendista Sorcio* e di dover pulire, in un dato tempo *t* che chiamiamo *anno*, una superficie molto, molto grande che chiamiamo *piano dell'Eclittica*. Vi forniscono una scopa, un mastello con acqua e sapone e un calendario. Poi vi dicono che quella superficie di area pari a:

$$\text{Area} \approx \pi R^2_{\text{Sole-Pianeta}}$$

circoscritta dall'orbita del pianeta che gira attorno al Sole nel tempo *t*, va spazzata precisamente entro l'anno *t*. Di sicuro pianificherete lo sforzo stabilendo con la semplice divisione *Area/Anno* – a tutti gli effetti una velocità detta *velocità areale* – quanti giorni dovrete dedicare a ogni singolo spicchio di superficie per finire esattamente nel tempo previsto. Da notare: saranno tutti spicchi di area uguale, aventi anche l'angolo al centro uguale. Nel fare la divisione precedente così da pianificare bene il lavoro, abbiamo fatto la semplificazione che il piano da pulire sia circolare.

Ora invece supponete che vi comandino di spazzarne uno ellittico. Scoprirete che non sarà più utile fare la semplice divisione di prima, perché ad angoli uguali contati da uno dei due fuochi – nel caso del piano delimitato dall'orbita ellittica di un qualsiasi pianeta, consideriamo il fuoco nel quale vi è il Sole (più fuoco di così!) – non corrisponderanno spicchi uguali. Alcuni risulteranno avere lati lunghi, altri invece avranno lati molto corti e di conseguenza, ad angoli al centro uguali, corrisponderanno spicchi triangolari con aree diverse. Capite allora che, dovendo spazzare, ciò che conviene fare è suddividere l'intero piano in spicchi triangolari di superficie uguale senza preoccuparsi dell'angolo nel vertice dove c'è il Sole: i lati curvi di tutti i 365 triangoli – per intenderci, quelli indicati con c e d, o giacenti sull'orbita e opposti agli angoli al centro – avranno tutti lunghezze differenti.

Fig. 1 **Fig. 2**

Se invece di spazzare le aree, vi chiedessero di percorrere questi lati dei triangoli in modo da completare il giro in un anno esatto, scoprireste di dovere accelerare il passo in alcuni pezzi di orbita e di doverlo rallentare in altri. Parimenti scoprireste che è possibile prendere i classici due piccioni con una fava: se usate una scopa dotata di una spazzola elastica, attaccandone un estremo a un fuoco dell'ellisse e tenendone in mano l'altro capo, muovendovi lungo l'orbita con velocità variabile, potreste spazzare la superficie ellittica nel tempo richiesto. Bene, adesso torniamo a parlare di pianeti e d'ora in poi non sarete più voi a pulire in quanto, da bravi *apprendisti sorci*, vi siete fatti sostituire da un cosiddetto *raggio vettore*, un segmento di lunghezza variabile al quale abbiamo attaccato fili di saggina, una specie di gigantesco tergicristallo: esso parte dal fuoco dell'ellisse dove c'è il Sole per arrivare a toccare l'orbita nelle varie posizioni occupate da un pianeta nel suo procedere attorno alla nostra stella.

Allora potremo dire che *il raggio vettore spazzerà aree uguali in tempi uguali* che tradotto in un linguaggio meno professorale, significa che il pianeta rallenterà quando sarà lontano dal Sole e accelererà quando gli sarà vicino. Questa è la seconda legge di Keplero!

Nettuno, il pianeta venuto dal freddo… calcolo

Una volta scoperto Urano, l'obiettivo principale perseguito effettuando osservazioni in vari periodi dell'anno, fu dare una forma matematica alla sua orbita. Questo, lungi dall'essere un vezzo degli scienziati i quali vengono spesso visti come matti interessati solo al mettere sotto forma di equazioni tutto ciò che vedono, aveva uno scopo ben preciso: si trattava di capire dove fosse Urano in qualsiasi momento del passato, del presente e del futuro. Il passato di Urano, così come il suo futuro, non può essere osservato. Ma ciò che forse sfugge è che, dato il suo lentissimo moto di rivoluzione attorno al Sole, per lunghi periodi dell'anno (terrestre!) anche il suo presente risulta inosservabile dal nostro pianeta che invece rivolve velocemente finendo dalla parte opposta del Sole in soli sei mesi. Una semplice equazione del moto, un modo come un altro di disegnare un'ideale linea in cielo, permette invece di sapere dov'è (dov'era, dove sarà) in qualsiasi istante, consentendoci di seguire nel suo corso "l'idea" di Urano. Quindi, nonostante sia stato il primo pianeta scoperto col telescopio, per sapere dove si trova Urano spesso non basterà l'uso di uno strumento che potenzi la nostra vista. Né tantomeno saranno l'udito, l'odorato, il gusto o il tatto a venirci in aiuto, ma solo la matematica, il *sesto senso*. Usandolo, però, si capì quasi subito che bisognava dubitare di ciò che questo *sesto senso* suggeriva poiché, col suo tramite, non si riusciva ad avere percezioni del tutto esatte: detto in parole povere, il pianeta non risultava essere visibile laddove le equazioni ci dicevano che l'avremmo trovato. Anche nei periodi in cui la Terra rivolveva attorno al Sole standosene dalla stessa parte di Urano che diventava così osservabile, puntando i telescopi dove le equazioni dicevano di guardare, si osservava uno spazio vuoto: il pianeta era sempre un po' in anticipo o in ritardo rispetto alle posizioni previste dalla forma matematica della sua orbita così come descritta dai teorici. Tra voi che leggete ci sarà di sicuro chi obietterà: "Ma come, fino a qualche pagina fa potevamo dire con sicurezza in quanto tempo Urano compie un giro completo attorno al Sole e ora invece si scopre che non si muove in modo regolare?". Sì, è così. Una cosa è il tempo medio che impiega un pianeta a muoversi lungo l'orbita che assumiamo, per semplicità, percorsa a velocità costante; un'altra cosa è valutare come si muove in segmenti sempre più piccoli del suo percorso. Se andiamo a vedere cosa succede al pianeta in istanti diversi (badate, non in periodi diversi…), scopriremo che esso non mantiene la sua velocità costante, ma la varia di continuo a seconda di ciò che le varie forze agenti su di esso gli dicono di fare.

D'altra parte, qualcosa del genere l'abbiamo già vista parlando della seconda legge di Keplero che ci dice come i pianeti mutino la loro rapidità al variare della posizione lungo il percorso attorno al Sole. A causa di queste discrepanze fra teoria e osservazioni, ci fu subito chi pensò che fossero sbagliate le leggi usate per simili previsioni; che questa fosse la prova dell'inapplicabilità delle leggi di Newton a ciò che sta lontano da qui dove invece esse dimostrano di funzionare benissimo. Qualcun'altro, credendo persistentemente nella validità delle equazioni newtoniane a tutte le distanze da noi, avanzò l'idea che, per fare in modo che il "telescopio matematico" riuscisse a puntare dritto su Urano, rimaneva solo l'alternativa rappresentata dall'ipotizzare l'esistenza di un altro pianeta massiccio che se ne stava acquattato nell'oscurità ad attirarlo da un'orbita ancora più esterna. Povero Urano! Dopo essere stato trascurato per millenni, sfrattato per errore umano dal consesso dei *pianeti-dei*, aveva da poco conquistato dignità di ultimo pianeta del Sistema Solare prendendo il posto di Saturno che comunque di attenzioni ne aveva già ricevute tante, quando a qualcuno venne in mente che poteva anche non essere l'ultimo… Probabilmente ancora non era stato smaltito lo stupore generato dalla scoperta che Saturno non era affatto l'ultimo pianeta, e includere nei calcoli l'influenza gravitazionale che Urano poteva subire da un ulteriore corpo planetario sarebbe stato indice di una spregiudicatezza scientifica non ancora nelle corde degli esperti di meccanica celeste. Ma a partire da un certo momento in poi, l'idea incominciò a serpeggiare nella comunità scientifica e più di uno scienziato deve aver fatto il seguente ragionamento: "Se un altro pianeta lontano esiste, non potendo vederlo, non sappiamo né dove si trova, né come è fatto. Proviamo allora a tentare di risalire alle sue caratteristiche fisiche e alla sua posizione in modo indiretto, partendo cioè dalle differenze esistenti tra le posizioni teoriche di Urano previste dai nostri calcoli e le posizioni reali in cui esso viene osservato". Fu così che il britannico John Couch Adams e il francese Urbain Le Verrier, indipendentemente l'uno dall'altro, per la prima volta *osservarono* il nuovo pianeta col loro nuovo *telescopio matematico* e lo *videro* come una serie di formule che ne stabilivano la posizione in cielo, fornendo anche una misura della sua grandissima massa teorica; un'osservazione ideale cui seguì con esito positivo quella sperimentale effettuata dall'osservatorio di Berlino dall'astronomo Johann Gottfried Galle su indicazioni di Le Verrier la sera del 23 settembre 1846. Erano passati solo settantacinque anni dalla scoperta di Urano che, così spodestato dal suo ruolo di nuovissimo confine del Sistema Solare, nel frattempo non aveva neanche avuto modo di ultimare il suo giro d'onore che avrebbe richiesto ancora nove anni per giungere al termine. Quindi il nuovo pianeta che oggi chiamiamo Nettuno venne fuori dal buio cosmico come a dirci: "in principio era il numero", quasi che quel pianeta non fosse mai esistito fintanto che qualcuno non ne ha inventato la forma matematica. Una situazione strana che non sfuggì al noto astronomo francese François Arago il quale affermò: "Monsieur Le Verrier ha trovato un pianeta sulla punta della sua penna".

Questa nuova scoperta fece registrare un nuovo, incredibile successo della teoria newtoniana che qualcuno aveva provato a mettere in dubbio. Essa avrebbe ricevuto uno scossone nei primi anni del '900, ma per il momento era salva e salda come mai. Nettuno è un gigante gassoso ghiacciato un po' più piccolo di Urano – possiede un raggio equatoriale pari a 3,8 volte

quello della Terra – e con una massa pari a diciassette volte quella del nostro pianeta. Combinando questi due dati si scopre che ha una densità pari a 1,7 g/m³, la più alta fra quelle dei pianeti giganti. Si muove alla distanza di circa trenta Unità Astronomiche dal Sole impiegando quasi 165 anni a compiere una rivoluzione completa e, dalla nostra posizione, lo si dovrebbe scorgere sotto un angolo dato da un calcolo analogo a quello già affrontato nel capitolo precedente dal quale, *mutatis mutandis*, risulta $\theta_{Nettuno} \approx 2''$: una dimensione apparente a tutti gli effetti non percebile dall'occhio nudo. Senza voler scendere nei dettagli matematici, grazie ai dati su Nettuno possiamo ora cercare di capire meglio il problema fisico dell'irregolarità del moto di Urano. Quella volta ogni 171 anni che Sole, Urano e Nettuno si trovano sulla stessa linea, Urano viene a essere soggetto a due forze contrastanti. Se non ci fosse Nettuno, continuerebbe il suo moto indisturbato e non devierebbe mai dal percorso descrivibile con la sola terza legge di Keplero, ma nel momento in cui interviene anche l'attrazione di Nettuno, il povero Urano diventa la corda di un immane *tiro alla fune* tra il nuovo pianeta e il Sole, e la sua orbita ne risulta perturbata.

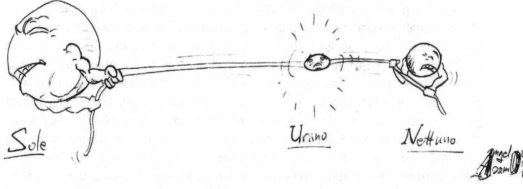

Sole Urano Nettuno

Il calcolo delle perturbazioni è una branca molto complicata della meccanica celeste e qui basterà solo far capire da dove prende le mosse il problema dandone una versione estremamente semplificata. Grazie alla (2.4) possiamo scrivere la forza che tiene legato Urano al Sole nella forma:

$$\left[\quad F_{\text{Sole-Urano}} = -G\ M_{\text{Sole}} \cdot M_{\text{Urano}} / d^2_{\text{Sole-Urano}} \quad \right]$$

e quella che Urano sente a causa della presenza di Nettuno come:

$$\left[\quad F_{\text{Nettuno-Urano}} = -G\ M_{\text{Nettuno}} \cdot M_{\text{Urano}} / d^2_{\text{Nettuno-Urano}} \quad \right]$$

Da cui si ricava che Urano, essendo durante l'allineamento distante undici Unità Astronomiche da Nettuno e diciannove dal Sole, avverte un'attrazione verso l'altro pianeta gigante circa diecimila volte meno intensa di quella che lo tiene legato alla nostra stella:

$$\left[\begin{array}{l} F_{\text{Nettuno-Urano}} / F_{\text{Sole-Urano}} = (M_{\text{Nettuno}} / M_{\text{Sole}}) \cdot (d_{\text{Sole-Urano}} / d_{\text{Nettuno-Urano}})^2 = \\ = (17 \cdot 5{,}97 \cdot 10^{27}\,g / 1{,}98 \cdot 10^{33}\,g) \cdot (19\ \text{U.A.} / 11\ \text{U.A.})^2 = 1{,}5 \cdot 10^{-4} \end{array} \right]$$

Un effetto piccolo ma, come le osservazioni ci dimostrano, non trascurabile.

Sarà forse per la sua colorazione bluastra dovuta alla presenza di composti come il metano che, similmente a quanto accade su Urano, trattengono la parte rossa della radiazione solare incidente sul pianeta, riflettendone solo la componente blu; fatto sta che questo pianeta ha più volte stimolato tra gli osservatori la connessione con l'elemento acqueo. Prima di essere battezzato dallo stesso Le Verrier col nome *Nettuno*, traduzione latina della divinità marina Poseidone della mitologia greca, qualcuno aveva proposto il nome Oceano. In seguito, una volta affermatosi il nome che ancora oggi porta, le maggiori otto delle sue tredici lune vennero chiamate come altrettante divinità marine: Tritone (la più grande e quella il cui moto ci ha permesso di risalire alla massa di Nettuno), Nereide, Naiade, Thalassa, Despina, Galatea, Larissa, Proteo.

Il brano di Holst *Nettuno, il mistico* che descrive questo pianeta in musica, inizia proprio con un "galleggiare" di flauti, clarinetti e arpe che mi sembra perfettamente in linea con il nome dato al pianeta e con il carattere che verrebbe istintivamente da associare al nuovo, ultimo contrafforte planetario prima del baratro cosmico. Il limite di conoscenza era stato spostato in avanti per ben due volte in meno di un secolo, e qualcosa di quell'ignoto era nel frattempo diventato noto. La verità sulla quale si affaccia Nettuno non era più qualcosa di oscuro, terrificante e definitivo, ma ritengo possibile che oramai venisse connessa semplicemente al processo conoscitivo umano, sempre *in fieri*. Il buio al di là dell'ultimo pianeta non incuteva più solo paura, ma suggeriva anche un certo senso di profonda bellezza perché capace di celare realtà alle quali la nostra fantasia può più facilmente approdare con l'ausilio del *sesto senso* matematico. Il movimento degli strumenti sembra quasi disegnare il diradarsi di nebbie *vaporacquee* che ridimensionano il concetto stesso di buio, lasciando intuire che qualcosa ancora nascondono; che la storia potrebbe non finire lì.

L'impostazione dell'*ensemble* orchestrale necessaria per l'esecuzione del brano di Holst rispecchia questa visione prevedendo l'uso di strumenti già usati in altri brani della suite capaci col loro timbro di richiamare atmosfere misteriose sì, ma anche misticheggianti, ap-

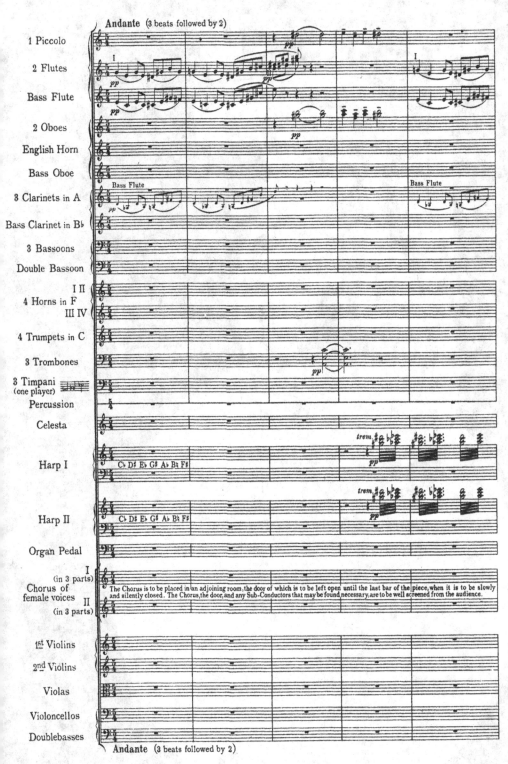

*La dualità
onto-corpuscolare
per Nettuno
(omaggio a Bologna)*

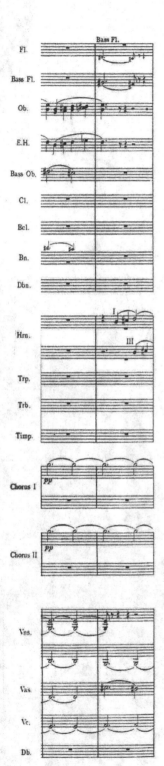

punto: organo, arpe, celesta e gong che si vanno ad aggiungere ai soliti archi e legni. Forse nelle intenzioni dell'autore queste scelte dovevano simboleggiare la possibilità di contemplare, dalla posizione di Nettuno, verità divine che in riti diversi vengono spesso commentate da alcuni di questi strumenti. Comunque il vero tocco da maestro, una pennellata che più che acustica diventa forte immagine visiva, lo si ritrova nell'uso del coro: dalla battuta quarantanove fino alla fine del brano, le voci dei soprani andranno a perdersi nella cavità cosmica come a coronare un salmodiare di angeli di dantesca memoria. E in effetti era dal cielo di Saturno che non ci seguivano più i versi del sommo poeta il quale poneva, dopo il pianeta inanellato, il *motore primo* di tutto il cosmo, contornato da schiere angeliche a celebrarne la potenza con canti di osanna. Non sbagliamo di molto, allora, se parliamo in questo momento del coro del brano dedicato a Nettuno: non saranno voci in rotazione attorno al punto che emana luce divina, ma in analogia a quanto narra Dante, arrivano comunque da un luogo molto più in là di quello che era il settimo cielo tolemaico.

> Io sentiva osannar di coro in coro
> al punto fisso che li tiene a li *ubi*,
> 96 e terrà sempre, ne' quai sempre fuoro.
> E quella che vedea i pensier dubi
> ne la mia mente, disse: "I cerchi primi
> 99 t'hanno mostrato Serafi e Cherubi".

Ormai il nostro Ulisse Celeste non indulge più alla tentazione di credere di essere arrivato alla fine del Sistema Solare e, reso fiducioso dagli ultimi inaspettati incontri, continua caparbio, a cavallo della cometa, la ricerca di nuovi limiti non più del cosmo, ma della propria conoscenza.

Plutone, il bocciato

(…) Nelle case dell'Ade, nelle profondità della terra
Omero, *Odissea*, Libro XXIV

Se fino a poche centinaia di anni fa l'uomo era stato ben disposto a riconoscere agli oggetti celesti natura e potere divini, una volta inventati nuovi strumenti e, grazie ad essi, acquisite nuove conoscenze scientifiche, diventò implacabile giudice dei pianeti e della loro importanza in Natura. Dopo i *degradati* Saturno e Urano che furono privati dell'ambito ruolo di confine ultimo del Sistema Solare, a farne le spese stavolta sarà Nettuno. Infatti, nonostante la sua notevole massa, il raccordo sperato tra le misurazioni delle reali posizioni di Urano e i dati forniti dalla sua equazione del moto ancora mancava della precisione necessaria. Oramai gli scienziati erano avvezzi a simili problemi e venne di nuovo teorizzata, stavolta senza indugi, l'esistenza di un altro pianeta posto addirittura più in là dell'orbita del già lontanissimo Nettuno. A fare i calcoli fu un personaggio che abbiamo già incontrato nel corso di questo libro: Percival Lowell, reso famoso dalla sua erronea convinzione dell'esistenza dei canali artificiali su Marte, il quale affidò la sua rivincita scientifica alla ricerca del nono pianeta che – ne era convinto – agiva con invisibili fili gravitazionali da lontano e all'insaputa di tutti. Purtroppo per lui, morirà prima di poter assistere al successo che toccò invece al giovane astronomo Clyde Tombaugh, il quale, il 18 febbraio del 1930, scoprì il nuovo pianeta a poca distanza da dove lo volevano le equazioni di Lowell e a circa trentotto Unità Astronomiche dalla nostra posizione. Ironia della sorte, lo stanò guardando proprio attraverso il telescopio costruito trentasei anni prima dallo stesso Lowell i cui conti risultarono comunque errati, dato che da essi emergeva il ritratto di un pianeta gigante dalla grande massa e, per questo, capace di fornire sufficienti spiegazioni alle perturbazioni subite da Urano e Nettuno. Una previsione totalmente disattesa dalla scoperta di un oggetto circa mille volte meno massiccio della Terra e con un diametro di soli 2.300 chilometri, quindi più piccolo anche della nostra Luna. Ancora una volta, i calcoli avevano preceduto le osservazioni e, in questo caso, le avevano anche seguite, dato che le dimensioni di questo inquilino del Sistema Solare si rivelarono – se paragonate a quelle dei suoi colleghi pianeti – degne di un *calculum*, in latino *piccola pietra*, oggetto che in età romana veniva usato per l'operazione del contare.

Venne battezzato Plutone – appellativo del dio dell'oltretomba Ade[1] – e una volta sco-

[1] Secondo una particolare tradizione, figlio di Demetra e del titano Giasone. Indica ricchezza in quanto derivato dall'usanza di porre molti sacchi pieni di grano sul cocchio nel quale viaggiava un fanciullo da sacrificare a Demetra.

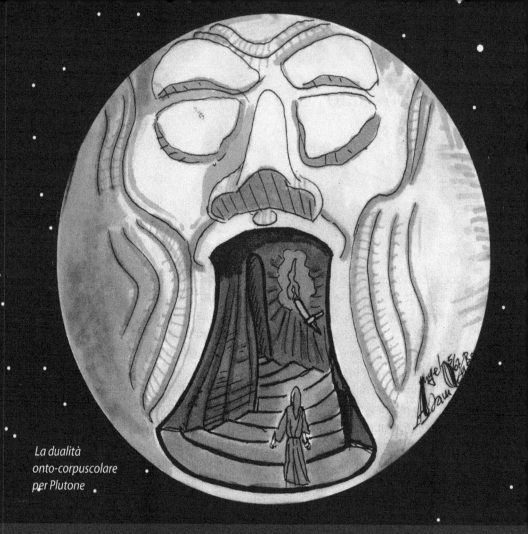

*La dualità
onto-corpuscolare
per Plutone*

perta nel 1978 la prima e maggiore delle sue tre lune, un corpo solo 12 volte più piccolo del pianeta attorno a cui ruota[2] da una distanza di circa 20.000 chilometri, essa venne chiamata Caronte in onore del traghettatore di anime perdute protagonista del terzo canto dell'Inferno di Dante:

> Non isperate mai veder lo cielo:
> i' vegno per menarvi a l'altra riva
> 87 ne le tenebre etterne, in caldo e 'n gelo

In effetti, se *col senno di (molto) poi* si interpretano i versi precedenti contestualizzandoli nella nuova cornice planetaria, possiamo notare come nel suo rivolvere attorno al pianeta, la luna

[2] In questo sembra essere l'equivalente esatto di Plutone nel paese di Lilliput immaginato da Swift dove ogni oggetto era proprio un dodicesimo delle dimensioni che avrebbe avuto nel nostro mondo.

Caronte si spinga davvero un po' più in là di Plutone, traghettando la nostra fantasia nell'oscurità e mostrando quanto opportuna sia stata la scelta del suo nome. Spettando a Plutone il ruolo di nuovo confine del sistema planetario immensamente distante dal Sole, ultimo balconcino con vista sul nulla poco oltre, l'unica cosa che non torna tra la realtà e i versi di Dante è il caldo. Infatti, se si escludono le stelle lontane certamente più infuocate di qualsiasi inferno immaginato, la zona nella quale Plutone si muove è tra le più fredde di tutte quelle fino a ora visitate. Il gelo cui fanno riferimento i versi, invece, è a dir poco perfetto e avremo modo di parlarne meglio nel capitolo successivo.

Se Dante solo avesse saputo dell'esistenza dei pianeti dopo Saturno, forse la Divina Commedia sarebbe divenuta un percorso circolare: dopo aver toccato la sommità del mondo oltre il settimo cielo, pur andando avanti, il sommo poeta avrebbe intrapreso il viaggio a ritroso attraverso il mare di competenza di Nettuno, per giungere di nuovo al mondo dei morti custodito da Plutone. Un lunghissimo ciclo letterario, un girone infernale... per gli studenti. Nella suite di Holst non compare nessun brano dedicato a questo pianeta. Il compositore morì quattro anni dopo la sua scoperta e pare che all'epoca avesse perso del tutto l'interesse nell'astrologia ai cui temi si era ispirato per comporre *The Planets*. A completarne l'opera ci penserà il britannico Colin Matthews, il quale descriverà brevemente in musica Plutone e la ventata di novità introdotte dalla sua scoperta. Come l'autore stesso ebbe a confessare, il progetto compositivo fu di rendere il suo brano *Plutone, il rinnovatore* una continuazione di quello di Nettuno composto da Holst, forse in conseguenza dell'idea avanzata da alcuni studiosi che Plutone possa essere stato in passato una luna nettuniana migrata verso l'esterno per l'aver perso il contatto con il campo gravitazionale del gigante gassoso; che, *nell'oscuro, ha perso la giusta (diritta) via*. Ma leggiamo dalle note di copertina del disco cosa ha da raccontare il compositore del suo brano:

> (...) L'unico modo possibile di riprendere da dove Nettuno scema è di non interrompere affatto la musica, e di conseguenza Pluto incomincia prima che Nettuno venga sfumato. Ed è molto veloce – più veloce di Mercurio: i venti solari sono stati il mio punto di partenza. Il movimento prende subito una propria identità, seguendo un suo percorso che mi sembra di avere assecondato nello sviluppo permettendogli di fare come più gli aggradava: in questo modo di procedere, forse mi avvicino a Holst più di quanto mi aspettassi, benché non mi sembra di avere fatto in nessun modo un *pastiche*. Alla fine la musica sparisce, quasi come se Nettuno stesse suonando sommessamente in sottofondo.

Le motivazioni addotte per le sue scelte compositive mi lasciano alquanto perplesso. In ogni caso, data la fama di Matthews, la rarità di opere su questo tema e la facile reperibilità del CD con la sua interpretazione, mi sembra sia comunque da citarne la partitura di cui riporto qui di seguito la prima pagina.

Tornando al pianeta vero e proprio, dai pettegolezzi delle solite sonde Voyager inviate a spiarlo e grazie a ciò che hanno scoperto i guardoni che si mimetizzano dentro gli osservatori, oggi sappiamo che la sua superficie è ricoperta prevalentemente di metano ghiacciato che va a nascondere un corpo roccioso. Al di sopra di tutto si stende una atmosfera molto tenue che sembra variare con "l'insolazione" ricevuta durante il lunghissimo anno plutoniano. Essa è stata scoperta osservando una stella lontana mentre il pianeta le transitava davanti, occultandola. Prima che fosse la massa planetaria a farla sparire del tutto, si è vista la stella tremolare come attraverso una nebbia, e questo ha fatto intuire la presenza di gas attorno al pianeta. Plutone si muove attorno al Sole lungo un'orbita inclinata di ben 17° 2' rispetto all'eclittica e questo lo porta a incrociare due volte, nei circa duecentoquarantotto anni terrestri che impiega a rivolvere attorno alla nostra stella, il piano di esistenza di tutti gli altri pianeti. Sembra così voler mantenere le distanze dai suoi colleghi con un atteggiamento alquanto insolente e *plutocratico*: forse a causa di un forte urto subìto durante la sua infanzia, se ne sta sdraiato con l'asse di rotazione piegato a formare un angolo di 122° con il solito riferimento dell'eclittica mentre tutti gli altri pianeti, con l'unica eccezione di Urano, si trovano a ruotare attorno al loro asse standosene *in piedi*, quasi perpendicolari a tale piano. Tra l'altro, la forte inclinazione dell'orbita di Plutone rispetto all'eclittica fa sì che, a volte, sia ancora Nettuno l'ultimo pianeta del Sistema Solare; l'ultimo *pro-tempore*. Oltre a tutto ciò, Plutone presenta ancora una particolarità: possiede una densità di 2,1 g/cm³, più piccola del valor medio 3,02 calcolato su tutti i componenti planetari del Sistema Solare, giganti gassosi e tellurici. Insomma, con la sua presenza disturba il quadro che ci si era fatti di regolarità nella successione delle masse e tipologie dei pianeti, stimolando la domanda: "Ma se non vuol fare il pianeta, perché non fa altro?". A far vacillare la sua posizione di pianeta-confine del Sistema Solare è stata anche la scoperta, un po' oltre la sua orbita, di altri corpi di massa e dimensioni comparabili con le sue, anche se leggermente più piccole, e per questo indicati con il nome di *Plutini*: *Quaouar, Varuna, Sedna*, ... Ma il colpo definitivo che ha provocato la sua degradazione a pianetino o corpo minore è arrivato con la scoperta di *Xena*, ribattezzato poi *Eris*, un altro plutino... di poco più grande di Plutone! Oggi si sa che in quella zona vi sono di sicuro tantissimi altri corpi di dimensioni minori ancora non scoperti e che, si spera, verranno censiti dalle osservazioni future condotte con strumenti ancora più potenti di quelli oggi a nostra disposizione.

Intanto mi preme citare quello che, al momento attuale, sembra essere il più piccolo corpo, osservato con un telescopio poetico, molto simile al telescopio matematico dei teorici. Si tratta del *Pianeta Bruscolo* scoperto da una nostra vecchia conoscenza, lo scrittore Gianni Rodari che insignirei *honoris causa* del titolo di "astronomo dei bimbi", il quale ce lo descrive così:

Si fa presto a parlare
del pianeta Bruscolo:
nell'intera Via Lattea
non c'è astro più minuscolo;

è grosso, a dire tanto,
quanto una damigiana,
il calendario dura
in tutto una settimana:

Lunedì è la Befana,
mercoledì Quaresima,
sabato San Silvestro
e si prende la tredicesima.

Forse mi sbaglio: esso non può stare dalle parti di Plutone. Infatti, con un tempo di rivoluzione – il suo anno – pari a una nostra settimana, dovrebbe girare attorno al Sole da una distanza $L_{bruscolo}$ di soltanto:

$$L_{Bruscolo} = (GM_{Sole} T^2_{Bruscolo}/4\pi^2)^{1/3} \approx 10{,}6 \text{ milioni di km}$$

In pratica, più vicino alla nostra stella di quanto non lo sia Mercurio che, come abbiamo visto, le gira attorno da una distanza di 58 milioni di chilometri. Se lì un Bruscolo c'era, a quest'ora è già andato in fumo...

Tirando un po' le somme parziali di questi ultimi tre capitoli, mi verrebbe da dire che la ricerca del famoso ultimo pianeta, oltre ad avere assestato colpi non da poco all'autostima dei *pianeti-dei* gassosi già da lungo tempo provati perché privati della loro autorità, sta diventando una chimera un po' trita alla quale si potrebbe contrapporre l'idea che non esista affatto soluzione di continuità tra il Sistema Solare e altri sistemi planetari "limitrofi" con i quali il nostro potrebbe avere una sorta di *legame covalente* (e vedremo nell'ultimo capitolo che tale ipotesi non è poi così peregrina). Per molti anni, la palma di confine del Sistema Solare è toccata a Plutone, il nono pianeta. Questo semplice dato numerico ha spinto molti a teorizzare persistentemente che ve ne fosse quindi un *decimo* ancora *incognito* – il famoso *pianeta X* – più in là della sua orbita. La motivazione ufficiale a sostegno di questa idea era ancora una volta il fatto che i famosi *conti non tornavano*: Urano e Nettuno sembravano indicare che vi fosse ancora molta massa oltre quella esigua di Plutone a *disturbare* i loro moti da lontano. Credo che la motivazione ufficiosa per questo accanimento sia invece da ricercare nel semplice fatto che per noi umani nove non è una cifra tonda, mentre dieci, avendo dieci dita per mano, lo è... In barba a questa tendenza tutta antropica di cercare il *pianeta X*, essendo stati scoperti diversi altri corpi confrontabili per massa e dimensioni con Plutone, in seguito a una risoluzione per votazione dell'Unione Astronomica Internazionale (I.A.U.) riunitasi il 24 agosto 2006, il Sistema Solare è stato semplificato e viene considerato composto da soli otto pianeti propriamente detti – Mercurio, Venere, Terra, Marte, Giove, Saturno, Urano, Nettuno – nonché da un numero ancora imprecisato di corpi minori: comete, asteroidi, pianetini e bruscoli vari.

Ormai non vale più la pena di scendere dalla cometa. Conviene piuttosto farsi condurre verso quello che sembra il suo *luogo naturale*. Essa infatti punta decisa verso zone per il momento oscure che, l'Ulisse Celeste ora può dirsene certo, gli riveleranno verità nascoste alla mente, destinate a diventare presto visibili e, soprattutto, tangibili.

La fascia di Kuiper e la nube di Oort: confini? Steccato? Fortificazioni? Gabbia?

Essi (gli astronomi di Laputa, N.d.R.)
hanno osservato novantatré diverse comete,
e definito i loro periodi con grande esattezza.
Se questo è vero (e i Lapuziani lo affermano
con grande sicurezza), v'è da augurarsi
che le loro osservazioni siano rese pubbliche,
onde poter portare a perfezione, come
le altre parti dell'astronomia,
anche la teoria delle comete, presentemente
ancora difettosa e zoppicante.
Jonathan Swift, *I viaggi di Gulliver*

Lo spazio è abbastanza grande da accogliere
ogni dissidente, spirito libero o fuorilegge.
Freeman Dyson, *L'importanza di essere imprevedibile*

Non serba ombra di voli il nerofumo
della spera (e del tuo non è più traccia).
È passata la spugna che i barlumi
indifesi dal cerchio d'oro scaccia.
Le tue pietre, i coralli, il forte imperio
che ti rapisce vi cercavo; fuggo
l'iddia che non si incarna, i desideri
porto fin che al tuo lampo non si struggono.
Ronzano èlitre fuori, ronza il folle
mortorio e sa che due vite non contano.
Nella cornice tornano le molli
meduse della sera. La tua impronta
verrà di giù: dove ai tuoi lobi squallide
mani, travolte, fermano i coralli.
Eugenio Montale, *Gli orecchini*, Finisterre

Proporrei ora di concentrarci per un po' sul mezzo di fortuna che il nostro Ulisse Celeste sta usando per muoversi nella parte più esterna del Sistema Solare. È da subito dopo l'orbita di Saturno che egli sta cavalcando una cometa, un'abitante del cielo che ha sempre stimolato la fantasia di artisti e scienziati. A oggetti del genere sono stati associati indifferentemente poteri benevoli e catastrofici: si pensi per esempio alla cometa natalizia che dovrebbe avere indicato la retta via ai Magi[1] o alle varie calamità che secondo alcuni le comete annunciavano apparendo all'improvviso, come fossero generate dal buio che squarciano ricordandomi tele di Fontana. A tal proposito, il famoso algebrista Girolamo Cardano, nel suo *De rerum varietatae* pubblicato nel 1557, ritiene che i vapori contenuti nelle code di cometa debbano essere tossici. Essi, mescolandosi con l'atmosfera, agiscono indebolendo il fisico e attaccando soprattutto coloro i quali conducono una vita oziosa e sedentaria, quindi agiata: secondo Cardano i più esposti alle malattie veicolate dalle comete dovevano di sicuro essere i principi! A distanza di circa quattro secoli da queste idee che oggi non possono che apparirci bislacche, possiamo dirci sicuri solo di un fatto: all'epoca esse rappresentavano una sventura solo per i sostenitori della visione tolemaica del cosmo. Infatti, il progressivo aumentare di luminosità di questi oggetti faceva sospettare che essi provenissero da zone molto "alte" del cielo, un moto che li avrebbe portati letteralmente a sfondare le *vetrate* delle sfere cristalline previste dalla teoria tolemaica. Il fatto che nulla di ciò capitasse ogniqualvolta venivano osservati, fece immaginare a qualcuno che queste *molli meduse della sera* fossero un fenomeno atmosferico. In ogni caso, essi avevano il buon gusto di sparire dalla vista nel giro di pochi giorni o settimane, così come erano venuti, facendo cadere nell'oblio simili questioni spinose a tutto vantaggio degli astronomi che proprio non sapevano come inquadrare il fenomeno all'interno dello schema delle sfere celesti. Gli studi scientifici che nel tempo sono stati compiuti su questa classe di oggetti hanno finalmente rivelato cosa veramente sono e mi piace usare l'immagine che spesso viene citata per essi: *palle di neve sporca*. Il loro nucleo, di dimensioni di circa una decina di chilometri, è composto da grani di polvere e sostanze varie come acqua, anidride carbonica, formaldeide, monossido di carbonio, che a basse temperature possono ghiacciare. Nella stragrande maggioranza dei casi, le loro orbite risultano chiuse indicando così

[1] Dai racconti pervenutici e da un attento studio del cielo del Natale di 2009 anni fa, sembra essersi trattato semplicemente dell'allineamento di Giove e Saturno.

Pastore errante dell'Asia Magi

che questi oggetti sentono l'attrazione gravitazionale del Sole e, dopo avergli girato intorno, ritornano da dove sono venuti dirigendosi verso le zone più lontane e fredde del Sistema Solare. Sono proprio quelle sostanze ghiacciate che, all'avvicinarsi alla nostra stella, a una distanza dal Sole pari più o meno a quella di Giove, sentono cambiare la temperatura. Esse si sciolgono, evaporano, ed evaporando vanno a costruire quella che in gergo viene indicata con il termine di *chioma* (in latino *coma* da cui il nome cometa). Da *calve* che erano, quindi esse passano ad avere una parrucca di ghiacci evaporati che viene pettinata dal vento solare – ne abbiamo già parlato nei primi capitoli – capace di soffiare a una velocità e con una pressione tali da spingere indietro la chioma, creando la coda che da sempre associamo alle comete. Va da sé che la coda sarà sempre dalla parte opposta al Sole e la cometa tornerà a essere calva quando si allontanerà da esso lungo la sua lunghissima orbita ellittica.

Da un attento studio statistico condotto sulle traiettorie e sulle velocità di questi oggetti, una ricerca effettuata nel primo dopoguerra dall'olandese Jan Oort che rese noti i suoi risultati nel 1950, sembra che molte di loro – quelle che impiegano dai 200 ai milioni di anni per tornare a manifestarsi dalle nostre parti e che per questo vengono dette di lungo periodo – provengano da una zona estremamente distante dal Sole, compresa tra le 3.000 e le 100.000 Unità Astronomiche. Questa buccia – indicata, appunto, come *nube di Oort* che pare proprio racchiudere sfericamente tutto il Sistema Solare – non è mai stata osservata, ma sembra proprio dover essere presente per potere giustificare il traffico cometario osservato. L'idea che questa struttura debba avere forma sferica, oltre che con lo studio delle direzioni di provenienza dei vari *proiettili* che da essa ci arrivano, si spiega considerando che nel lunghissimo tempo intercorso dalla formazione del Sistema Solare a oggi, le interazioni gravitazionali con il suo interno planetario e quelle casuali con l'ambiente esterno a essa costituito dalle stelle vicine che arrivano di sicuro a fare sentire la propria influenza da quelle parti, hanno avuto il tempo di rendere la distribuzione uniforme, quindi molto simile a una sfera. Nel 1951, Gerard Peter Kuiper propose che vi fosse un'altra classe di oggetti cometari che differivano da quelli classificati da Oort per i brevi periodi – mediamente minori di 200 anni – e per le traiettorie che invece di disegnare una sfera attorno al Sole, facevano piuttosto intuire di provenire da una striscia circolare posta a circondare i pianeti da poco oltre l'orbita di Nettuno, un margine tondeggiante che mi ricorda lo scudo di Achille forgiato da Efesto, così come descritto da Omero:

> E fece per primo uno scudo grande e pesante,
> ornandolo dappertutto; un orlo vi fece, lucido,
> 480 triplo, scintillante, e una tracolla d'argento.
> Erano cinque le zone dello scudo, e in esso
> fece molti ornamenti coi suoi sapienti pensieri.

> Vi fece la terra, il cielo e il mare,
> l'infaticabile sole e la luna piena,
> 485 e tutti quanti i segni che incoronano il cielo,
> le Pleiadi, l'Iadi e la forza d'Orione
> e l'Orsa, che chiamano col nome di Carro:
> ella gira sopra se stessa e guarda Orione,
> e sola non ha parte dei lavacri d'Oceano.

Nonostante dovesse essere notevolmente più vicina della nube di Oort, anche questa cosiddetta *fascia di Kuiper* risultò inosservabile per diverso tempo e rimase solo un'ipotesi utile a spiegare la provenienza di alcune delle comete a breve periodo che mostravano di seguire un'orbita schiacciata sul piano dell'eclittica. Poi finalmente, grazie a telescopi sempre più potenti, fu possibile osservare uno di questi *iceberg cosmici* e – similmente a quanto accadde per la fascia degli asteroidi fra Marte e Giove – una volta scoperto il primo, fu tutto un susseguirsi di avvistamenti di oggetti analoghi posti più o meno tutti alla stessa distanza e molto simili sia a Plutone che a Caronte, entrambi orbitanti lì vicino. Se si potesse dare un'occhiata d'insieme a tutto il panorama del Sistema Solare, la fascia di Kuiper apparirebbe come una specie di recinto, una *muraglia cinese spaziale* che argina i moti planetari.

Dato che, come si diceva, il sistema planetario doppio Plutone-Caronte non ha nulla da condividere con i pianeti giganti nelle orbite più interne, sembrò plausibile ipotizzare che, piuttosto che essere considerati un sistema *pianeta più luna*, sia Plutone che il suo satellite fossero da annoverare fra gli oggetti rocciosi e ghiacciati che popolano quelle fredde lande desolate e questo ha pesato non poco sulla risoluzione dell'Unione Astronomica Internazionale seguita dalla *bocciatura* inflitta a Plutone. Il nostro Ulisse Celeste non sa ancora a quale delle due categorie appartenga la cometa sulla quale sta viaggiando: sarà a corto periodo, e quindi tra poco invertirà la rotta per riportarlo verso il Sistema Solare interno, o sarà a lungo periodo, e quindi tirerà dritto portandolo ben oltre, quasi a toccare le altre stelle? Lo scoprirà presto, anche se il fatto di esserle saltato su dalle parti di Saturno e l'avere incrociato i vari pianeti standosene quindi sul piano dell'eclittica, lo porta a pensare che possa trattarsi di una cometa appartenente alla prima categoria. In realtà le comete che arrivano dalla nube di Oort hanno traiettorie tra le più disparate, e quella da lui cavalcata potrebbe anche arrivare dall'*equatore* della lontana nube sferica di Oort. Man mano che avanza, il nostro Ulisse Celeste incomincia a scorgere gli oggetti frastagliati della fascia di Kuiper che brillano timidamente nel freddo buio di questa periferia planetaria e gli spuntoni ghiacciati che ne inaspriscono i profili gli richiamano alla memoria versi imparati molto tempo prima e ispirati a elementi diversi della Natura. Ma poi, così tanto diversi?

> (…) E andando nel Sole che abbaglia
> sentire con triste meraviglia
> com'è tutta la vita e il suo travaglio

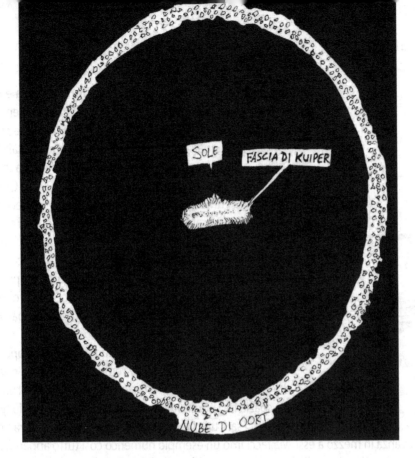

in questo seguitare una muraglia
che ha in cima cocci aguzzi di bottiglia
Eugenio Montale, *Ossi di seppia*

Sì, ma dopo *aver pesato il buio* stabilendo quanta massa dovesse avere un corpo planetario che si cela nell'oscurità, vogliamo capire una buona volta cosa si intende quando si dice *buio* e *freddo*? Non tutti i *bui* sono uguali: c'è il buio *semplice*, il buio *pesto*, il buio *totale*, ... Tutte espressioni qualitative che qualificano l'oscurità, ma non la quantificano in modo preciso. Stessa cosa vale per il freddo: c'è il *fresco*, il *freddino*, il freddo *pungente*, quello glaciale, quello *cane*, ... Ma alla domanda: "Sì, ma *quanto* buio? Sì, ma *quanto* freddo?" non sappiamo dare una risposta esaustiva. Forse possiamo provare ad aggirare il problema vedendo il buio come poca luce, al limite come assenza totale di luce; il freddo come poco calore, al limite, assenza totale di esso. Pensiamo prima a "chiarire il buio": a tal proposito, vi invito a immaginare di star leggendo un libro, magari questo libro, vicino a un *abat-jour* che illumini l'ambiente con una lampadina da 100 Watt. Dato che è l'incandescenza del filo di tungsteno all'interno del bulbo a produrre la luminosità, la luce verrà emessa allo stesso modo in tutte le direzioni, eccezion fatta per la parte inferiore, dove vi è la base filettata della lampadina stessa. Di questi 100 W – e notate che si parla di Watt, quindi di una potenza: la luce è una forma di energia! Energia detta *elettromagnetica* – quanti ve ne arriveranno alla distanza alla quale siete seduti? 100? Di meno? Di più? Cerchiamo di capirlo con un ragionamento. Consideriamo per

semplicità una lampadina dal bulbo di forma sferica e non a pera come spesso è facile trovarli. La lampadina emetterà luce in modo uguale in tutte le direzioni e due raggi di luce qualsiasi, partiti dal centro e assimilabili agli stessi raggi del bulbo sferico, arriveranno a toccarlo in posti diversi, lontani tra loro $l = R sen\theta$. Questo è un calcolo che abbiamo già fatto in precedenza e oramai sappiamo applicarlo anche ad altri problemi, vero? Bene.

Come vedete, la distanza l tra i punti del bulbo toccati dai due raggi dipende proprio dalla lunghezza del raggio del bulbo stesso, oltre che dall'angolo diverso con il quale sono partiti. Se manteniamo l'angolo costante e andiamo a vedere dove i due raggi di luce andranno a colpire dopo avere attraversato il bulbo, scopriremo che i punti sui quali cadrà la luce saranno a una distanza l ancora maggiore l'uno dall'altro. Lo spazio fra i punti illuminati sarà di conseguenza più grande e quindi potremo dire che ci sarà una illuminazione più rada, che l'ombra timidamente avanza in mezzo a essi. Ma facciamo un esempio numerico così tutto apparirà più… *illuminato*. Stando vicino alla lampadina, misuriamo i soliti 100 W di potenza sul bulbo. Se siamo seduti a un metro da essa, per calcolare con quanta potenza la luce arriverà alla nostra posizione, basterà pensare al problema di dover vedere quanta luce arrivi su un bulbo immaginario con un raggio lungo un metro. Come vedete dal disegno, due raggi partiti vicini tra loro, a una piccola distanza angolare, arrivano progressivamente più distanti l'uno dall'altro man mano che si considerano bulbi più grandi. In pratica, dividendo tutta la potenza della lampadina per la superficie sferica attorno a essa, si ottiene quanta luce effettivamente arriva su un suo punto. Allora, a un metro dalla lampada, avremo che il flusso luminoso che attraversa la superficie sferica, che possiamo indicare con Flusso$_{Sfera}$, sarà dato da:

$$\text{Flusso}_{\text{Sfera a 1 m}} = \text{Potenza} / 4\pi R^2 = 100\,\text{W} / 4\pi = 7{,}95\,\text{Watt/m}^2 \qquad (14.1)$$

A dieci metri avremo, invece:

$$\text{Flusso}_{\text{Sfera a 10 m}} = 100\,\text{W} / 400\,\pi = 0{,}0795\,\text{Watt/m}^2$$

Insomma, come già sapevate, se vi allontanerete dalla lampada, riceverete meno luce. Ora immaginiamo che il nostro Sole sia una potentissima lampadina con una potenza pari a quella prodotta da $3{,}8 \cdot 10^{24}$ lampadine come quella da voi usata! Servendoci della (14.1) e sostituendo in essa di volta in volta i diversi valori di R, calcoliamo quanta luce da esso ar-

riva in due punti estremamente distanti tra loro: alla distanza di Mercurio e a quella di Plutone, considerato ancora una volta, forse l'ultima, termine del Sistema Solare. Su Mercurio, a 56 milioni di chilometri di distanza, arriverà su ogni metro quadro di superficie una potenza di circa 100 lampadine da 100 W. Su Plutone invece, a 39,5 Unità Astronomiche, pari a cinque miliardi e ottocentottantacinque milioni di chilometri, su ogni metro quadro di superficie arriveranno 0,8 Watt! Se poi andiamo a considerare quello che sembra essere il vero confine del Sistema Solare, la parte più lontana della buccia cometaria di Oort posta a 100.000 Unità Astronomiche dal Sole, troviamo che lì la potenza della luce solare è pari a 0,0000001 W, quindi circa un miliardo di volte meno della potenza emessa dalla lampadina con la quale state illuminando questi calcoli.

Una volta definito cosa è il buio da un punto di vista operativo, parliamo del freddo. Se standovene sempre lì dove siete seduti intenti a leggere, avvicinate la mano alla lampadina, sentirete di sicuro il calore che essa emana. Poggiando la mano sul bulbo, vi scotterete. Allontanandola, a partire da una certa distanza la sensazione di tepore cesserà ma vi sarà rimasta la certezza che la luce, in quanto energia, ha una sua traduzione in termini di calore: l'avete sentito poco prima quindi ne avete la prova empirica. La lampadina allora potrà essere riguardata come una piccola stufa incapace di riscaldare più di tanto l'ambiente, nonostante in certi casi si suol dire che anche una fiammella di candela è capace di scaldare i nostri cuori, *bla bla bla*…

Nel 1879 un signore di nome Josef Stefan scoprì che una fonte di luce come il nostro Sole che irradia nel vuoto cosmico (lì nello spazio interplanetario non vi è aria o altro e questo ne fa la migliore approssimazione al concetto di vuoto che possediamo) riscaldando lo spazio circostante per irraggiamento, possiede una luminosità che è proporzionale al prodotto tra la sua superficie e la sua temperatura elevata alla quarta potenza. Può sembrare complicato, ma a ben vedere stiamo parlando solo di semplici moltiplicazioni. Più sinteticamente, indicando con Lum la luminosità e con $S_{corpo\ emittente}$ la superficie del corpo emittente, si ha in formula:

$$\left[\qquad Lum \approx S_{corpo\ emittente} \cdot T^4 \qquad (14.2) \qquad \right]$$

Se consideriamo la lampadina Sole, avremo che la luminosità prodotta dalla sua superficie esterna di raggio $R_{Sole} \approx 6,9 \cdot 10^5$ chilometri e calda 5,770 °Kelvin verrà sparpagliata in modo uguale in tutte le direzioni e per sapere quanto calore fluirà attraverso una superficie di raggio R più grande del raggio solare, basterà pensare che la nostra stella, pur mantenendo immutata la sua luminosità, sia diventata più grande raggiungendo le dimensioni di una immensa sfera di raggio R. Ma procediamo con ordine. La luminosità solare che fluisce attraverso il suo *bulbo*, la sua superficie esterna, detta *fotosfera*, è data da:

$$\left[\qquad Flusso_{Sole} = Lum_{Sole} / S_{Sole} \qquad \right]$$

dove $Flusso_{Sole}$ indica il flusso di luce e calore che attraversa la superficie esterna del Sole. Dato che la legge di Stefan dice come la luminosità si leghi alla temperatura, allora possiamo scrivere anche:

$$\left[\quad \text{Flusso}_{\text{Sole}} \approx S_{\text{corpo emittente}} \cdot T^4_{\text{corpo emittente}} / S_{\text{Sole}} \quad \right]$$

Ma il corpo emittente che stiamo considerando è proprio il Sole, quindi i due termini $S_{\text{corpo emittente}}$ e S_{Sole} si semplificano e otteniamo:

$$\left[\quad \text{Flusso}_{\text{Sole}} \approx T^4_{\text{Sole}} \quad \right]$$

Ricordo che vogliamo calcolare la temperatura presente in un punto qualsiasi dello spazio occupato dal Sistema Solare lontano da sorgenti di calore come Sole e pianeti, in qualche modo attivi da un punto di vista termico. Ci tengo a precisare che non mi è riuscito di trovare un simile calcolo nei libri da me consultati e che quindi il metodo che propongo qui è farina del mio sacco: me ne assumo tutta la responsabilità! Allora vediamo cosa succede a distanza R maggiore della dimensione R_{Sole}. Abbiamo detto che, nel calcolare il flusso attraverso la superficie sferica di area $4\pi R^2$, possiamo agire come se si trattasse dello stesso Sole, il quale, pur emettendo la stessa potenza luminosa, è diventato più grande, essendosi espanso fino a raggiungere un raggio $R > R_{\text{Sole}}$. Allora il flusso di luce e calore attraverso la superficie esterna di un Sole di raggio $R > R_{\text{Sole}}$ sarà dato da:

$$\left[\begin{array}{c} \text{Flusso}_{\text{Sole di raggio R>Rsole}} = \text{Lum}_{\text{Sole}} / S_{\text{Sole di raggio R>Rsole}} \approx \\ \approx S_{\text{Sole}} \cdot T^4_{\text{corpo emittente}} / S_{\text{Sole di raggio R>Rsole}} = \\ = S_{\text{Sole}} \cdot T^4_{\text{Sole}} / S_{\text{Sole di raggio R>Rsole}} = 4\pi R^2_{\text{Sole}} \cdot T^4_{\text{Sole}} / 4\pi\, R^2 = (R_{\text{Sole}} / R)^2\, T^4_{\text{Sole}} \end{array} \right]$$

Ma dovendo anche essere vero, sempre per la legge di Stefan (14.2), che il flusso di luce e calore attraverso la superficie di raggio $R > R_{\text{Sole}}$ è:

$$\left[\quad \text{Flusso}_{\text{Sole di raggio R>Rsole}} \approx 4\pi R^2 \cdot T^4_{\text{Sole di raggio R}} / 4\pi R^2 = T^4_{\text{Sole di raggio R}} \quad \right]$$

Si ha:

$$\left[\quad T^4_{\text{Sole di raggio R}} = (R_{\text{Sole}} / R)^2 \cdot T^4_{\text{Sole}} \quad \right]$$

Semplificando:

$$\left[\quad T_{\text{Sole di raggio R}} = (R_{\text{Sole}} / R)^{1/2} \cdot T_{\text{Sole}} \quad \text{(14.3)}[1] \quad \right]$$

[1] In quest'ultima relazione abbiamo posto il segno di uguale in quanto è facile verificare che, se fossimo partiti dalla relazione corretta: Lum = $S_{\text{corpo emittente}}\,\sigma T^4$, si sarebbe trovato che la costante di Stefan-Boltzmann σ (pari a $5{,}67 \cdot 10^{-8}$ W m^{-2} °K^{-4}) si semplificherebbe nei vari passaggi, rendendo la (14.3) una uguaglianza esatta.

Questa relazione ci dona un grande potere! Essa ci permette di calcolare un valore approssimato (abbiamo fatto delle assunzioni che, qui e là, possono dimostrarsi non proprio vere) della temperatura presente a qualsiasi distanza dal Sole all'interno della sfera di sua influenza. Intanto, prima di metterla alla prova, studiamola per capire cosa ci racconta.

Quando consideriamo distanze R sempre più piccole, al limite nulle (se consideriamo $R = 0$, vuol dire che stiamo cercando di capire che temperatura c'è all'interno del Sole, nel suo nucleo), essa ci dice che la temperatura $T_{Sole\ di\ raggio\ R}$ va all'infinito. La matematica serve alla fisica, ma poi la fisica deve stabilire cosa significhino realmente le formule quando vanno raccordate con ciò che si osserva in Natura. In questo caso, $T_{Sole\ di\ raggio\ R<<RSole}$ = infinito vuol dire semplicemente una temperatura molto, molto alta e sappiamo infatti che al centro della nostra stella vi sono circa 15 milioni di gradi. Se invece facciamo crescere R indefinitamente, andando a considerare zone sempre più distanti dal Sole, otteniamo una temperatura che è *asintoticamente* nulla, quindi che diverrà prossima a zero senza mai annullarsi del tutto. In questo caso, la traduzione in termini realistici del risultato matematico è da interpretarsi nel seguente modo: la temperatura scenderà così tanto da avvicinarsi allo zero assoluto che, nella scala centigrada si traduce in $-273,16\ °C$. In teoria, a questa temperatura tutto si dovrebbe fermare perché letteralmente cristallizzato nelle posizioni possedute un attimo prima del congelamento. In realtà, la meccanica quantistica ci spiega che questa situazione non è di fatto realizzabile in quanto violerebbe un famoso principio scoperto da *un certo* Werner Heisenberg. Senza impantanarci in spiegazioni che, per essere apprezzate, richiederebbero una estesa trattazione, ci basti qui sapere che pur giungendo dalle parti dello zero assoluto, le particelle elementari continuerebbero ad avere un seppur minimo movimento, dimostrando così di possedere una temperatura di poco differente da zero; più "calda" di zero, anche se di pochissimo. In effetti, è quello che al momento si misura: evitiamo di nuovo di scendere nel dettaglio stavolta cosmologico che verrà sondato in una trattazione futura. Basti qui sapere che, anche laddove non vi è materia stellare a surriscaldare una qualsiasi zona del nostro cosmo, vi è comunque una temperatura per così dire *basale* di 2,7 °K rinvenibile ovunque e che dona a tutto ciò che la scatola universale contiene questa quantità minima di calore. La relazione precedente (17.3) allora cambierà di conseguenza e andrà scritta nella nuova forma:

$$\left[\quad T_{Sole\ di\ raggio\ R} = (\,R_{Sole}\,/\,R\,)^{1/2}\,T_{Sole} + T_{Universo} = (\,R_{Sole}\,/\,R\,)^{1/2}\,T_{Sole} + 2,7\ °K \quad\right]$$

da usare come se fosse:

$$\left[\quad \begin{aligned} T_{a\ distanza\ R\ dal\ Sole} &= (\,R_{Sole}\,/\,R\,)^{1/2}\,T_{Sole} + T_{Universo} = \\ &= (\,R_{Sole}\,/\,R\,)^{1/2}\,T_{Sole} + 2,7\ °K \end{aligned} \quad\right]$$

Mettiamo ora alla prova questa relazione calcolando la temperatura in alcuni dei posti che abbiamo già visitato. Dalle parti di Mercurio si ha, per esempio:

$$\left[\begin{array}{c} T = (R_{Sole} / R)^{1/2} T_{Sole} + T_{Universo} \approx \\ = [6{,}9 \cdot 10^5 \text{ km} / (56{,}6 \cdot 10^6 \text{ km})]^{1/2} \cdot 5.770 \text{ °K} + 2{,}7 \text{ °K} = 639{,}7 \text{ °K} \end{array} \right]$$

Che equivalgono a 639,7 – 273,16 = 366,54 gradi centigradi, che – vi ricordate? – corrisponde più o meno a quanto si registra dalle parti del primo pianeta contato a partire dal Sole.

Dalle nostre parti, invece, a 149 milioni di chilometri dal Sole, si ha:

$$\left[\begin{array}{c} T = (R_{Sole} / 1 \text{ U.A. })^{1/2} \cdot T_{Sole} + T_{Universo} = \\ = [6{,}9 \cdot 10^5 \text{ km} / (149 \cdot 10^6 \text{ km})]^{1/2} \cdot 5.770 \text{ °K} + 2{,}7 \text{ °K} = 395{,}35 \text{ °K} \end{array} \right]$$

ovvero 395,35 – 273,16 = 122,19 gradi centigradi che è molto simile alla temperatura misurabile questa volta sulla faccia illuminata della Luna. Perché parlare della Luna? Per il semplice motivo che è un corpo geologicamente morto collocato nello spazio con il quale è in equilibrio termico. Non producendo calore nel suo interno e non ricevendone da altra fonte che non sia il Sole che la irradia di luce da grande distanza, è il miglior termometro che possiamo usare per misurare la temperatura dalle parti della Terra in un posto che non sia quello occupato dal nostro pianeta il quale – come ben sappiamo – produce calore interno e ne irradia una quantità non trascurabile dalla sua atmosfera. In fondo, con questo mio procedimento, sto cercando di calcolare la temperatura in vari punti dello spazio vuoto facendo l'ipotesi che si tratti invece di spazio occupato da materia stellare estremamente rarefatta. Questo significa che l'approssimazione risulterà progressivamente migliore man mano che aumenterà la distanza dalla sorgente di calore, mentre a *piccole* distanze si potrebbero trovare delle discrepanze di qualche decina di gradi dovute al fatto che, se vi fosse del gas laddove c'è il vuoto, esso si riscalderebbe anche per convezione.

Dalle parti di Giove, a più o meno 750 milioni di chilometri dalla nostra stella, si ha:

$$\left[\begin{array}{c} T = (R_{Sole}/R)^{1/2} \cdot T_{Sole} + T_{Universo} = \\ = [6{,}9 \cdot 10^5 \text{ km} / (750 \cdot 10^6 \text{ km})]^{1/2} \cdot 5.770 \text{ °K} + 2{,}7 \text{ °K} = 177{,}7 \text{ °K} \end{array} \right]$$

Ovvero circa 273,15 - 177,7 = 95,46 gradi centigradi sotto zero. Se vogliamo sapere a partire da dove una cometa incomincia a sentire un calore tale da sciogliere il ghiaccio d'acqua sulla sua superficie – ghiaccio che a basse pressioni sappiamo formarsi alla temperatura di 0 °C = 273,16 °K – dobbiamo trovare a quale distanza si ha questa temperatura. Per trovarla, basta porre:

$$\left[\quad 0 \text{ °C} = 273{,}16 \text{ °K} = (R_{Sole} / R)^{1/2} \cdot 5.770 \text{ °K} + 2{,}7 \text{ °K} \quad \right]$$

e da questa relazione si ottiene facilmente R che risulta pari a 345 milioni di chilometri, una distanza, questa, che, se divisa per 149 milioni di chilometri (= una Unità Astronomica), ci colloca a 2,1 Unità Astronomiche dal Sole, quindi nel bel mezzo della fascia degli asteroidi tra

Marte e Giove. Una volta diventata acqua, continuando ad avvicinarsi imprudentemente al Sole come una Icaro cosmica, la chioma evaporerà e, spinta dal vento solare, diverrà la lunghissima coda che si osserva. Come è facile intuire, in questo loro muoversi attorno alla stella, le comete perdono buona parte del loro materiale superficiale e alcune di quelle a breve periodo, avendo già compiuto nei miliardi di anni di onorata attività innumerevoli passaggi attorno al Sole, appaiono spesso come sassi senza chioma che pedissequamente fanno lo stesso tragitto di sempre, anche se in modo meno trionfale, come spose senza il velo. La progressiva perdita di materiale ha anche un altro effetto notevole. Molti pezzetti di ghiaccio e polveri rimangono a disegnare le scie, i percorsi lungo i quali si sono mosse le comete, quasi che fossero degli enormi Pollicino – ancora lui! – timorosi di smarrire la strada. Data la grande regolarità dei movimenti planetari nel Sistema Solare – a tutti gli effetti, un immenso orologio svizzero – queste scie vengono attraversate dai pianeti più o meno nelle stesse date e il fenomeno che risulta da tale attraversamento da parte della Terra va sotto il nome di *stelle cadenti*: la nostra atmosfera cattura i frammenti di ghiaccio e polveri che stavano lì per i fatti loro e li incendia per attrito. A loro volta, essi *feriscono* l'atmosfera ionizzandola e mostrando così la scia che ci fa pensare a una stella in caduta libera.

Questi sciami di stelle cadenti sembrano arrivarci in ogni stagione da punti diversi detti *radianti*. Per esempio, d'estate sembra che qualcuno ci spari addosso le cosiddette *Perseidi* provenienti dalla costellazione di... Perseo ma, in realtà, è la nostra Terra che va addosso ai frammenti lasciati dalla cometa Swift-Tuttle in vecchi passaggi attorno al Sole! In pratica, l'effetto è lo stesso che si verifica quando si va in macchina durante una bufera di neve. Con tutti i fiocchi che cadono nella nostra direzione, sembra proprio che la tormenta voglia tormentare solo noi, ma non preoccupatevi: succede a tutti. La faccenda si risolve nell'ambito di un concetto fisico spiegato per la prima volta dal solito Galileo e che va sotto il nome di *relatività*. In ogni caso, guai se cadessero le stelle! Date le dimensioni, forse sarebbe piuttosto il caso di temere la nostra caduta su una stella e non il caso opposto.

So di avervi deluso spiegandovi cosa realmente sono le stelle cadenti, è un po' come avervi detto che Babbo Natale non esiste, ma mi farò perdonare con un suggerimento: se proprio ci tenete a esprimere desideri a ogni stella cadente che vedrete, perché aspettare la notte di San Lorenzo? Procuratevi una fiamma ossidrica, andate in cucina, aprite il *freezer*, prendete dei cubetti di ghiaccio e, mentre li fate svanire con il getto incandescente, esprimete i vostri *desiderata*. Potete anche invitare gli amici a osservare l'evento, magari ognuno con i suoi cubetti e con il suo flessibile...

Coda o Epilogo

"O frati", dissi, "che per cento milia
perigli siete giunti a l'occidente,
114 a questa tanto picciola vigilia
de' nostri sensi ch'è del rimanente
non vogliate negar l'esperïenza,
117 di retro al sol, del mondo sanza gente.
Considerate la vostra semenza:
fatti non foste a vivere come bruti,
120 ma per seguir virtute e canoscenza".
Dante Alighieri, *Divina Commedia*, Inferno, Canto XXVI

Oramai siamo arrivati a fine corsa. Il nostro mezzo va a mescolarsi a tutti gli altri oggetti simili che stazionano da queste parti, andando a costruire quella che Oort ha intuito essere la buccia sferica che contiene il Sistema Solare, un immenso scenario che ci racchiude ricordando un fantasmagorico *Truman Show*. Visto da qui, può richiamare alla memoria una cellula con il suo DNA ben nascosto vicino al suo nucleo, lì dalle nostre parti (e magari, a nostra insaputa, anche da qualche altra parte).

Sulle comete abbiamo scoperto esservi molti frammenti di amminoacidi che sappiamo essere pezzi di DNA e, in un certo modo, le comete stesse potrebbero essere riguardate come una sorta di filamenti di RNA che portano l'informazione in giro nel citoplasma

– l'intero spazio occupato dal Sistema Solare – e al di fuori di esso. Un'altra immagine suggestiva che mi viene suggerita dal pensare alla nube di Oort e al suo contenere sì elementi che viaggiano verso il nostro Sole, ma anche altri che si muovono verso le stelle vicine, è quella di un immane orbitale esterno di un atomo che condivide i suoi *elettroni rocciosi* con gli altri atomi limitrofi, se vi è una energia di estrazione sufficientemente elevata. Si crea così una seppur breve "corrente di comete" che vanno a visitare *sistemi planetari-atomi* adiacenti cucendoli assieme e spingendosi chissà fino a dove.

Una volta giunto qui, il nostro Ulisse Celeste potrebbe prendere un altro passaggio verso il Sole così da ritornare a casa, dove *casa* indica sì la nostra Terra, ma anche la nostra cultura, il punto da cui si generano le nostre storie, i nostri miti, le nostre credenze e superstizioni. In questo momento egli si trova in una zona conosciuta solo per induzione, teorizzata ma non ancora osservata e che potrebbe essere la nostra futura dimora, come già Freeman Dyson – similmente a quanto fatto da Asimov con la fascia degli asteroidi – ha teorizzato nel suo interessantissimo *L'importanza di essere imprevedibile* quando dice che

In un migliaio di anni, la vita si sarà diffusa nel sistema solare fino alle zone più esterne della fascia di comete di Kuiper, mille volte la distanza della Terra dal Sole: allora, le società che non si saranno accordate sui principi di base, sul significato e sullo scopo della vita potranno porre lo spazio tra di loro, emigrando ai poli opposti del sistema solare, poiché lo spazio è grande abbastanza per tutti. Se riusciremo a fuggire dalla Terra e a diffonderci nell'universo, le prossime migliaia di anni potranno rappresentare un'età d'oro per la scienza: i viaggi spaziali esplorativi potranno aver superato i confini del sistema solare, a distanze interstellari, e i viaggi di esplorazione mentale si saranno forse già mossi in direzioni oggi difficili da immaginare. Non conosciamo nemmeno i nomi delle nuove scienze che potranno nascere e morire nell'arco di mille anni.

Man mano che mi sono imbattuto in storie ambientate nelle varie zone del nostro sistema planetario, mi è sembrato di scorgere una serie di interessanti andamenti; tendenze, oserei dire, che ho tentato di esemplificare nel diagramma Spazio-Narrativo ottenuto dal prodotto cartesiano *R · naRra*.

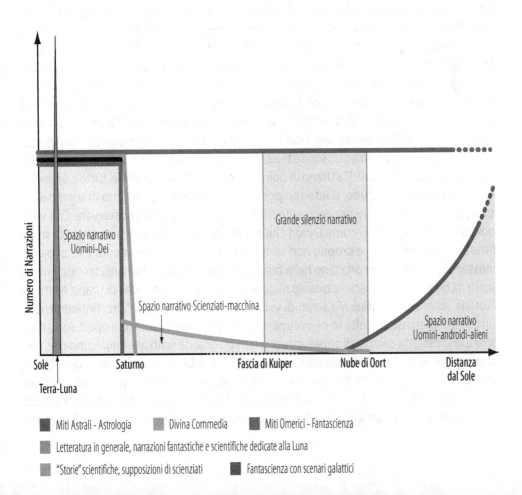

Numero di Narrazioni

Spazio narrativo Uomini-Dei

Grande silenzio narrativo

Spazio narrativo Scienziati-macchina

Spazio narrativo Uomini-androidi-alieni

Sole Saturno Fascia di Kuiper Nube di Oort Distanza dal Sole

Terra-Luna

Miti Astrali - Astrologia Divina Commedia Miti Omerici - Fantascienza

Letteratura in generale, narrazioni fantastiche e scientifiche dedicate alla Luna

"Storie" scientifiche, supposizioni di scienziati Fantascienza con scenari galattici

In esso vi sono cinque zone facilmente riconoscibili, tutte contenute sotto la linea blu praticamente ininterrotta che procede da qui alle stelle e che rappresenta il particolare spazio narrativo degli astrologi antichi e – *ahimè!* – moderni: la prima, indicata con la dicitura "uomini-dèi", è quella racchiusa nella linea rossa e nella quale si svolgono le vicende omeriche e, in generale, tutte le narrazioni antiche e moderne incentrate sulla figura umana. Essa contiene il picco arancione visibile in corrispondenza della Terra, scenario della maggior parte delle vicende umane. Un picco la nostra gabbia, dalla base larga più di 400.000 chilometri, rappresentata così per racchiudere, oltre alla Terra, anche il nostro satellite naturale dove siamo riusciti a traslare davvero qualche storia senza aver dovuto solo immaginarla. Con la *Divina Commedia*, linea verde, lo spazio umano delle narrazioni classiche è stato ampliato fino a raggiungere zone oltre l'orbita di Saturno.

In generale, i primi cinque pianeti a partire dal Sole, conosciuti sin dall'antichità in quanto visibili a occhio nudo, sono stati descritti – quindi spiegati a un primo livello – in modo massiccio con il mito e, solo nell'ultimo secolo, con la scienza. Le divinità-pianeti – co-protagoniste delle varie saghe nelle quali hanno condiviso lo spazio narrativo con umani particolari, eroi e per questo semidei – all'incalzare dell'indagine scientifica che ha svuotato il mito del suo presunto contenuto di realtà lasciandogli solo valore simbolico, hanno perduto terreno; nella zona del diagramma contenuta nella linea lilla, identificata dalla dicitura "spazio narrativo uomo-macchina", sono state sostituite con nuovi eroi dalla virilità meno epica e combattiva, ma caratterizzata da passione e competenza scientifica. Scienziati-eroi, quindi, che rimangono sulla Terra arrivando a immaginare quelle lande lontane con il solo pensiero o inviandovi nuovi, fedeli interlocutori, i classici *personaggi spalla* con i quali i protagonisti delle grandi storie condividono i loro pensieri più intimi. Interlocutori tecnologici che, se nel quadrante precedente erano ottimisticamente androidi semi-uomini – traduzione moderna dei semi-dei classici a nostra immagine e somiglianza – ora sono, più realisticamente, sonde telecomandate: in pratica, dei *Sancho Panza* fatti di metallo e circuiti integrati. Da Urano in poi, le narrazioni diminuiscono e, tutto a un tratto, superata l'orbita di Nettuno, si interrompono del tutto in corrispondenza di zone del cosmo poco conosciute, ancora oscure; teorizzate, ma poco o affatto osservate. Qui sono quindi gli stessi scienziati come Dyson che azzardano un abbozzo di narrazione di storia futura, ma di storie vere e proprie non ve ne sono. Ben inteso: sono sicuro che, al pari di inosservati asteroidi che orbitano nella fascia di Kuiper, esistano romanzi fantascientifici scritti da qualcuno sconosciuto quanto me, che arrivano a parlare anche di Urano, Nettuno, Plutone, asteroidi e Plutini. Ma sento di volere e dovere operare un filtro: fintanto che di un certo aspetto della realtà se ne occupa un autore "minore", uno le cui opere sono note solo a una ristretta cerchia di appassionati, e non un grande scrittore – qualcuno che, giustamente famoso, viene diffuso così bene da potere sensibilizzare ampie fasce di pubblico al fascino degli scenari che descrive – preferisco non annoverarne le opere in questo libro, tra le pietre miliari della letteratura di genere che hanno aiutato e che aiutano la scienza nel suo procedere. Quando Omero, Dante, Asimov, Clarke, Leopardi… scrivono di universo,

propongono una visione che rispecchia fedelmente ciò che davvero la scienza del loro tempo sa di esso: la loro è una scrittura consapevole e non solo un più o meno gratuito proiettare le vicende umane in un nuovo scenario senza porsi seriamente il problema di come lo scenario stesso può influire sulla vita dei protagonisti delle loro storie. Inoltre, le loro opere possono essere reperite ovunque, tradotte in tutte le lingue; sono *villaggio globale*. Questa a mio parere è letteratura ispirata alla scienza e che alla scienza fa del bene. Direi addirittura che, in una qualche misura, è essa stessa scienza: fintanto che di una cosa non vi sono narrazioni sufficienti, vuol dire che la scienza di quel qualcosa non sa molto; a volte vale anche l'opposto, ma spesso la fantascienza ha visto cose che l'indagine scientifica, stimolata dalla letteratura, ha scoperto solo a posteriori: si pensi ai romanzi di Verne o all'uso addirittura esagerato di teletrasporti in *Star Trek* e affini.

Le narrazioni letterarie riprendono subito dopo il "buio conoscitivo" o, se preferite, "il grande silenzio narrativo" posto tra i sistemi planetari limitrofi: stelle vicine e lontane, galassie, quasar… Pur essendo estremamente più lontani da noi della fantomatica nube di Oort, grazie alla grande quantità di luce che questi oggetti emettono, possono essere studiati così bene da costituire una ghiotta occasione per quanti sognano storie proiettate su grandi scale cosmiche. L'andamento delle narrazioni scientifiche qui subisce di nuovo un'impennata (linea viola) che lo fa assomigliare a quello delle narrazioni mitologiche, quasi a riprodurre, a distanze di tempo e di spazio enormemente più grandi, un nuovo evo dal sapore antico. Uomini, eroi (dei) e androidi (semidei) tornano a condividere il quadrante più a destra del mio schema incontrandovi spesso delle presenze aliene che, ci aspettiamo, esistano al di là dei confini del nostro Sistema Solare. Se poi pensiamo a come dal 1995 in poi abbiamo scoperto circa trecentocinquanta pianeti attorno ad altre stelle della nostra galassia, possiamo ragionevolmente pensare che vi siano altre intelligenze qui e là che scrutano lo stesso nostro universo da una diversa angolazione. Se così è, mi viene facile credere che la nostra Galassia, prima ancora di essere un enorme agglomerato di centinaia di miliardi di stelle, sia da riguardare come un coacervo di infinite storie raccontate nei linguaggi più strani. Una galassia antologica, a sua volta piccola parte di una immane Biblioteca di Babele, *L'universo (che altri chiama la Biblioteca)*, capace di darmi una vertigine per nulla diversa da quella regalatami dalla lettura dell'omonimo racconto di Borges in *Finzioni*. Il nostro Ulisse Celeste – *apripista* dell'umanità – decide, esattamente come l'eroe omerico nell'interpretazione di Dante, di proseguire per andare a cogliere quanto si dice altrove, fuggendo dalla provincia nella quale tutti noi viviamo. Me lo immagino accompagnato in modo più che discreto dalla lunga pausa che costruisce la composizione di Cage intitolata *4:33* il cui spartito specifica solo che qualsiasi strumento si scelga per l'esecuzione, bisogna attenersi a un *TACET* lungo quanto indica il titolo. Pare che fosse nelle intenzioni dell'autore riferire il titolo alla espressione numerica della temperatura in gradi centigradi corrispondente allo zero assoluto – i circa -273°C che, come abbiamo visto, si misurerebbero nel vuoto interstellare se non vi fosse la radiazione di fondo – ottenuta mediante la somma dei secondi contenuti in quattro minuti e trentatré:

$$\left[\quad 60'' + 60'' + 60'' + 60'' + 33'' = 273'' \quad \right]$$

Ancora una volta troviamo spazio, tempo e musica uniti a descrivere il mondo.

Ascoltando solo il ritmo interno del suo battito cardiaco, con una *elegante speranza a rallegrare la sua solitudine*, il nostro Ulisse Celeste scivola silenzioso verso nuove stelle, verso nuove storie, verso un nuovo libro…

E subito riprende
il viaggio
come
dopo il naufragio
un superstite
lupo di mare

Ungaretti, *Allegria dei naufragi*

Appendice A
Indice delle illustrazioni

Indice
Pianeti alla chitarra VIII

Preludio · Come leggere una partitura
Dominio-Co(n)dominio 8

Una cipolla di vetro: l'universo Swarovski
Cosmo-Cipolla Swarovski 10
Sfogo stellare 16
Atlas eclipticalis 18
Unico spettacolo 1 19
Unico spettacolo 2 19
Unico spettacolo 3 19
Unico spettacolo 4 19
Un caffè alto, *please*! 19
Il catalogo 20
Leggere il cielo 21
Spettatore in prima fila 23
Pianeta ubriaco 25
Cosmo carillon 26
Melodie 28
Quel drogato di Pitagora 29
Non ne vuol sapere 1 30
Non ne vuol sapere 2 30
L'*ellissatura* dell'ellisse 31

Gravità, mele e cipolle

Una mela al giorno 32

Mondo spigoloso 33

Orizzonti cubici 34

E tornammo a rivedere le stelle 36

Bi-eclisse… mignolare 37

Cono Aristarco 38

Diverse cadute 39

Cipolla empedoclea 44

Pianeti alla chitarra 51

Rock-Blues pitagorico 52

Tetraktys 53

Pianote-LP Kepleriano 53

Fiat Cosmos 55

Carta di identità cosmica 56

Spago & Rotolo 58

Ai sensi della legge 666 59

Newton e la Meluna 60

Intermezzo matematico

Addizione di idee 63

La gocciolina di Mercurio

Tintarella su Mercurio 64

Nascita del Caloris Planitia 66

Transito di Mercurio 70

Cartina Olimpo-Hissarlick 71

Sole-Orco e Mercurio-Pollicino 37

Ipotesi sull'origine di Mercurio 76

Dualità onto-corpuscolare per Mercurio 78

Venere: le fregature della bellezza

Velista per necessità 80

Botticelli spaziale 80

La dualità onto-corpuscolare per Venere 83

Venere e i suoi unici satelliti 89

Venere 1 91
Venere 2 92
Assaggiare il campo gravitazionale 92
Abbandonando Venere 95

Interludio · Il pianeta Giuseppe
Giuseppe 96

La Luna, lo specchietto retrovisore
Retrospettiva 98
Chi ha rubato le lancette alla Luna? 101
Luna salvadanaio 103
For sale 107
Luna politica 109
Sequenza pizza "Luna Rossa" 109

Improvviso · Evasioni planetarie
Calandosi col lenzuolo 112
T-chimetro 115

La Terra, il covo dei cafoni
Terra Casa 118
Inquinamento spaziale 120
Vietato Sputnik! 121
Se lo Shuttle fosse svizzero… 123
Shuttle colpito dai detriti 124
La stazione Spaziale Internazionale 125
Murales spaziale 126
La dualità onto-corpuscolare per la Terra 129
Pessimismo cosmico 130
Serenata per un satellite 132
Satellite Maderna 134
Stelle evaporate 135
Il satellite Filomena 137

Marte, la terra promessa (ma non ancora mantenuta)

Velocità di fuga 138
Prima tappa 140
Colpo di reni 141
Landing 1 142
Landing 2 142
Atterraggio morbido 143
La dualità onto-corpuscolare per Marte 144
Invasione da Marte 146
Guardati a dista(nza) 148
La faccia sul pianeta rosso 157
Marte-Lattina 159

I mattoni avanzati: la fascia degli asteroidi

Spazi abusivi 162
Io c'ero! 166
Ohi! 167
Rattoppo gravitazionale 168
Pirati degli asteroidi 170
Cercando Cerere – Appoggio – Stacco 171
Salpare dalle isole 173

Giove, il gigante o la bambina?

Assalto a Giove 174
Mongolfiera 177
Mongolfiera Sole 177
La dualità onto-corpuscolare per Giove 179
Vorrebbe essere una star! 182
A tu per tu con Polifemo 183
TMA 186
Balzo – Intenzione – L'ho fatto! – Mi è andata bene! 192
Planet climbing 192

Saturno, la lama rotante

Scendere in pista 194

Pista da disco 198

La dualità onto-corpuscolare per Saturno 199

Il vecchio Saturno e la sua dentiera 203

Blade Runner 204

Salto in lungo 207

Urano, il corpo... celeste!

A tu per tu con il fantasma 208

Sorpresa! 209

La dualità onto-corpuscolare per Urano 212

Urano K.O. 215

Fiammella trigonometrica 218

Iper Urano 221

Intermezzo · Spazz-Aree: fondamenti di scopone scientifico

Torta angolare 223

Discorsi ellittici 224

Eclittica vista di tergi 225

Nettuno, il pianeta venuto dal freddo... calcolo

Sfiorando Nettuno 226

La penna di Le Verrier 229

Tiro alla fune 229

La dualità onto-corpuscolare per Nettuno 232

Plutone, il bocciato

Calculum Plutinianum 234

La dualità onto-corpuscolare per Plutone 236

Altri calcoli 239

AbbrusColito 240

Oltre Caronte 241

La fascia di Kuiper, il nostro recinto – La nube di Oort, la cellula

Muro a secco di Kuiper 242

Prospettive in retrospettiva 244

Coda e calvizie 245

Mura di cinta 247

Lampadine cinesi 248

Guarda! Delle stelle cadenti! Dove? Qui… 253

Coda o Epilogo

Comet-surfing 254

Cosmo-cellula 255

Correnti cometarie 256

Diagramma Spazio-Narrativo 257

Invito 260

Salto 261

Ad Astra 261

Biblio-disco-filmo-web-grafia 271

Disco Inn-dice 261

Appendice B
Un po' di numeri

Costanti fisiche utili

Costante	Simbolo	Valore
Costante gravitazionale	G	$= 6{,}67 \cdot 10^{-8}$ dyne cm^2 g^{-2}
Velocità della luce	c	≈ 300.000 km/s
Costante di Boltzmann	k	$1{,}38 \cdot 10^{-16}$ erg °K^{-1}
Massa del protone	m_p	$1{,}67 \cdot 10^{-24}$ g
Massa dell'elettrone	m_e	$9{,}10 \cdot 10^{-28}$ g

Sistema Solare: alcuni dati

Massa del Sole	$1,98 \cdot 10^{33}$ g
Raggio equatoriale del Sole	$6,9 \cdot 10^{10}$ cm
Luminosità del Sole	$3,82 \cdot 10^{33}$ erg s^{-1} = $3,82 \cdot 10^{26}$ W (1 Watt = 10^7 erg s^{-1})
Temperatura superficiale del Sole	5.770 °K
Unità Astronomica (A.U.)	$1,49 \cdot 10^8$ km
Massa della Terra (M_{Terra})	$5,97 \cdot 10^{27}$ g
Raggio equatoriale della Terra (R_{Terra})	6.378 km
Massa della Luna	$7,35 \cdot 10^{25}$ g
Raggio equatoriale della Luna	1.738 km
Massa di Mercurio	0,05 M_{Terra}
Raggio equatoriale di Mercurio	0,38 R_{Terra}
Massa di Venere	0,8 M_{Terra}
Raggio equatoriale di Venere	0,95 R_{Terra}
Massa di Marte	0,1 M_{Terra}
Raggio equatoriale di Marte	0,5 R_{Terra}
Massa di Giove	317,89 M_{Terra}
Raggio equatoriale di Giove	11,19 R_{Terra}
Massa di Saturno	95 M_{Terra}
Raggio equatoriale di Saturno	9,46 R_{Terra}
Massa di Urano	14,5 M_{Terra}
Raggio equatoriale di Urano	4 R_{Terra}
Massa di Nettuno	17 M_{Terra}
Raggio equatoriale di Nettuno	3,8 R_{Terra}
Massa di Plutone	0,002 M_{Terra}
Raggio equatoriale di Plutone	0,18 R_{Terra}

Ringraziamenti

Devo omaggiare molte anime che si sono prestate, in un modo o nell'altro, a sostenermi nell'impresa di scrivere, ascoltare e disegnare questo libro. Gli aiuti che da loro ho ricevuto spaziano dal confronto su temi tecnici, al semplice e importantissimo farmi sapere che, anche nei momenti più difficili, erano lì per stimolarmi a procedere. Qualcuno mi ha poi fornito un libro introvabile; qualcun altro ha letto parti del libro che avete in mano permettendomi di studiare le sue reazioni mentre scorreva in mia presenza le prove di impaginato; una di loro mi regala da dieci anni la sua muta e rassicurante presenza segnalata da sguardi languidi e scodinzolate eloquenti e generose. La quotidiana normalità di alcuni interventi (tra cui annovererei il paziente lavoro compiuto da tutta la redazione della Springer, in testa Barbara: un affascinante mastino in gonnella dall'abbaiare flautato che mi è stato messo alle calcagna dalla furbissima Marina Forlizzi) e l'eccezionalità di altri, ha costituito un ottimo appoggio per lavorare con la necessaria serenità.

Quindi procedo a ringraziarli tutti ponendoli in ordine alfabetico e sperando di non dimenticare nessuno. Si tratta di:

Cristina Adamo, Lulamae Adamo, Barbara Amorese, Gianluca Barbaro, Alice Barbaro, Roberto Bartolini, Pierluigi Battistini, Roberto Bedogni, Alessandro Bonetti, Antonio Busellato, Roberto Busellato, Max Caleffi, Alberto Cappi, Dolores Carnemolla, Barbara Chiari, Rodrigo Contreras, Mauro Di Martino, Claudia Femora, Flavio Fusi Pecci, Marina Forlizzi, Renato & Salvatore Geremicca, Gianmarco Gualandi, Marco Lorenti, Elisa Magistrelli, Irene Notaro, Stefano Sandrelli.

Tengo in modo particolare a sottolineare il ruolo ricoperto dal curatore del libro, Massimo "Max" Calvani. Mentre in molti casi ho apprezzato tanto il suo personale apporto, in altri mi sono trovato in totale disaccordo con i suoi commenti, arrivando anche ad arrabbiarmi non poco per alcuni di essi. Insomma, tutto nella norma. Ma ciò che ai miei occhi lo ha posto definitivamente in una luce particolare è il fatto singolare che molti anni fa, nel mio peregrinare tra diverse facoltà italiane (Arcavacata, Padova, Bologna) mi sono imbattuto nel suo corso di Fisica Solare, una etichetta pro-forma che – come spesso accade – non dice nulla del reale contenuto dell'insegnamento impartito. In questo caso il titolo celava un corso di Relatività Generale (Max è un esperto di oggetti collassati) e, nel chiudere l'ultima

lezione del corso, dopo avere riempito alcune lavagne di tensori & affini, il buon Max ha così chiosato, sottolineando le sue parole con un ampio segno circolare del gesso sulla lavagna, teatralmente perfetto: "Questa è la migliore teoria che abbiamo per spiegare il cosmo. Anzi, questa è la migliore teoria che pensiamo di avere. Magari, a nostra insaputa, la migliore per comprendere l'Universo si cela in una sonata di Bach". All'epoca ero molto più giovane ed ero già intimamente convinto che le cose dovessero stare così e che le risposte di cui siamo ghiotti possono e devono essere cercate nell'intersezione tra le migliori creazioni intellettuali – artistiche e scientifiche – che la nostra razza è stata capace di elaborare e da quando, diversi anni prima, ho iniziato a studiare musica arrivando a conoscere l'opera di Bach, ho sentito che lì c'era molto di più di un semplice fatto musicale. Beninteso, non sono il primo a dirlo: basta dare un'occhiata anche solo al libro di Hofstadter *Gödel, Escher, Bach* (che, ho scoperto, piace molto anche a Calvani) per trovare questa idea molto ben sviluppata. Il problema era che all'epoca non mi sentivo autorizzato a esternare questa mia visione trasversale in una facoltà che spingeva l'acceleratore solo sulla dimensione fisico-matematica dello studio del cosmo, e il sentire le parole di Max mi ha fornito un po' di quella benzina utile per insistere a tenere nel giusto conto anche ciò che nessun altro lì dentro sembrava reputare importante. Qualcuno mi dice che altrove non è così, che addirittura in alcune facoltà scientifiche americane viene incoraggiato l'ingresso di artisti con l'obiettivo di stimolare una reciproca ispirazione tra ricercatori e pittori, scrittori, musicisti… Se ciò corrisponde al vero, peccato per noi italiani, che saremmo "inter-culturali" per storia e vocazione. In ogni caso, grazie Max. E infine, grazie Bach.

Biblio-disco-filmo-web-grafia

Alighieri Dante (2008) *La Divina Commedia*, Garzanti, Milano

Aristotele (2002) *Il cielo*, Bompiani, Milano

Asimov Isaac (1988) *Lucky Starr e i pirati degli asteroidi*, Mondadori, Milano

Asimov Isaac (1989) *Lucky Starr e gli Oceani di Venere*, Mondadori, Milano

Asimov Isaac (1991) *Lucky Starr e le lune di Giove*, Mondadori, Milano

Asimov Isaac (1995) *Lucky Starr e gli anelli di Saturno*, Mondadori, Milano

Asimov Isaac (1995) *Lucky Starr e il grande Sole di Mercurio*, Mondadori, Milano

Asimov Isaac (1998) *Lucky Starr il vagabondo dello spazio*, Mondadori, Milano

Asimov Isaac (2003) *Io, robot*, Mondadori, Milano

Barbieri Cesare (1999) *Lezioni di Astronomia*, Zanichelli, Bologna

Barrie James M. (2009) *Peter Pan*, Mondadori, Milano

Beethoven Ludwig Van (2001) Sonata quasi una fantasia No 14 in Do diesis minore, Op. 27 No. 2 "Al chiaro di Luna", Maria-João Pires, piano, Apex, Warner Classics, UK

Beethoven Ludwig Van (2005) *Sonate per pianoforte*, vol. 1, Sonata quasi una fantasia No 14 in Do diesis minore, Op. 27 No. 2, Ricordi, Milano

Benjamin Walter (2000) *L'opera d'arte nell'epoca della sua riproducibilità tecnica*, Einaudi, Torino

Birolli Viviana (a cura di) (2008) *Manifesti del Futurismo*, Ed. Abscondita

Borges Jorge Luis (1989) *Tutte le opere*, Vol. I, Mondadori, Milano

Brahic Andrè (2001) *Figli del tempo e delle stelle*, Bollati Boringhieri, Torino

Brown Dan (2009) *Il codice Da Vinci*, Mondadori, Milano

Cage John, *Atlas Eclipticalis*, Edition Peters

Cage John, *Atlas Eclipticalis*, WERGO 1993

Cage John, *4'33"*, Edition Peters

Calvino Italo (1992) Le cosmicomiche, in: Berenghi M.; Falcetto B.; Milanini C. (a cura di) Romanzi e racconti. Vol. 2, I Meridiani, Mondadori, Milano

Carroll Bradley W., Ostlie Dale A. (1996) *An introduction to modern astrophysics*, Addison Wesley

Cattabiani Alfredo (2001) *Planetario*, Mondadori, Milano

Clarke Arthur C. (1952) *Le sabbie di Marte*, Mondadori, Milano

Clarke Arthur C. (1981) *2001 Odissea nello spazio*, BUR, Milano

Clarke Arthur C. (1986) *2010 Odissea due*, BUR, Milano

Copernico Niccolò (1975) De rivolutionibus orbium caelestium, Einaudi, Torino

Diamond Jared (2000) *Armi, acciaio, malattie*, Einaudi, Torino

Disney Walt (1953) *Le avventure di Peter Pan*, Animazione, USA

Dukas Paul (1997) *The Sorcerer's apprentice*, Dover, USA

Dukas Paul (1990) *The Sorcerer's apprentice*, Leopold Stokowski and the Philadelphia Orchestra, Buena Vista records

Dyson Freeman (1998) *L'importanza di essere imprevedibile*, Di Renzo Editore, Roma

Esiodo (1998) *Opere*, Einaudi-Gallimard, Torino

Esiodo (2007) *Teogonia*, BUR, Milano

Fubini Enrico (2004) *La musica: natura e storia*, Einaudi, Torino

Galilei Galileo (1993) *Sidereus Nuncius*, Marsilio, Venezia

Galilei Galileo (2002) *Dialogo sopra i due massimi sistemi del mondo*, Einaudi, Torino

Graves Robert (2008) *I miti greci*, Longanesi, Milano

Greco Pietro (2009) *L'astro narrante*, Springer-Verlag Italia, Milano

Gombrich Ernst H. (2008) *La storia dell'arte*, Phaidon, Londra, UK

Heinlein A. Robert (1987) *Storia futura*, Arnoldo Mondadori Editore, Milano

Hyams Peter (Regia di) (1984) *2010 – L'anno del contatto*, interpretato da Roy Scheider

Hofstadter Douglas R. (1990) *Gödel, Escher, Bach: un'eterna Ghirlanda Brillante*, Adelphi, Milano

Holst Gustav (1996) *The Planets*, Dover

Holst Gustav, *The Planets*, Berliner Philarmoniker, H. von Karajan, Deutsche Grammophon

Holst Gustav, *The Planets*, S. Rattle, Berliner Philarmoniker, EMI Classic (Contiene "Pluto, the Renewer" di C. Matthews, "Asteroids 4179: Toutatis" di Kai Jai Saariaho, "Ceres" di Mark-Antony Turnage)

Hoskin Michael (a cura di) (2001) *Storia dell'Astronomia di Cambridge*, BUR, Milano

Igino (2009) *Mitologia Astrale*, Adelphi, Milano

Ings Simon (2008) *Storia naturale dell'occhio*, Einaudi, Torino

Kubrick Stanley (Regia di) (1968) *2001: Odissea nello spazio*,

Kandinsky Wassily (1968) *Punto, linea, superficie*, Adelphi

Leopardi Giacomo (2007) *Operette Morali*, BUR, Milano

Levi Primo (2005) *Il sistema periodico*, Einaudi, Torino

Lovelock James (2002) *Gaia – Nuove idee sull'ecologia*, Bollati Boringhieri, Torino

Luciano (1991) *Storia vera*, Mondadori, Milano

Mach Ernst (1977) *La meccanica nel suo sviluppo storico-critico*, Bollati Boringhieri, Torino

Maderna Bruno, *Serenata per un satellite*, Ricordi

Manilio (2001) *Il poema degli astri*, Volume I, Fondazione Lorenzo Valla/Mondadori, Milano

Matthews Colin (2000) *Pluto, the Renewer*, Faber music

Mila Massimo (1999) *Maderna musicista europeo*, Einaudi, Torino

Minkowski Eugène (2005) *Verso una cosmologia*, Einaudi, Torino

Montale Eugenio (2009) *Tutte le poesie*, Mondadori, Milano

Perrault Charles (2007) *Le fiabe di Perrault*, Hoepli, Milano

Publio Ovidio Nasone (1994) *Metamorfosi*, Einaudi, Torino

Omero (1989) *Iliade*, Einaudi, Torino

Omero (2009) *Iliade*, Trad. Vincenzo Monti, Oscar Mondadori, Milano

Omero (2005) *Odissea*, Einaudi, Torino

Omodeo Pietro (2001) *Alle origini delle scienze naturali (1492-1632)*, Rubbettino editore, Soveria Mannelli (CZ)

Pannekoek Anton (1961) *A history of Astronomy*, Dover

Peebles P.J.E. (1993) *Principles of Physical Cosmology*, Princeton University Press, Princeton, New Jersey, USA

Poe Edgar Allan (1996) *Racconti*, Einaudi, Torino

The Police (1979) *Regatta de Blanc*, A&M Records, Inc., Hollywood, California, USA

Prokofiev Serge (1990) *Pierino e il lupo*, Deutsche Grammophon, , Roberto Benigni, Claudio Abbado

Rodari Gianni (1995) *I cinque libri*, Einaudi, Torino

Rosino Leonida (1979) *Lezioni di Astronomia*, Edizioni Cedam, Padova

Russo Lucio (2001) *La rivoluzione dimenticata*, Feltrinelli, Milano

Schiaparelli Giovanni Virgilio (1998) *La vita sul pianeta Marte. Tre scritti di Schiaparelli su Marte e i «marziani»*, P. Tucci, A. Mandrino, A. Testa (a cura di), Mimesis, Milano

Schopenhauer Arthur (2008) *Il mondo come volontà e rappresentazione*, Laterza, Bari-Roma

Schönberg Arnold (2002) *Manuale di armonia*, Net, Il Saggiatore, Milano

Shakespeare William (1996) *Sogno di una notte di mezza estate*, Mondadori, Milano

Sobel Dava (2005) *Pianeti*, Rizzoli, Milano

Sonnenfeld Barry (1997) *Men in Black*, Columbia Pictures, USA

Strauss Richard, *Also Sprach Zarathustra*, Dover

Strauss Richard, *Also Sprach Zarathustra*, in: "Hollywood Collection – Vol. 2", CBS

Swift Jonathan (2004) *I viaggi di Gulliver*, Feltrinelli

Tolkien John Ronald Reuel (2005) *Il signore degli anelli*, Bompiani, Milano

Ungaretti Giuseppe (1969) *Vita di un uomo. Tutte le poesie*, Piccioni Leone (a cura di), I Meridiani, Mondadori, Milano

Verdet Jean-Pierre (1995) *Storia dell'Astronomia*, Longanesi, Milano

Vernant Jean-Pierre (2001) *L'universo, gli dèi, gli uomini*, Einaudi, Torino

Verne Julius (1959) *Dalla Terra alla Luna*, Rizzoli, Milano

Virgilio (1989) *Eneide*, Einaudi, Torino

Weir Peter (Regia di) (1998) *The Truman Show*, con Jim Carrey,

Welles Orson (1990) *La guerra dei mondi*, Baskerville, Bologna

Wells Herbert George (1991) *La guerra dei mondi*, Mursia, Milano

Varie voci dell'enciclopedia libera online Wikipedia: www.wikipedia.org, http://it.wikipedia.org/wiki/Pagina_principale

i blu - pagine di scienza

Passione per Trilli
Alcune idee dalla matematica
R. Lucchetti

Tigri e Teoremi
Scrivere teatro e scienza
M.R. Menzio

Vite matematiche
Protagonisti del '900 da Hilbert a Wiles
C. Bartocci, R. Betti, A. Guerraggio, R. Lucchetti (a cura di)

Tutti i numeri sono uguali a cinque
S. Sandrelli, D. Gouthier, R. Ghattas (a cura di)

Il cielo sopra Roma
I luoghi dell'astronomia
R. Buonanno

Buchi neri nel mio bagno di schiuma *ovvero* **L'enigma di Einstein**
C.V. Vishveshwara

Il senso e la narrazione
G.O. Longo

Il bizzarro mondo dei quanti
S. Arroyo

Il solito Albert e la piccola Dolly
La scienza dei bambini e dei ragazzi
D. Gouthier, F. Manzoli

Storie di cose semplici
V. Marchis

Noveper**nove**
Segreti e strategie di gioco
D. Munari

Il ronzio delle api
J. Tautz

Perché Nobel?
M. Abate (a cura di)

Alla ricerca della via più breve
P. Gritzmann, R. Brandenberg

Gli anni della Luna
1950-1972: l'epoca d'oro della corsa allo spazio
P. Magionami

Chiamalo x!
ovvero **Cosa fanno i matematici?**
E. Cristiani

L'astro narrante
La Luna nella scienza e nella letteratura italiana
P. Greco

Il fascino oscuro dell'inflazione
Alla scoperta della storia dell'Universo
P. Fré

Sai cosa mangi?
La scienza nel cibo
R.W. Hartel, A.K. Hartel

Water trips
Itinerari acquatici ai tempi della crisi idrica
L. Monaco

I lettori di ossa
C. Tuniz, R. Gillespie, C. Jones

Pianeti tra le note
Appunti di un astronomo divulgatore
A. Adamo

Il cancro e la ricerca del senso perduto
P.M. Biava

Di prossima pubblicazione

La strana storia della Luce e del Colore
R. Guzzi

La fine dei cieli di cristallo
L'Astronomia al bivio del '600
R. Buonanno

ISBN 978-88-470-11847

€ 23,00

Finito di stampare nel mese di ottobre 2009

Printed in the United States
By Bookmasters